KT-462-362

Graphis Inc. is committed to celebrating exceptional work in international Design, Advertising, Illustration & Photography.

US$375.00 UK£220.00

ISBN 978-1864705584

9 781864 705584 37500

Published by **Graphis** ǀ Publisher & Creative Director: **B. Martin Pedersen** ǀ Executive Director: **Perry Betts** ǀ Designer: **Hee Ra Kim**

Editor: **Rachel Lowry** ǀ Production: **Kelvin Ng** ǀ Design Assistant: **Hyeon Kyeong Seo**

We extend our heartfelt thanks to the international contributors who have made it possible to publish a wide spectrum of the best work in Design, Advertising, Art/Illustration and Photography. Graphis is located at 389 Fifth Avenue, Suite 1105, New York, NY 10016. Anyone is welcome to submit work at www.graphis.com. Copyright @ 2015 Graphis, Inc. All rights reserved. Jacket and book design copyright © 2015 by Graphis, Inc. No part of this book may be reproduced, utilized or transmitted in any form without written permission of the publisher. ISBN: 978-1-932026-96-2. Printed in China.

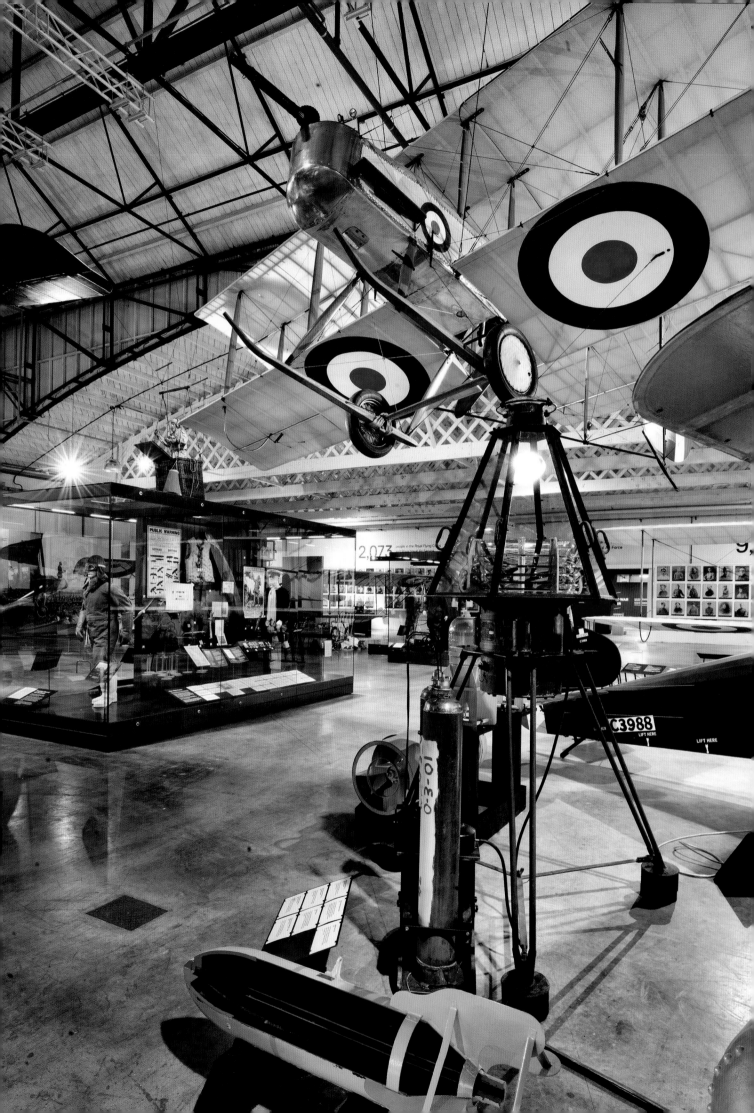

Contents

Previous page: *"Safdie," by Pentagram* | Opposite page: *"The First World War in the Air," by Ralph Appelbaum Associates, Inc.*

In Memoriam

The Americas

Carlos Falchi
1944-2015
Accessories Designer

Michael Graves
1934-2015
Architect and Designer

Robert Kinoshita
1914-2014
Production Designer

Patrick McDarby
1957-2015
Logo Designer

Patricia Norris
1931-2015
Designer

Robert Pellegrini
1939-2015
Graphic Designer

Rex Ray
1956-2015
Graphic Designer

Oscar de la Renta
1932-2014
Fashion Designer

Deborah Sussman
1931-2014
Pioneer in Environmental Graphic Design

Europe & Africa

Koos van den Akker
1939-2015
Fashion Designer

Vince Camuto
1936-2015
Designer

Keith Cunningham
1929-2014
Graphic Designer

Francesco Smalto
1927-2015
Fashion Designer

Janet Turner
1936-2015
Designer

Betty Willis
1923-2015
Graphic Designer

Hermann Zapf
Typeface Designer and Calligrapher
1918-2015

Asia & Oceania

Keith Cunningham
1929-2014
Graphic Designer

Kenji Ekuan
1929-2015
Industrial Designer

Basil Soda
1967-2015
Fashion Designer

For additional work and biographies for these and other Graphis Design Masters, visit Graphis.com/masters.

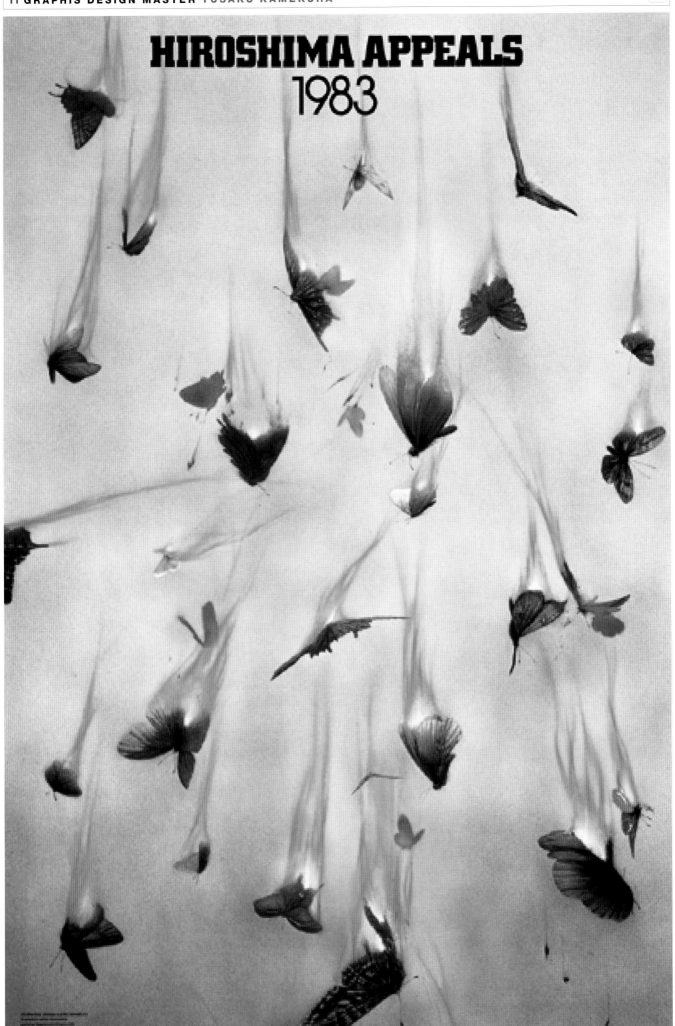

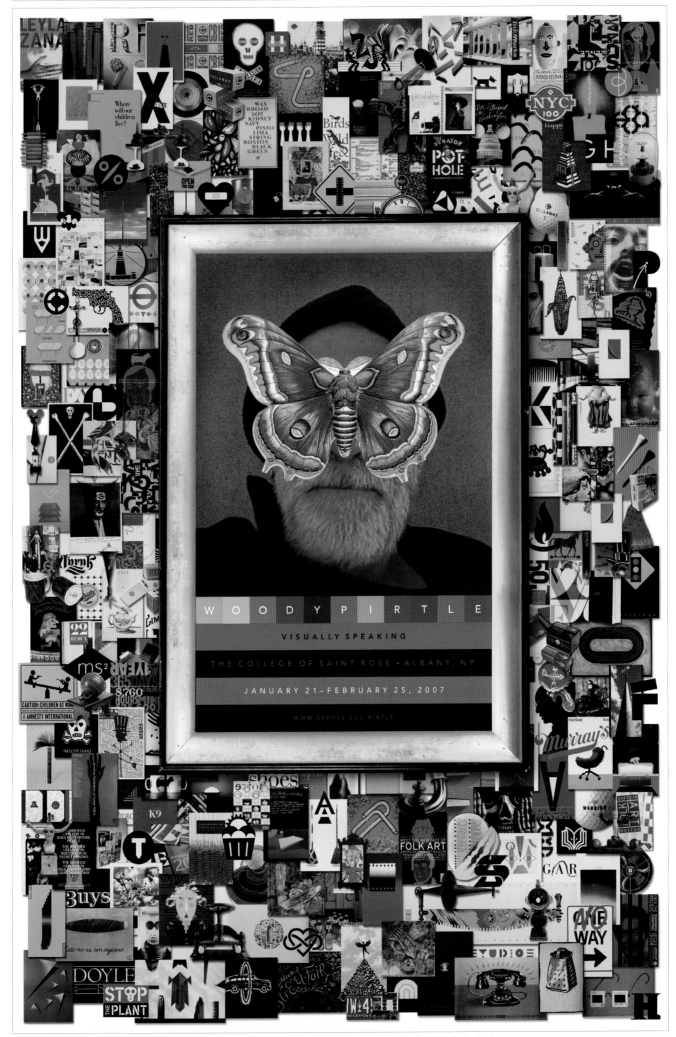

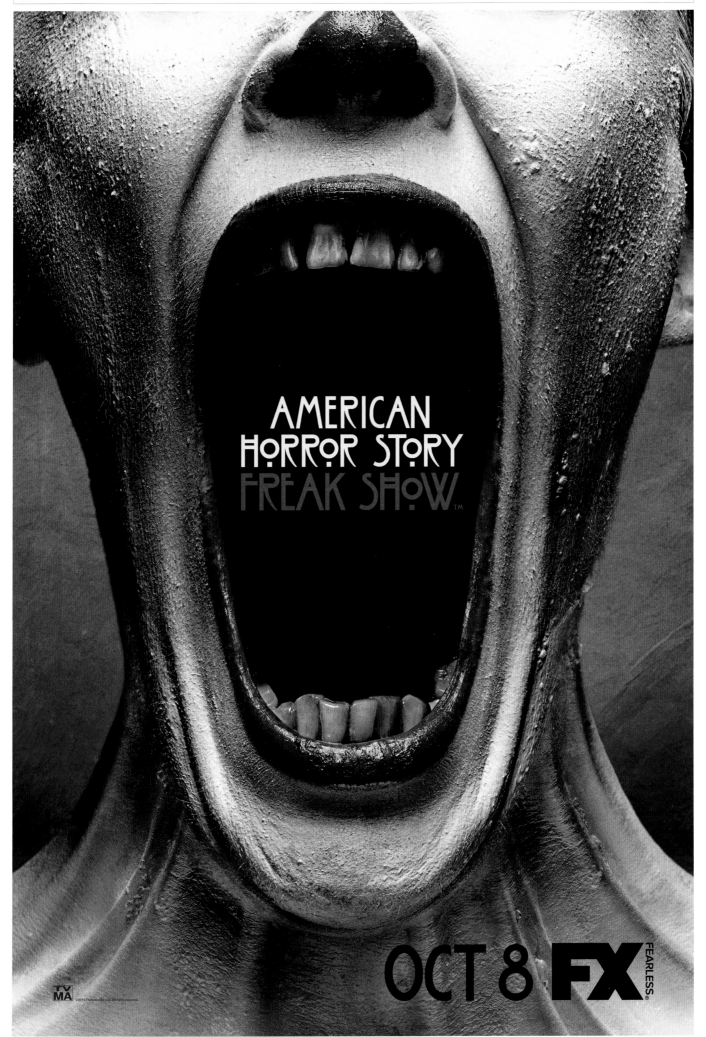

hofmann.to

LIEBER LESEN

!

1. Luzerner Bücher-Weihnachtsmarkt

Kultur-Forum, Bruchstrasse 53, Luzern

FR 16. Dezember, 16-20 Uhr
SA 17. Dezember, 10-17 Uhr
FR 19 Uhr: Büchertombola !

mit Büchern der Verlage AURA, Das Fünfte Tier, Der gesunde Menschenversand, Open Door, Pro Libro, pudelundpinscher, Quart, Martin Wallimann, Vier-Augen und der Hirschmatt Buchhandlung.

Kaffee und Kuchen der IG Kultur Luzern.

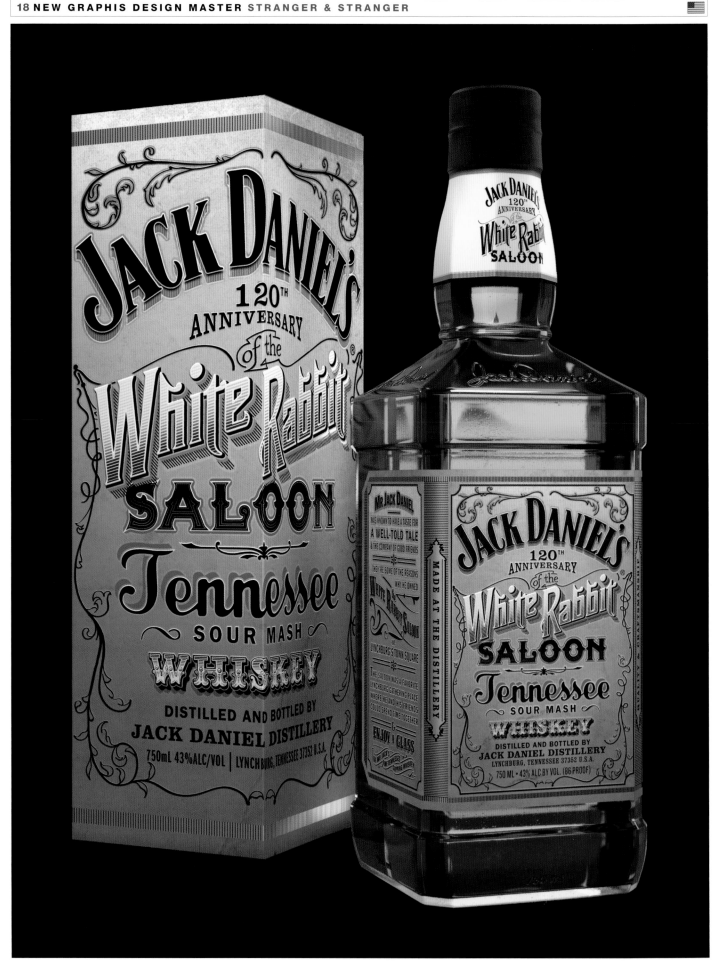

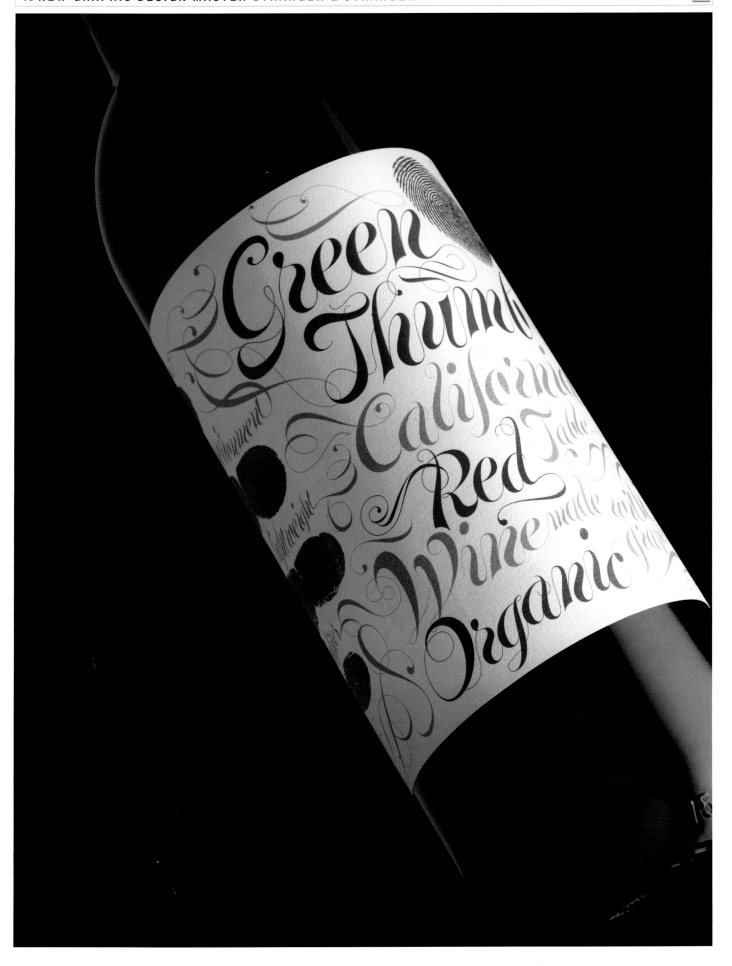

Leopoldo Milà i Sagnier (Barcelona, 1921–2006) was a Catalan industrial designer, founder of the Polinax and DAE companies. In 1958 he became the technical director of the motorcycle company Montesa, where he created and designed the highly successful Impala model, winner of the Golden Delta Award (ADI–FAD) in 1962. Based on a simple 2 stroke monocylinder engine and a very stable frame, it is characterized by a rounded tank, a unique engine sound and a guitar shaped seat. The clean and simple design of the Impala quickly became an icon of the motorcycling industry. To demonstrate the quality and reliablility of the motorcycle, three Impala prototypes successfully crossed Africa from all the way from Cape Town to Tunis in a historic endeavour baptized the "Impala operation". Milá went on to create the award winning Montesa Cota 247. He continues being a reference in the Spanish motorbike industry.

Leopoldo Milá

23

Museu del Disseny
de Barcelona

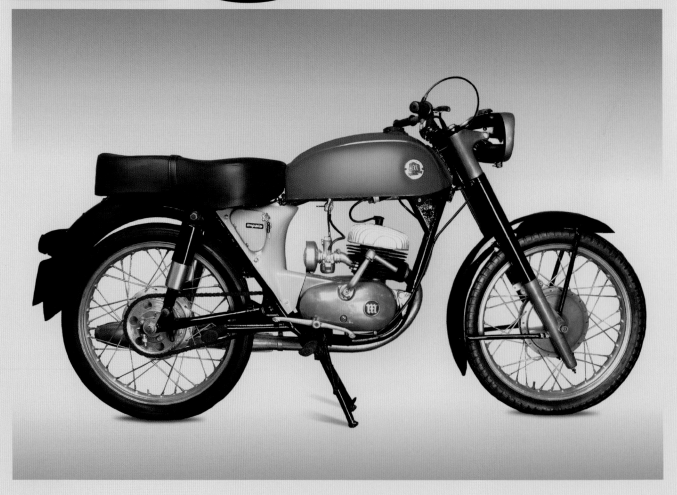

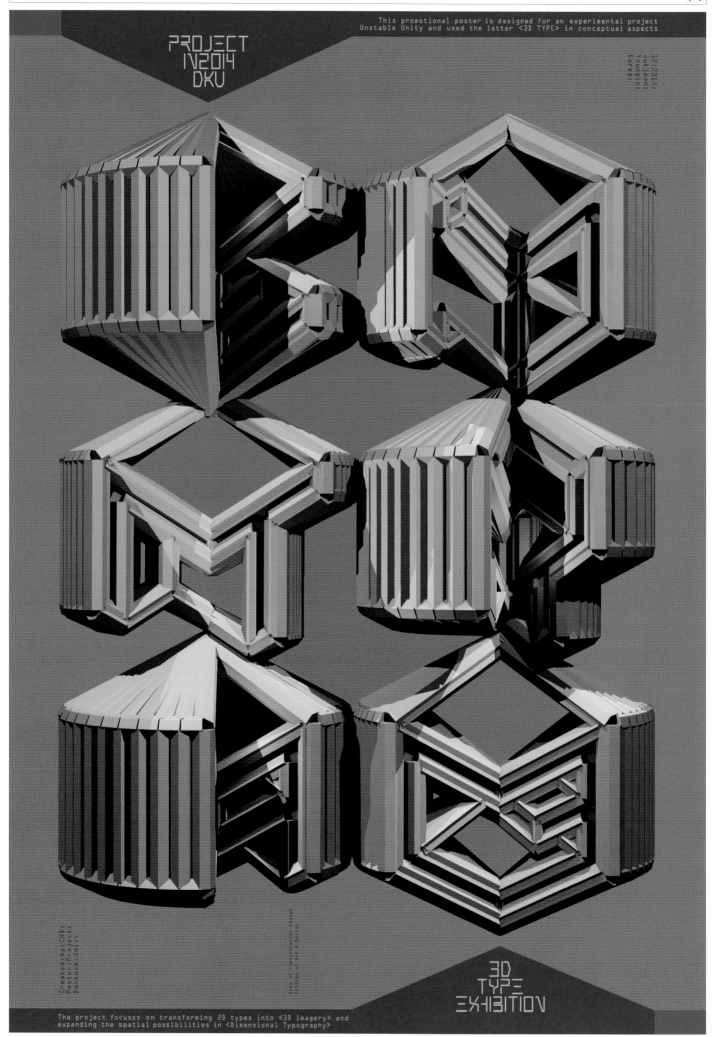

Design Firm: **Dankook University** | Client: **Self-initiated** | Category: **Poster** | Page: **127**

Sunday / February 8 / 2015

ART CENTER

OPEN HOUSE

UNDERGRADUATE DEGREE PROGRAMS IN: ADVERTISING, ENTERTAINMENT DESIGN, ENVIRONMENTAL DESIGN, FILM, FINE ART, GRAPHIC DESIGN, ILLUSTRATION, INTERACTION DESIGN, PHOTOGRAPHY AND IMAGING, PRODUCT DESIGN, TRANSPORTATION DESIGN

Ongoing 12:00–4:30 pm

View student work from
the undergraduate programs

Talk with faculty and staff

Two Campus Locations

Hillside Campus: All majors except Fine Art
1700 Lida Street, Pasadena, CA 91103

South Campus: Fine Art Majors
870 S. Raymond, Pasadena, CA 91105

Special Sessions at Both Campuses

Admissions / Financial Aid: 1:30 & 3:00 pm

Directions: www.artcenter.edu
No RSVP Necessary

Shuttle available between campuses

@ Art Center College of Design

Design Firm: **Brad Bartlett Design, LA** I Client: **Art Center College of Design** I Category: **Poster** I Page: **131**

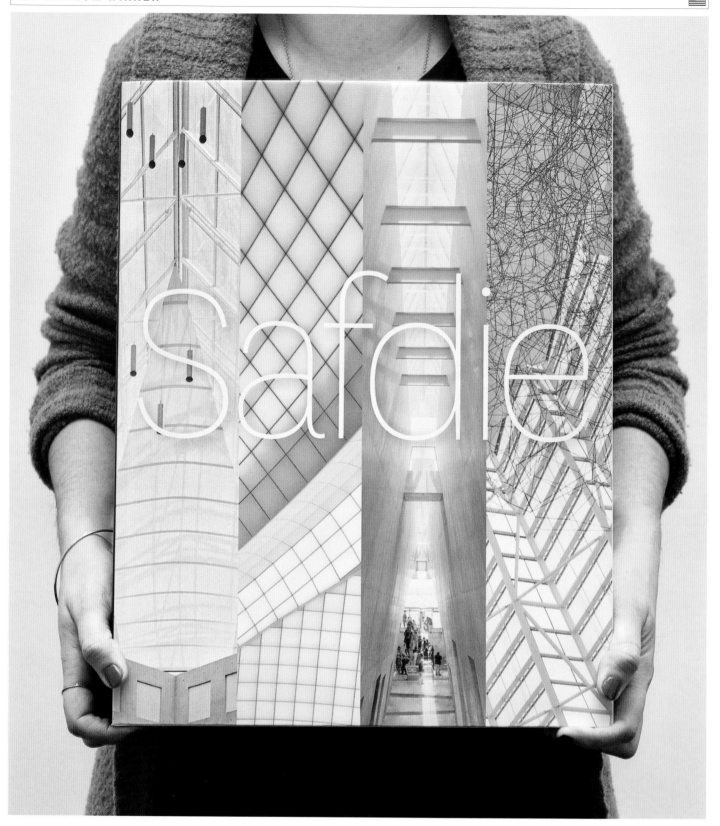

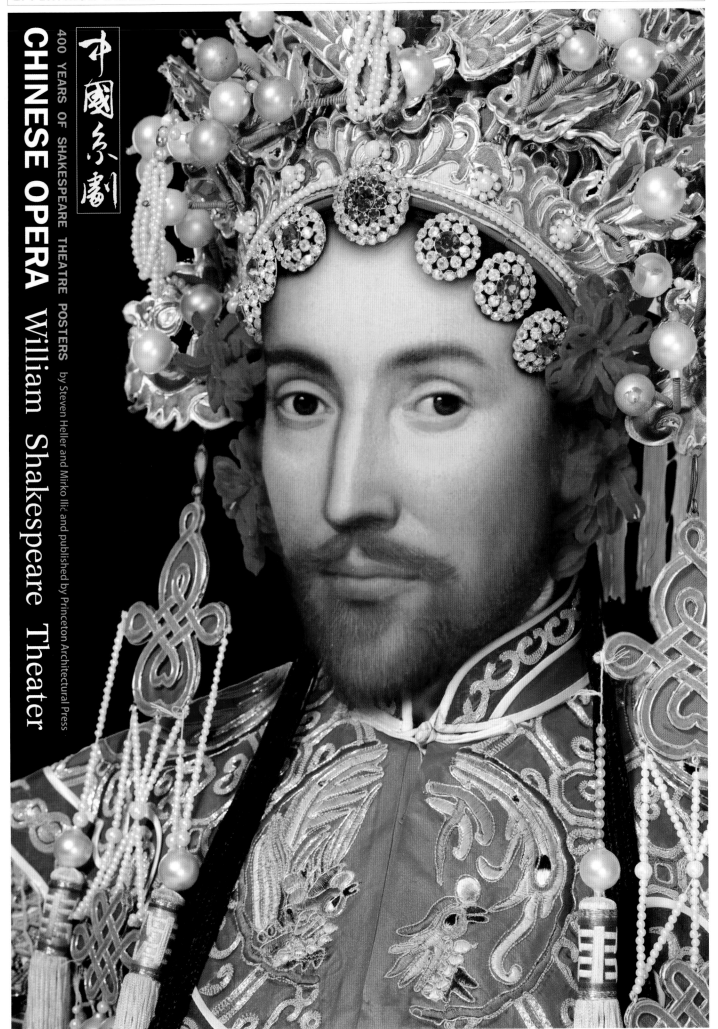

中國京劇

CHINESE OPERA William Shakespeare Theater

400 YEARS OF SHAKESPEARE THEATRE POSTERS by Steven Heller and Mirko Ilić and published by Princeton Architectural Press

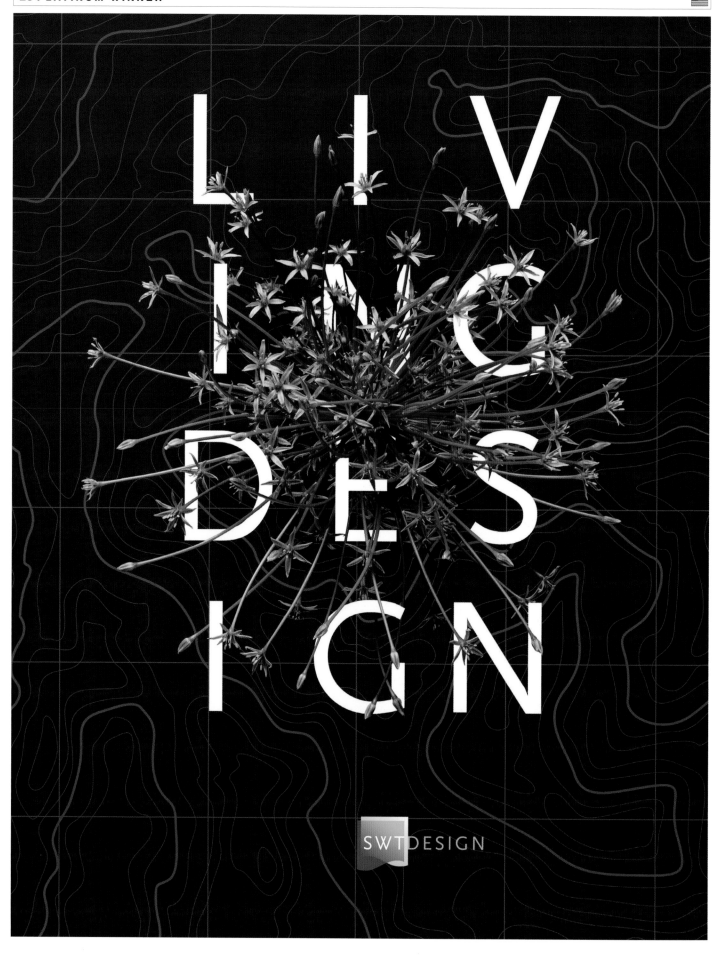

Design Firm: **TOKY** | Client: **SWT Design** | Category: **Branding** | Page: **48, 49**

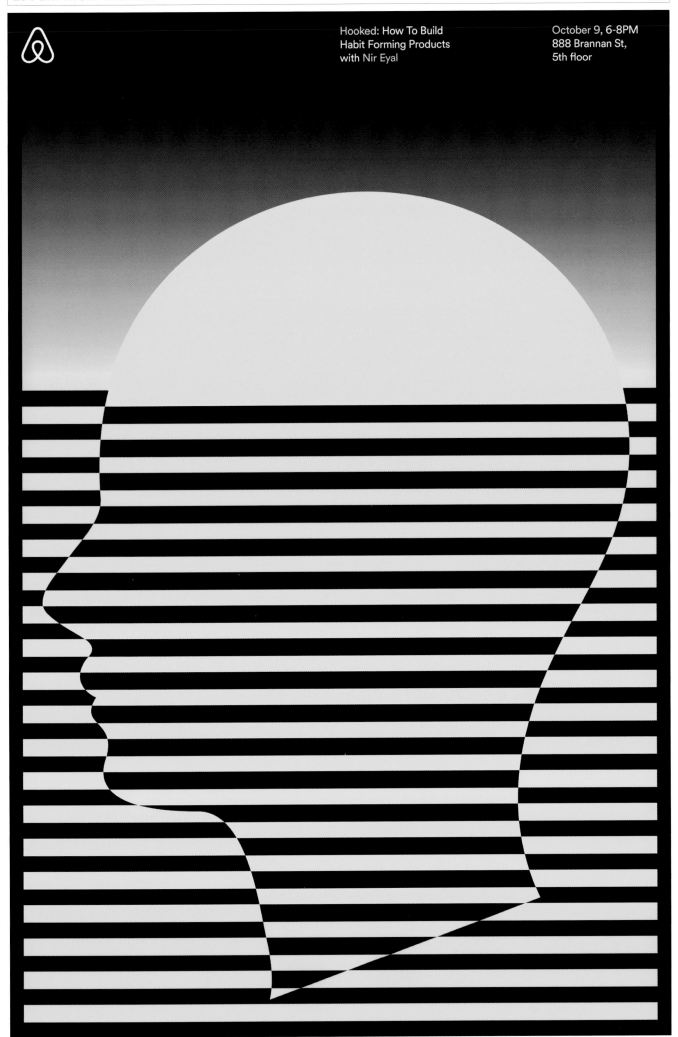

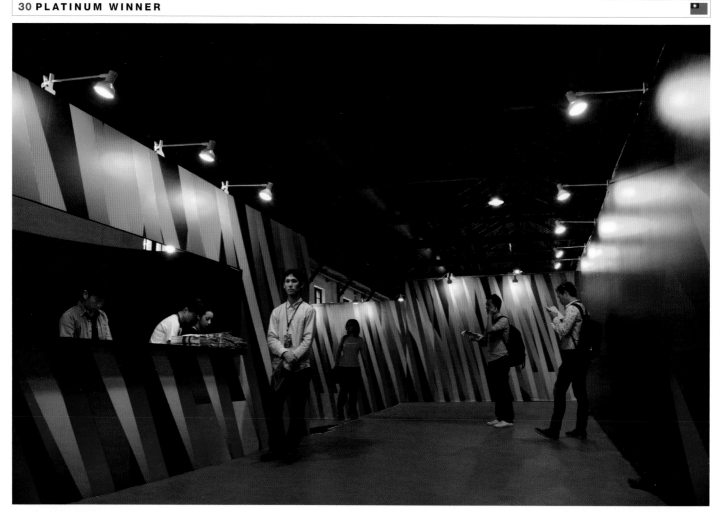

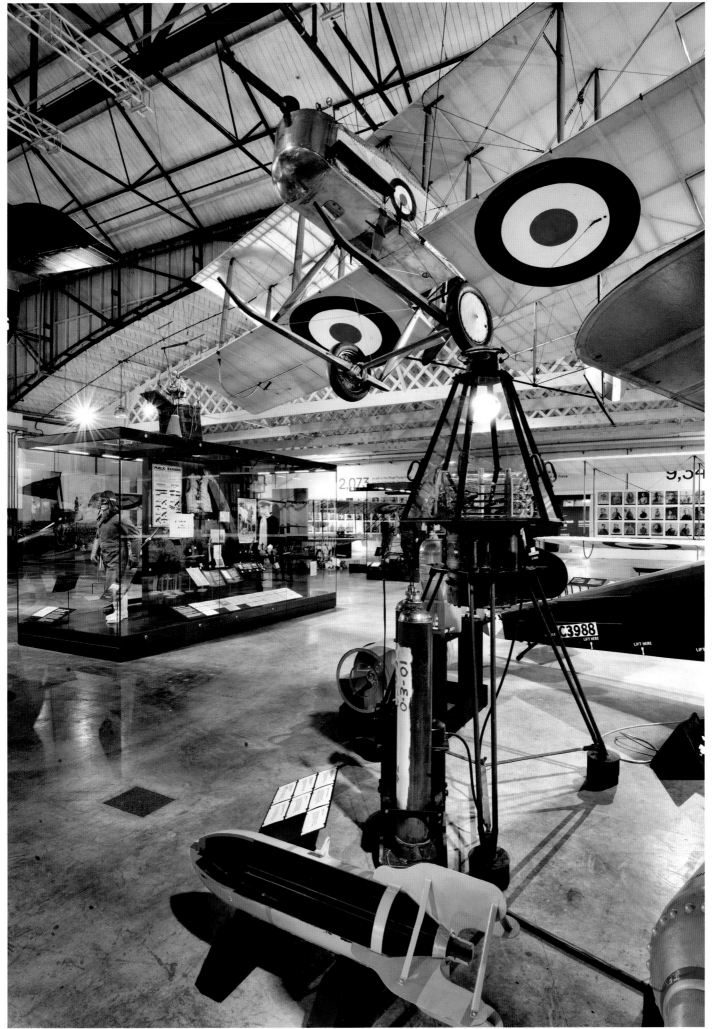

"Flawless Beauty," photographed by Christopher Marley

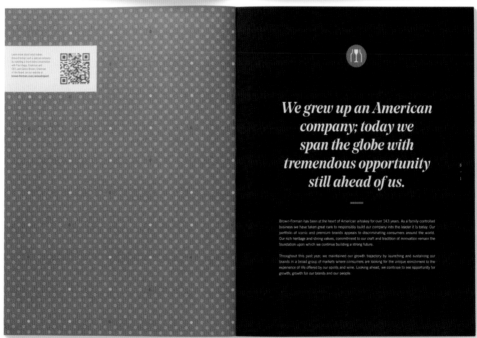

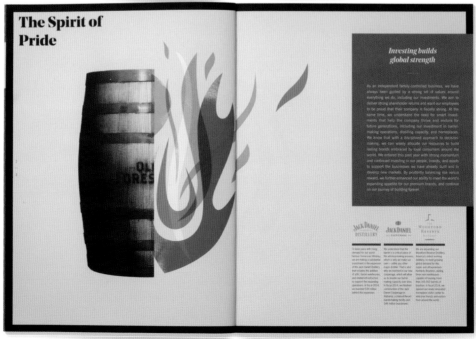

Richard Colbourne | Brown-Forman | Addison

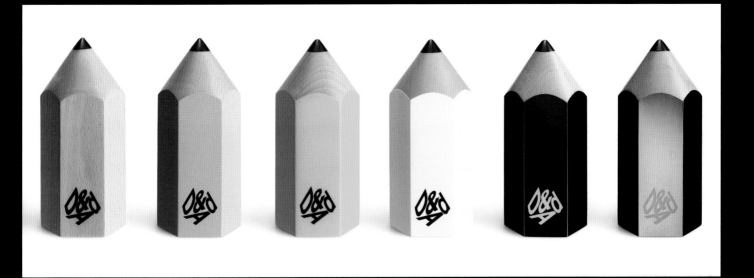

David Turner, Bruce Duckworth, Paula Talford | **D&AD** | **Turner Duckworth Design: London & San Francisco**

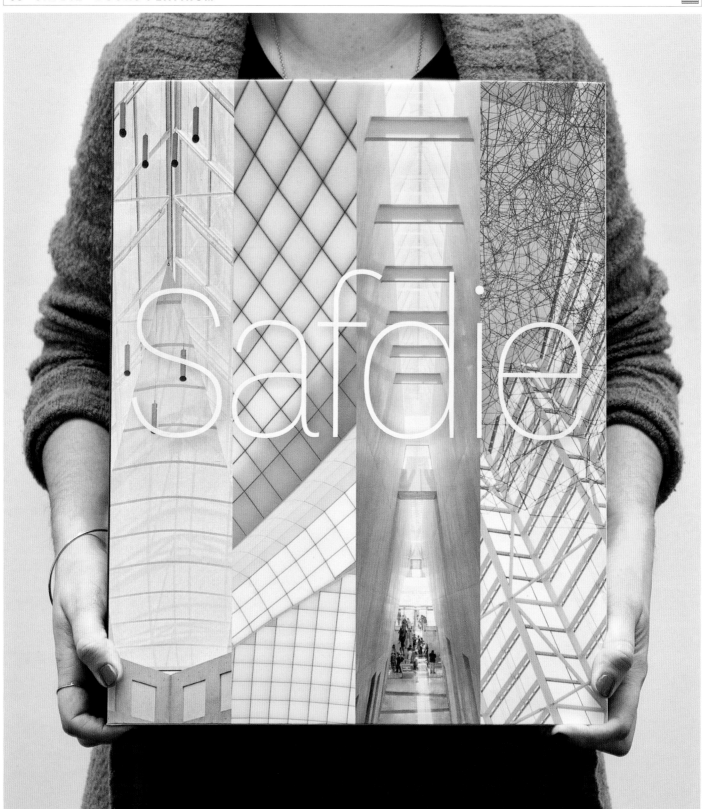

Made in
America
1986-2013

United States Institute
of Peace Headquarters,
Washington, DC

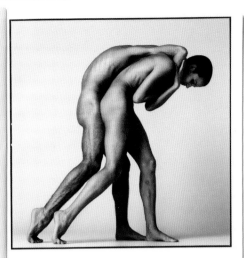

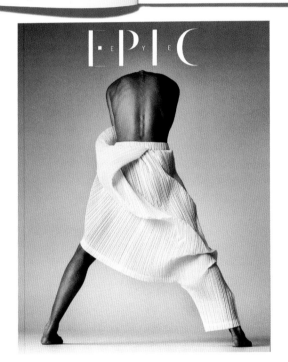

Toshiaki Ide | Epic Litho | IF Studio

Trust
YOURSELF.

Listen to
YOUR GUT.

Make
YOUR OWN DECISIONS.

Believe
IN YOURSELF!

DESIGN YOUR LIFE VINCE FROST

DESIGN YOUR LIFE

Applying design principles to your life.

VINCE FROST

Penguin
LANTERN

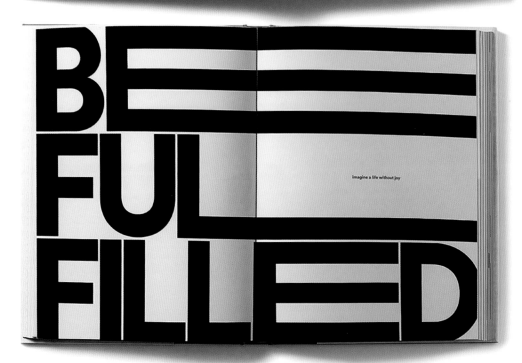

imagine a life without joy

CONTENTS:

Vince Frost | Penguin Books Australia | Frost*collective

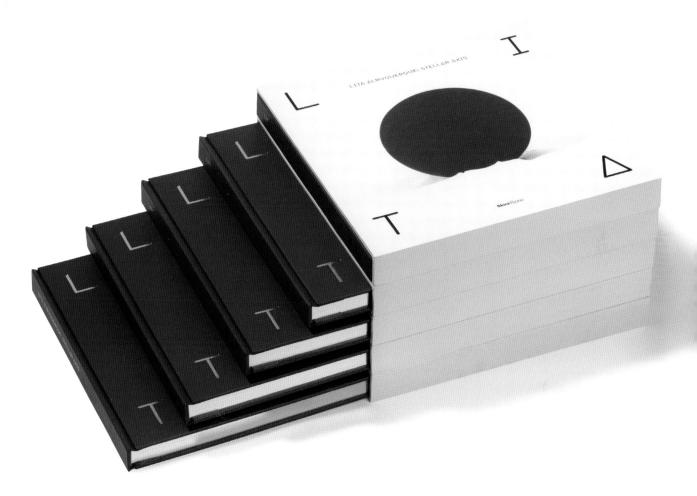

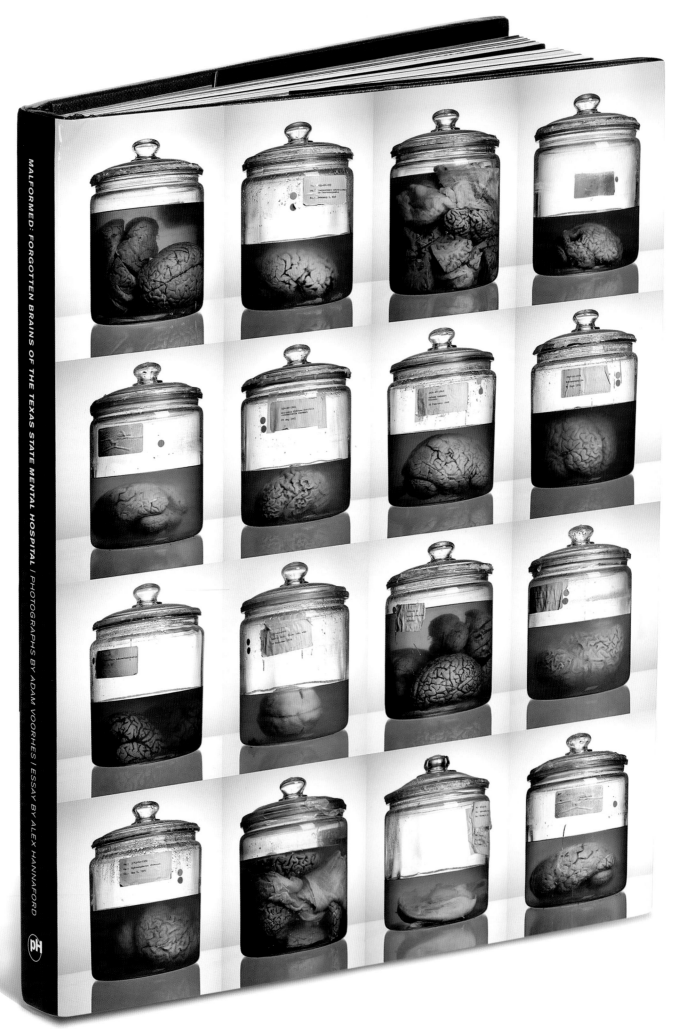

MALFORMED: FORGOTTEN BRAINS OF THE TEXAS STATE MENTAL HOSPITAL / PHOTOGRAPHS BY ADAM VOORHES / ESSAY BY ALEX HANNAFORD

DJ Stout | **Adam Voorhes** | **Pentagram**

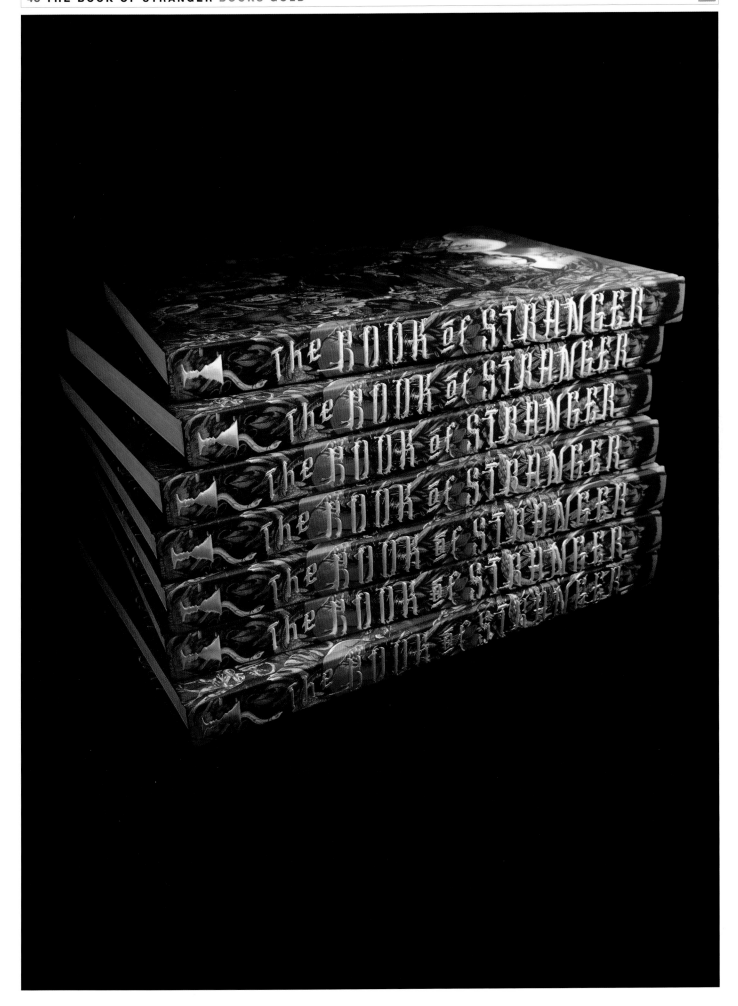

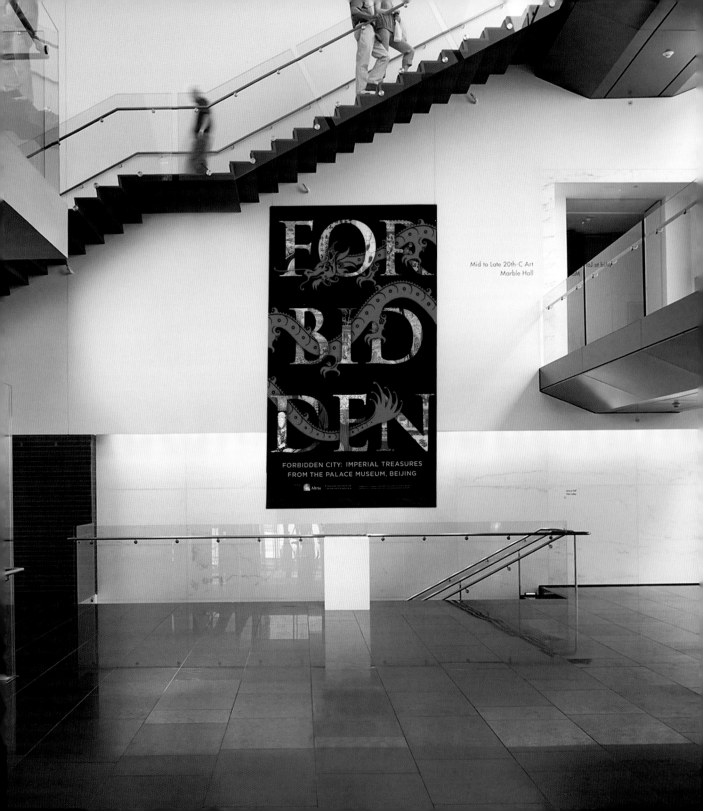

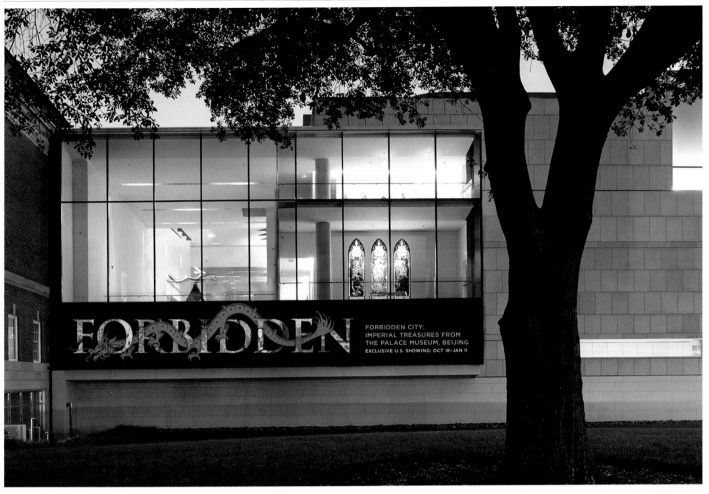

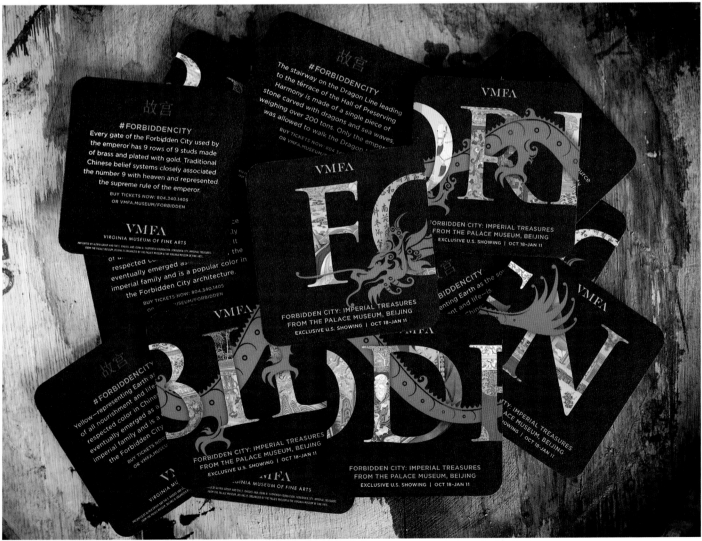

Hal Tench & John Mahoney | *Virginia Museum of Fine Arts* | **Karnes Coffey Design**

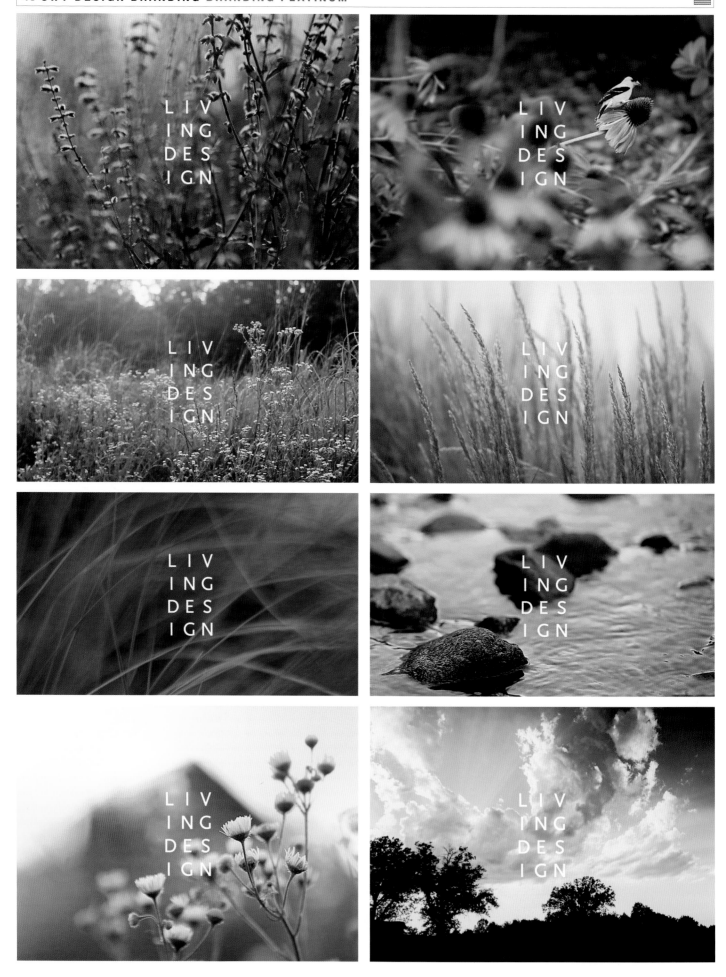

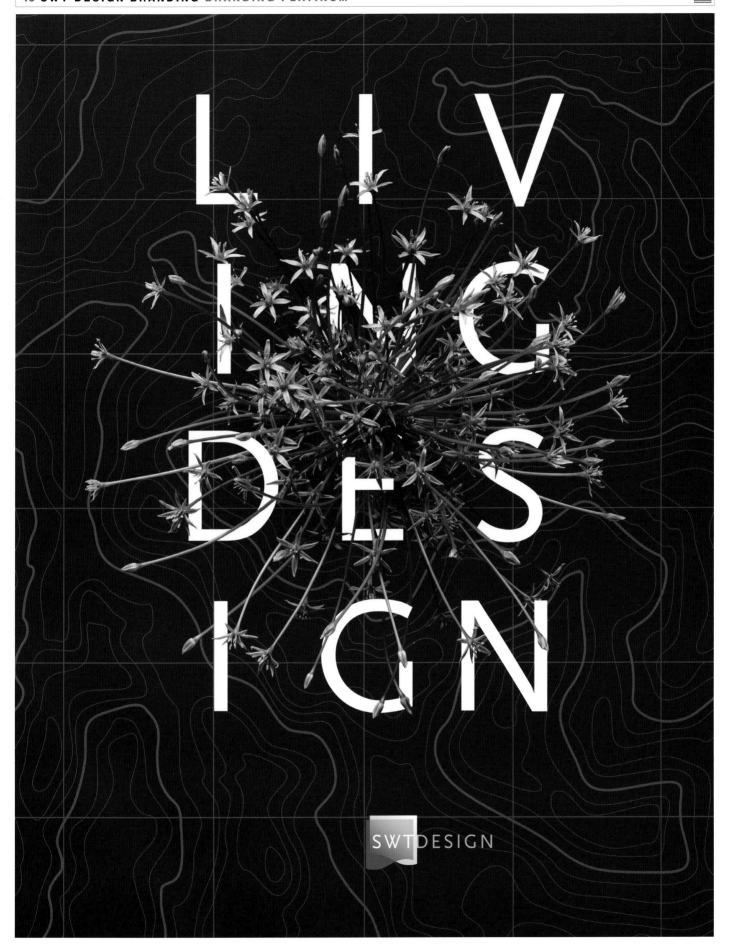

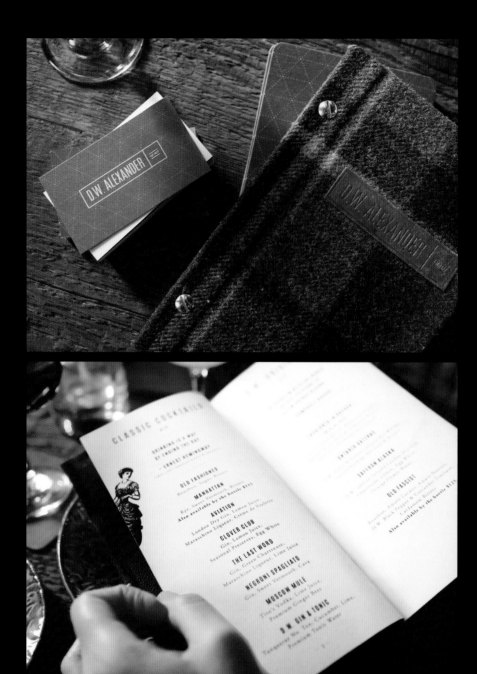

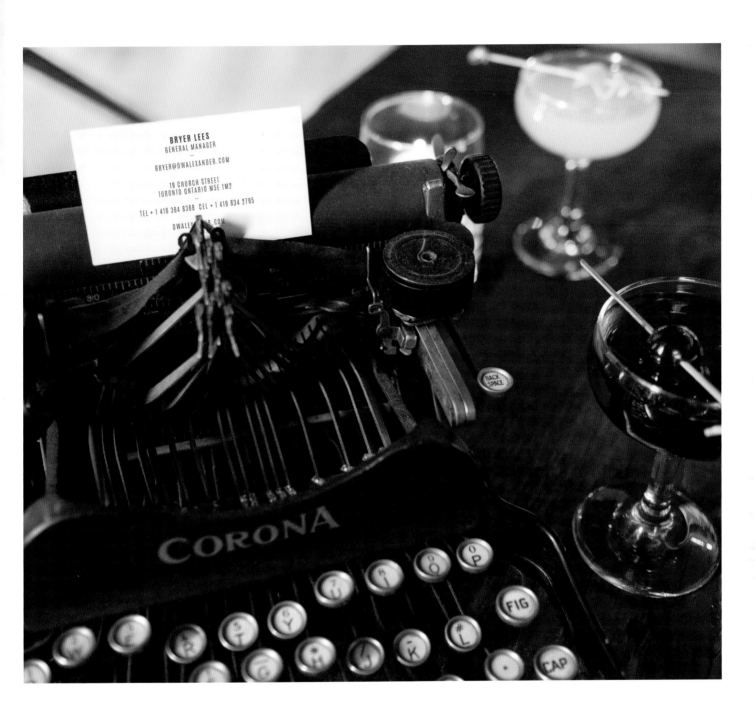

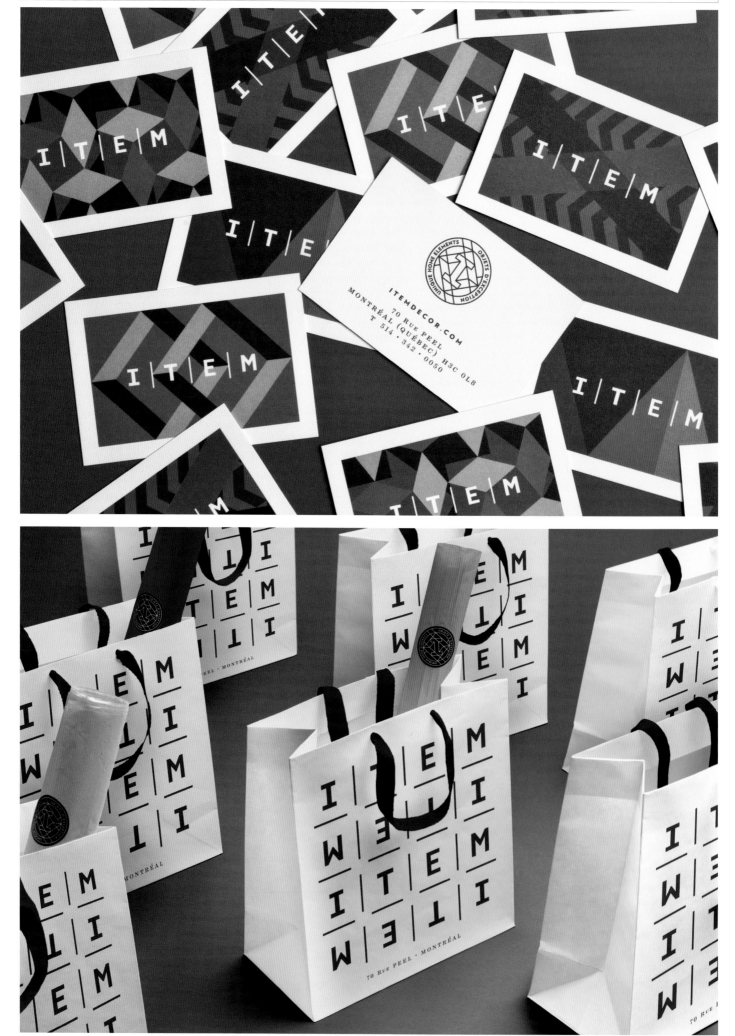

Claude Auchu | Item, Ross Fraser | lg2boutique

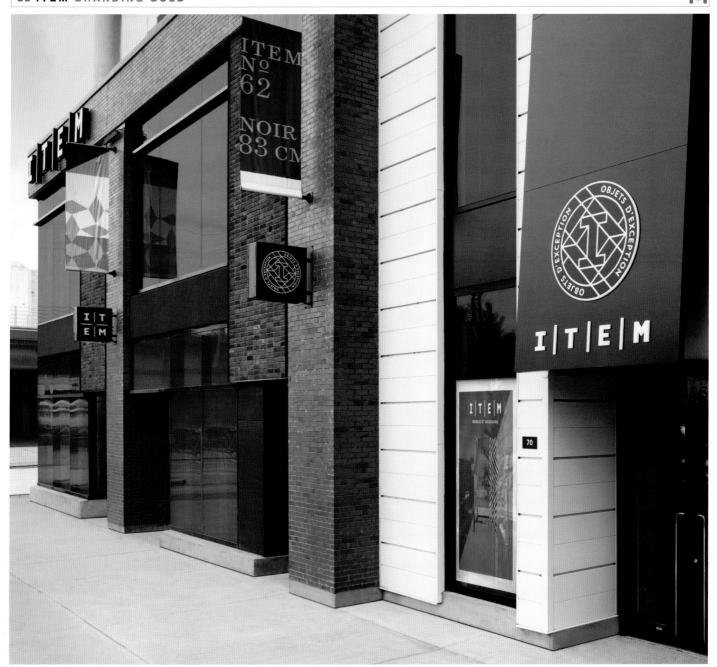

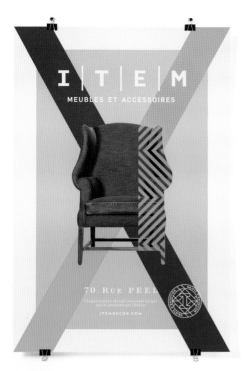

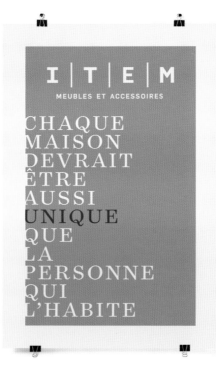

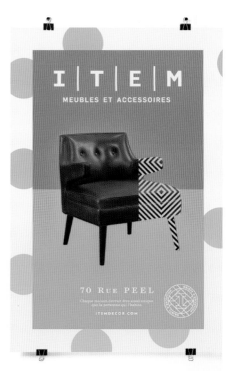

Claude Auchu | Item, Ross Fraser | lg2boutique

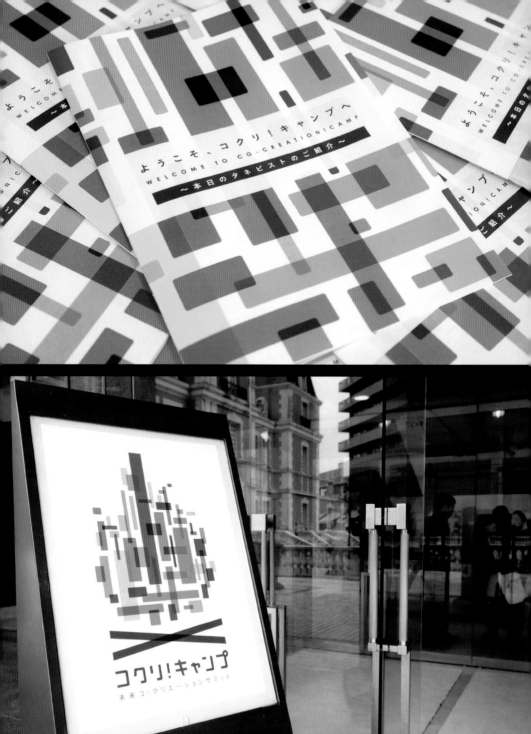

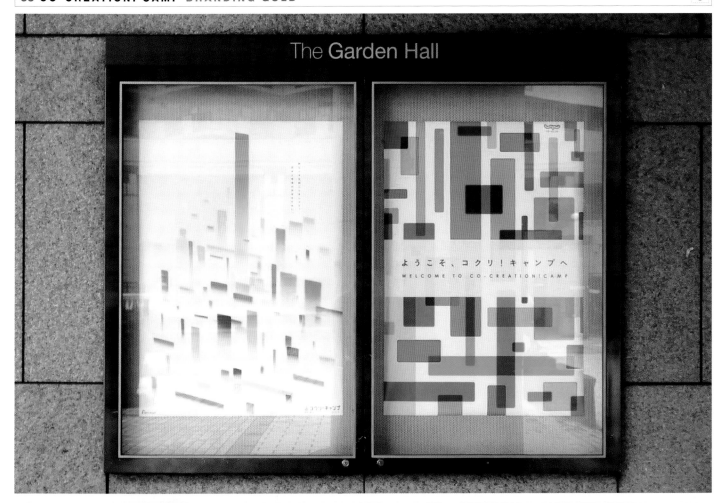

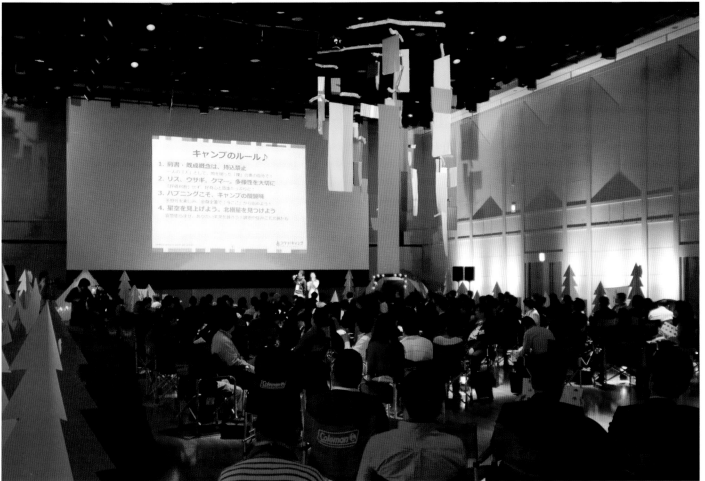

Takahiro Nagahama | Recruit Lifestyle Co., Ltd. | **Recruit Communications Co., Ltd.**

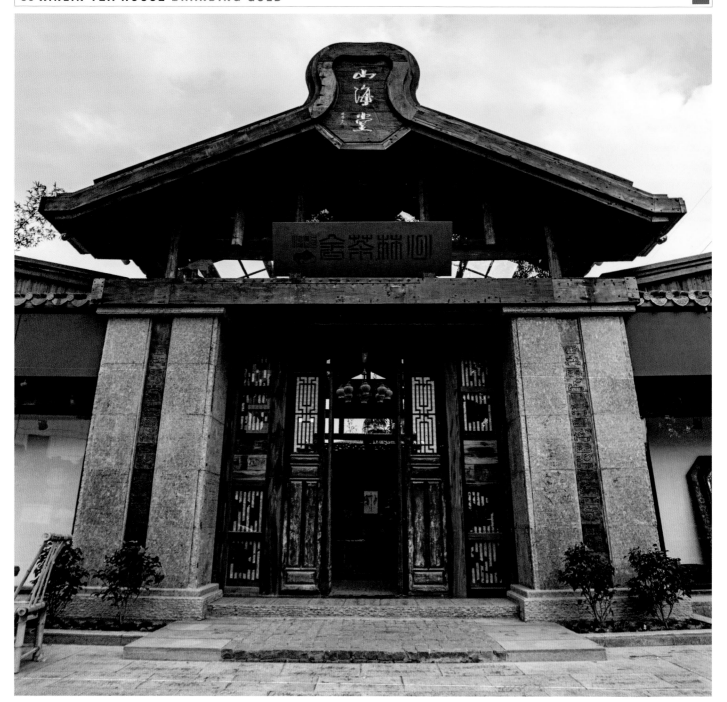

Lin Shaobin | Xinlin Tea House | Lin Shaobin Design

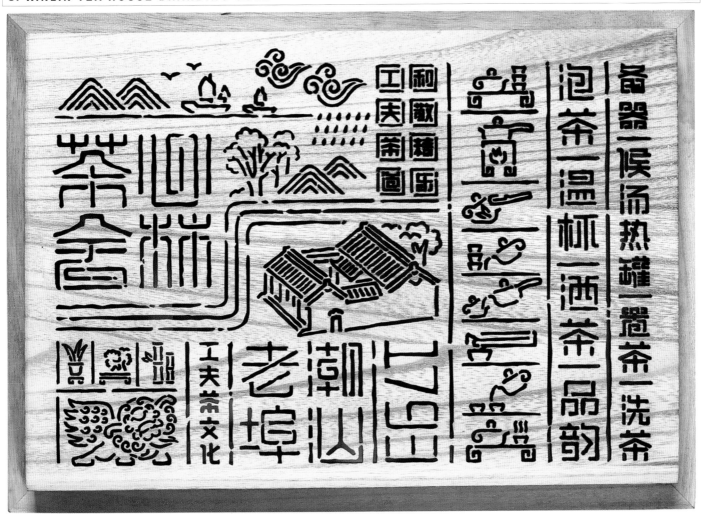

Lin Shaobin | *Xinlin Tea House* | **Lin Shaobin Design**

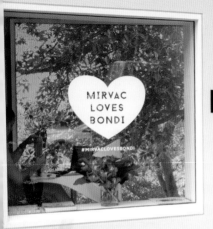

MIRVAC
LOVES
BONDI

#MIRVACLOVESBONDI

mirvac

THE
MORETON
BONDI

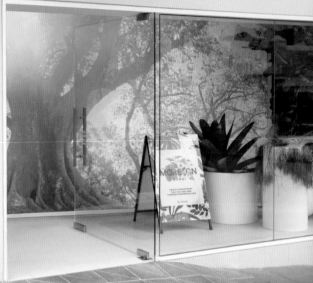

MORETON
BONDI

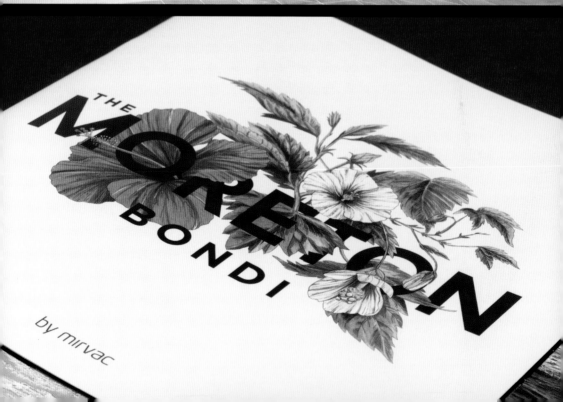

THE
MORETON
BONDI

by mirvac

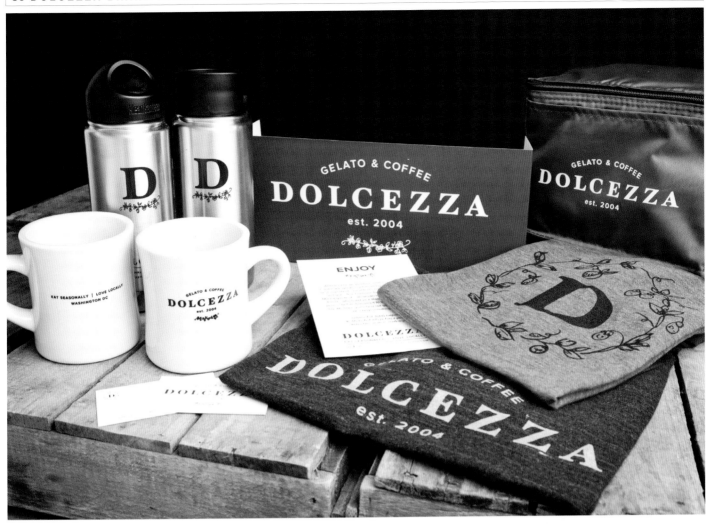

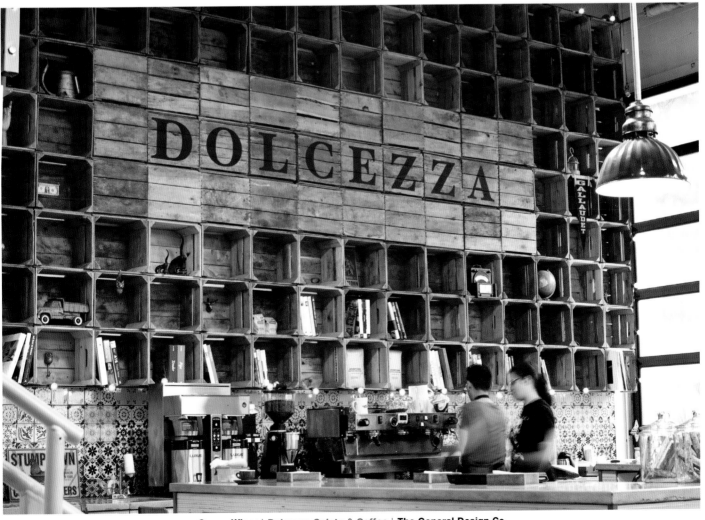

Soung Wiser | Dolcezza Gelato & Coffee | **The General Design Co.**

Say it can't be done and watch the glimmer develop in our eyes.
Nothing excites us more than taking on a complex challenge.
Because we are problem solvers. Driven and always focused on
the big picture. It's a commitment to taking the time to ask the
right questions and figure out the right solutions, no matter what.
Identifying potential problems before they arise. And if there is
a bump in the road, adjusting immediately to find the perfect fix.
Caring about doing the right thing. Applying an immense breadth
of knowledge and experience to bring a vision to life.

.07734

Pages 8 and 46

Thumbs up to Henry Leutwyler for his studio portrait photographs and special thanks to C.R. Morgan's editorial expertise.

Dear Reader,

Every once in a while we find ourselves somewhere fresh, charming, and a little bit daring. This is the way I felt when I first visited Hudson Square. The blocks are textured with Independence-era history and an appropriately inspired pinch of industrial grit.

To express these contradictions—intimate yet expansive, historic but modern, sophisticated yet down to earth—we designed a building that integrates contemporary textures and refined materials with classic urban living.

We also carefully curated and commissioned a collection of stories to playfully highlight Hudson Square. In this single edition of 15 Renwick magazine, we invite you to experience the neighborhood and, of course, the residential building through our inspired unconventional characters and tastemakers.

Happy explorations!

Sincerely,
Eldad Blaustein
IGI-GGP Renwick LLC

Pages 22 and 46

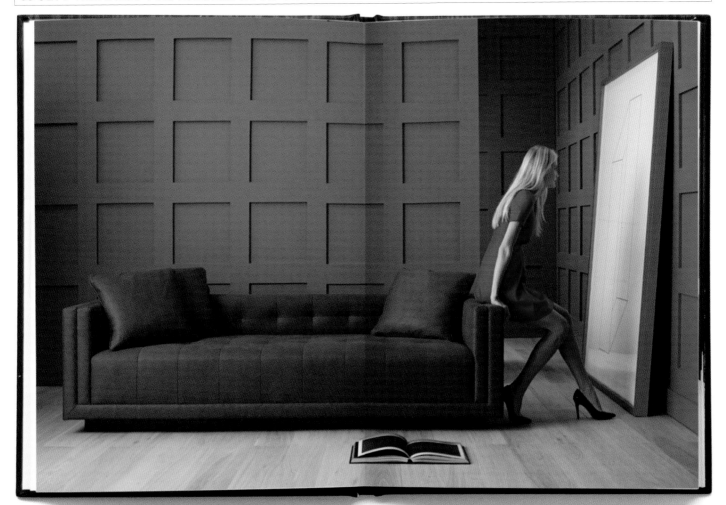

A.Rudin introduces a distinctly glamorous collection of lounge furniture created by the internationally celebrated interior designer Jeff Andrews. Known for the sophisticated yet livable interiors that he designs for a high profile clientele, Andrews has partnered with A.Rudin to create fresh, contemporary editions of traditional forms, infusing bold design concepts with warmth, comfort and simplicity. Classic and current, each elegant piece is hand built and hand finished to produce the highest quality of upholstered furniture and occasional tables for today's luxury lifestyles.

Michael Vanderbyl | A.Rudin | Vanderbyl Design

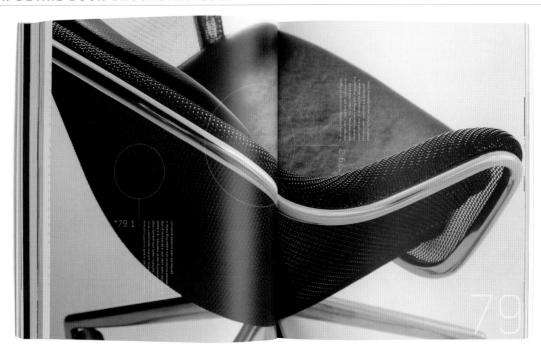

Michael Vanderbyl | Teknion | Vanderbyl Design

KOMORI

MAY		01	02	03	04	05	06	07	08	09	10	11	12	13	14	15	16	17	18	19	20	21	22	23	24	25	26	27	28	29	30	31		
2015		F	S	S	M	T	W	T	F	S	S	M	T	W	T	F	S	S	M	T	W	T	F	S	S	M	T	W	T	F	S	S	M	T
JUN			01	02	03	04	05	06	07	08	09	10	11	12	13	14	15	16	17	18	19	20	21	22	23	24	25	26	27	28	29	30		

Masahiro Aoyagi & Fuyuki Hashizume | **Komori Corporation** | **Toppan Printing Co., Ltd.**

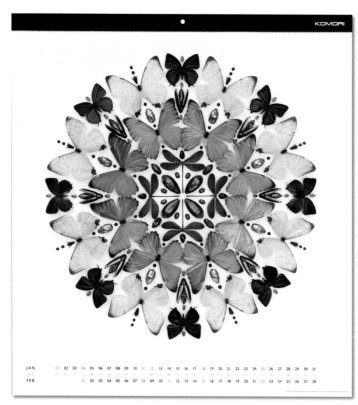

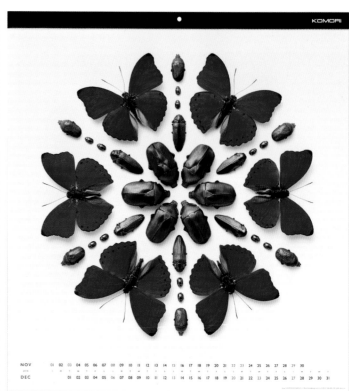

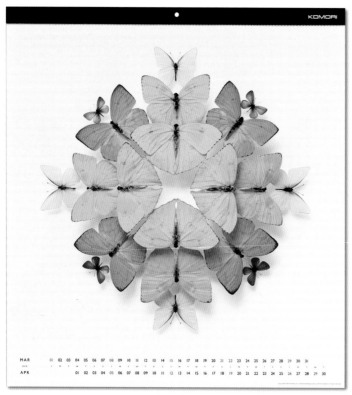

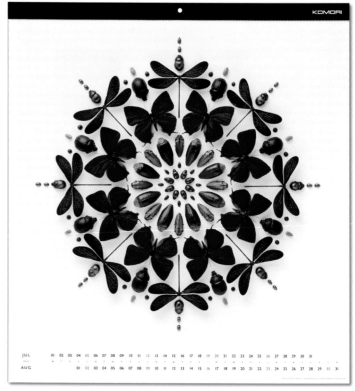

Masahiro Aoyagi & Fuyuki Hashizume | **Komori Corporation** | **Toppan Printing Co., Ltd.**

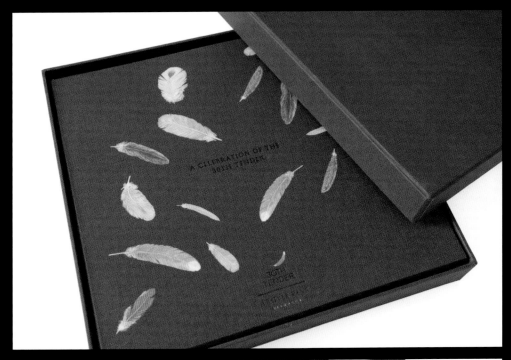

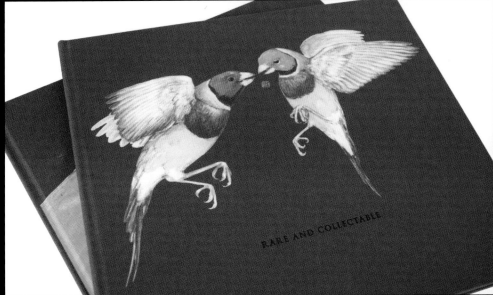

Emma Scott | Argyle Pink Diamonds | **Tiny Hunter**

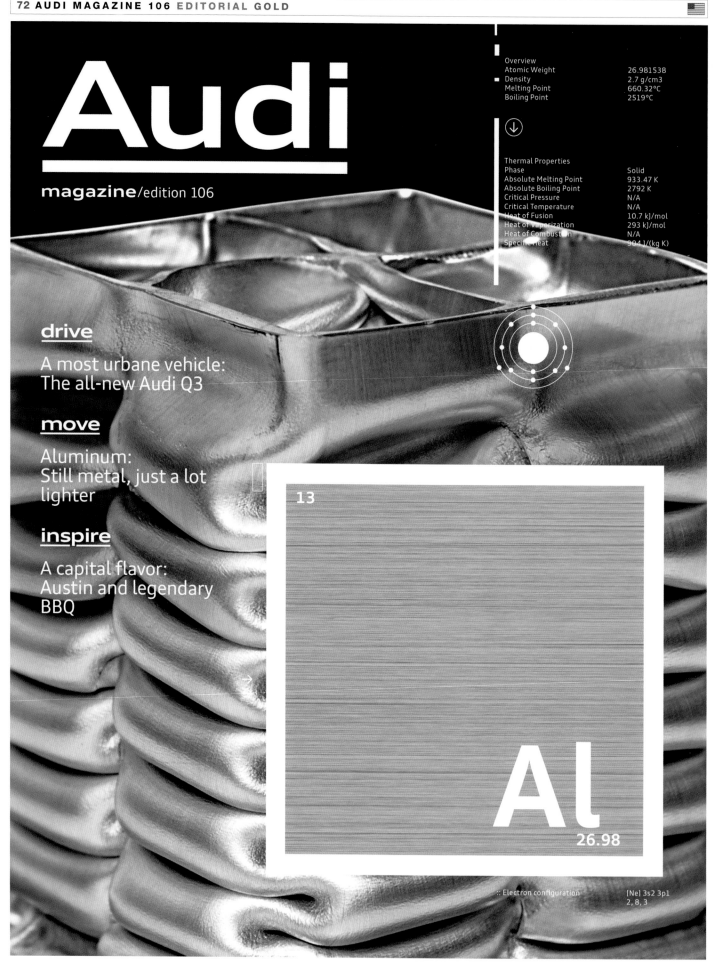

Audi

magazine/edition 106

Overview
Atomic Weight 26.981538
Density 2.7 g/cm3
Melting Point 660.32°C
Boiling Point 2519°C

Thermal Properties
Phase Solid
Absolute Melting Point 933.47 K
Absolute Boiling Point 2792 K
Critical Pressure N/A
Critical Temperature N/A
Heat of Fusion 10.7 kJ/mol
Heat of Vaporization 293 kJ/mol
Heat of Combustion N/A
Specific Heat 904 J/(kg K)

drive

A most urbane vehicle:
The all-new Audi Q3

move

Aluminum:
Still metal, just a lot
lighter

inspire

A capital flavor:
Austin and legendary
BBQ

13

Al
26.98

:: Electron configuration [Ne] 3s2 3p1
 2, 8, 3

Ulrich Lange & Kathy Chia Cherico | **Audi USA** | **designory.**

Will Hackley | Wake Forest University School of Business | **Elephant In The Room**

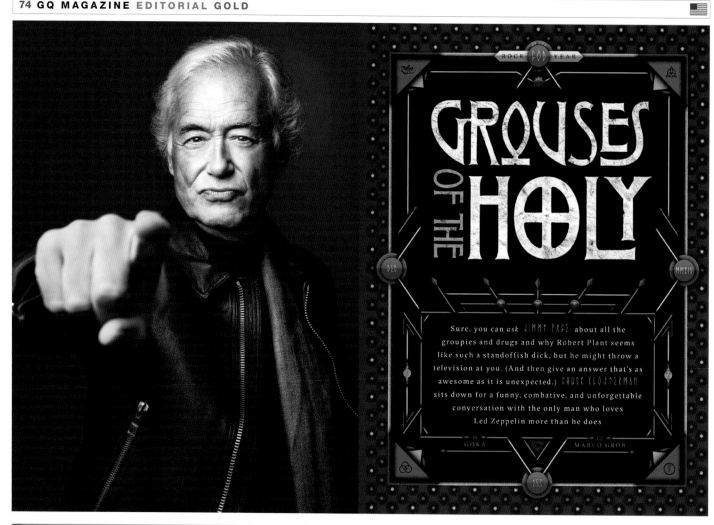

ROCK GOD OF THE YEAR

GROUSES OF THE HOLY

Sure, you can *ask* JIMMY PAGE about all the groupies and drugs and why Robert Plant seems like such a standoffish dick, but he might throw a television at you. (And then give an answer that's as awesome as it is unexpected.) CHUCK KLOSTERMAN sits down for a funny, combative, and unforgettable conversation with the only man who loves Led Zeppelin more than he does

The GQ&A — MARCO GROB

▸ In our second story on the ways **ACCIDENTS SHAPE OUR LIVES**, a fatal car crash shatters a small town and a group of friends one evening long ago. Now, thirty-plus years later, MICHAEL PATERNITI finally tells the tale

The first, about the search for Malaysia Airlines 370, is on page 194.

the Accident

Photographs by
Tuukka Koski

THE *Most* Adventurous
RESTAURANT IN THE
WORLD
IS ON A `SMALL HILLTOP` IN
Spain

Andoni Luis Aduriz
lives and cooks in a quiet corner of Spain, above the postcard beaches of San Sebastián. He has developed, in his renowned restaurant, MUGARITZ, a dining experience unlike any other—as much about food as immersion into the simple, thoughtful, self-effacing temperament of his homeland, the Basque Country. In their efforts to build a food commune on a hill, Aduriz and his team just happened to have also built the finest place to eat on earth

BY MICHAEL PATERNITI

194 GENTLEMEN'S QUARTERLY / April 2011

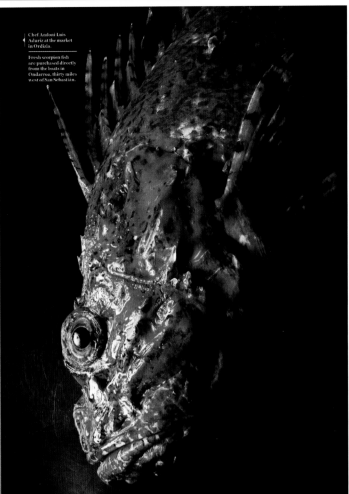

Chef Andoni Luis Aduriz at the market in Ordizia.

Fresh scorpion fish are purchased directly from the boats in Ondarroa, thirty miles west of San Sebastián.

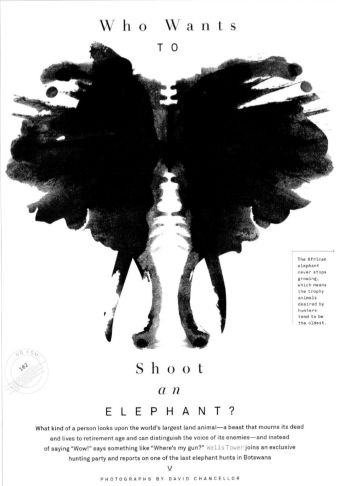

Who Wants
TO

Shoot
an
ELEPHANT?

What kind of a person looks upon the world's largest land animal—a beast that mourns its dead and lives to retirement age and can distinguish the voice of its enemies—and instead of saying "Wow!" says something like "Where's my gun?" Wells Tower joins an exclusive hunting party and reports on one of the last elephant hunts in Botswana

v
PHOTOGRAPHS BY DAVID CHANCELLOR

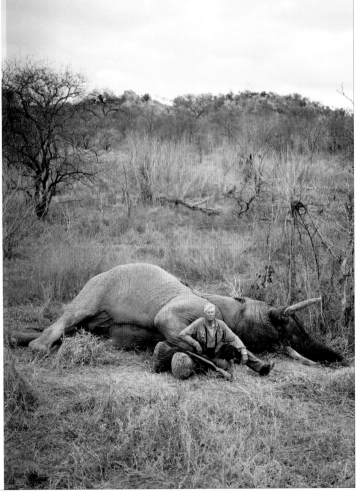

The African elephant never stops growing, which means the trophy animals desired by hunters tend to be the oldest.

Chef Andoni Luis Aduriz at the market in Ordizia.

Fresh scorpion fish are purchased directly from the boats in Ondarroa, thirty miles west of San Sebastián.

YEAH,
BUT CAN
SHE ACT?
DAVID FINCHER
THINKS SO. A YEAR
AFTER EMILY
RATAJKOWSKI
SOMEHOW
PARLAYED A ONE-
DAY GIG ON
A ROBIN THICKE
VIDEO INTO
WORLDWIDE
MEGA-BOMBSHELL
STATUS, SHE
MAKES HER
SCREEN DEBUT
THIS FALL
IN FINCHER'S
GONE GIRL.
(A LITTLE LESS
SURPRISINGLY,
SHE'LL ALSO
BE IN THE
ENTOURAGE
MOVIE.) EMRATA
WOULD LIKE
TO THANK YOU,
MEN OF EARTH,
FOR ALL THE
LOVE...BUT COULD
YOU MAYBE
STOP TELLING
HER SHE'S "THE
HOTTEST BITCH IN
THIS PLACE"?
By Daniel Riley

Michael
Thompson

THIS IS YOUR BODY ON SUPERFOODS

ARMIN ZOGBAUM

Want extreme vitality, boundless energy, and
a solution to pretty much all of your bodily woes?
A new wave of health foods—ancient so-called
SUPERFOODS—is being hailed as the answer.

JUNE 2014

GQ 158

What the hell is this stuff? Should you eat it? *How* do
you eat it? We asked BEN MARCUS to spend
six weeks on a superfood diet. That was three months
ago, and he's still guzzling the goji-berry Kool-Aid

FOR NEARLY THIRTY YEARS, A PHANTOM HAUNTED THE WOODS OF
CENTRAL MAINE. UNSEEN AND UNKNOWN, HE LIVED IN SECRET, CREEPING
INTO HOMES IN THE DEAD OF NIGHT AND SURVIVING ON WHAT HE COULD
STEAL. TO THE SPOOKED LOCALS, HE BECAME A LEGEND—OR MAYBE A
MYTH. THEY WONDERED HOW HE COULD POSSIBLY BE REAL. UNTIL ONE DAY
LAST YEAR, THE HERMIT CAME OUT OF THE FOREST BY MICHAEL FINKEL

THE

STRANGE
& CURIOUS
Tale of the

LAST
TRUE
HERMIT

TIM O'BRIEN

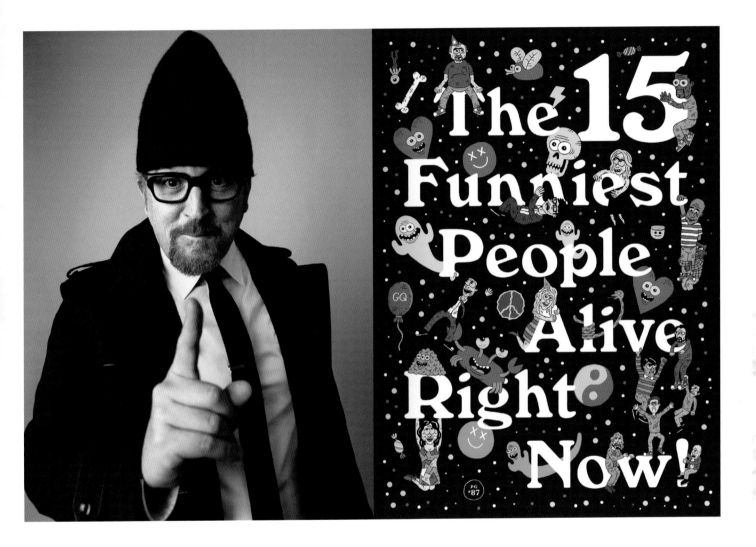

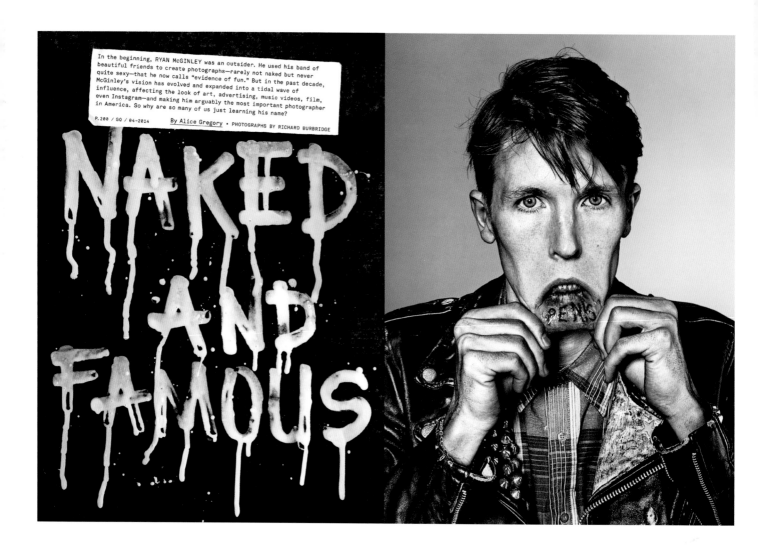

In the beginning, RYAN McGINLEY was an outsider. He used his band of beautiful friends to create photographs—rarely not naked but never quite sexy—that he now calls "evidence of fun." But in the past decade, McGinley's vision has evolved and expanded into a tidal wave of influence, affecting the look of art, advertising, music videos, film, even Instagram—and making him arguably the most important photographer in America. So why are so many of us just learning his name?

P.200 / GQ / 04-2014 By Alice Gregory • PHOTOGRAPHS BY RICHARD BURBRIDGE

Is your look starting to feel a little one-note? Then flip it like mega-producer Pharrell Williams—a man who sees sounds, hears hues, and is having his best year ever at age 40— by cranking up the colors →ZACH BARON ▸ PAOLA KUDACKI

21 RE➤ MIX YOUR WARD ➤ROBE

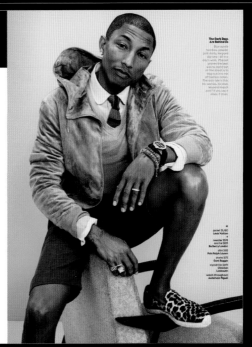

The Dark Days Are Behind Us

Have you seen *Taken*, *Taken 2*, *Non-Stop*? At 61, Liam Neeson's reinvented himself as an action hero, proving it's never too late for an overhaul. No matter what your age, a new, razor-sharp mogul suit will make you look like the boss →MICHAEL HAINEY ▸ PAOLA KUDACKI

01 RE➤ BOOT YOUR POWER SUIT

Show the Young Guns How It's Done

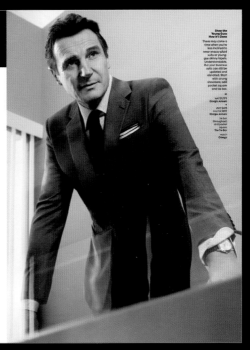

If you've lost touch with your inner rebel, your interior badass, the little bit of Marlon Brando in your soul—we're here to help you reconnect. Take your cues from Kit Harington, one of the few *Game of Thrones* stars who didn't die last season in a puddle of arterial spray →CHRIS HEATH ▸ PAOLA KUDACKI

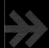

52 DRESS LIKE A TOUGH BAS➤ ➤TARD

How to Break Hearts Completely

Fred Woodward | Self-initiated | **GQ**

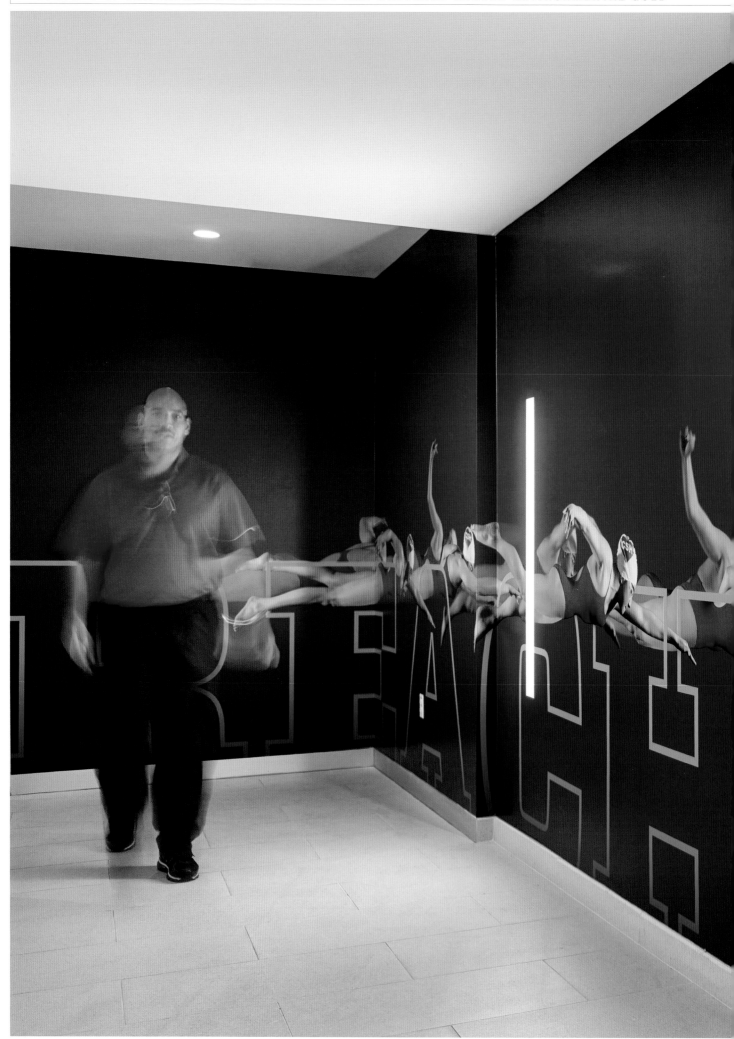

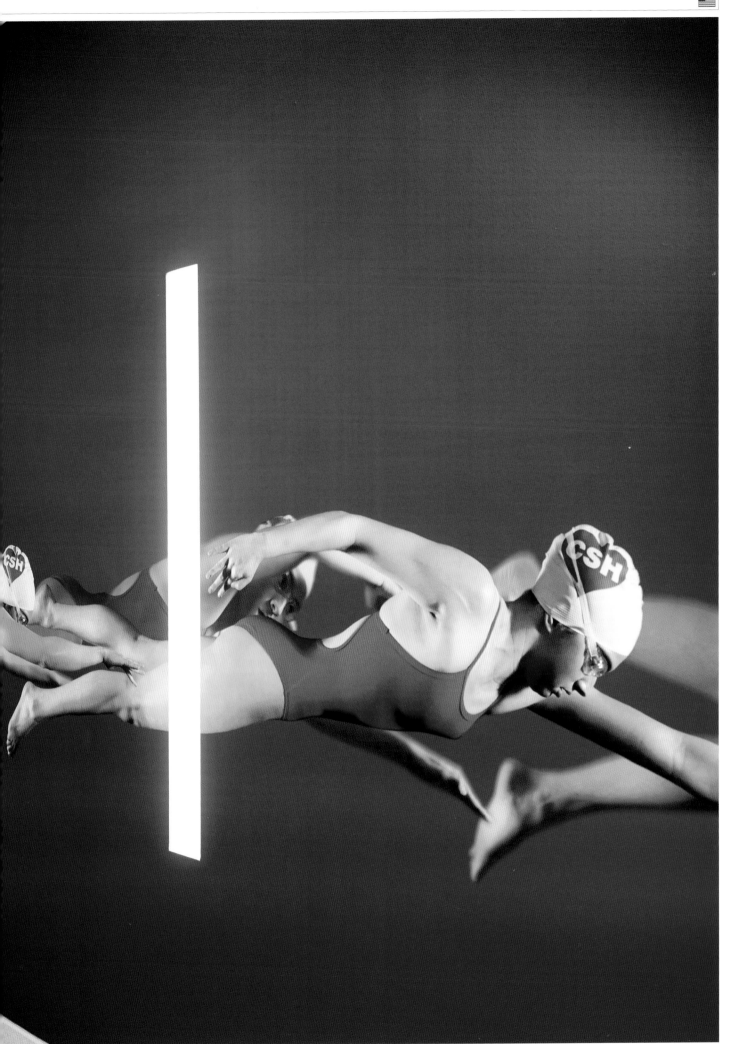

Richard Poulin | Convent of the Sacred Heart | **Poulin + Morris Inc.**

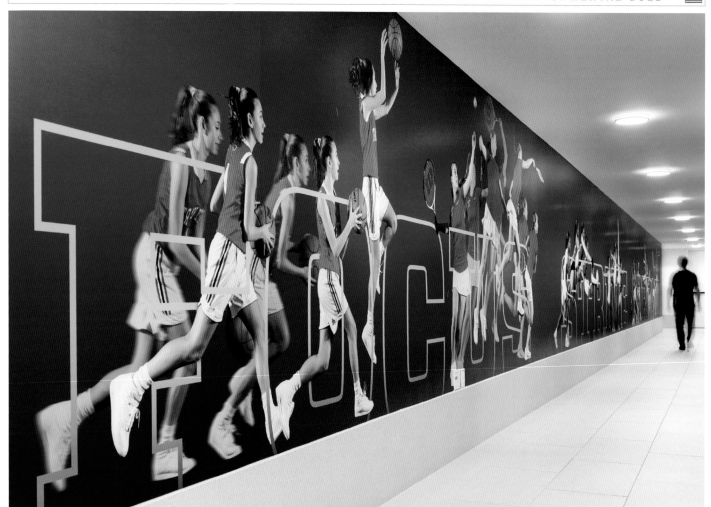

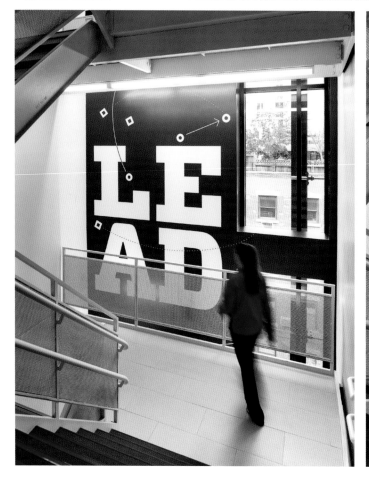

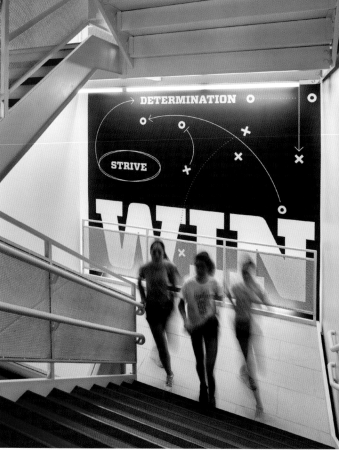

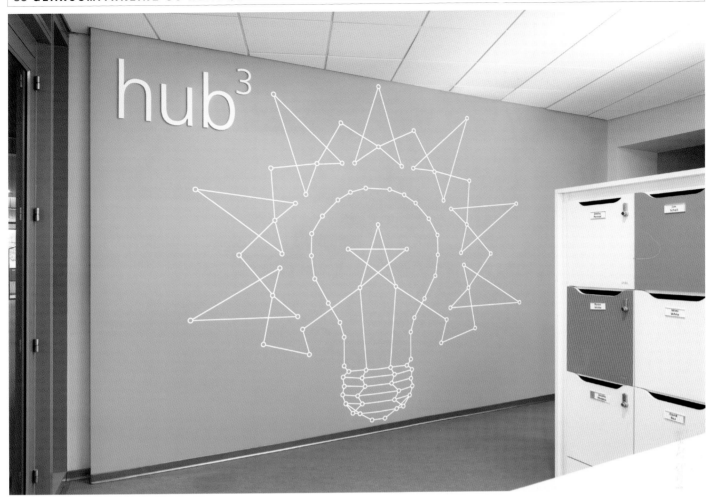

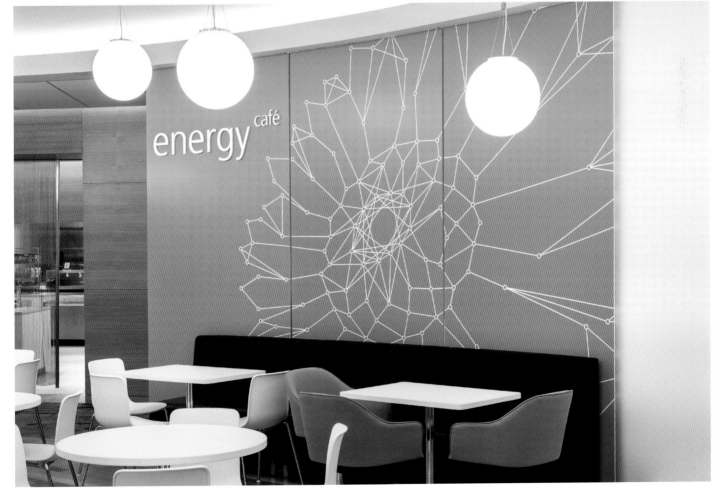

Michael Gericke | GlaxoSmithKline | Pentagram

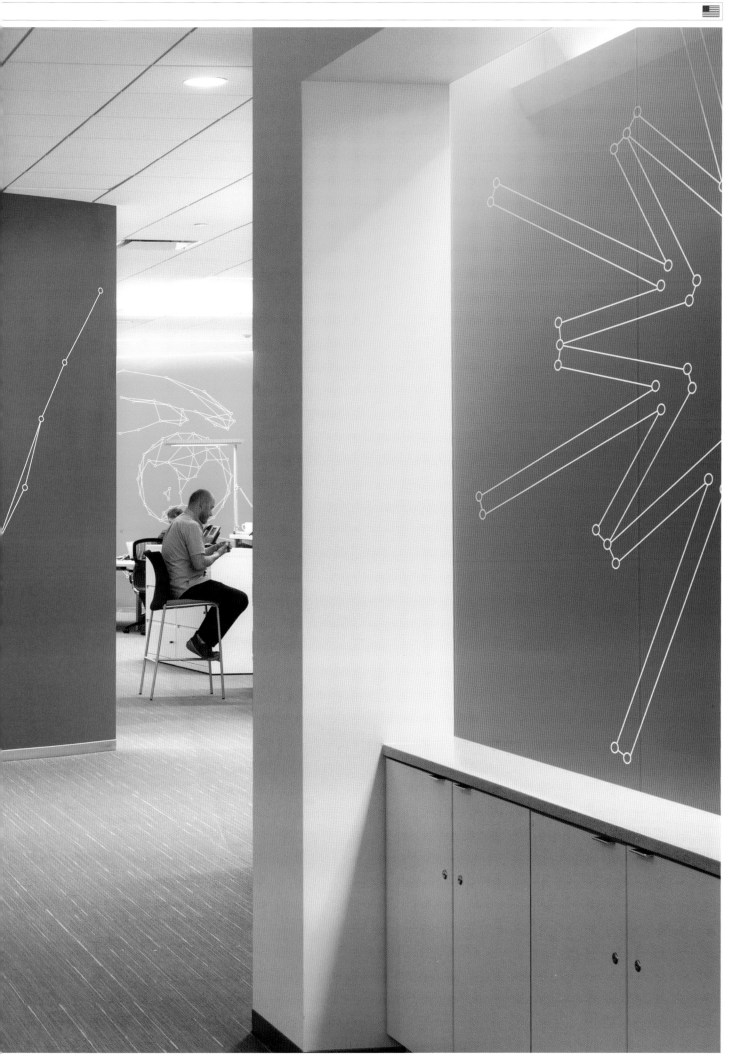

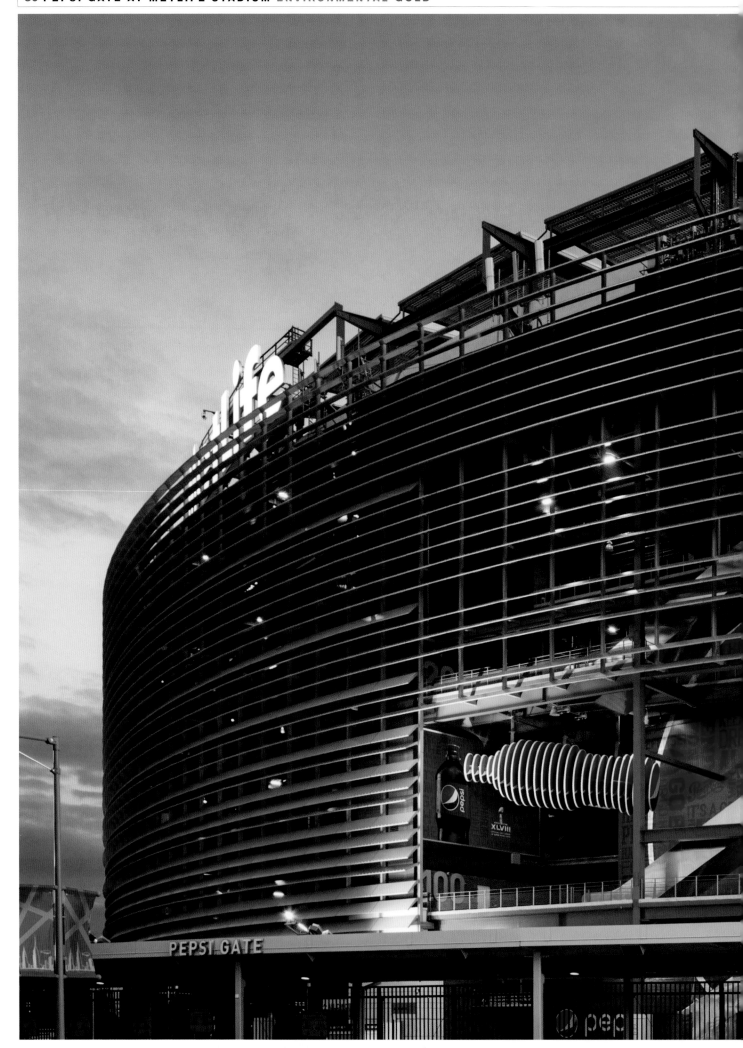

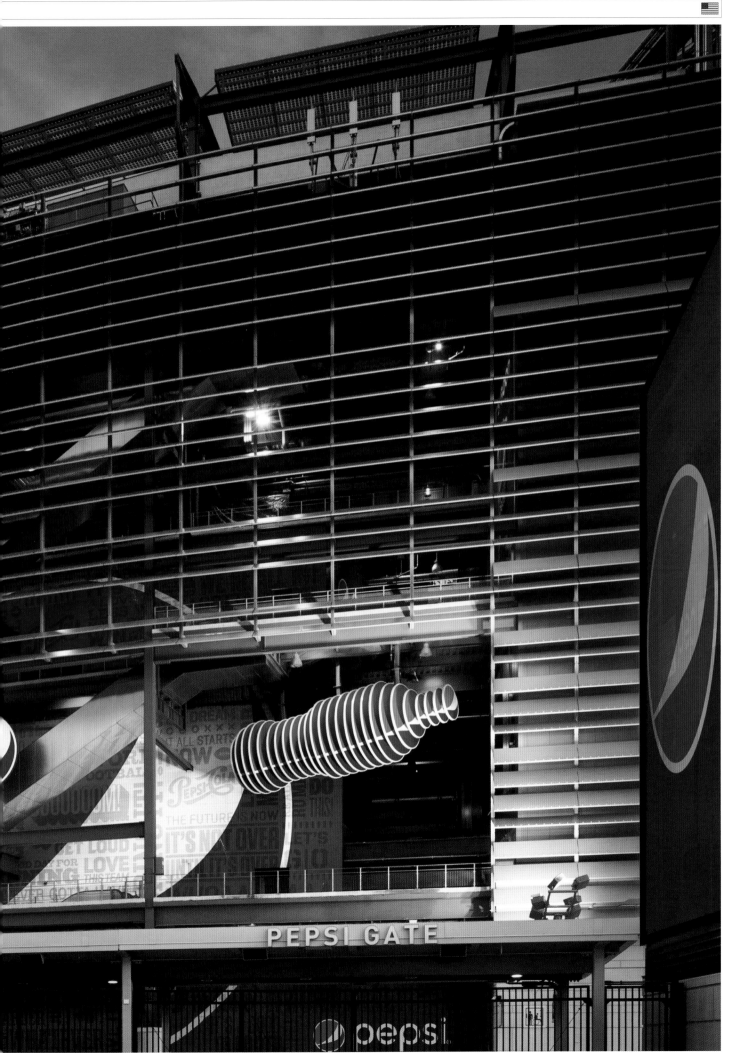

Michael Gericke | Pepsi Co./Pepsi Design and Innovation Center | **Pentagram**

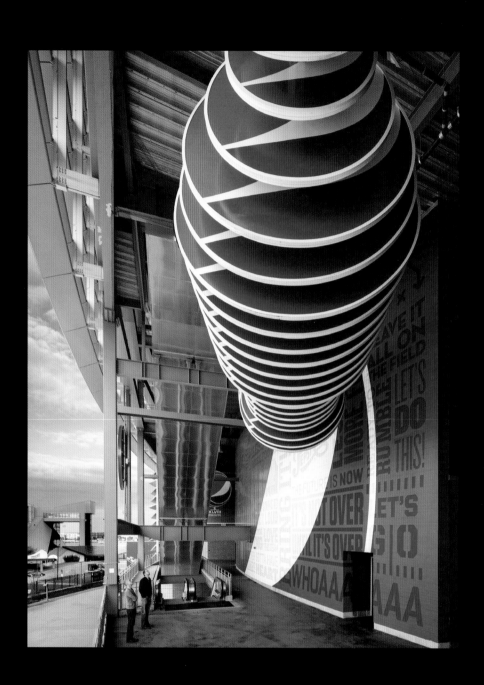

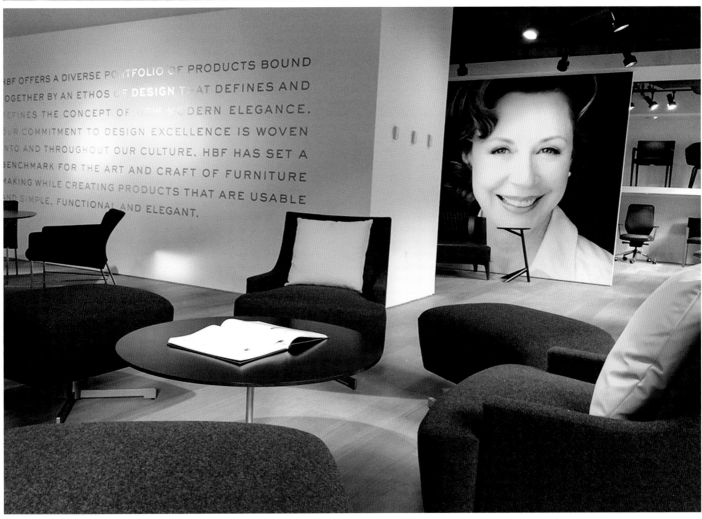

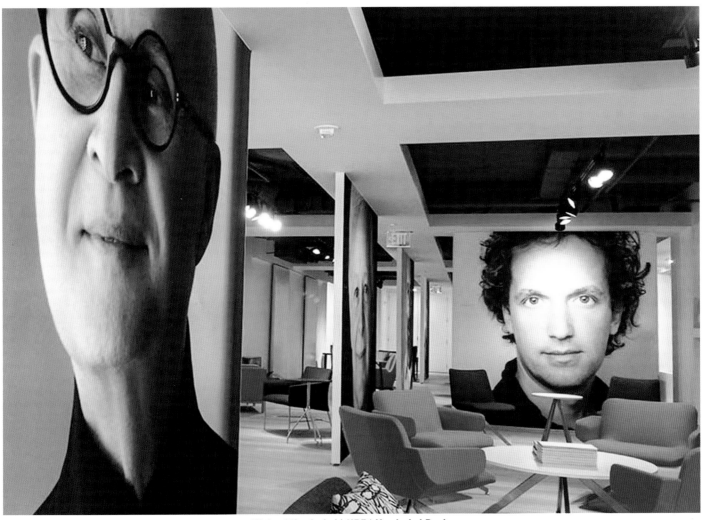

Michael Vanderbyl | HBF | Vanderbyl Design

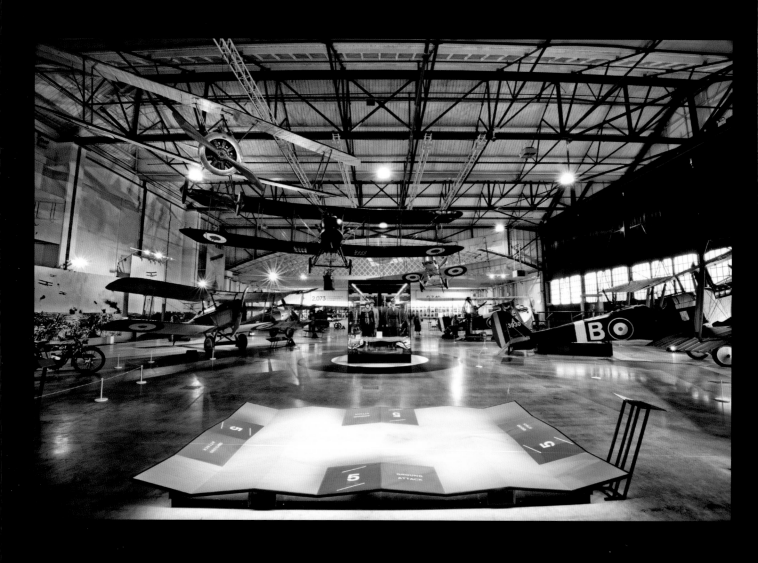

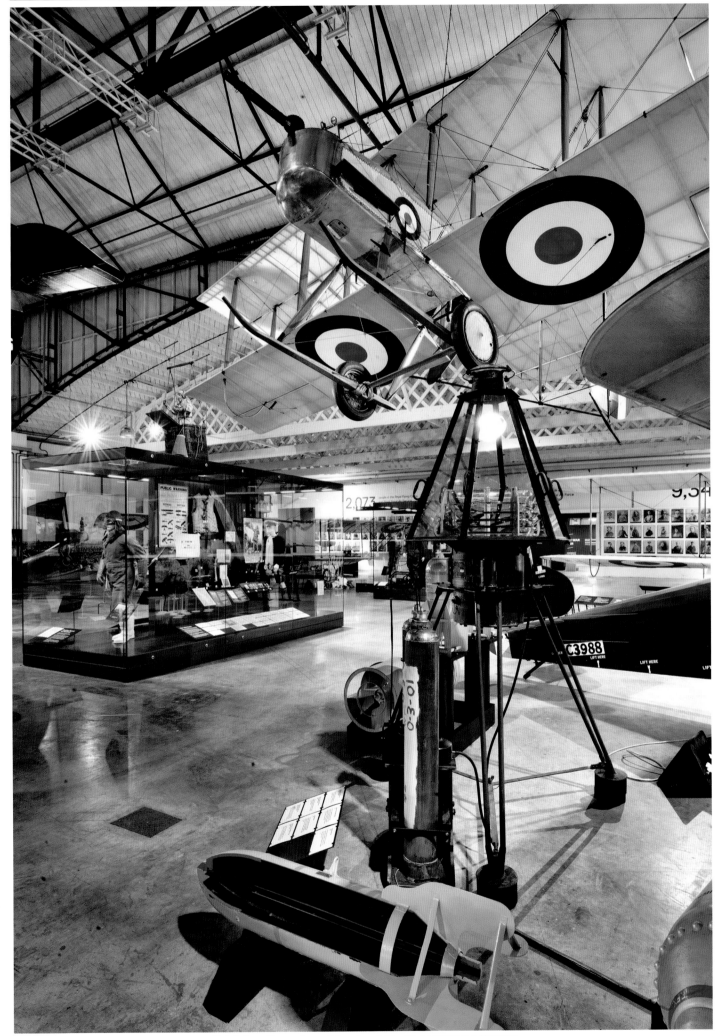

Ralph Appelbaum Associates, Inc. | The Royal Air Force Museum

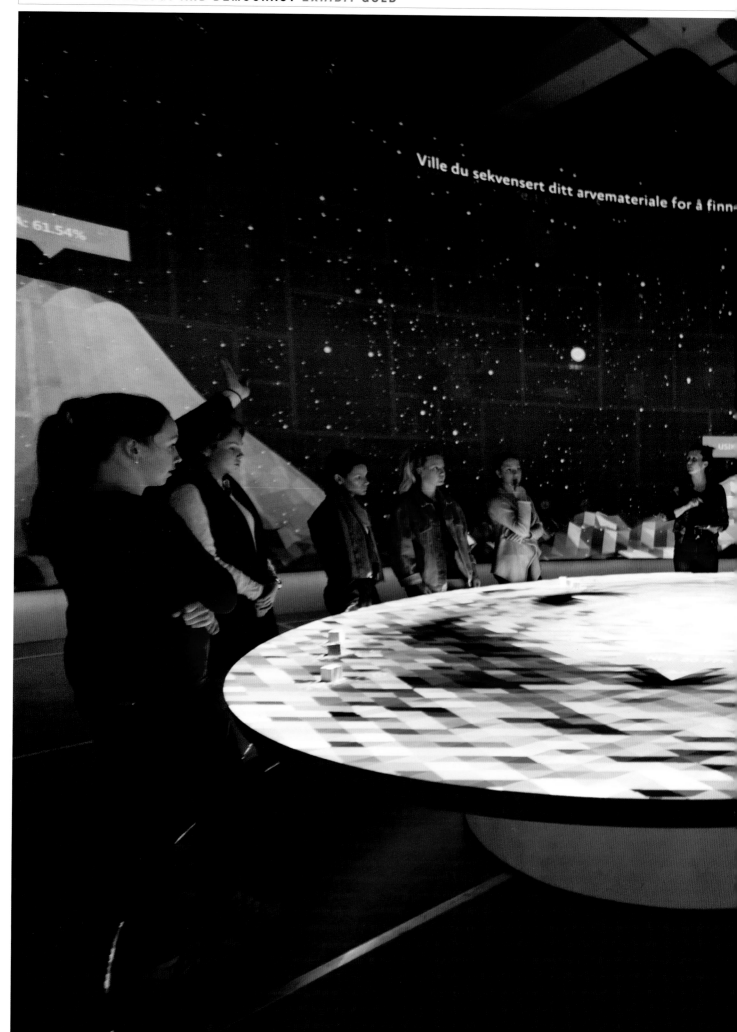

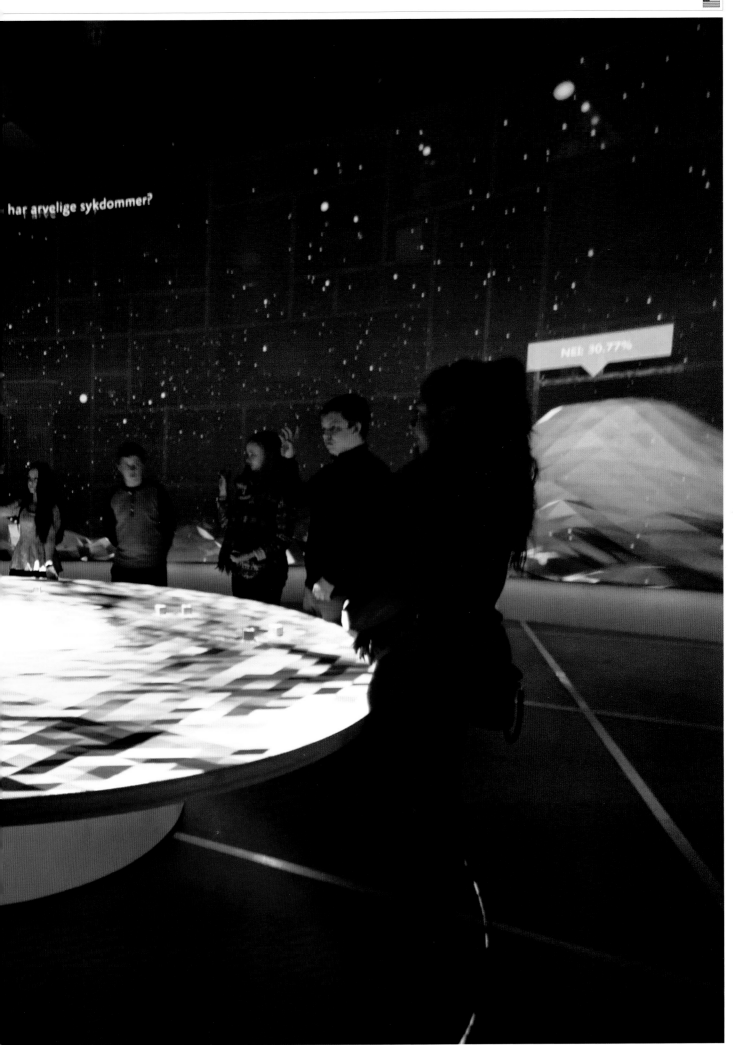

har arvelige sykdommer?

NEI 30,77%

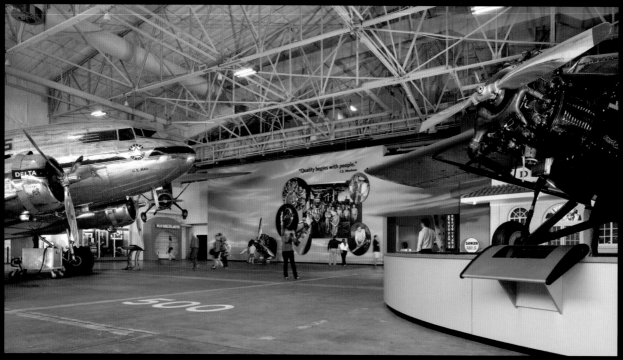

Michael Pantuso | Self-initiated | **Michael Pantuso Design**

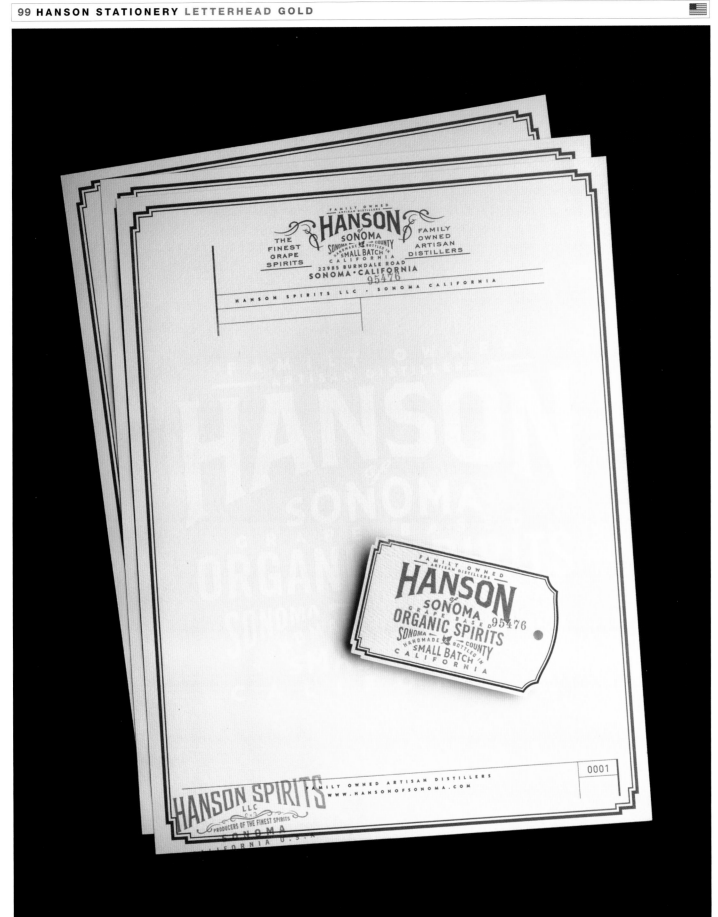

Silver | **Butler Looney** | Boundless | **Butler Looney Design**

Gold | **Vince Frost** | University of Wollongong | **Frost*collective**

Gold | **John Ball** | Shure | **MiresBall**

Silver | **Tim McGrath** | Humble Coffee | **3 Advertising**

Silver | **Michael Vanderbyl** | Proof Loyalty | **Vanderbyl Design**

Silver | **Einar Gylfason** | Reykjavik Karate Club | **Leynivopnid**

Heather Crosby & Jeshurun Webb | Drizly | **Breakaway**

Sharon Lloyd McLaughlin | BridgeLine Property Management | **Mermaid, Inc.**

João Machado | Palácio Nacional de Mafra | **João Machado Design**

Vanessa Ryan | The Aminata Maternal Foundation | **SML Design**

Melissa Chavez | BayGeo | **Butler Looney Design**

Shadia Ohanessian | Denise Picton, oztrain pty ltd | **Shadia Design**

Toshiaki Ide | DHA Capital and Continental Properties, Cantor & Pecorella, Inc. | IF Studio

10th ANNIVERSARY

SMALL ORCHESTRA WITH A BIG DIFFERENCE

TOKYO SINFONIA

Robert Ryker conducts

ORCHESTRA OF 19

SINCE TWO THOUSAND AND FIVE ANNIVERSARY SPECIAL CONCERT

TICKETS:GROUPS ¥5,500 EACH:SINGLE ¥6,000 · 2015 AUGUST BACH

OJI HALL · GINZA ·

FOR INFORMATION / RESERVATIONS TEL:03-3588-0738

WWW.TOKYOSINFONIA.COM

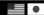

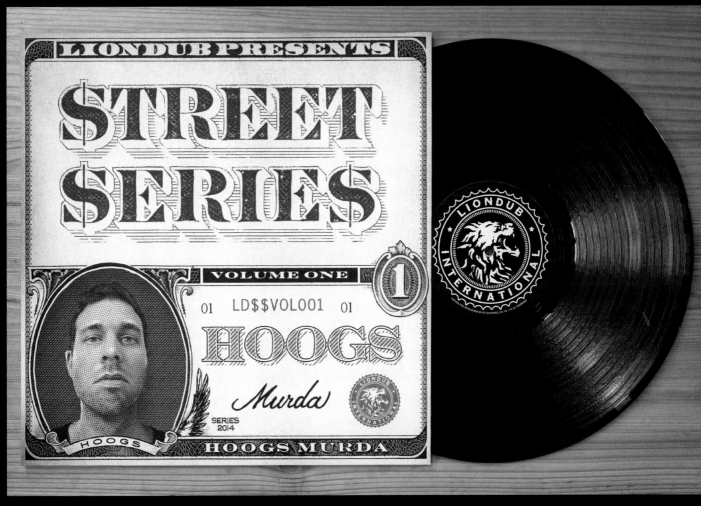

Brady Waggoner | Liondub International | **HOOK**

Mayumi Kato | Tokyo Sinfonia | **beacon communications k.k. graphic studio**

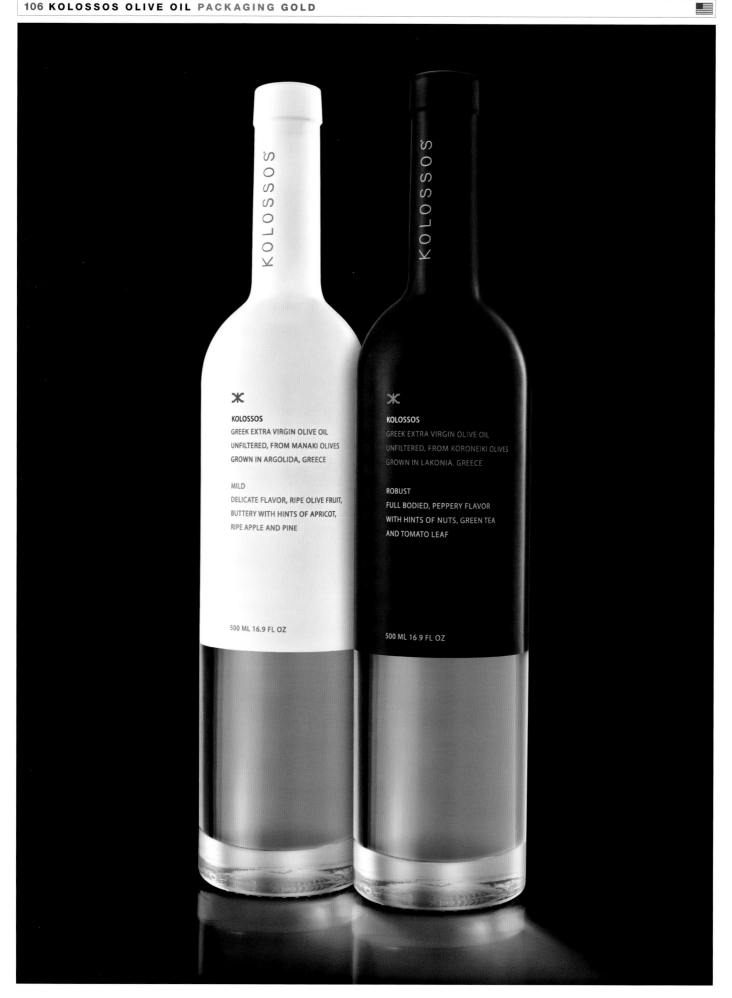

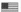

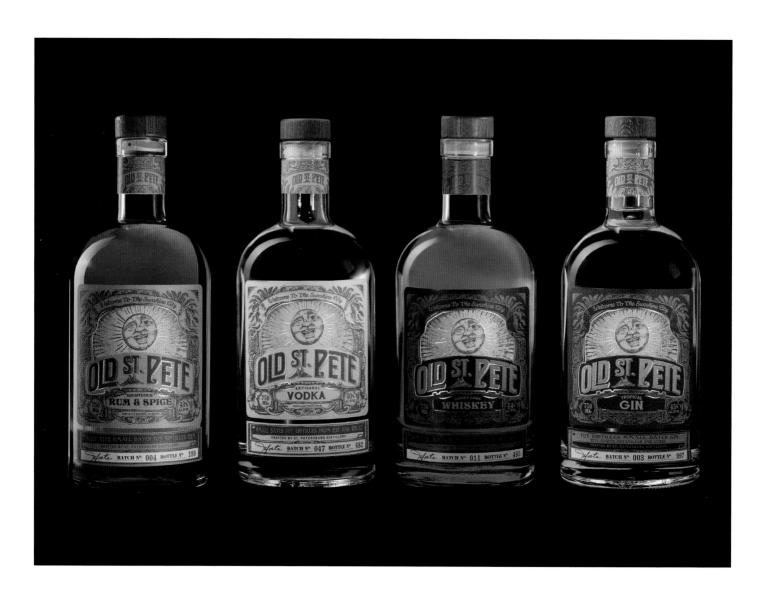

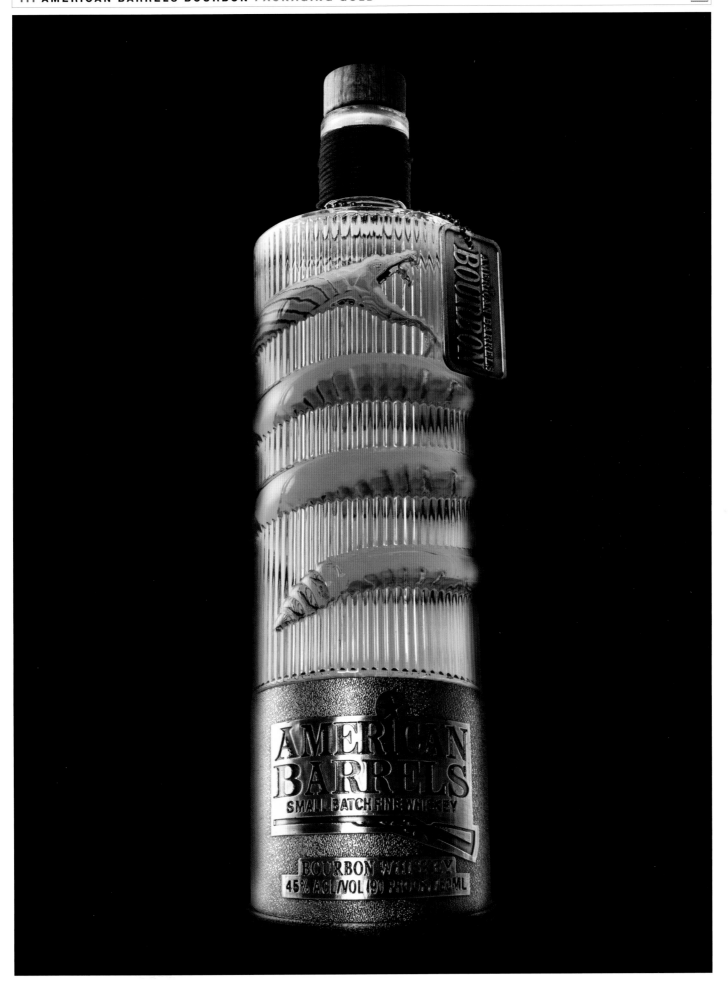

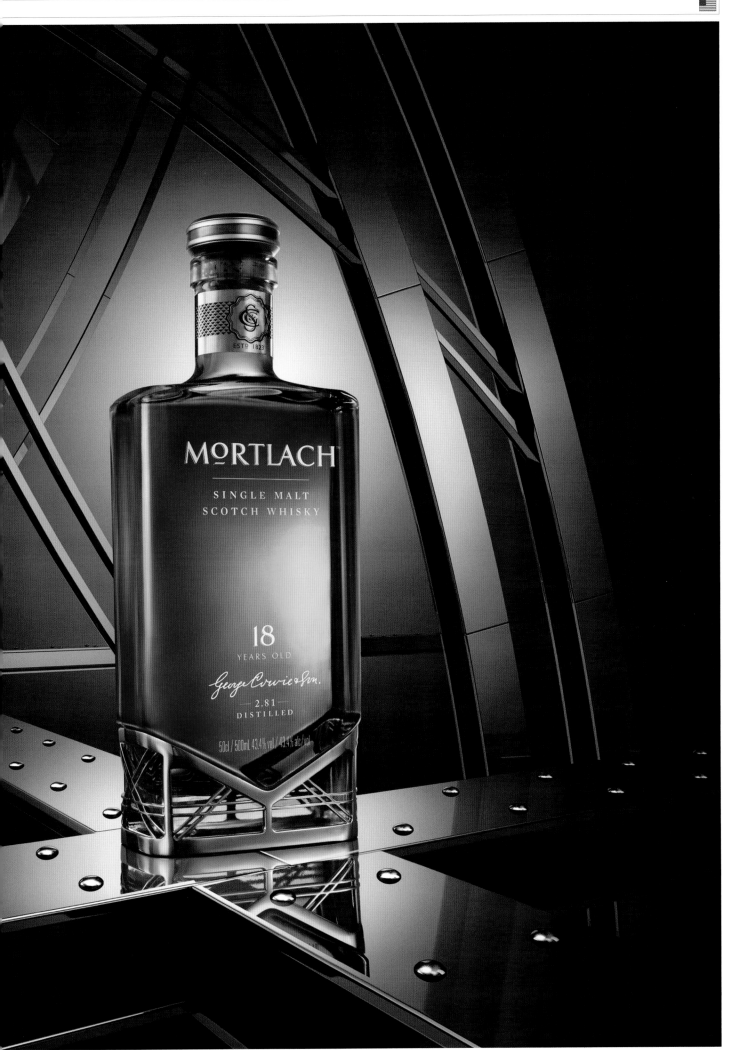

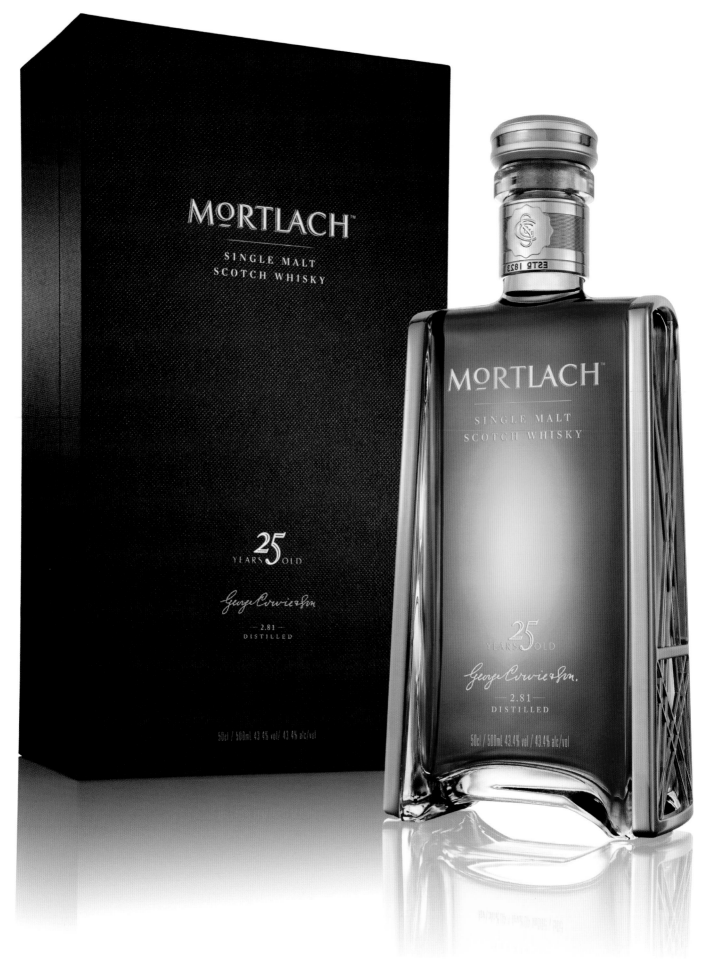

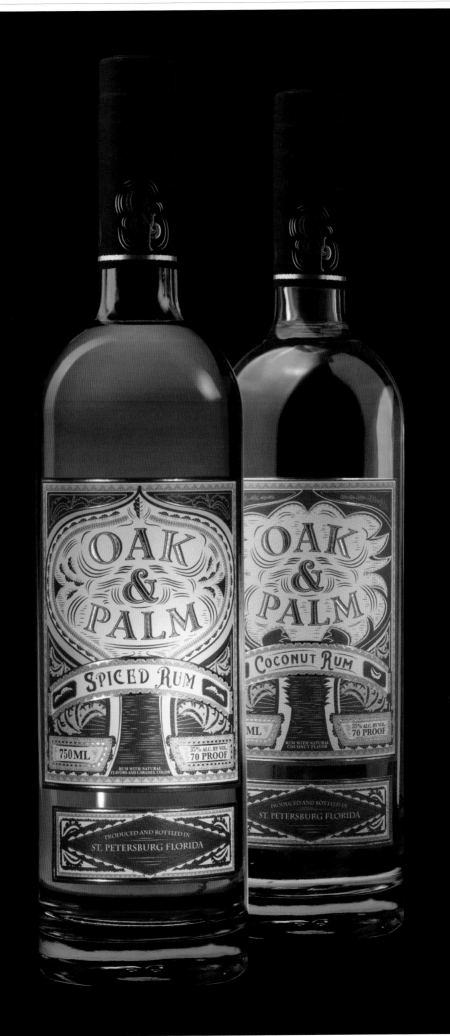

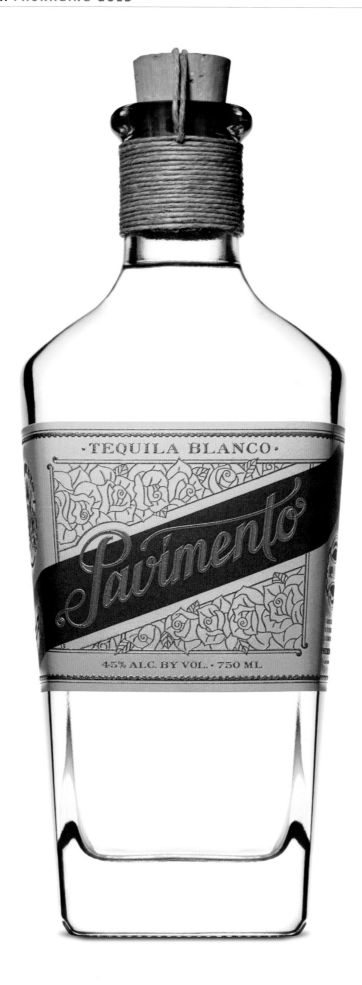

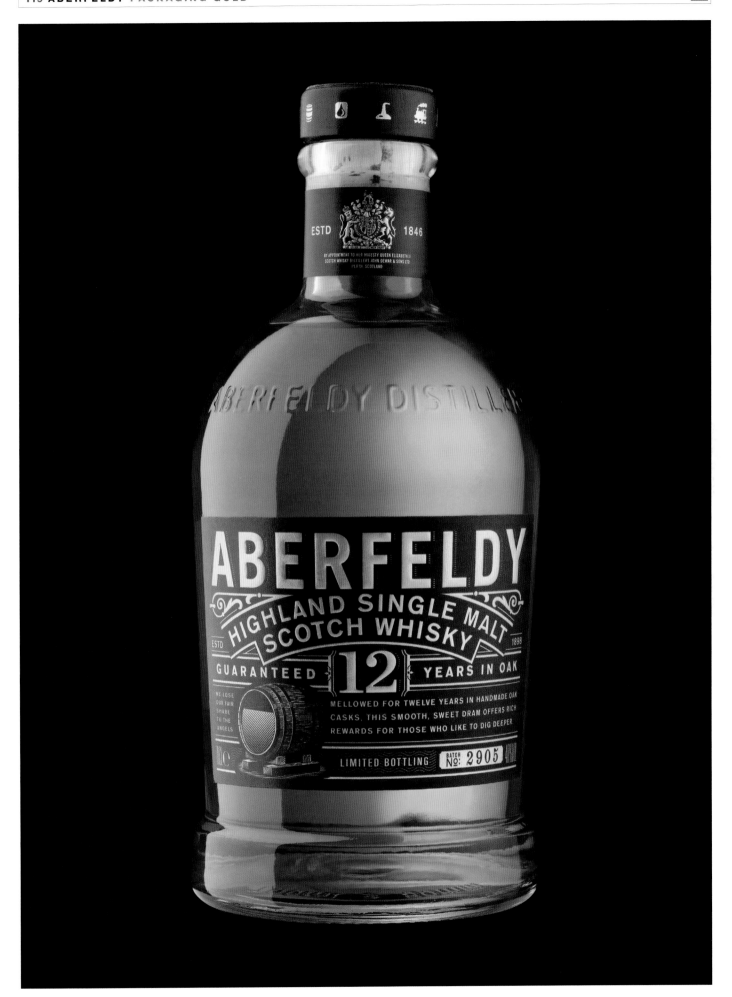

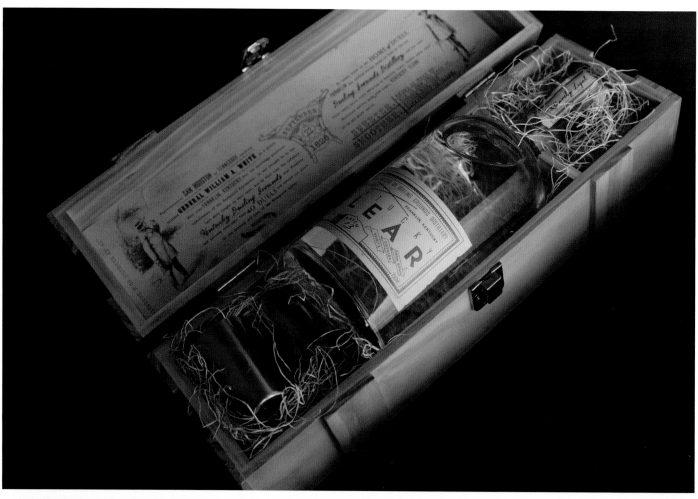

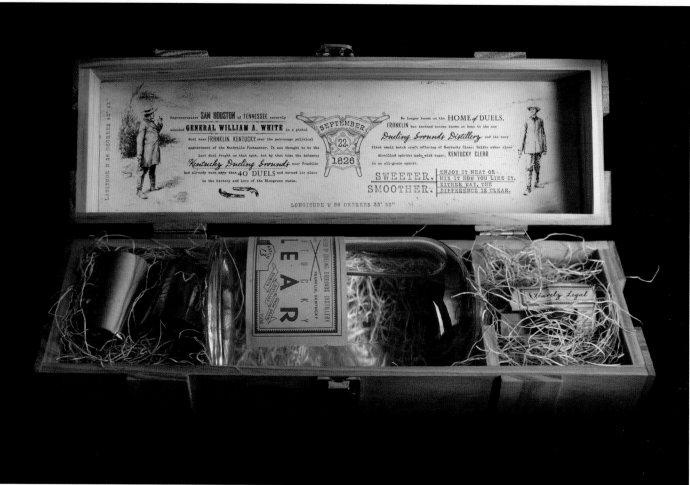

Jon Arnold | Dueling Grounds Distillery | **Bohan Advertising**

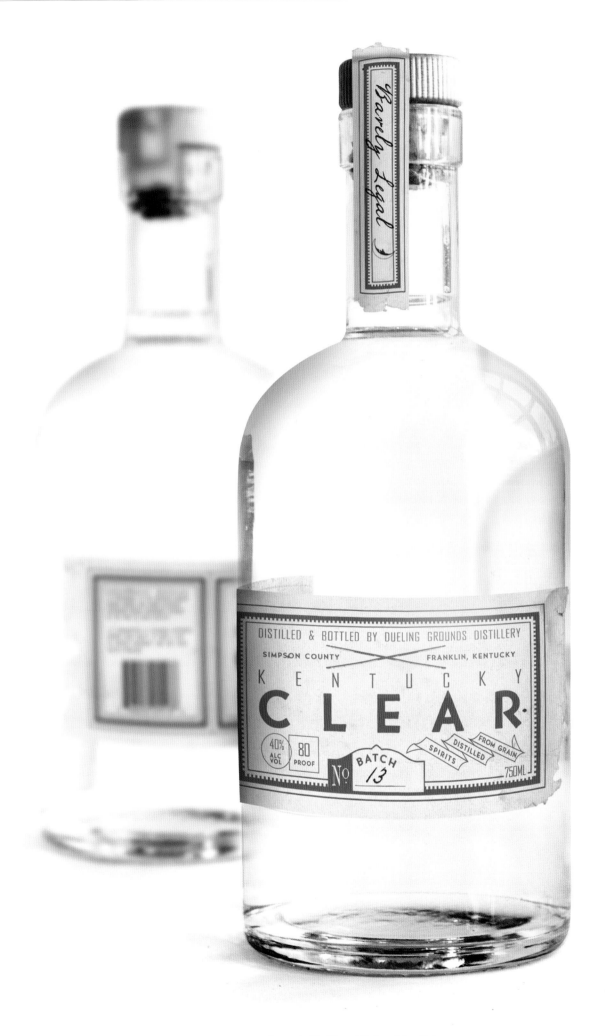

Jon Arnold | **Dueling Grounds Distillery** | **Bohan Advertising**

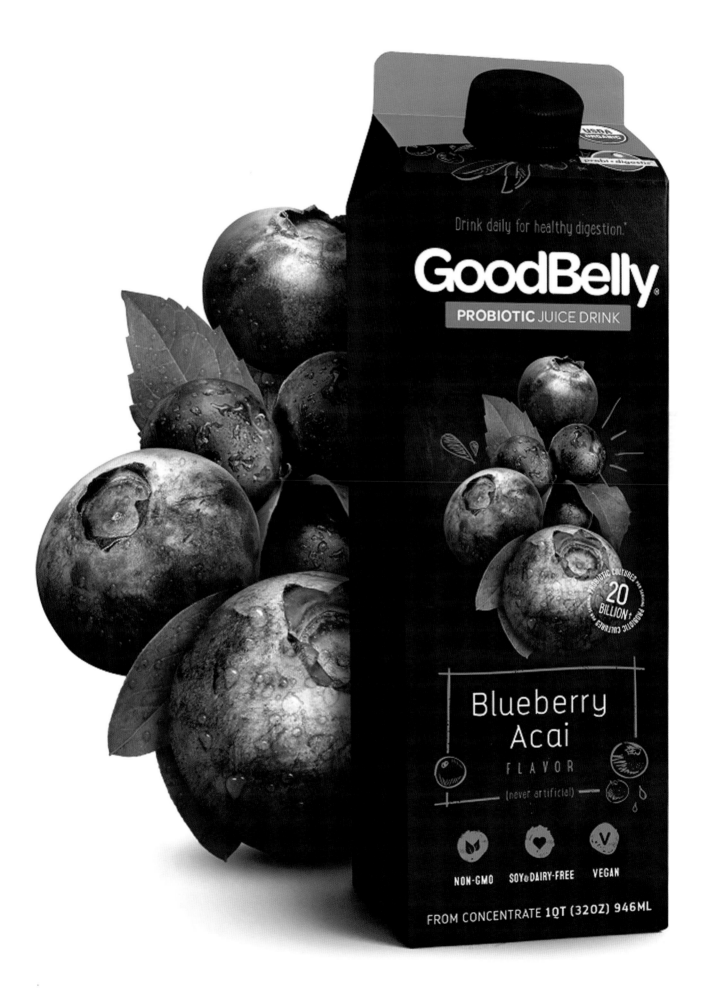

Drink daily for healthy digestion.*

GoodBelly®

PROBIOTIC JUICE DRINK

20 BILLION+

Blueberry Acai
FLAVOR
(never artificial)

NON-GMO SOY & DAIRY-FREE VEGAN

FROM CONCENTRATE 1QT (32OZ) 946ML

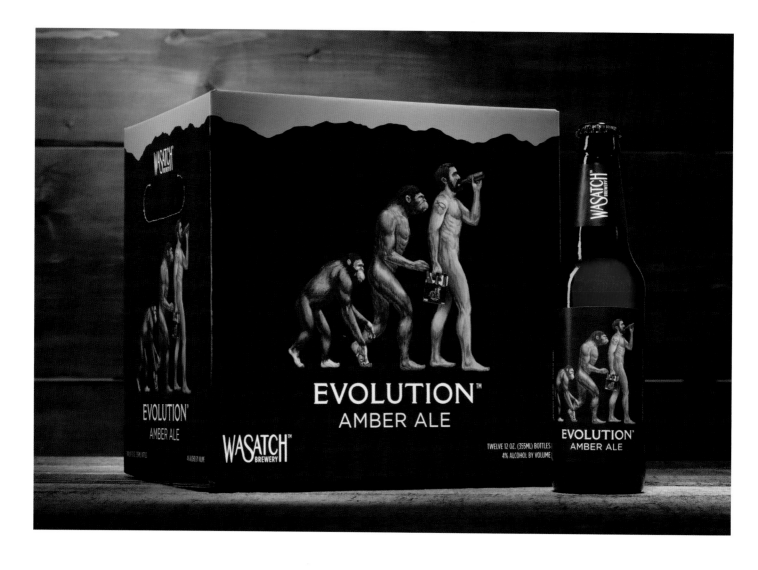

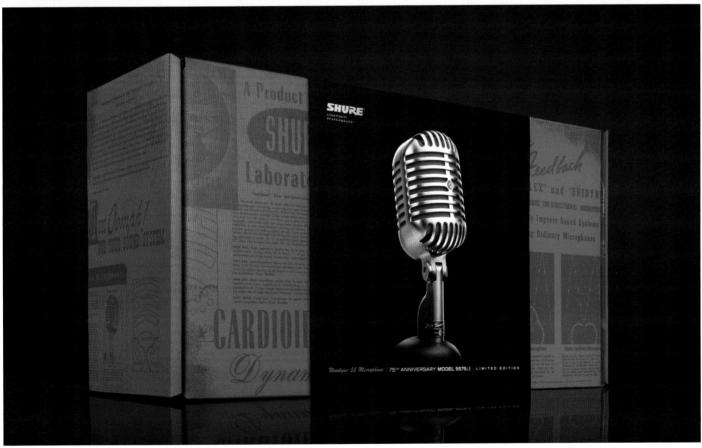

Carl Mazer | Terra Tech | Anthem Worldwide

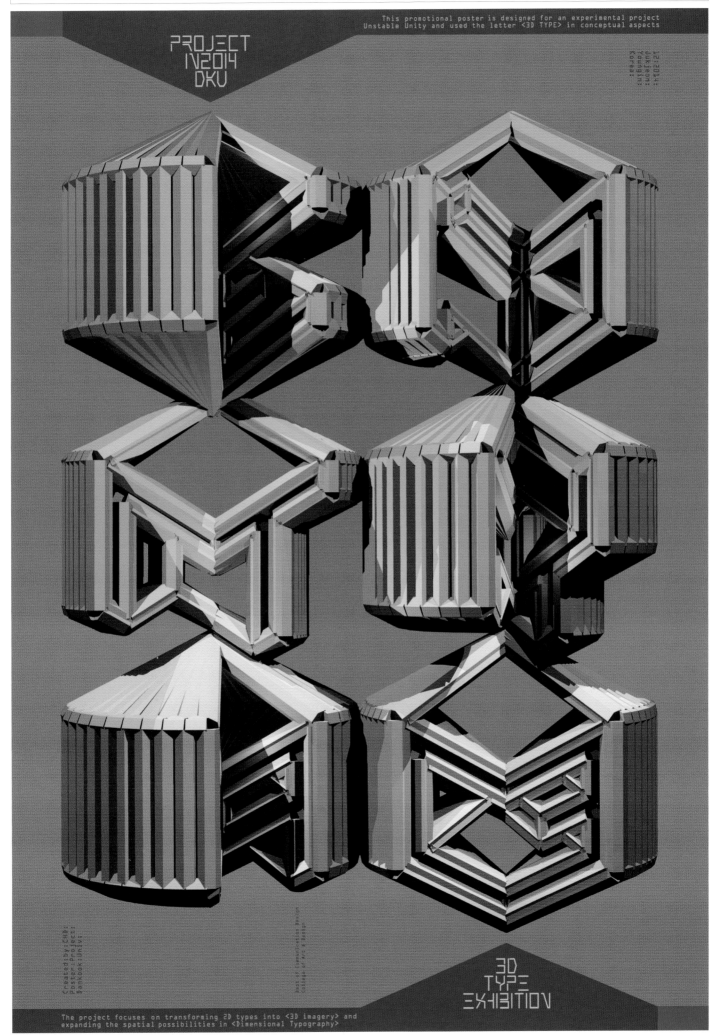

Hoon-Dong Chung | Self-initiated | Dankook University

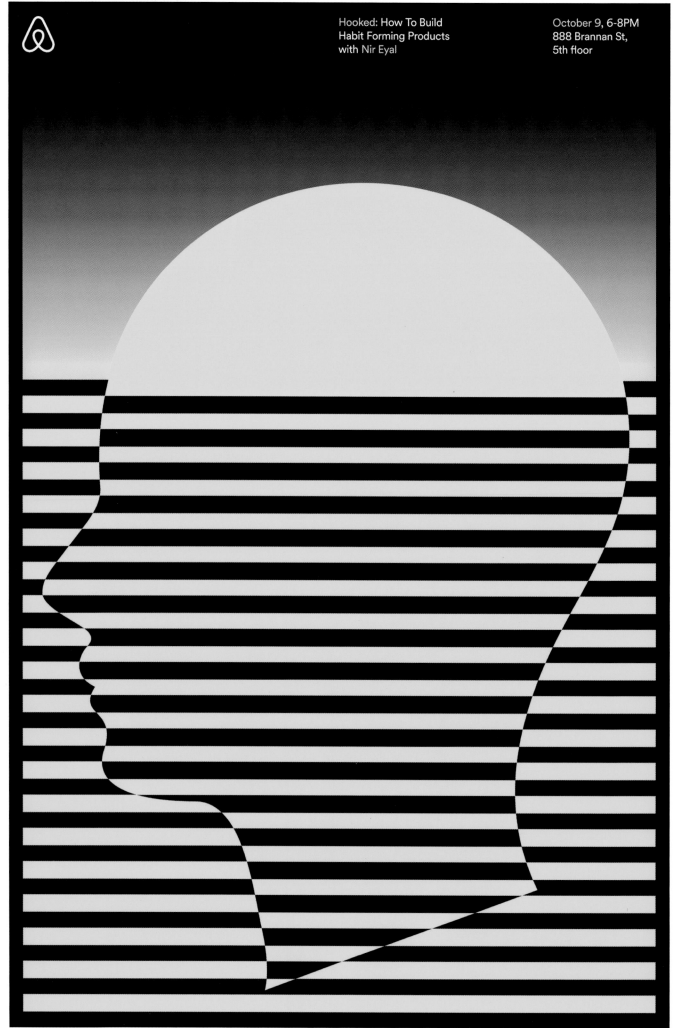

Hooked: How To Build
Habit Forming Products
with Nir Eyal

October 9, 6-8PM
888 Brannan St,
5th floor

Matt Luckhurst | **Self-initiated** | **Airbnb**

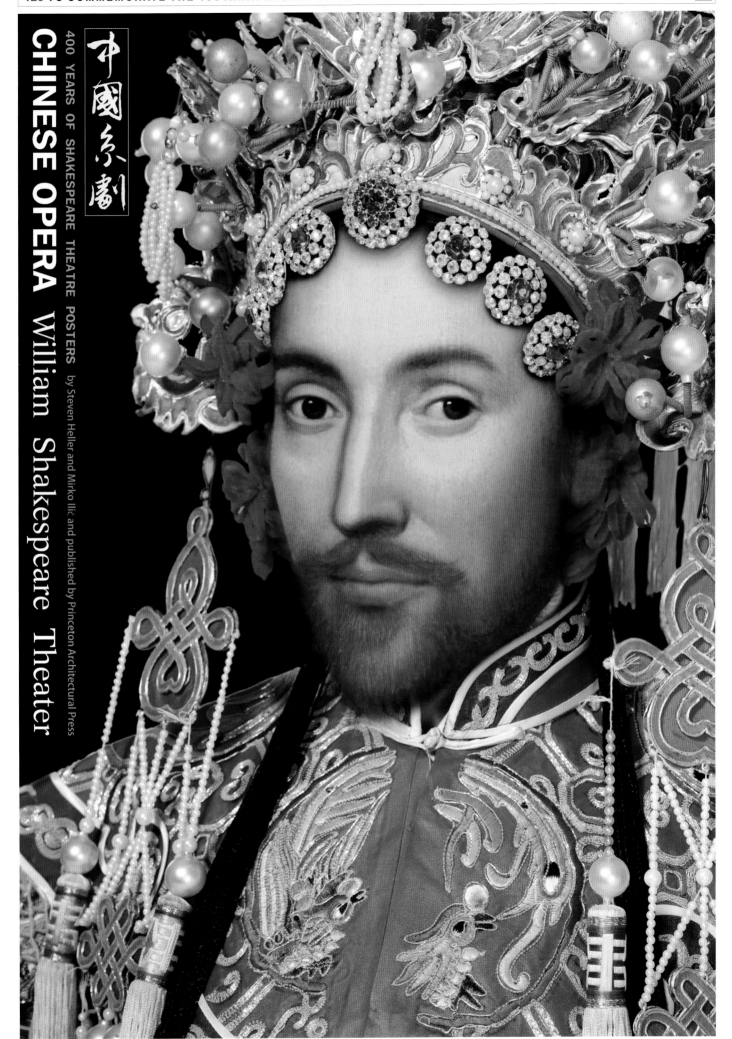

CHINESE OPERA 中國京劇 William Shakespeare Theater

400 YEARS OF SHAKESPEARE THEATRE POSTERS by Steven Heller and Mirko Ilić and published by Princeton Architectural Press

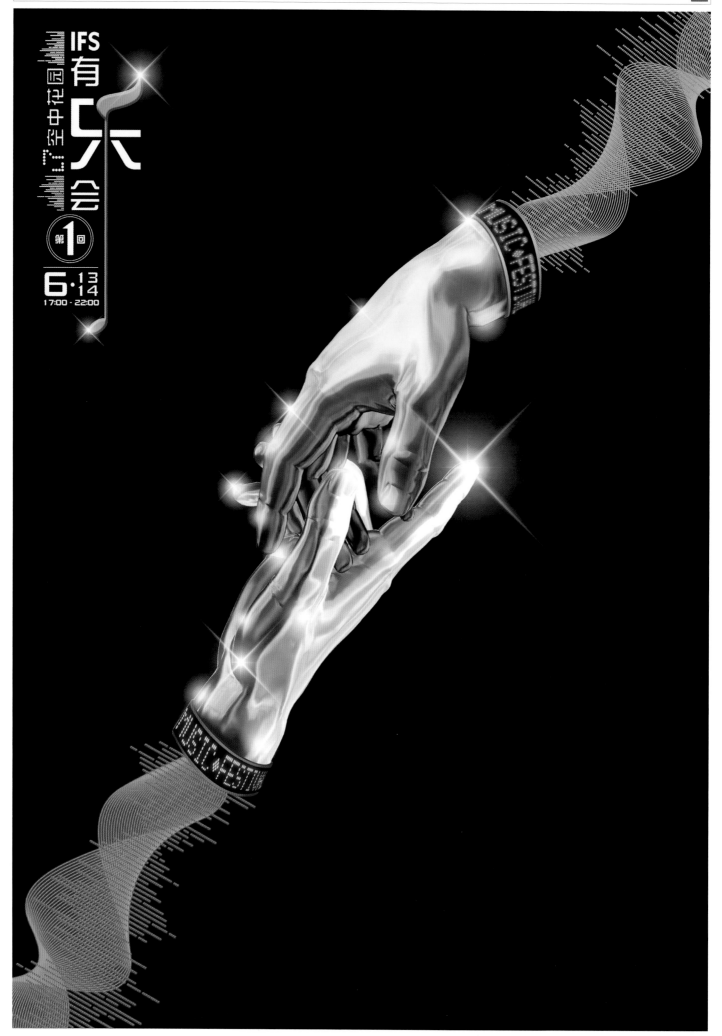

Sunday / February 8 / 2015

ART CENTER

OPEN HOUSE

UNDERGRADUATE DEGREE PROGRAMS IN: ADVERTISING, ENTERTAINMENT DESIGN, ENVIRONMENTAL DESIGN, FILM, FINE ART, GRAPHIC DESIGN, ILLUSTRATION, INTERACTION DESIGN, PHOTOGRAPHY AND IMAGING, PRODUCT DESIGN, TRANSPORTATION DESIGN

Ongoing 12:00–4:30 pm

View student work from
the undergraduate programs

Talk with faculty and staff

Two Campus Locations

Hillside Campus: All majors except Fine Art
1700 Lida Street, Pasadena, CA 91103

South Campus: Fine Art Majors
870 S. Raymond, Pasadena, CA 91105

Special Sessions at Both Campuses

Admissions / Financial Aid: 1:30 & 3:00 pm

Directions: www.artcenter.edu
No RSVP Necessary

Shuttle available between campuses

● Art Center College of Design

Brad Bartlett | Art Center College of Design | **Brad Bartlett Design, LA**

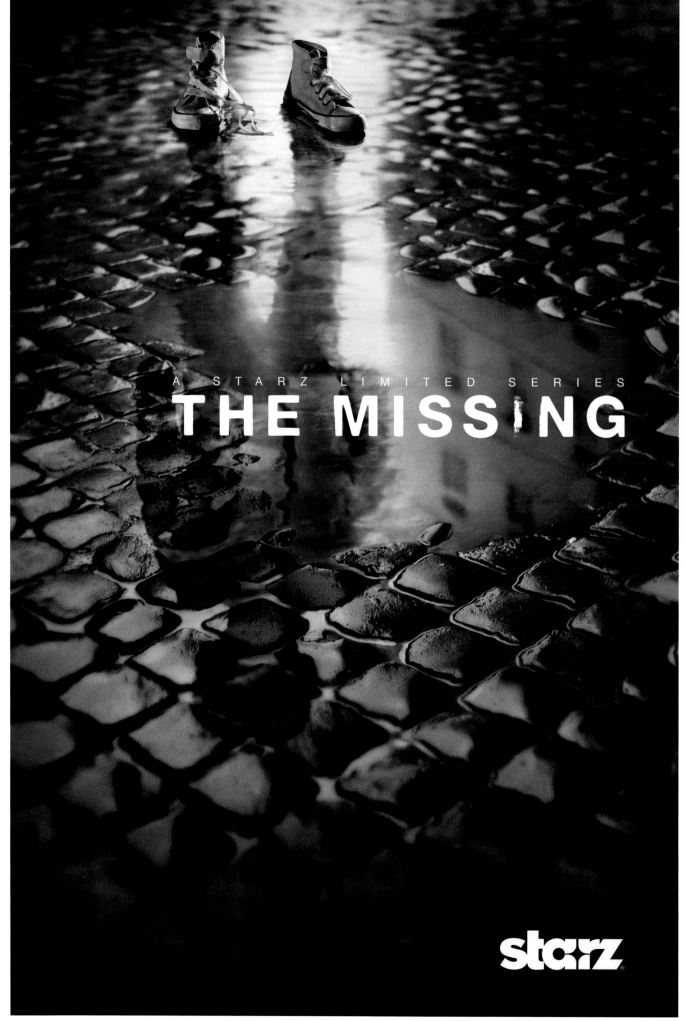

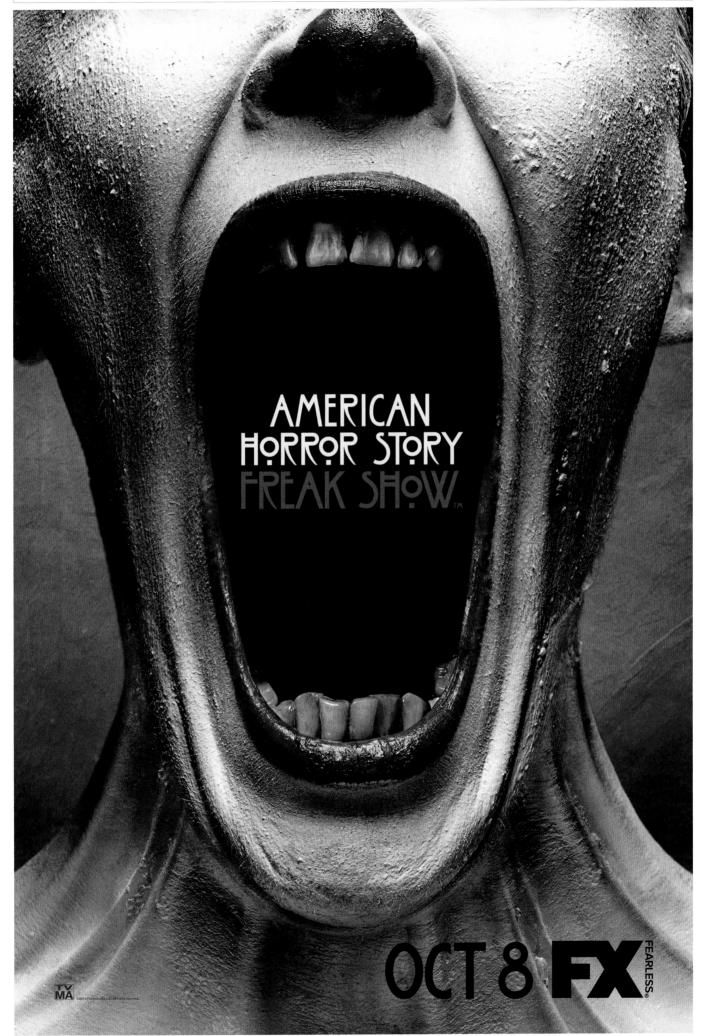

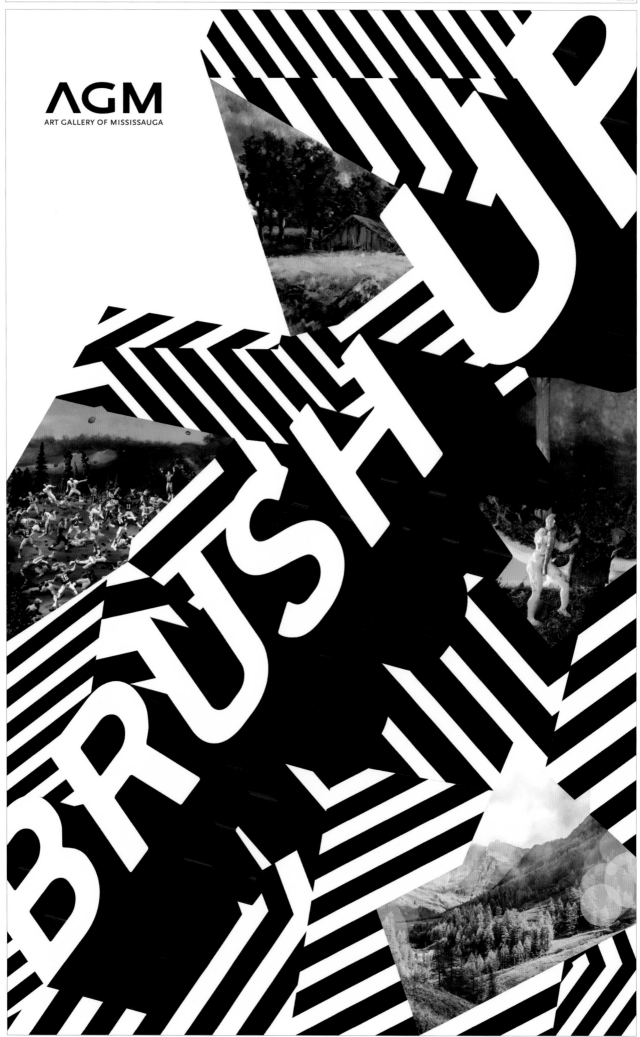

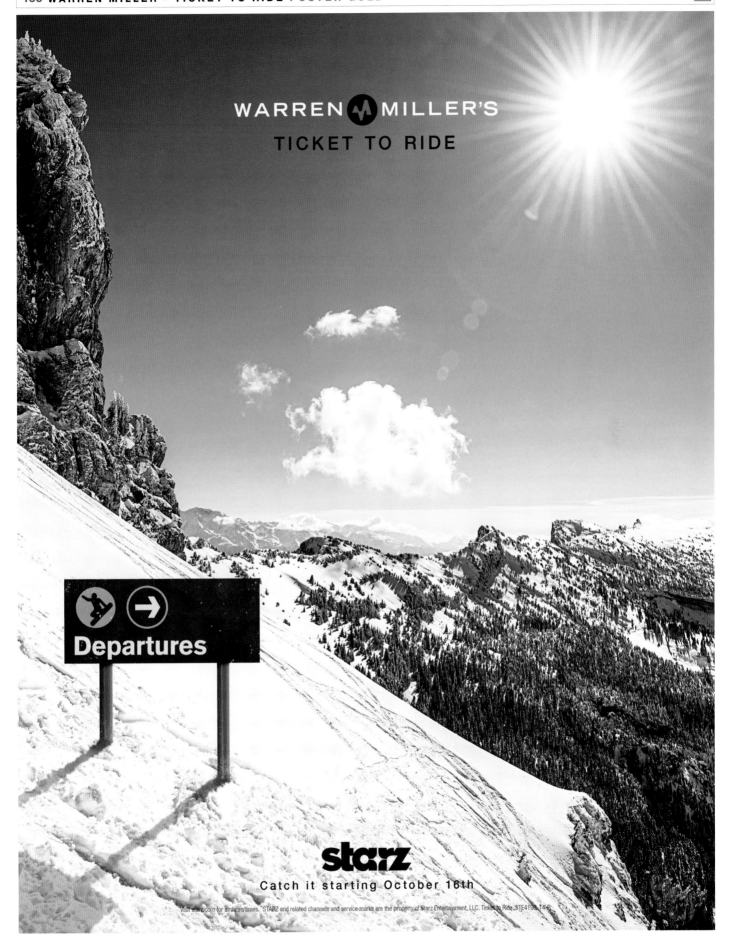

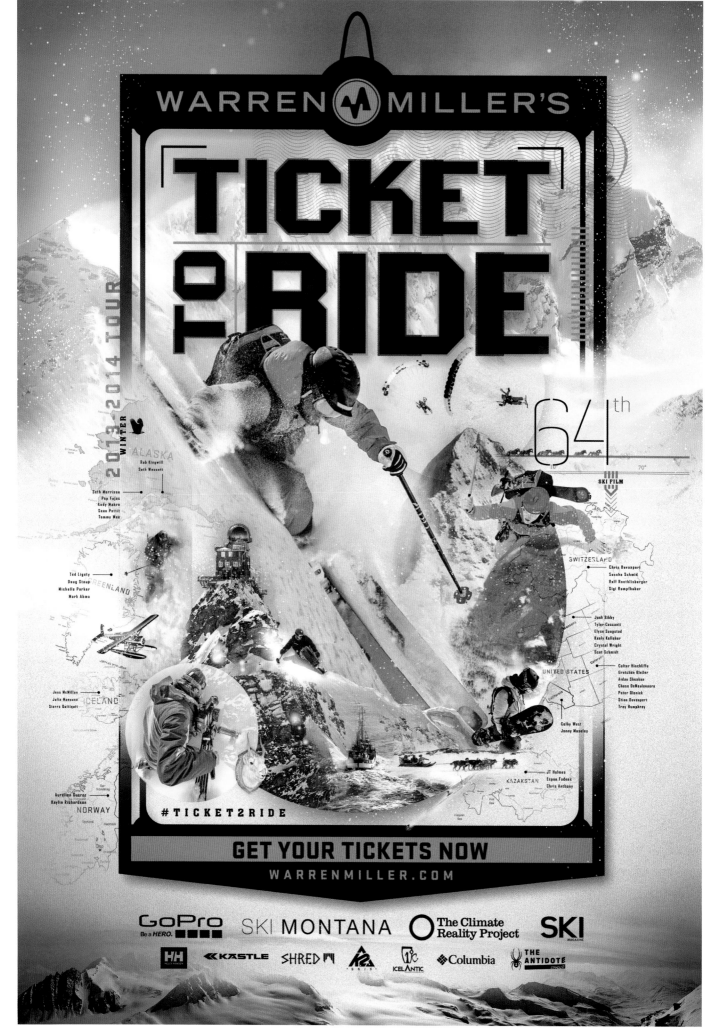

Leif Stiener | Warren Miller Entertainment | Moxie Sozo

15 Annual SDSU Juried Student
& Design Competition and Exhibition
onsored by the Department of Visual Arts
en: South Dakota State University students
ries accepted through April 13–15, 2015
ll 605.688.4103 for entry information
hibition: Ritz Gallery Apr 30–Aug 30

Randy Clark | Department of Visual Arts/South Dakota State University | **Randy Clark Graphic Design**

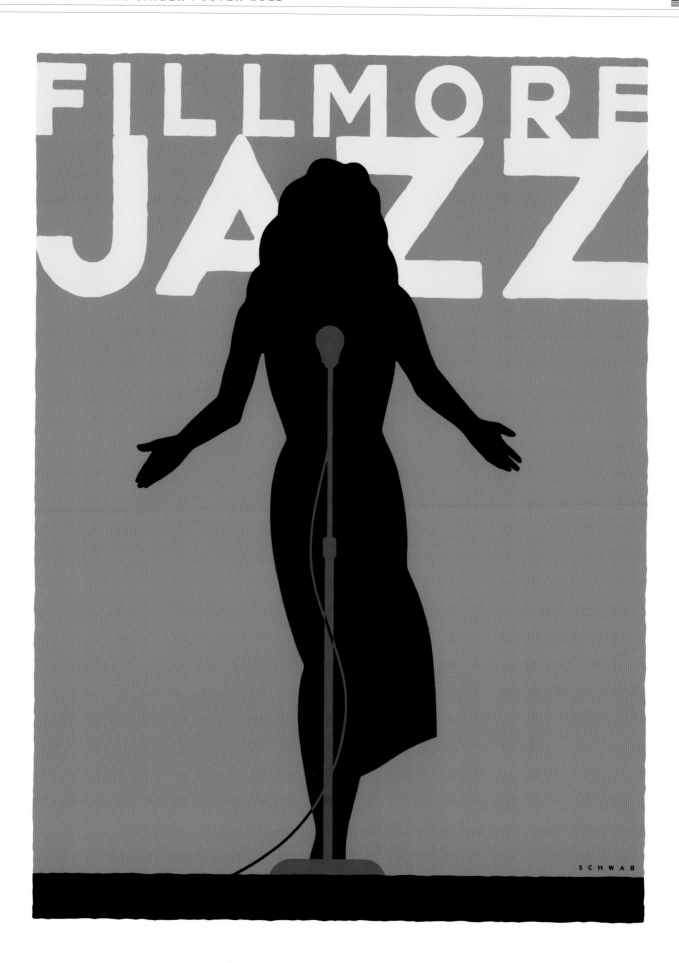

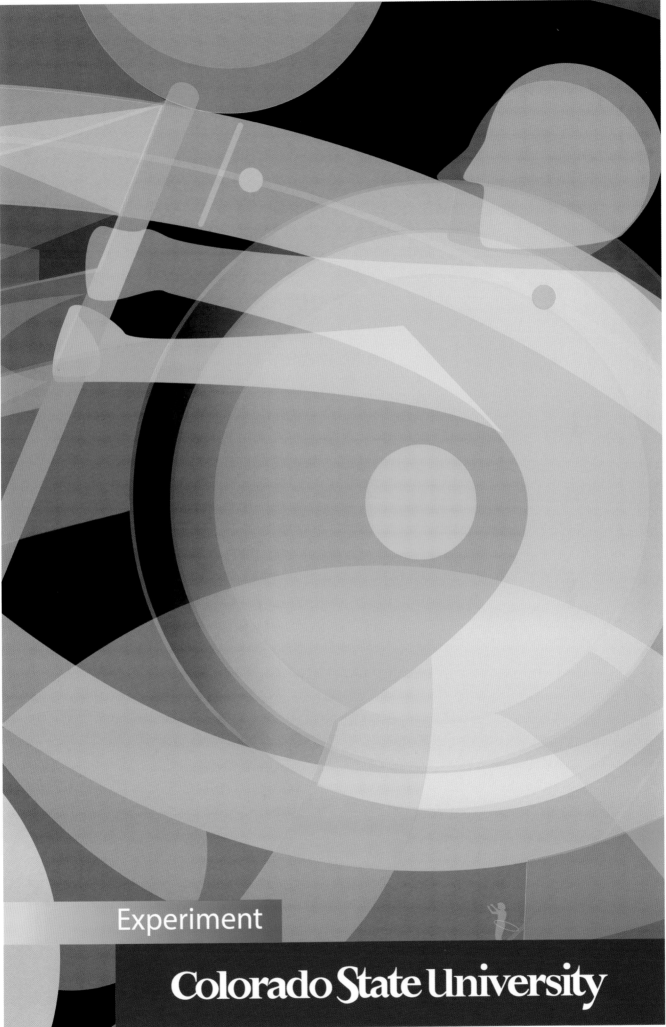

Experiment

Colorado State University

John Gravdahl | Colorado State University | **John Gravdahl Design**

Analyze

Colorado State University

John Gravdahl | Colorado State University | John Gravdahl Design

Team Alvimedica
Volvo Ocean Race 2014-2015

Michael Vanderbyl | *Alvimedica* | **Vanderbyl Design**

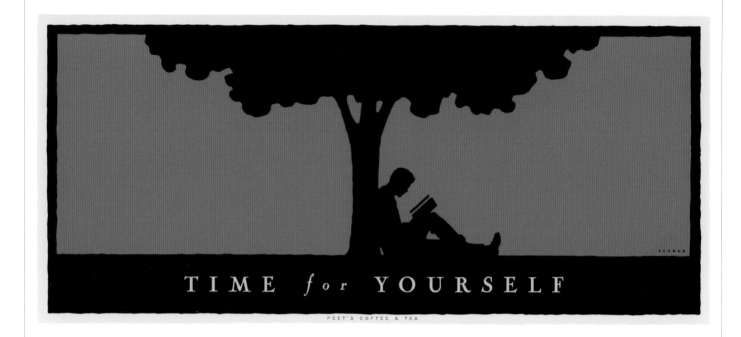

Michael Schwab | Peet's Coffee & Tea | **Michael Schwab Studio**

Michael Schwab | San Anselmo Library | **Michael Schwab Studio**

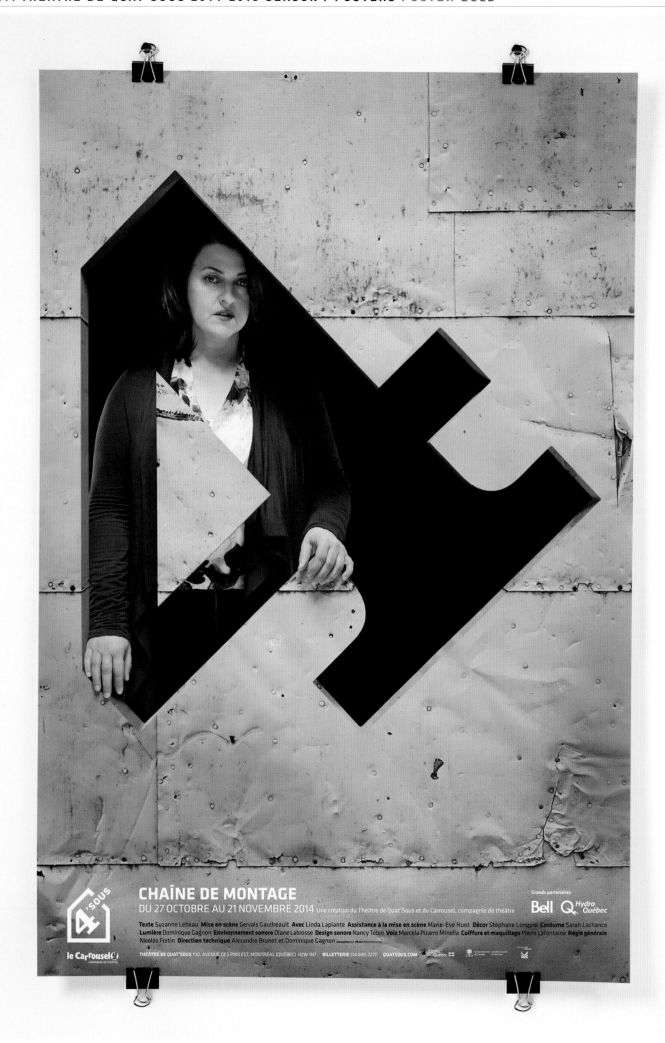

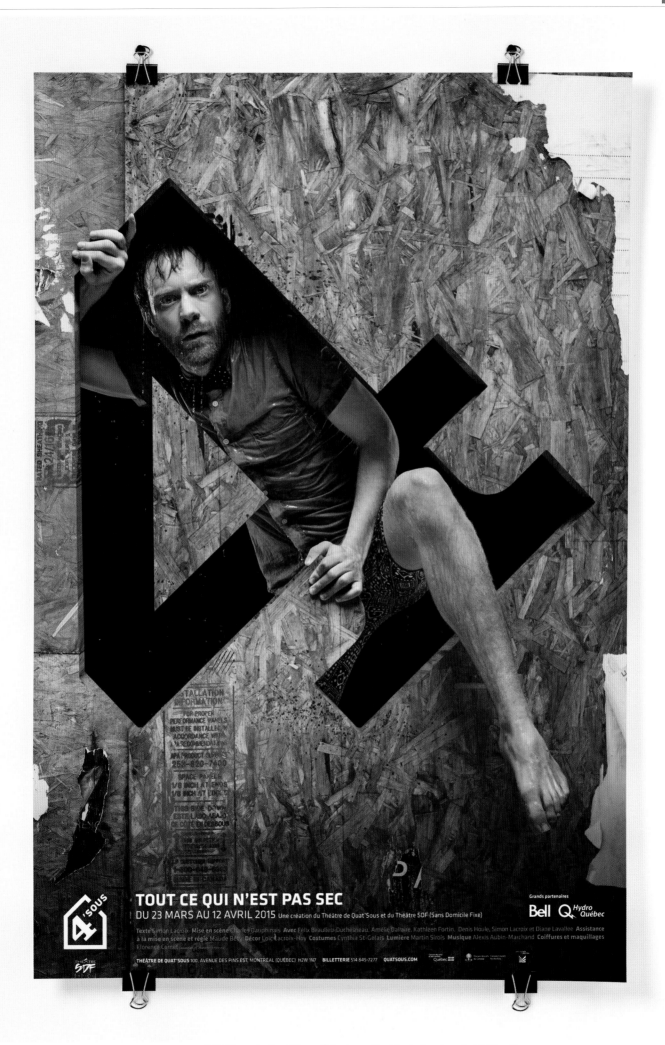

Claude Auchu | Théâtre de Quat'Sous, Éric Jean, Sophie de Lamirande | **lg2boutique**

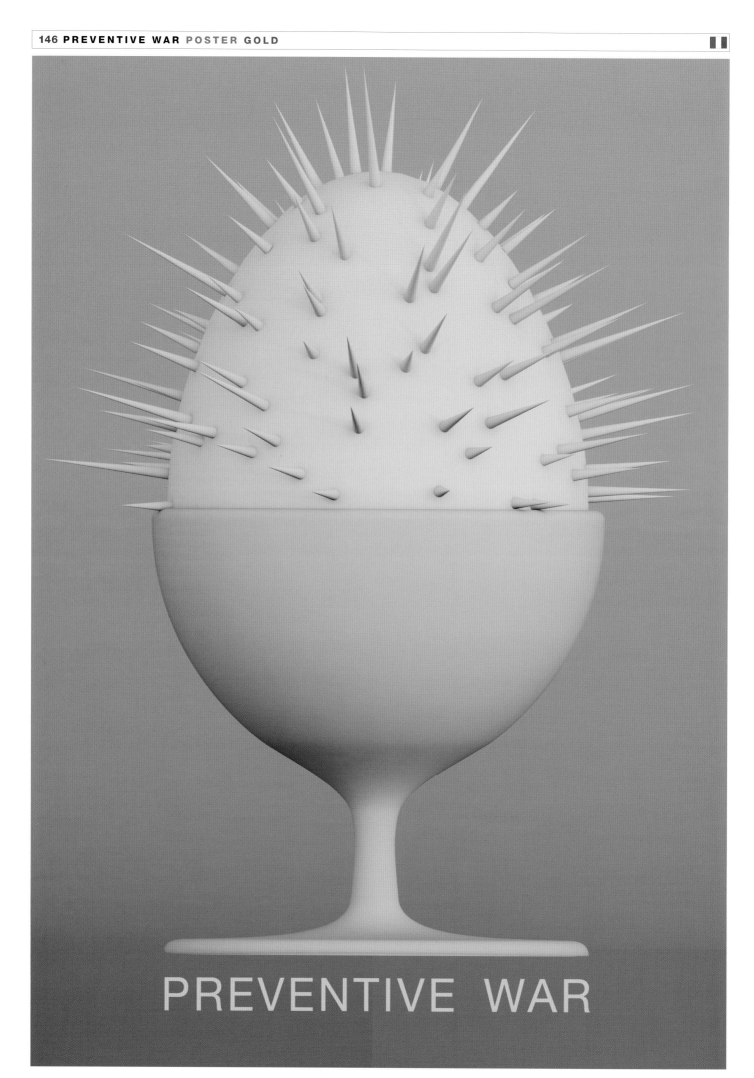

PREVENTIVE WAR

Sergio Olivotti | Spontaneous protest movement

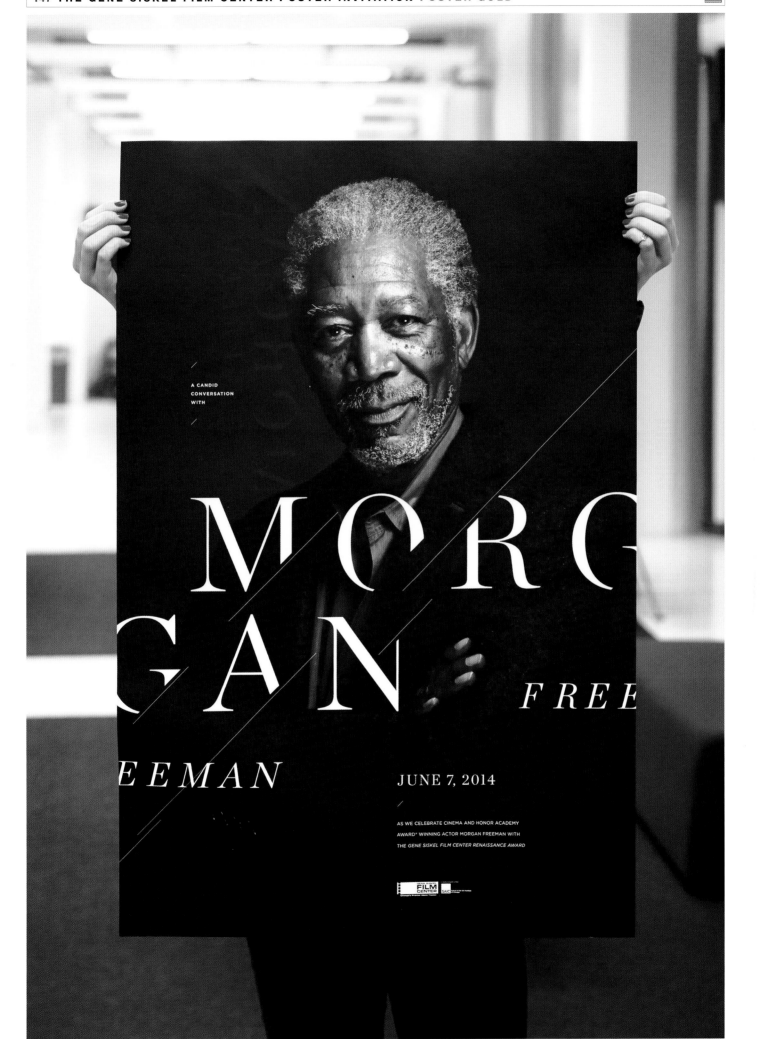

Jamie Koval | Gene Siskel Film Center | VSA Partners

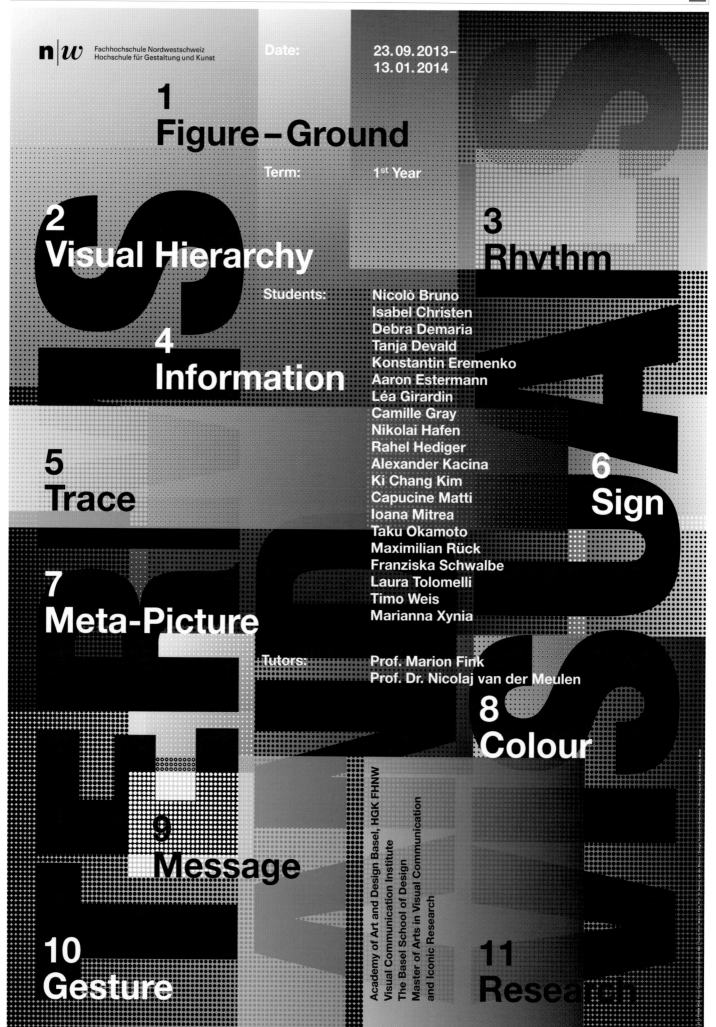

2.4.15 *through* **2.22.15** THE BLACK REP

TICKETS: 314.534.3810 | THEBLACKREP.ORG

STICK FLY

BY LYDIA DIAMOND

SOME FAMILIES NEED DYSFUNCTION TO FUNCTION.

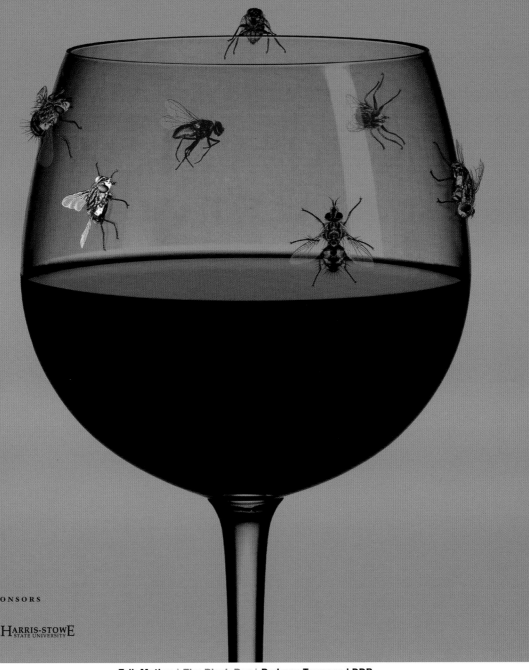

SPONSORS

RAC HARRIS-STOWE STATE UNIVERSITY

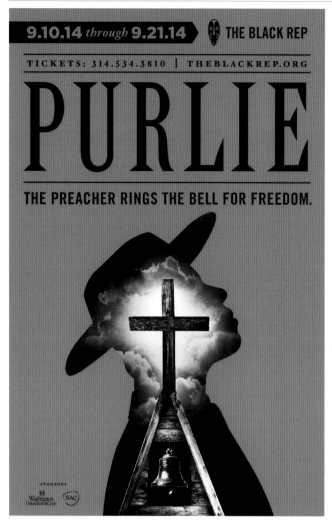

9.10.14 *through* 9.21.14 🎭 THE BLACK REP

TICKETS: 314.534.3810 | THEBLACKREP.ORG

PURLIE

THE PREACHER RINGS THE BELL FOR FREEDOM.

SPONSORS
Washington University in St. Louis · RAC

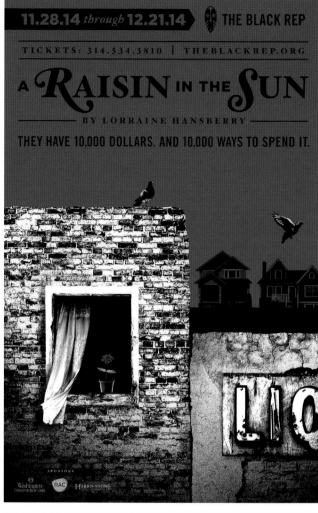

11.28.14 *through* 12.21.14 🎭 THE BLACK REP

TICKETS: 314.534.3810 | THEBLACKREP.ORG

A RAISIN IN THE SUN

BY LORRAINE HANSBERRY

THEY HAVE 10,000 DOLLARS. AND 10,000 WAYS TO SPEND IT.

SPONSORS
Washington University in St. Louis · RAC · HARRIS-STOWE

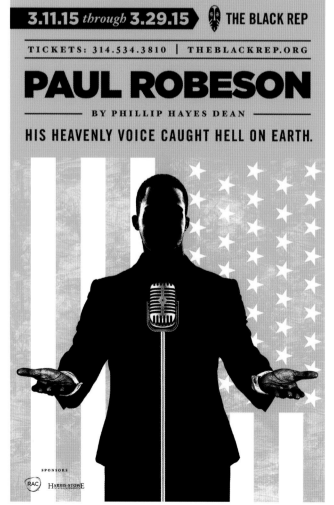

3.11.15 *through* 3.29.15 🎭 THE BLACK REP

TICKETS: 314.534.3810 | THEBLACKREP.ORG

PAUL ROBESON

BY PHILLIP HAYES DEAN

HIS HEAVENLY VOICE CAUGHT HELL ON EARTH.

SPONSORS
RAC · HARRIS-STOWE

4.22.15 *through* 5.3.15 🎭 THE BLACK REP

TICKETS: 314.534.3810 | THEBLACKREP.ORG

ONCE *on this* ISLAND

HER ROOTS CAME FROM THE WRONG SIDE OF THE ISLAND.

SPONSORS
Washington University in St. Louis · RAC

Erik Mathre | The Black Rep | Rodgers Townsend DDB

STARLIGHT MUSIC SERIES

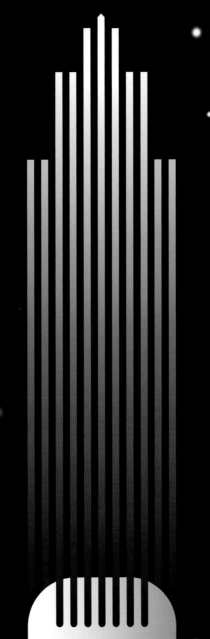

Observation Deck at
Rockefeller Center®
50th Street between
5th and 6th Avenue

Michael Gericke | **Tishman Speyer** | **Pentagram**

骨 再 生 、 復 活 の テ ク ノ ロ ジ ー 。

Toshiyuki Kojima | **Okada Medical Supply co.,ltd.** | **Kojima Design Office Inc.**

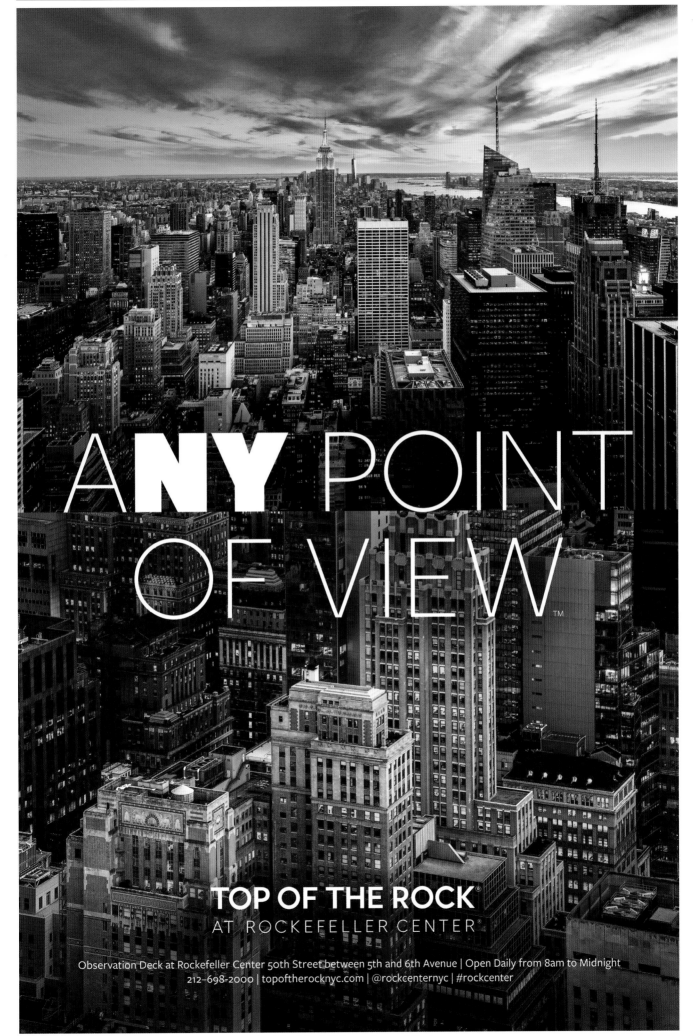

Michael Gericke | Tishman Speyer | Pentagram

Michael Gericke | Tishman Speyer | **Pentagram**

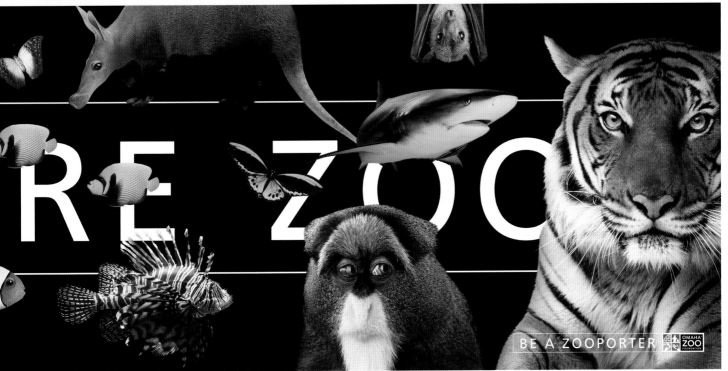

James Strange & Raleigh Drennon | Omaha Zoo Foundation | **Agent**

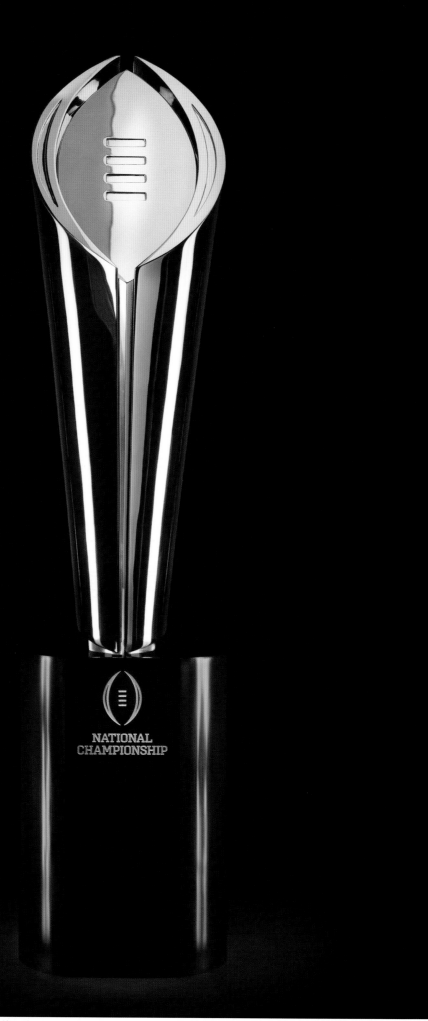

Michael Gericke | College Football Playoff | **Pentagram**

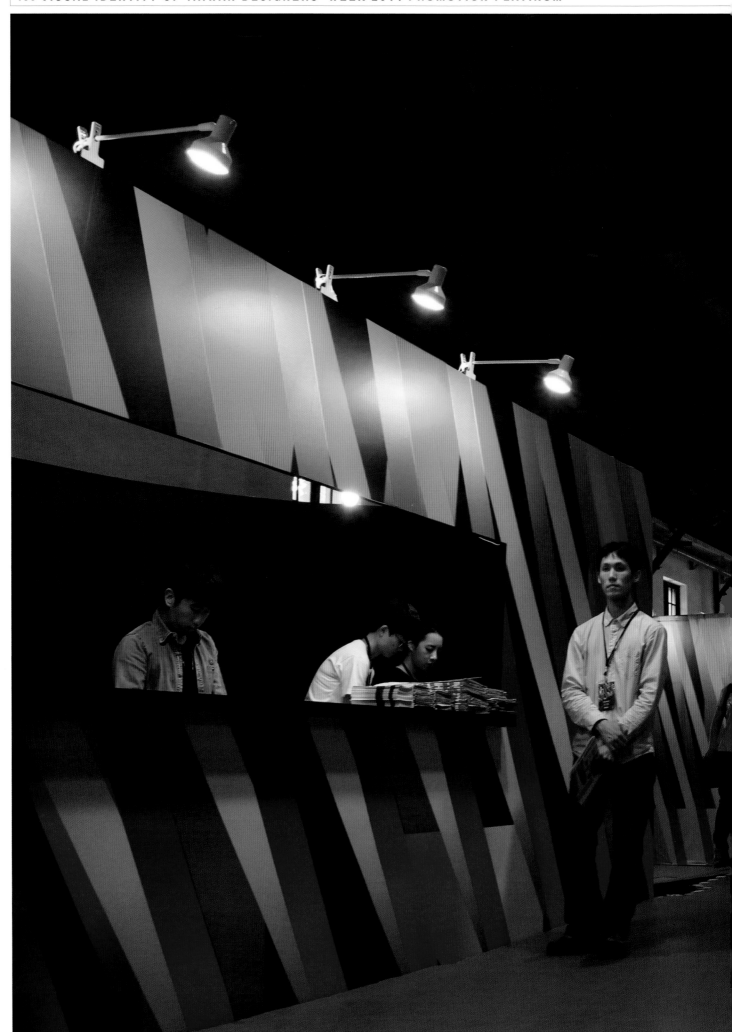

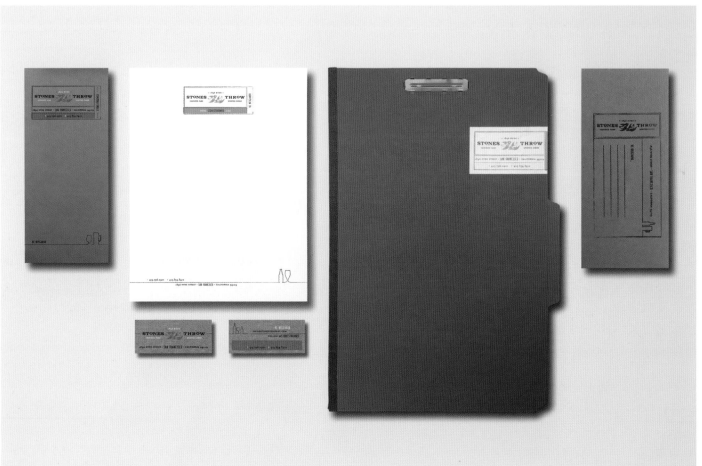

Ann Jordan & Shardul Kiri | **Hi Neighbor** | **UNIT partners**

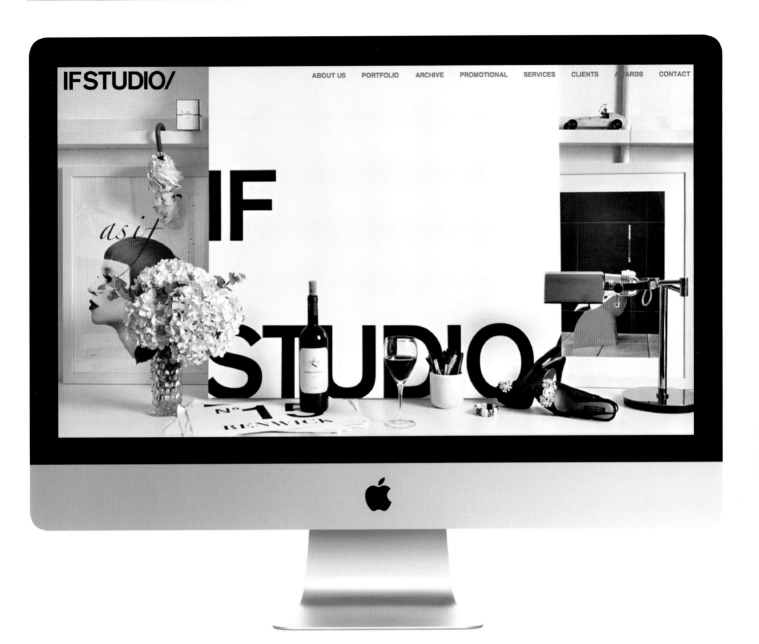

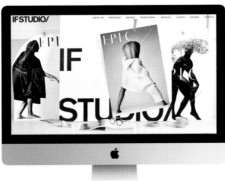

Toshiaki Ide | Self-initiated | IF Studio

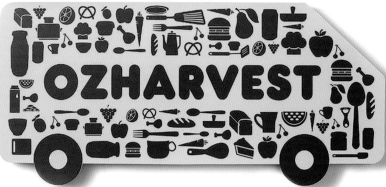

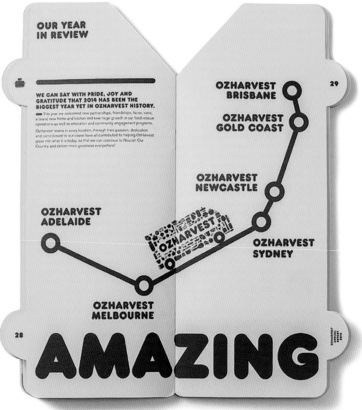

Vince Frost | OzHarvest | Frost*collective

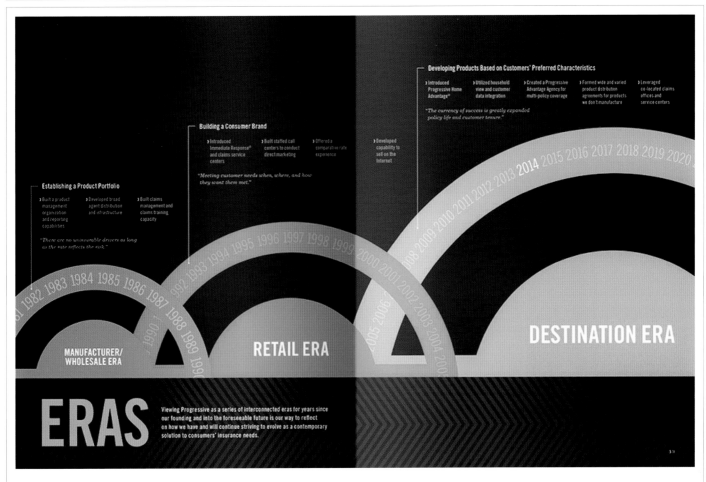

Michelle Moehler | The Progressive Corporation | Nesnadny + Schwartz

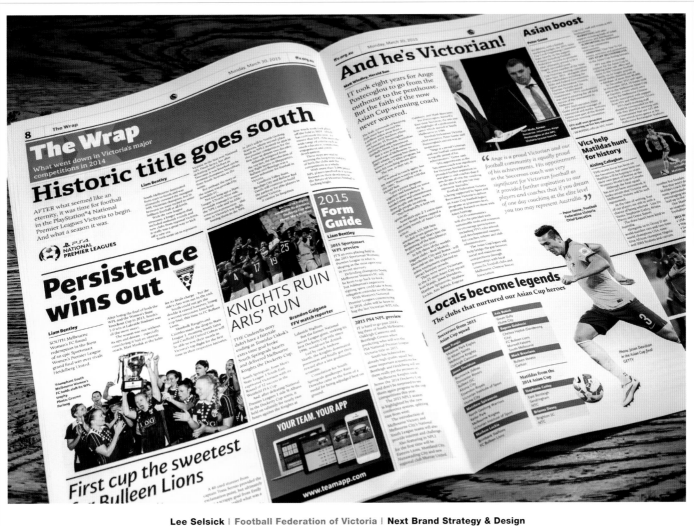

Lee Selsick | Football Federation of Victoria | Next Brand Strategy & Design

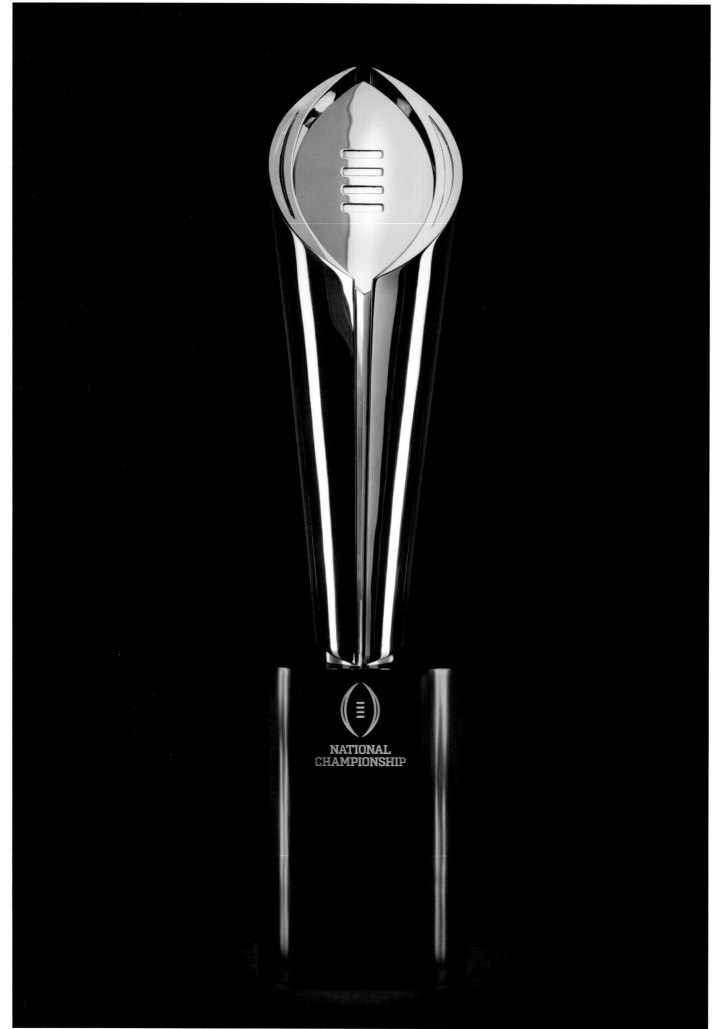

Michael Gericke | College Football Playoff | **Pentagram**

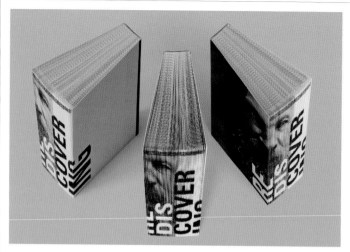

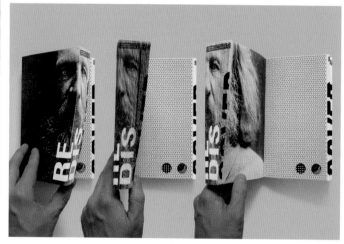

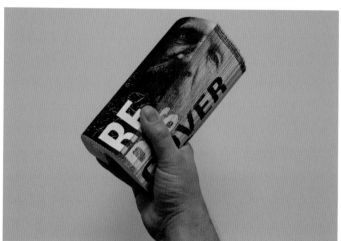

Konstantin Eremenko | FHNW HGK Visual Communication Institute, Basel School of Design

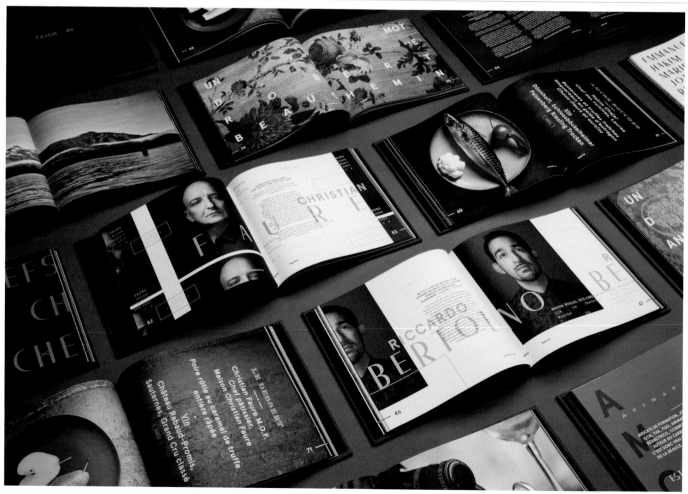

Claude Auchu | Communications Johanne Demers | lg2boutique

Dyal and Partners | The University of Texas School of Architecture

BG Hernandez | Philippine Embassy in Germany | **Studio 5 Designs, Inc.**

Anne Jordan and Mitch Goldstein Stanford University Press

animalopoeia | Chronicle Books

Anne Jordan and Mitch Goldstein Stanford University Press

Steven Taylor Associates | Edmiston

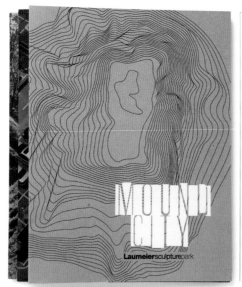

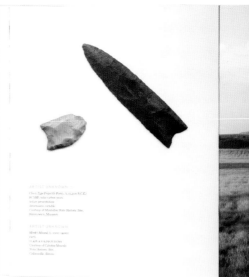

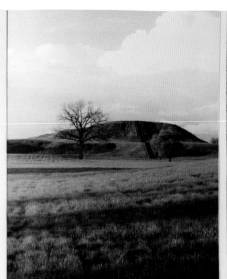

Eric Thoelke | **Laumeier Sculpture Park** | **TOKY**

Caroline Meads | **Self-initiated** | **AkzoNobel**

Nathan Ross Davis | **Virginia Commonwealth University in Qatar** | **Arcadian Studio**

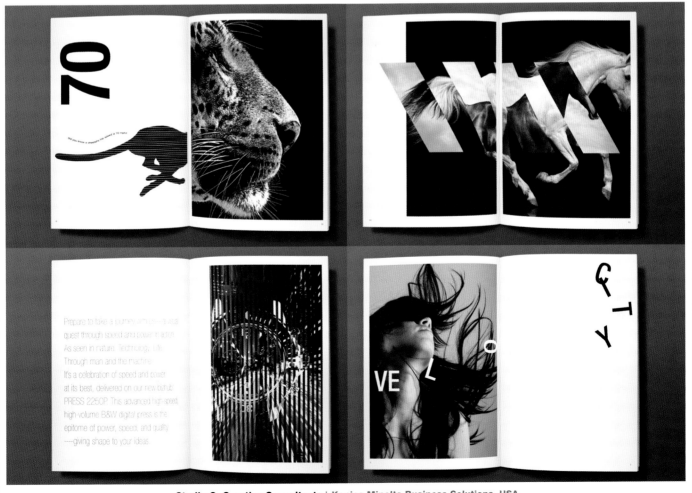

Studio C, Creative Consultants | Konica Minolta Business Solutions, USA

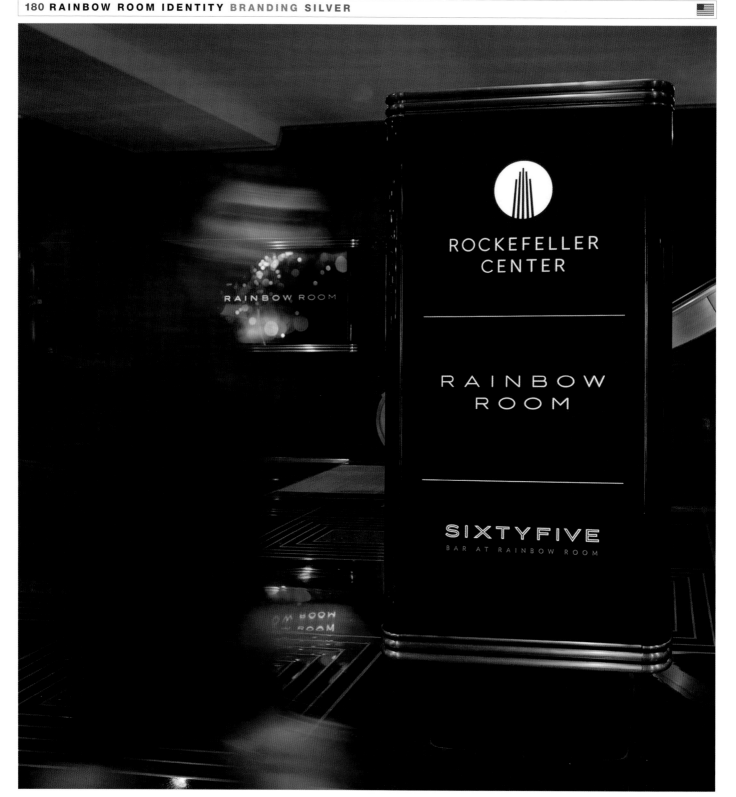

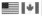

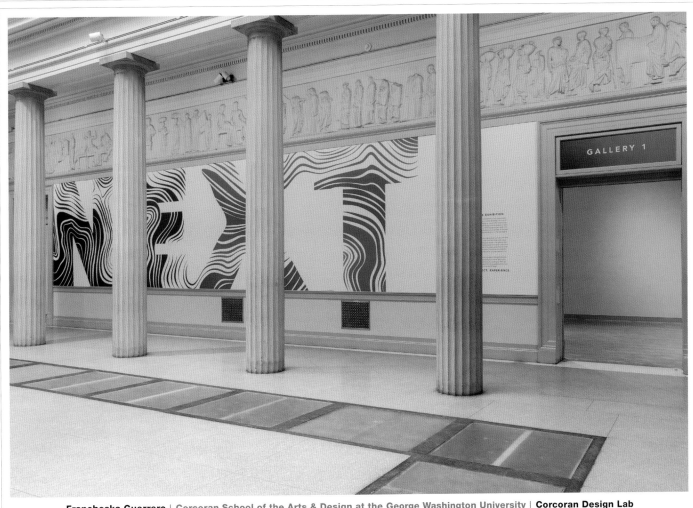

Francheska Guerrero | Corcoran School of the Arts & Design at the George Washington University | **Corcoran Design Lab**

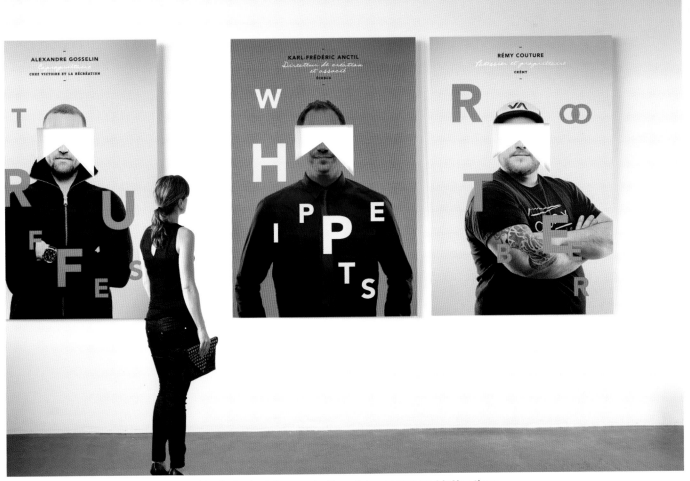

Claude Auchu | Communications Johanne Demers | **lg2boutique**

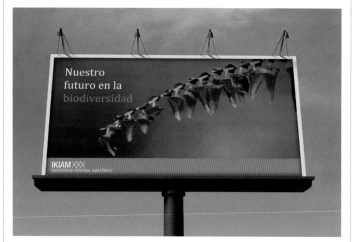

Pablo Iturralde | IKIAM, Universidad Regional Amazónica | **ÁNIMA**

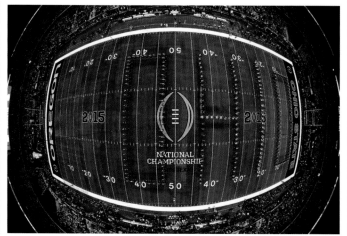

Michael Gericke | College Football Playoff | **Pentagram**

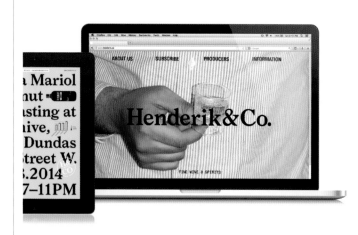

John Pylypczak & Diti Katona | Henderik & Co.
Concrete Design Communications

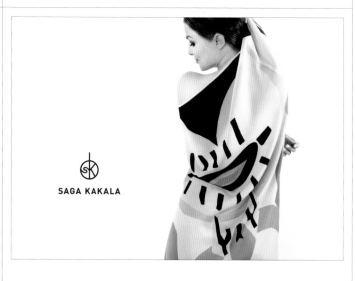

María Ericsdóttir | Saga Kakala | **Karousel, karlssonwilker**

Brendán Murphy & Connie Birdsall | Creative Art Works | **Lippincott**

Sasha Vidakovic | Moroso | **SVIDesign Ltd**

Target Creative | **Self-initiated**

Mayumi Kato | **Matsu Matsumoto**
beacon communications k.k. graphic studio

Osamu Misawa | **TAIYO KIKAKU Co.,Ltd.** | **omdr Co.,Ltd.**

James Strange & Raleigh Drennon | **Le Quartier Bakery & Café** | **Agent**

Joseph Szala | Burger Radio / David Levine | **Vigor**

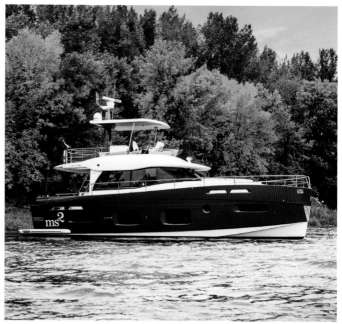

Claude Auchu | MS2 | **lg2boutique**

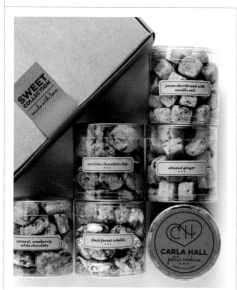

Soung Wiser | Carla Hall
The General Design Co.

VSA Partners | **Mack Trucks**

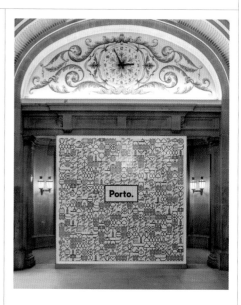

Eduardo Aires | City Hall of Porto, Portugal
White Studio

Rodney Abbot | Southwest Airlines | **Lippincott**

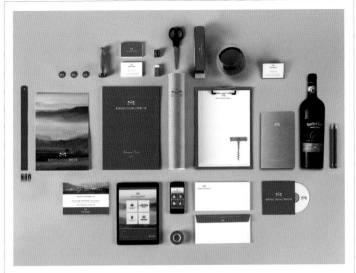

William Raineril | Agricole Gussalli Beretta | **Raineri Design Srl**

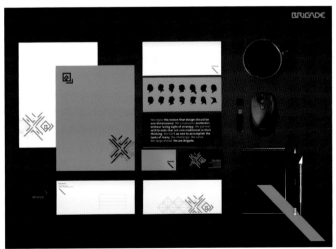

Torkel Bjørnstad Sveen & Marianne Sæther
The Royal House of Norway | **Kitchen Leo Burnett**

Ektaa Aggarwal | Cinnamon Hotels & Resorts | **Landor**

Ben Gallop | Lorton | **Brand & Deliver**

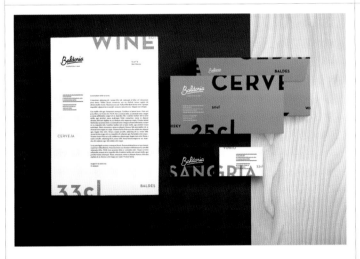

Another Collective | Baldoria – Garrafeira x Bar

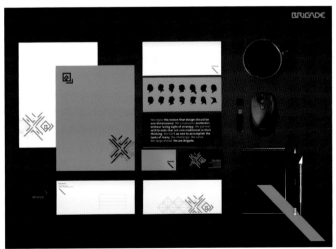

Kirsten Modestow | Self-initiated | **BRIGADE**

beacon communications k.k. graphic studio | Asahi Kindergarten

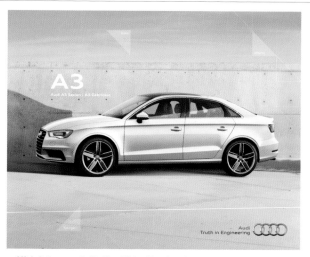

Ulrich Lange & Kathy Chia Cherico | Audi USA | designory.

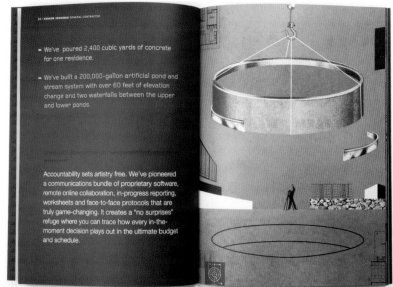

Sandstrom Partners | Krekow Jennings

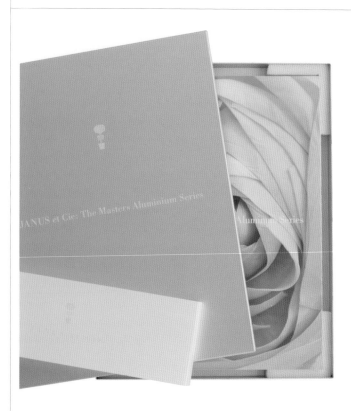

Michael Vanderbyl | JANUS et Cie | Vanderbyl Design

Savannah College of Art and Design | Self-initiated

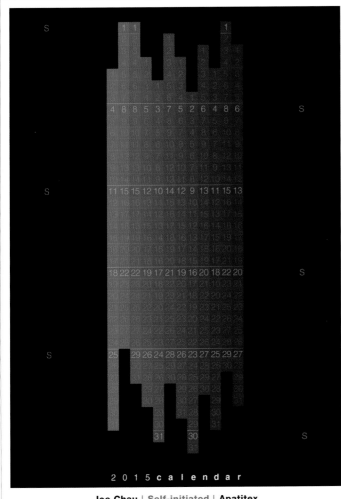

Joe Chau | Self-initiated | Apatitex

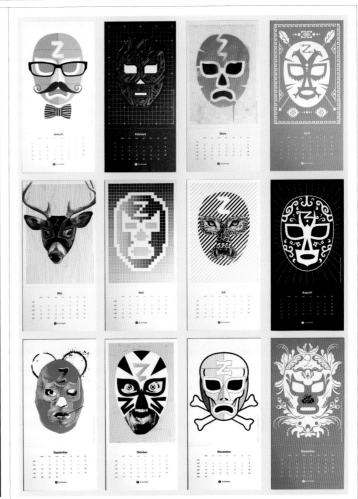

Odear | Zetatrade

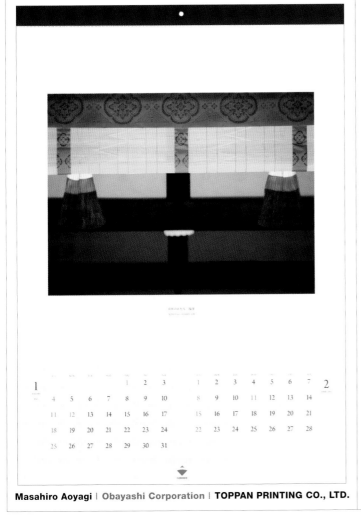

Masahiro Aoyagi | Obayashi Corporation | TOPPAN PRINTING CO., LTD.

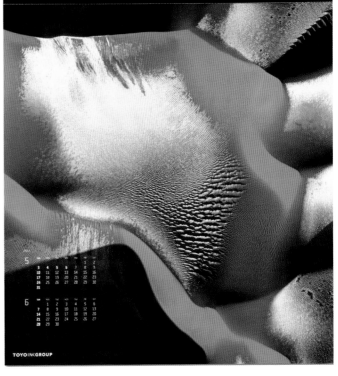

**Maho Shimada | Toyo Ink SC Holdings Co., Ltd.
TOPPAN PRINTING CO., LTD.**

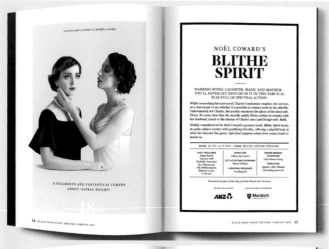

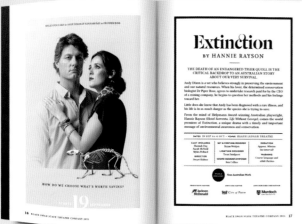

Geoff Bickford | Black Swan State Theatre | Dessein

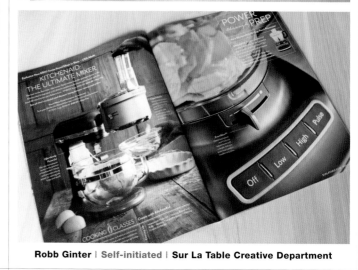

Robb Ginter | Self-initiated | Sur La Table Creative Department

Jennifer Bernstein | Pratt Graduate Communications & Package Design, Pratt Institute | Level Design Group

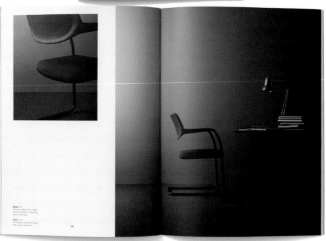

John Pylypczak & Diti Katona | Keilhauer Concrete Design Communications

stylebible2015

▶ WELCOME TO THE REBIRTH OF THE MUG-RUG. IT'S NOT ENOUGH THAT DAMN NEAR EVERY HOLLYWOOD ACTOR AND STYLISH ATHLETE IS SPORTING A METICULOUSLY GROOMED BEARD THESE DAYS—NOW EVEN CEOs IN CORNER OFFICES ARE BRISTLING, TOO. AND IF YOU'RE BEING HONEST, YOU'RE READY TO JOIN THE BEARD-WAGON YOURSELF. HERE'S HOW TO DO IT RIGHT

be-ard me!

X SEAN McCABE

190 gq april·2015

THE GREAT PAPER CAPER

MH 17199464 A

• Years of running drugs and boosting cars left FRANK BOURASSA thinking: *There's got to be an easier way to earn a dishonest living.* That's when he nerved up the idea to make his fortune. (Literally.) Which is how Frank became the most prolific counterfeiter in American history—a guy with more than $200 million in nearly flawless fake twenties stuffed in a garage. How he got away with it all, well, that's even crazier. BY WELLS TOWER

✉ NATHANIEL PENN

"SON, MEN DON'T GET RAPED"

Sexual assault is alarmingly common in the U.S. military, and more than half of the victims are men. According to the Pentagon, thirty-eight military men are sexually assaulted every single day.

These are the stories you never hear—because the culprits almost always go free, the survivors rarely speak, and no one in the military or Congress has done enough to stop it

▶ PLATON

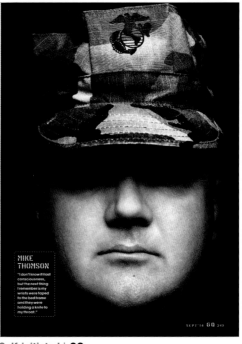

MIKE THOMSON

"I don't know if I lost consciousness, but the next thing I remember is my wrists were taped to the bed frame and they were holding a knife to my throat."

SEPT '14 GQ 245

Fred Woodward | Self-initiated | GQ

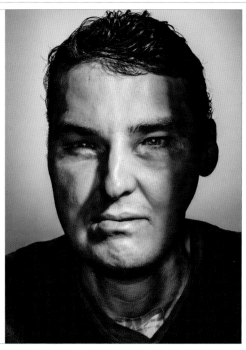

→ For fifteen years, Richard Norris had a face too hideous to show. Then, one day, a maverick doctor gave him a miracle too fantastic to believe. Richard got a face transplant, a new life, and a new set of burdens too strange to predict. What's it like to live with a face that wasn't yours—and that may never quite be?

→ By Jeanne Marie Laskas

PHOTOGRAPH DAN WINTERS

110 GQ.COM AUGUST 2014

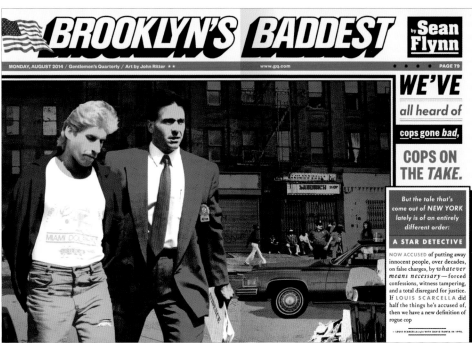

🇺🇸 **BROOKLYN'S BADDEST** by Sean Flynn

MONDAY, AUGUST 2014 / Gentlemen's Quarterly / Art by John Ritter ★ ★ www.gq.com • • • • PAGE 79

WE'VE
all heard of
cops gone *bad*,
COPS ON THE *TAKE*.

But the tale that's come out of *NEW YORK* lately is of an entirely different order:

A STAR DETECTIVE

NOW ACCUSED of putting away innocent people, over decades, on false charges, by *whatever means necessary*—forced confessions, witness tampering, and a total disregard for justice. If LOUIS SCARCELLA did half the things he's accused of, then we have a new definition of rogue cop

→ LOUIS SCARCELLA (right) WITH DAVID RANTA IN 1990.

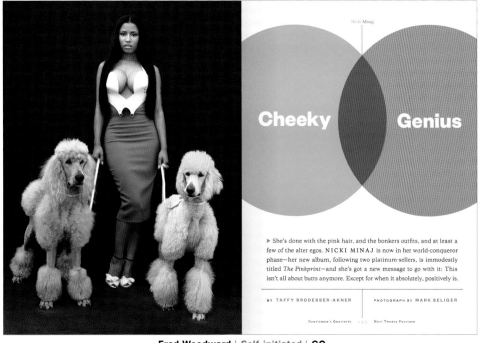

Nicki Minaj

Cheeky ### Genius

▶ She's done with the pink hair, and the bonkers outfits, and at least a few of the alter egos. NICKI MINAJ is now in her world-conqueror phase—her new album, following two platinum-sellers, is immodestly titled *The Pinkprint*—and she's got a new message to go with it: This isn't all about butts anymore. Except for when it absolutely, positively is.

BY TAFFY BRODESSER-AKNER PHOTOGRAPH BY MARK SELIGER

Gentlemen's Quarterly Novl Twenty Fourteen

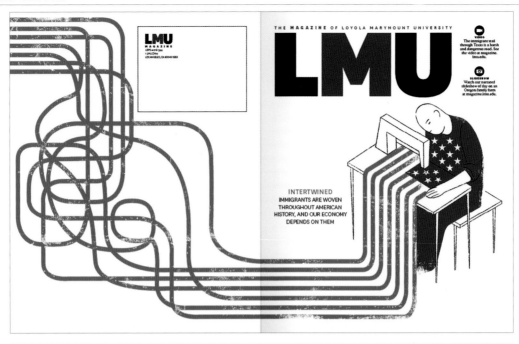

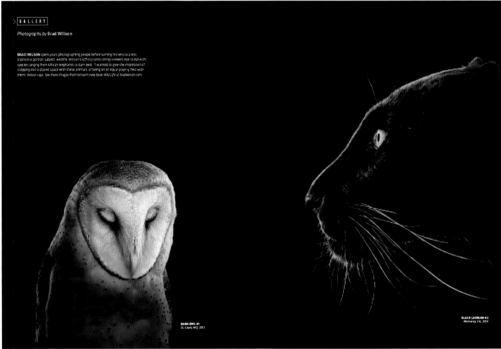

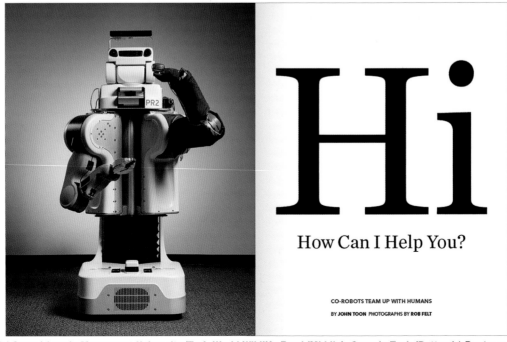

DJ Stout | Loyola Marymount University (Top), World Wildlife Fund (Middle), Georgia Tech (Bottom) | **Pentagram**

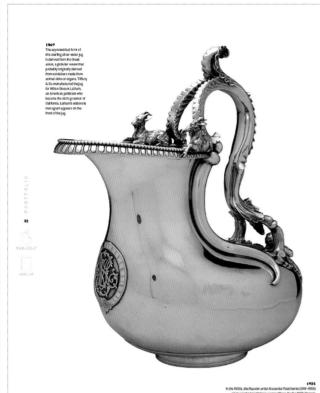

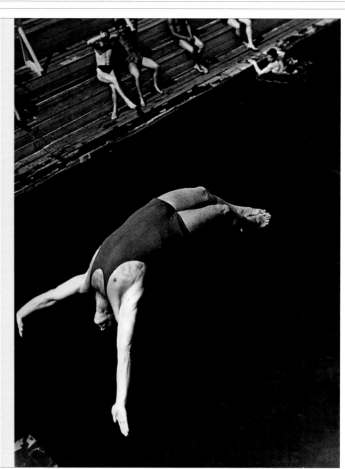

DJ Stout | The Museum of Fine Arts, Houston | **Pentagram**

Jennifer Morla & Reymundo Perez III | Print Magazine | **Morla Design**

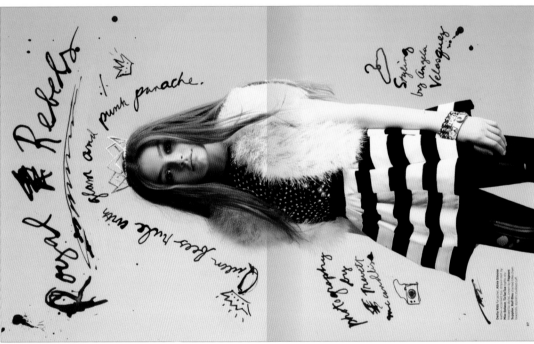

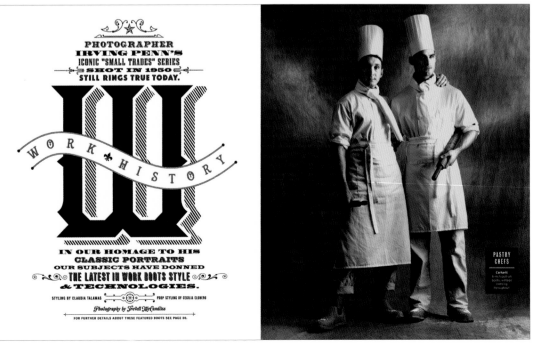

Nancy Campbell & Trevett McCandliss | Earshaw's magazine (Top, Middle), Footwear Plus magazine (Bottom) | McCandliss and Campbell

Ciprian Badalan | BIZ | Brandient

Bernd Vollmöller | Sal. Oppenheim jr. & Cie. | Peter Schmidt Group

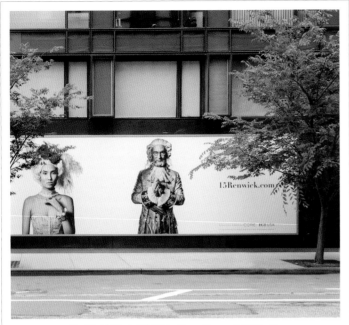

Toshiaki Ide | IGI USA, Core Group | **IF Studio**

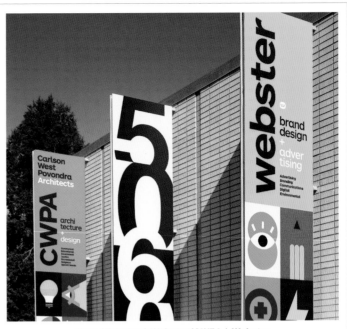

Dave Webster | Webster/CWPA | **Webster**

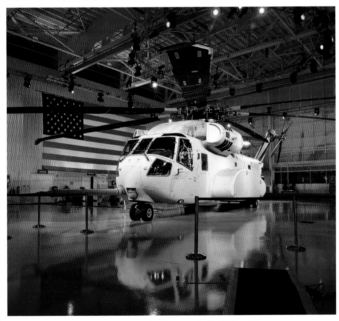

Charlie McMillan | Sikorsky | **McMillan Group**

Graham Hanson Design | Google

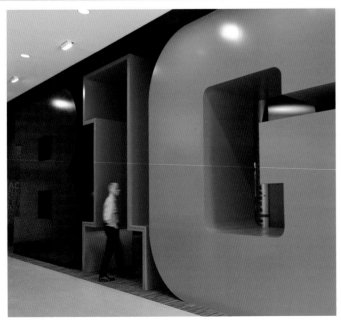

Michael Gericke | Big Ten | **Pentagram**

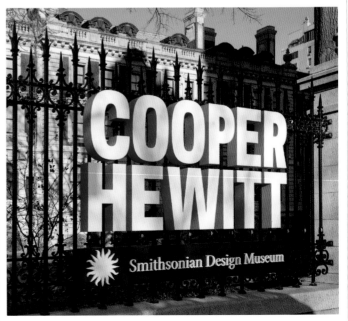

Michael Gericke | Cooper Hewitt, Smithsonian Design Museum | **Pentagram**

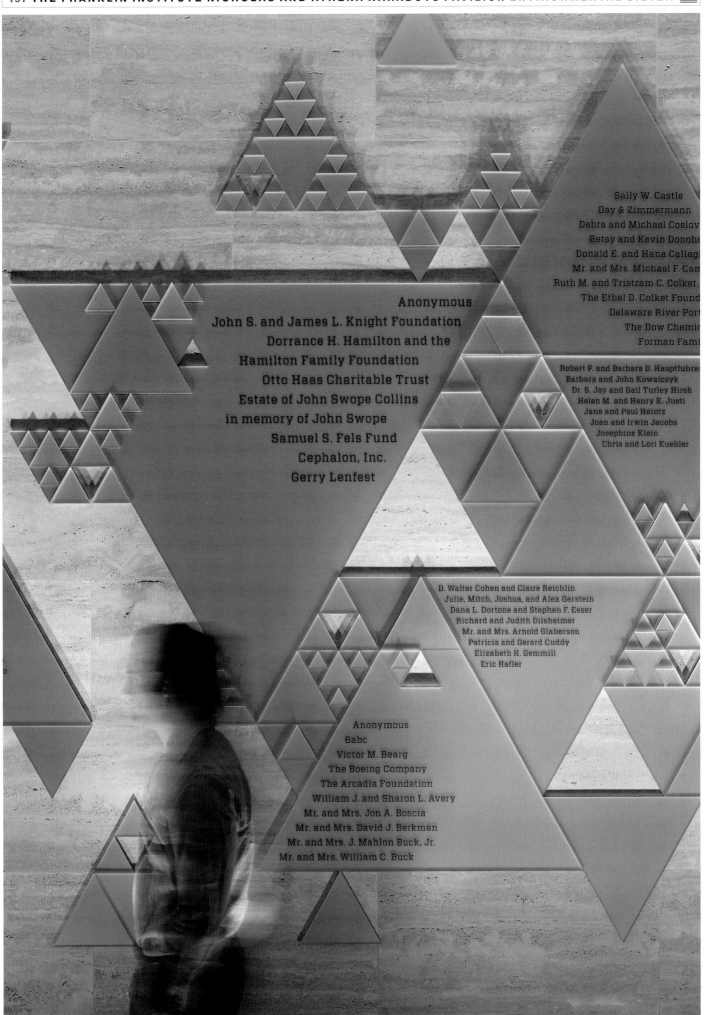

Anonymous
John S. and James L. Knight Foundation
Dorrance H. Hamilton and the
Hamilton Family Foundation
Otto Haas Charitable Trust
Estate of John Swope Collins
in memory of John Swope
Samuel S. Fels Fund
Cephalon, Inc.
Gerry Lenfest

Sally W. Castle
Day & Zimmermann
Debra and Michael Coslov
Betsy and Kevin Donoho
Donald E. and Hana Callagh
Mr. and Mrs. Michael F. Can
Ruth M. and Tristram C. Colket,
The Ethel D. Colket Found
Delaware River Port
The Dow Chemic
Forman Fami

Robert P. and Barbara D. Hauptfuhre
Barbara and John Kowalczyk
Dr. S. Jay and Gail Turley Hirsh
Helen M. and Henry K. Justi
Jane and Paul Heintz
Joan and Irwin Jacobs
Josephine Klein
Chris and Lori Kuebler

D. Walter Cohen and Claire Reichlin
Julie, Mitch, Joshua, and Alex Gerstein
Dana L. Dortone and Stephen F. Esser
Richard and Judith Dilsheimer
Mr. and Mrs. Arnold Glaberson
Patricia and Gerard Cuddy
Elizabeth H. Gemmill
Eric Hafler

Anonymous
6abc
Victor M. Bearg
The Boeing Company
The Arcadia Foundation
William J. and Sharon L. Avery
Mr. and Mrs. Jon A. Boscia
Mr. and Mrs. David J. Berkman
Mr. and Mrs. J. Mahlon Buck, Jr.
Mr. and Mrs. William C. Buck

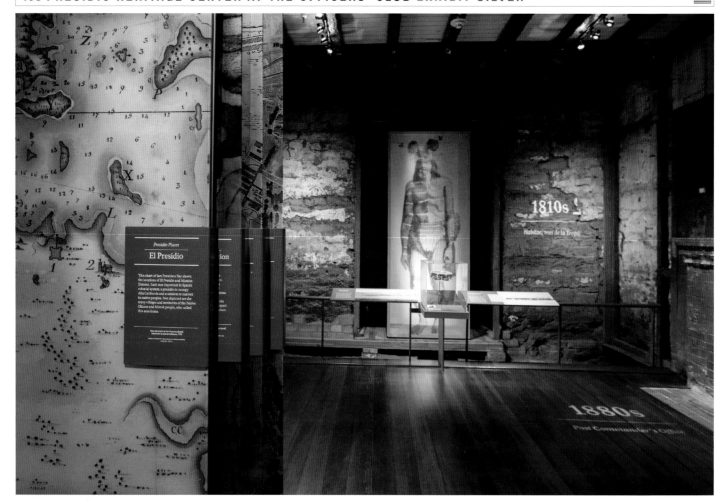

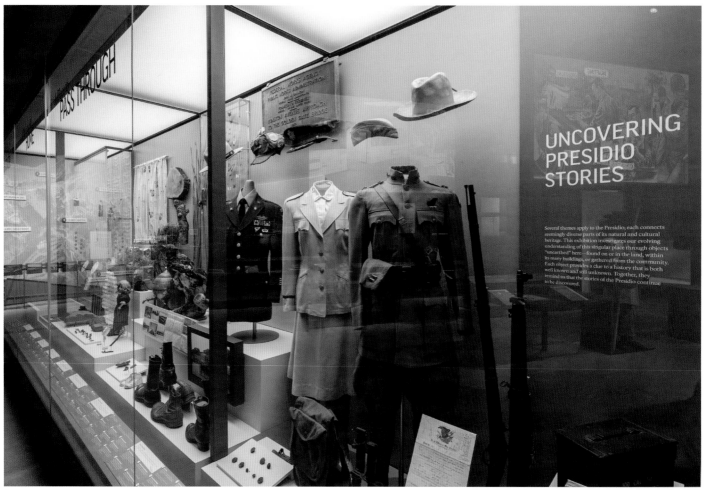

Konstantin Eremenko | SfG Basel, FHNW HGK Visual Communication Institute, Plakatsammlung Basel

David Vawter | Beam Suntory, Inc. | **Doe-Anderson Advertising**

Richard Patterson | **Self-initiated** | **PH Studio**

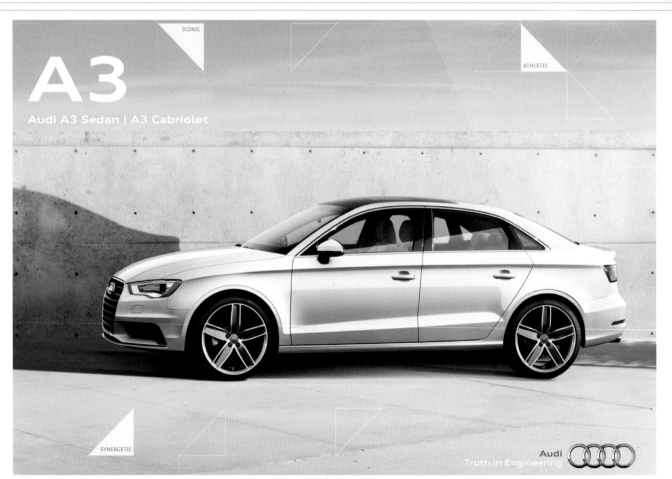

Ulrich Lange & Kathy Chia Cherico | **Audi USA** | **designory.**

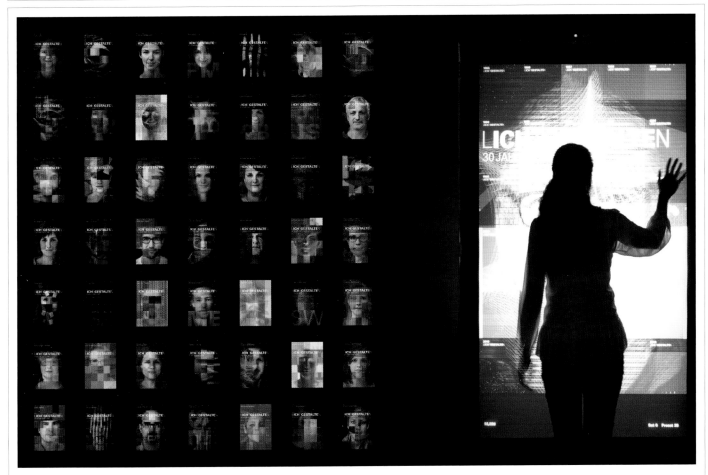

Patrick Märki | Self-initiated | **KMS TEAM**

Todd Lancaster | Fort Worth Zoo | **Schaefer Advertising Co.**

TOURISM & COMMERCE, INC.

806 1st Avenue, Nebraska City, NE 68410 · Red to the Core · **GoNebraskaCity.com**

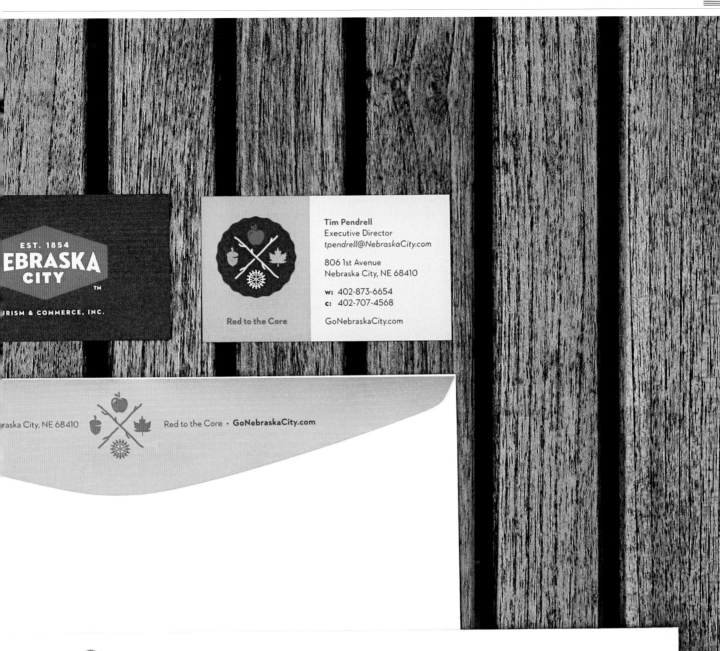

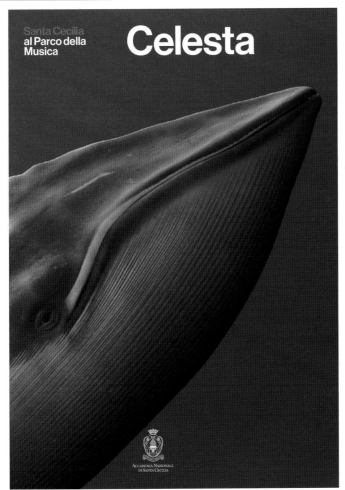

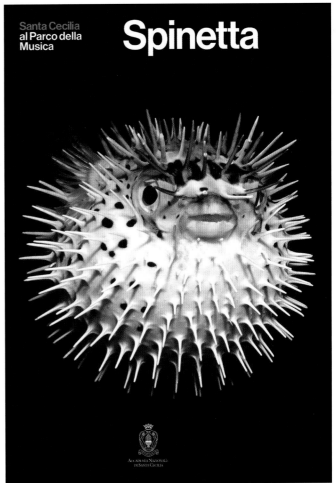

Carlo Fiore | Accademia Nazionale di Santa Cecilia | **Venti caratteruzzi**

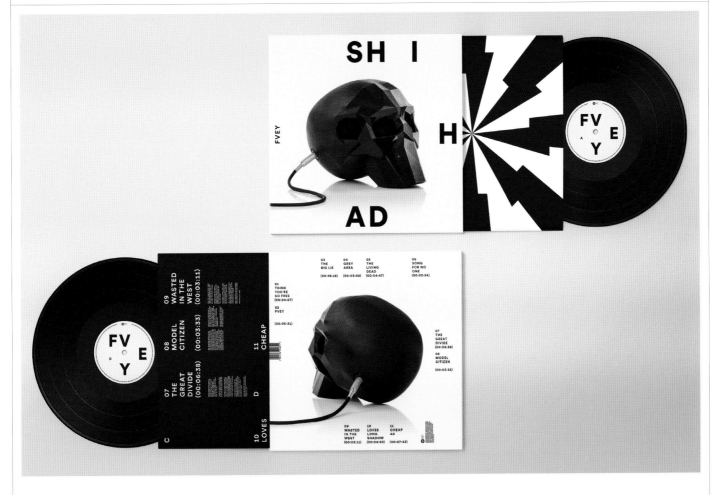

Dean Poole | Warner Music NZ | **Alt Group**

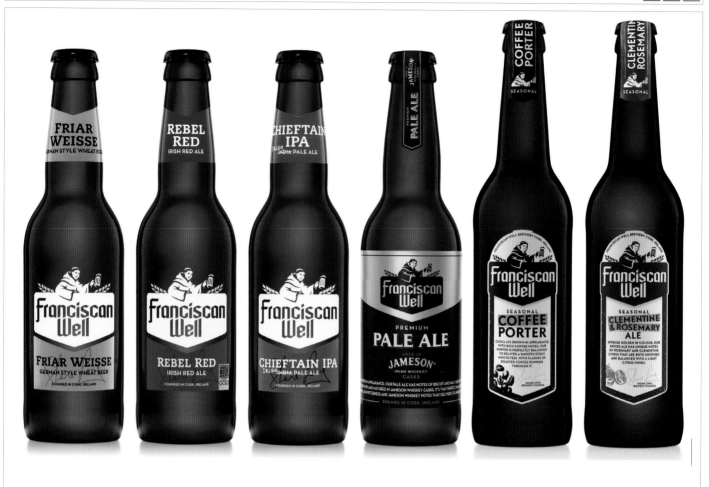

Alan Smith | Franciscan Well Brewery | **Trinity Brand Group**

Roy Burns | Good People Brewing Company | **Lewis Communications**

Sandstrom Partners | Full Sail Brewing Company

Michael Vanderbyl | Blankiet Estate | **Vanderbyl Design**

Sedley Place | Diageo

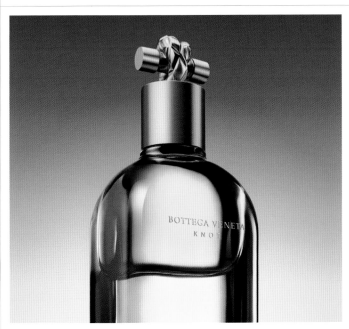

Doug Lloyd | Coty, Bottega Veneta | **LLOYD&CO**

Michael Vanderbyl | Checkerboard Vineyards | **Vanderbyl Design**

Joel Derksen | Birgit Wolff

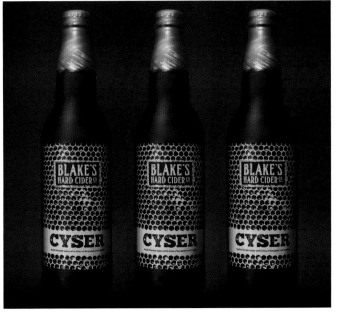

Adam Yarbrough | Blake's Hard Cider Co.

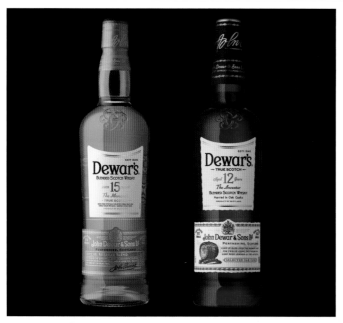

Stranger & Stranger | John Dewar and Sons

Sam Hamilton | March | **Design is Play**

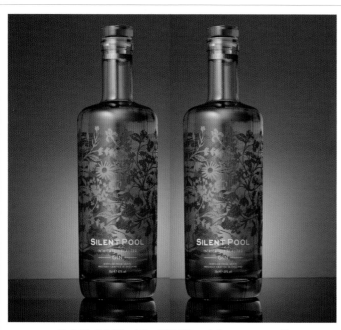

Neil Hirst | Silent Pool Distillers | **Seymourpowell**

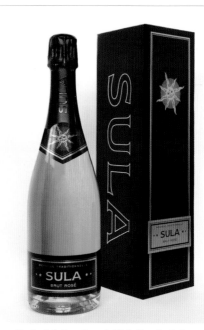

Xerxes Baria | Sula wines | **Alok Nanda & Company**

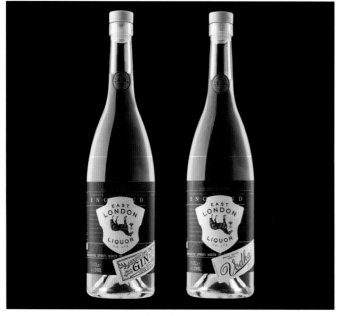

Stranger & Stranger | East London Liquor Company

Sallie Reynolds Allen | 35 Maple Street Spirits | **Studio 32 North**

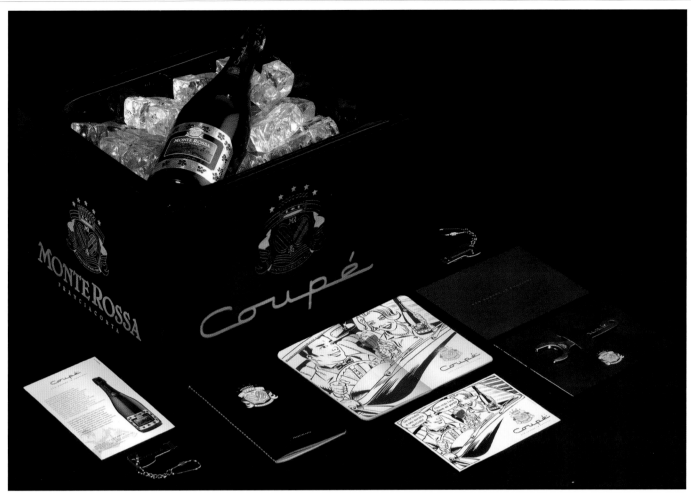

William Raineri | Monte Rossa | Raineri Design Srl

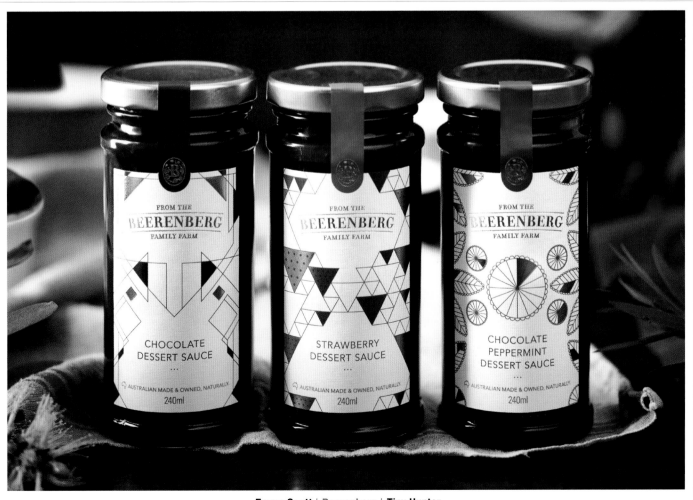

Emma Scott | Beerenberg | Tiny Hunter

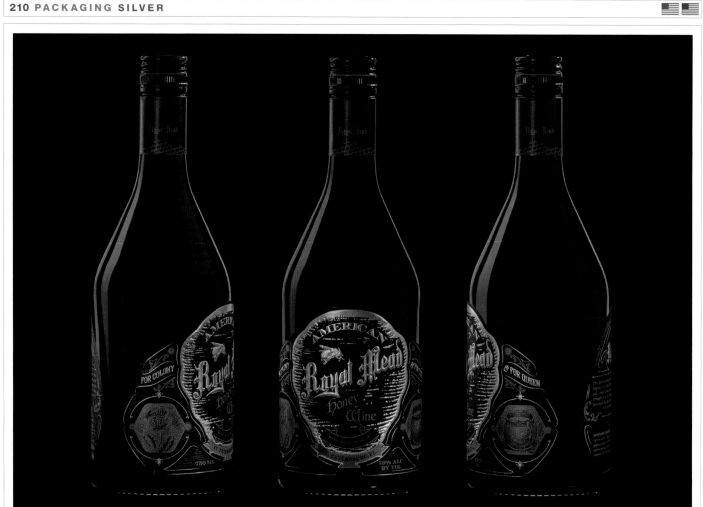

Grant Gunderson | **St. Petersburg Distillery** | **Dunn&Co.**

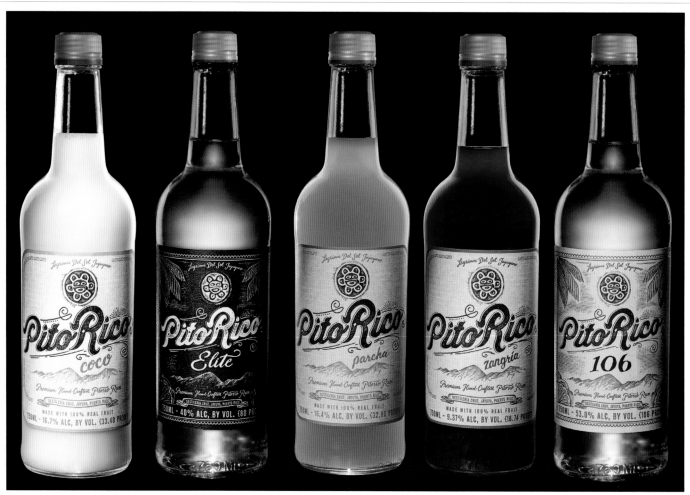

Dunn&Co | **PitoRico**

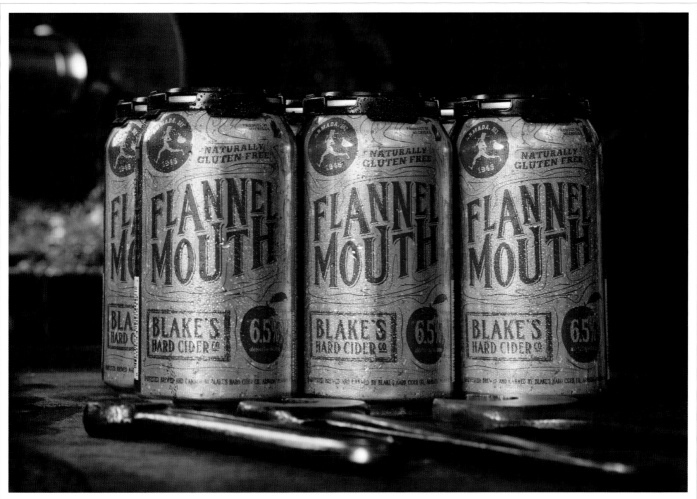

Adam Yarbrough | Blake's Hard Cider Co.

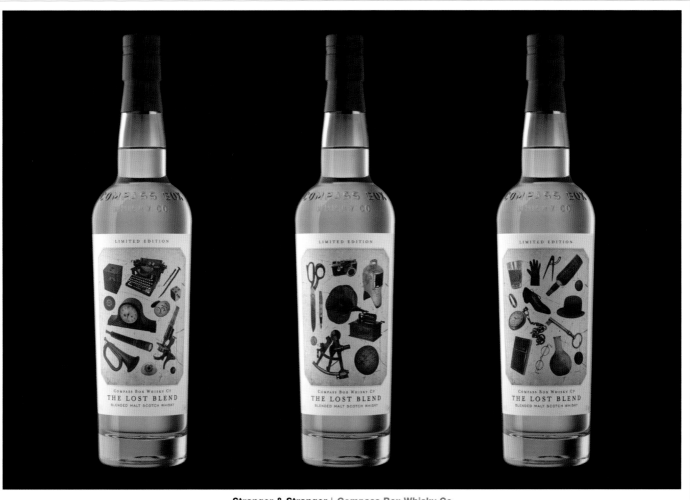

Stranger & Stranger | Compass Box Whisky Co.

Michael McCormick | AT&T | Rodgers Townsend DDB

Geoff Bickford | Hunsa | Dessein

Stan Church | Self-initiated | Wallace Church, Inc

Stan Church | Self-initiated | Wallace Church, Inc

Steve Sandstrom | Full Sail Brewing Company | Sandstrom Partners

Steve Sandstrom | Full Sail Brewing Company | Sandstrom Partners

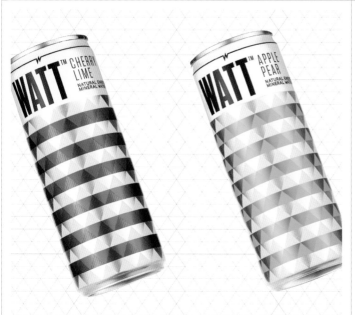

Kristen Caston | Buszesz | Alchemy Branding Group

Stewart Devlin | Lisa Sanders Public Relations | Red Peak

Ajoy Adwani & Mahesh Ramparia | Filter | Alok Nanda & Company

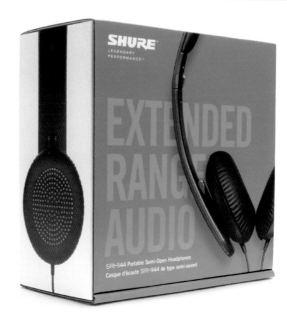

John Ball | Shure | MiresBall

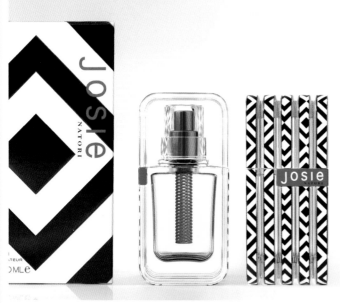

Sayuri Shoji | LUXE Brands, Josie Natori | Sayuri Studio, Inc.

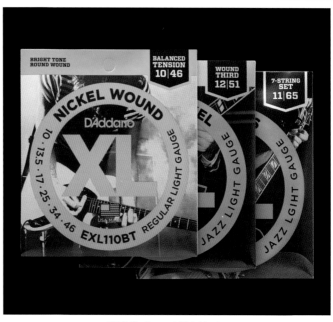

VSA Partners | D'Addario

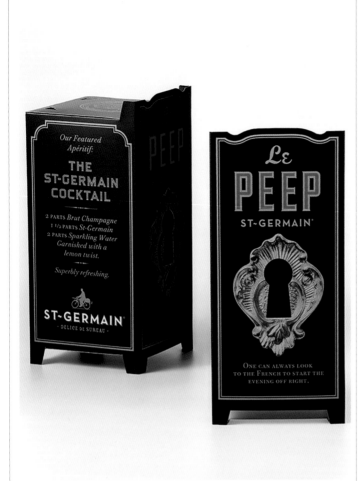

Steve Sandstrom | Bacardi USA | Sandstrom Partners

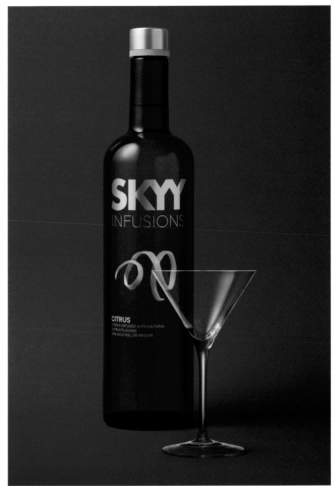

Turner Duckworth Design: San Francisco London | Gruppo Campari

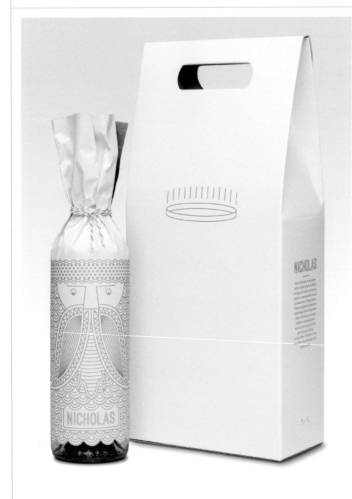

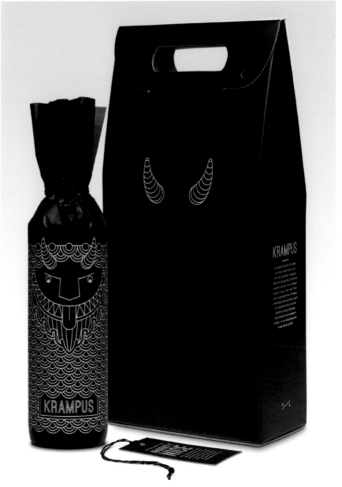

Carey George & Sue McCluskey | Self-initiated | Goods & Services Branding

Zak Mroueh | Town of Collingwood, Rosemarie O'Brien | **Zulu Alpha Kilo**

Ely Orias | 20th Century Fox - Ely Orias | **ARSONAL**

Mike Stocker & Robin Chrumka | Keira Watering Cans | **McCann Worldgroup**

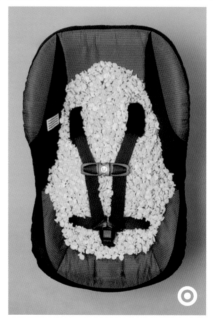

Target Creative | Self-initiated

The White Room Inc. | Self-initiated

Stephanie Gibbons | FX | **ARSONAL**

Target Creative | Self-initiated

Fidel Peña & Claire Dawson | Advertising and Design Club of Canada | Underline Studio

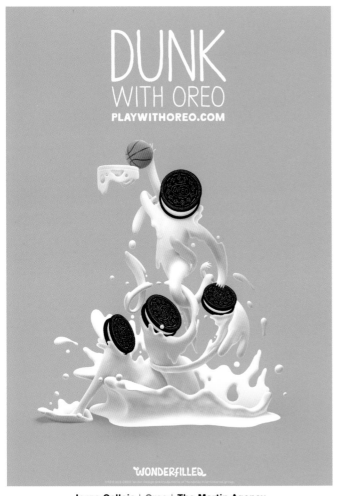

Jorge Calleja | Oreo | **The Martin Agency**

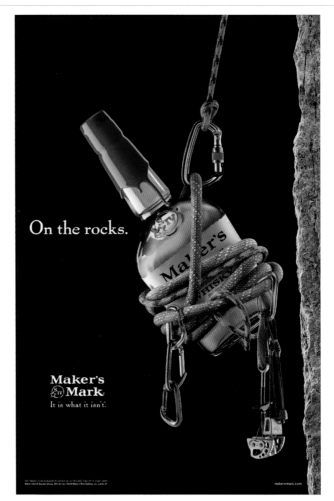

Wes Keeton | Maker's Mark | **Doe-Anderson Advertising**

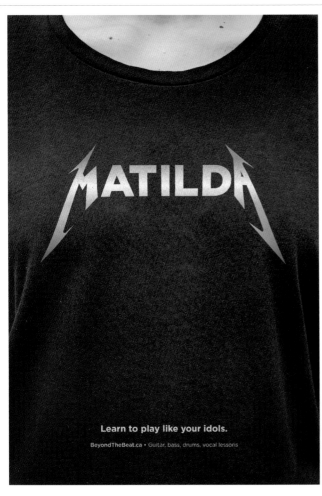

Zak Mroueh | Beyond the Beats, David MacKenzie | **Zulu Alpha Kilo**

Michael Vanderbyl | The Wolfsonian, Florida International University
Vanderbyl Design

Fidel Peña & Claire Dawson | **Self-initiated** | **Underline Studio**

Ryan Anderson | **AAF-Utah** | **Fluid**

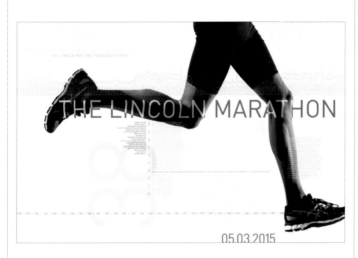

Carter Weitz | **Lincoln Marathon** | **Bailey Lauerman**

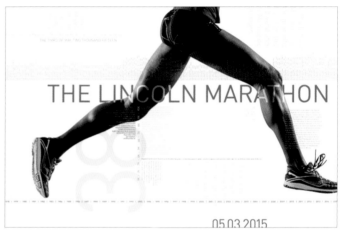

Carter Weitz | **Lincoln Marathon** | **Bailey Lauerman**

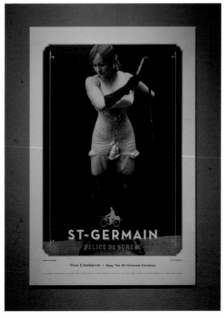

Steve Sandstrom | **Bacardi USA** | **Sandstrom Partners**

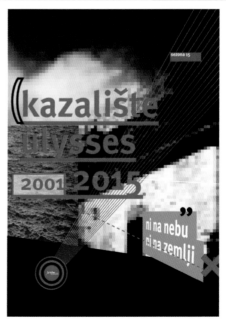

Eduard Cehovin | **ulysses theatre** | **design center**

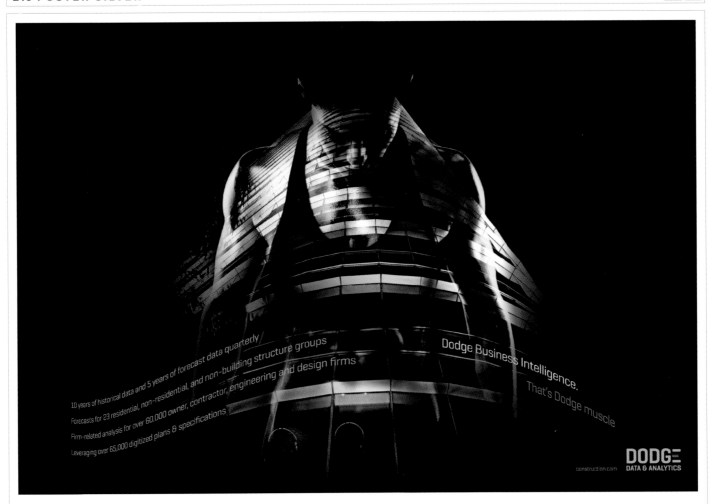

William Taylor | Dodge Data & Analytics | **DD&A**

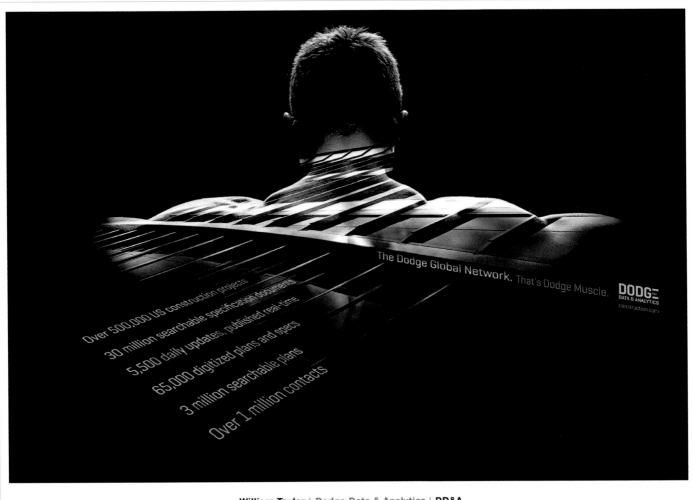

William Taylor | Dodge Data & Analytics | **DD&A**

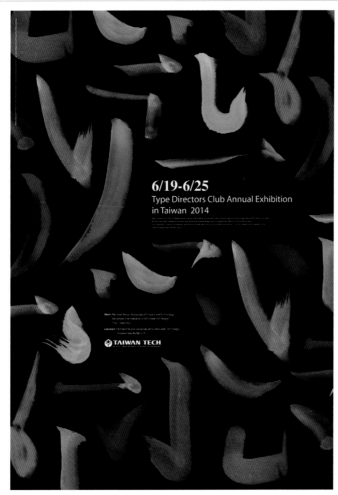

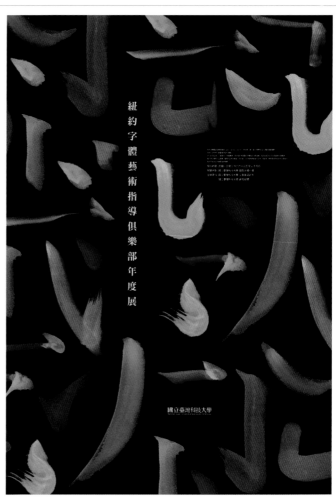

Ken-Tasi Lee | **Self-initiated** | **Ken-Tasi Lee Design Lab/Taiwan Tech**

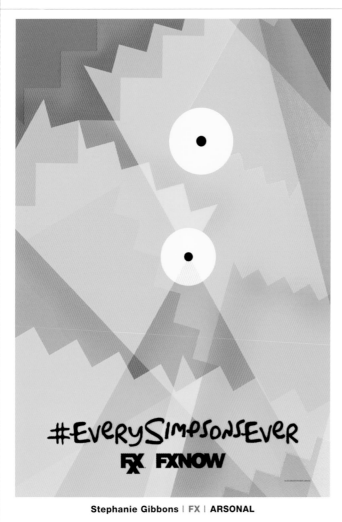

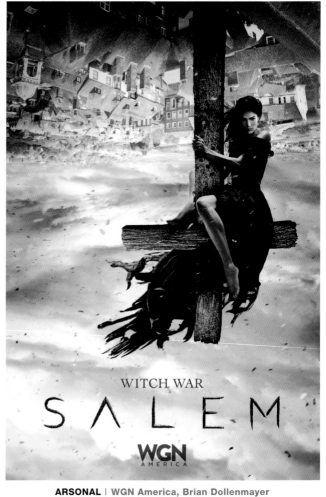

Stephanie Gibbons | **FX** | **ARSONAL**

ARSONAL | **WGN America, Brian Dollenmayer**

Roy White & Matthew Clark | Subplot | Subplot Design Inc.

Ronn Lee | Le Grand Films Co., Ltd | BEAMY

Ken-Tasi Lee | Self-initiated | Ken-Tasi Lee Design Lab/Taiwan Tech

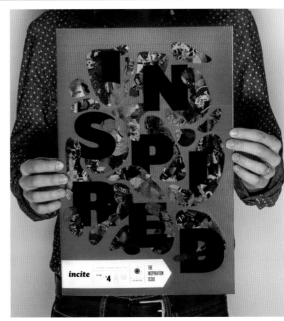

Dixon Schwabl | Self-initiated

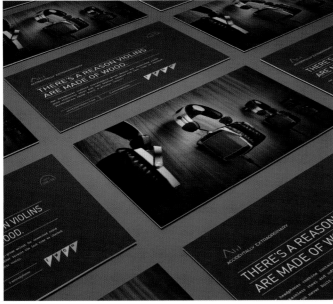

**DJ O'Neil & Peter Judd | HUB STRATEGY & COMMUNICATION
Accidentally Extraordinary**

Lewis Communications | Design Week

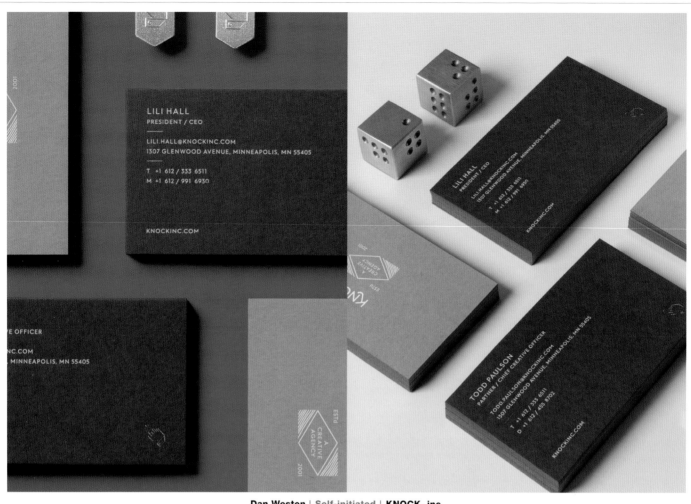

Dan Weston | Self-initiated | **KNOCK, inc**

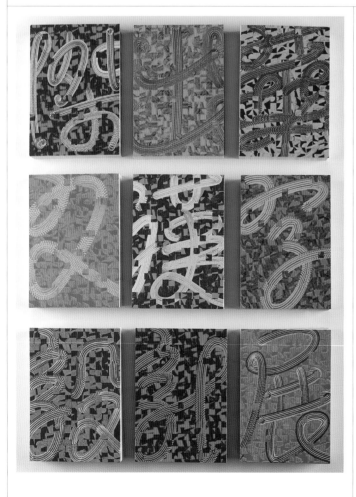

Ken-Tasi Lee | Self-initiated | **Ken-Tasi Lee Design Lab/Taiwan Tech**

Steve Sandstrom | Bacardi USA | **Sandstrom Partners**

Young Kim | sáv hospitality | **FutureBrand**

Thorsten Kulp | Art Series Hotel Group / The Schaller Studio | **Toben**

Einar Gylfason | Glo | Leynivopnid

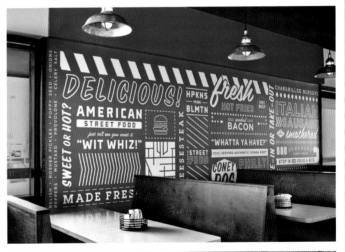

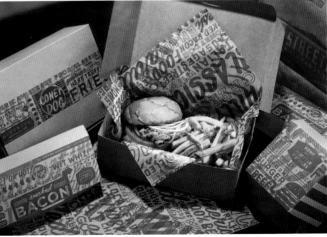

Alan Colvin | Streetz American Grill | **Cue, Inc.**

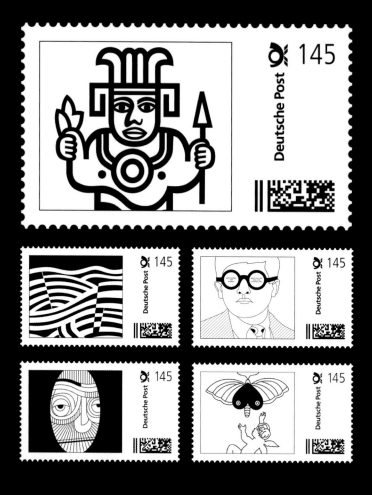

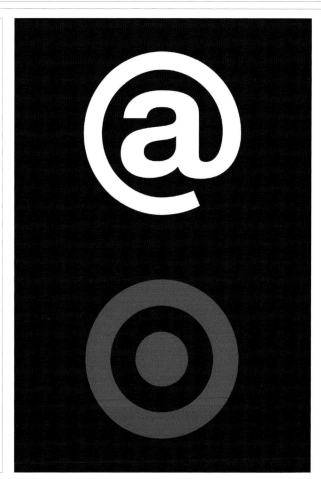

Helvetica for Target
Bold 75

Target Creative | Self-initiated

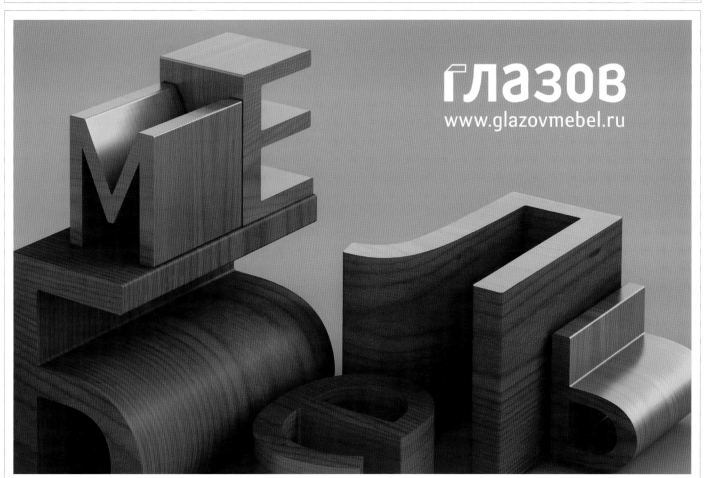

Mikhail Puzakov | Glazov Furniture Factory | **12 points**

Toshiaki Ide | Benchmark Real Estate Group | **IF Studio**

Toshiaki Ide | Clodagh | **IF Studio**

Pete Johnson & Wade Devers | Jack Daniel's | **Arnold Worldwide**

Sharon Lloyd McLaughlin | National Resources | **Mermaid, Inc.**

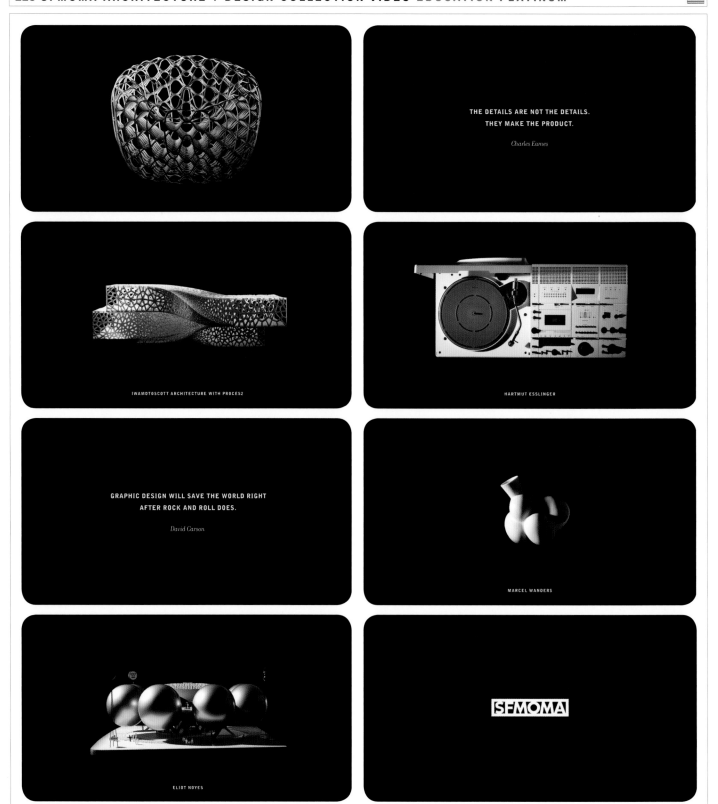

THE DETAILS ARE NOT THE DETAILS.
THEY MAKE THE PRODUCT.

Charles Eames

IWAMOTOSCOTT ARCHITECTURE WITH PROCES2

HARTMUT ESSLINGER

GRAPHIC DESIGN WILL SAVE THE WORLD RIGHT
AFTER ROCK AND ROLL DOES.

David Carson

MARCEL WANDERS

ELIOT NOYES

SFMOMA

Jennifer Morla | San Francisco Museum of Modern Art | **Morla Design**

Assignment: The San Francisco Museum of Modern Art collects historical and contemporary works of architecture, furniture design, product design, and graphic design. Morla identified that the collection needed more visibility to both the design community as well as those less familiar with the purpose and scope of design and the department. She worked directly with the curators to review and determine product, identify product attributes and researched interviews for designer quotes. Morla recognized that in order to achieve the drama and quality of the product imagery, she would have to turn to high resolution, still photography. She directed lighting the pieces dramatically on set to reveal the subtleties of the details. Morla created and supervised all aspects of the video production including photo art direction, typography, soundtrack selection and editing. This video was produced pro-bono for SFMOMA's Architecture and Design Department and can also be viewed on the SFMOMA website.

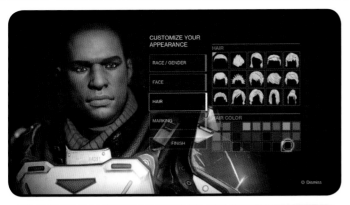

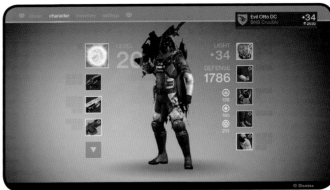

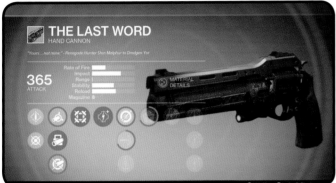

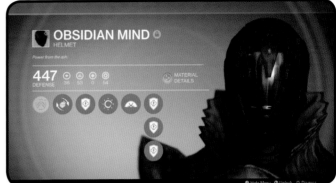

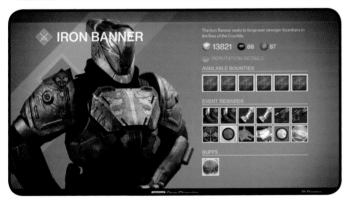

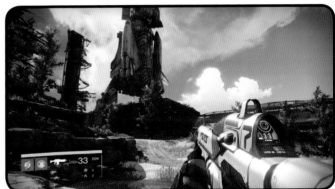

Christopher Barrett | Self-initiated | Bungie

Assignment: After coming from a 10 year stint developing the Halo series of games exclusively for the Xbox, we were tasked to create a user interface for an entirely new IP, Destiny. For the first time in company history, we needed to simultaneously ship a title on four major platforms. The interface had to support a dense investment system, social gathering and matching, a large number of 3D assets that stream on-demand from the hard drive, and seven languages that it could be displayed in. This interface needed to be authored using a proprietary tool we worked closely with our engineers on.

Approach: When people think of sci-fi interfaces and HUD, they usually think of cool hues and lots of noisy bits & tech. Our approach in Destiny was to take a less expected route and lean on Swiss type, minimal footprint, and clean form factors. We also wanted to hint at the fantasy aspect of the fiction,

so we gave the Director map a look that echoed old mariner cartography. This disparity between the two styles is made more harmonious as subtle echoes of both stylistic approaches permeate each other here and there throughout the game.

Results: We opted to use a free cursor in the interface. While common on a PC where mice and track pads are predominant, consoles rarely, if ever, employ cursors to browse game interfaces. This allowed us to hide blocks of data on tooltips to free up screen real estate. It also made the browsing of dense inventories require much less effort by eliminating button presses to navigate. Panning around with the cursor also allowed us to open up the interface and allow the compelling 3D assets from the game to have a visual impact on the user.

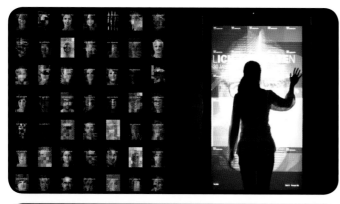
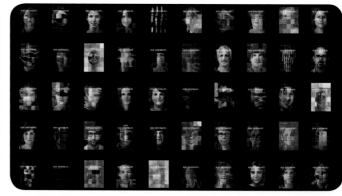
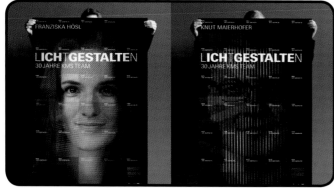
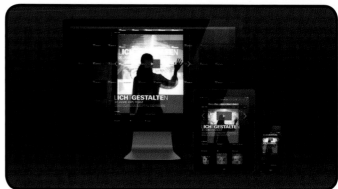
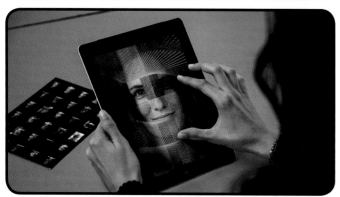
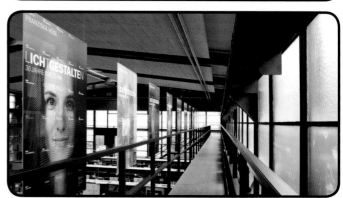
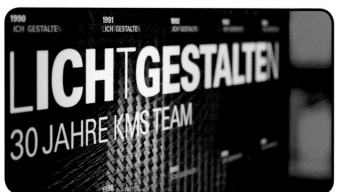
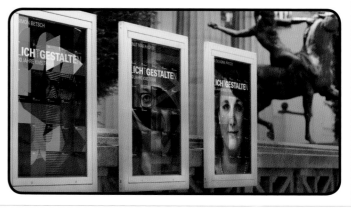

Patrick Märki | Self-initiated | **KMS TEAM**

Assignment: Branding agency KMS TEAM developed the interactive Lichtgestalten installation to mark its 30th anniversary. Lichtgestalten was intended to heighten the user brand experience with KMS TEAM and to demonstrate the elaborate design process. Designing brands means designing personalities: The name Lichtgestalten (in English luminous figures) is also a play on words. It consists of the two German words "ich gestalte," which mean I Design and entails creating your own me-design.

Approach: At museum Villa Stuck in Munich, the site of the anniversary celebration, the 6 x 4 meter interactive installation was displayed for the first time. It takes a picture of the user, who then uses intuitive gestures to design the image: There are over eight billion ways to add colors, typography and stylistic elements to the portrait. Every image is the result of an individual design process. The unique motifs were generated as a PDF and also printed as a DIN A0 poster for each user of the installation. Real-time data from

the installation was used for the light display on the stage during the event. Simultaneously, the artworks were published on the corporate Facebook channel. A selection of unique portraits was displayed on DIN A0 posters as part of an exhibition at the agency. They were also used outdoors for the event communication at the museum. Lichtgestalten is also featured as a microsite and can be shared via social media.

Results: The cross-media application turns design into a spatial experience and brings digital innovation to analogue reproductions. To wrap up its 30th anniversary, design agency KMS TEAM extended the installation into an app for iOS and Android: This app turns Lichtgestalten into a live experience for all smartphone and tablet users. A mailing with a QR code drew attention to the introduction of the app. The installation received overwhelming feedback from all employees, clients, partners and guests. It won three DDC 2014 awards (2x silver, 1x award) and a silver award at the Best of Corporate Publishing 2015.

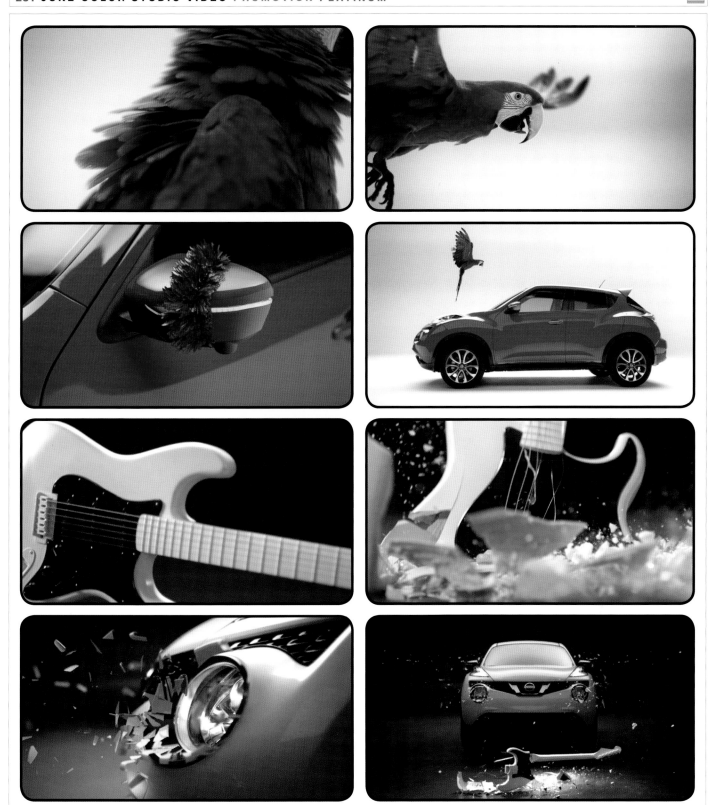

Carol Fukunaga | Nissan North America, Accessories Marketing | **The Designory, Inc.**

Assignment: A short video to promote Nissan's first ever Color Studio, a line of colored accessory accents that let you customize your car the way you might a pair of sneakers. Nissan chose JUKE, its quirky sport utility, as the perfect candidate to launch the line. At the same time, Color Studio was also designed to give the odd, little JUKE a more premium appeal.
Approach: We saw this as an opportunity to take accessories out of the realm of floor mats and make them something truly cool and desirable. Our aesthetic inspiration came from music videos and fashion photography. Our concept played on the idea that color changes everything. It's a catalyst that makes

things happen. The video features some unexpected "agents of change" that have a colorful impact on the JUKE. The video is a mix of live action and CGI, with visual effects that simulate the transfusion of color to the different vehicle parts, and a music track that lends a sultry swagger.
Results: This was the first time accessories played the starring role in a vehicle's launch. The video concept was so well received by the client, it inspired a full showroom campaign, as well as a print ad executed by the advertising agency that ran in automotive enthuisast publications. To date, sales of Color Studio accessories are $1.3 million.

MOTO MAXX :60 BROADCAST SPOT

**CHOOSE TO
STAY SHARP**
32% More Detail Than Full HD

FRIDAY 10:44 PM

SATURDAY 11:06 AM

SATURDAY 6:59 PM

SUNDAY 8:14 AM

50,000feet | Motorola

BOY SCOUTS OF AMERICA BUILD AN ADVENTURE CAMPAIGN

CRANE OPERATORS.
CHECK.

NO BLUEPRINTS

Tom Hudder | Boy Scouts of America | **FleishmanHillard Creative**

WHERE IMPOSSIBLE COMES TO DIE ANIMATION

Lucus Brooking | **Coghlin Companies** | **Breakaway**

GRAPHICS RCA 50 INTERACTIVE DESIGN

Kyuha Shim | **Royal College of Art** | **Q**

AUSTERE PROMOTION

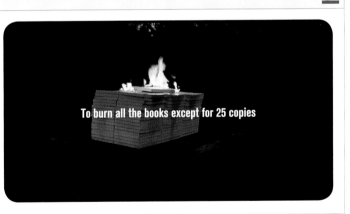

To burn all the books except for 25 copies

Xose Teiga | **Self-initiated** | **xose teiga, studio.**

ÁNIMA PROMO PROMOTION

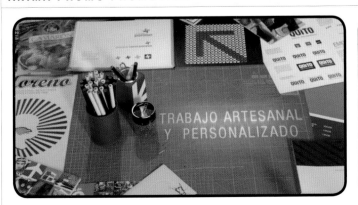
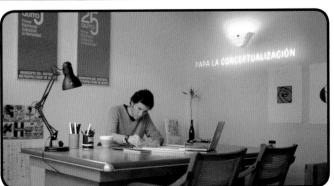

TRABAJO ARTESANAL Y PERSONALIZADO

PARA LA CONCEPTUALIZACIÓN

Pablo Iturralde | **Self-initiated** | **Trasluz / Ánima**

GRAPHIS PLATINUM & GOLD WINNERS:

36 BROWN-FORMAN 2014 ANNUAL REPORT | Design Firm: Addison
Client: Brown-Forman | Designer: J. Kenneth Rothermich | Creative Director: Richard Colbourne

37 D&AD PENCILS | Design Firm: Turner Duckworth Design: London & San Francisco
Client: D&AD | Production: James Norris | Other: Mark Bonner, Craig Oldham
Designers: Jamie Nash, Mathilde Solanet | Creative Directors: David Turner,
Bruce Duckworth, Paula Talford | Account Manager: Kate Elkins
Assignment: D&AD is the most respected creative industry award to win.
The Yellow and Black pencils are industry icons. However the other award
levels of "In Book" and the Nominations are also award levels in their own
right, but their importance is misunderstood and subsequently less valued
than they should be. In other award programs they would be the equivalent of
a bronze and silver award, the Yellow pencil is the equivalent of a gold award
and the Black Pencils the best of show.
Approach: To celebrate the achievement of winning, actual pencil awards
will be given out for these previously 'un-awarded' levels. But what should
they look like? We needed to preserve the specialness of the iconic Yellow
and Black pencil, and to demystify the D&AD Award hierarchy and make a
system that will last the test of time and align with D&AD values.
Results: This new pencil award system preserves the specialness of the Yel-
low Pencil by adding new pencil awards in a neutral colour palette that keep
the Yellow and Black Pencils as the heroes. The two new pencils are in stages
of preparation leading up to the Yellow pencil: Natural wood (previously 'In
Book' Level) followed by undercoat (previously 'Nomination' level). The
Yellow pencil remains as it has always been and the Black pencil becomes
the reverse colour scheme of it, creating a clear hierarchy where all awards
are desirable. They represent D&AD's values.

38, 39, 40 "SAFDIE" | Design Firm: Pentagram | Client: Safdie Architects
Designers: Michael Gericke, Matt McInerney, Janet Kim | Client: Safdie Architects
Art Director: Michael Gericke
Assignment: "Safdie" is a comprehensive lifetime monograph that traces the
evolution of Moshe Safdie and chronicles the work of the prolific architect,
urban planner, educator, theorist and author.
Approach: The book portrays Safdie's planning and design work over the
past 50 years, with a complete chronology of projects since the inception of
his wide-ranging and influential practice. Organized to follow the architect's
career and design explorations, the monograph is illustrated with architectur-
al imagery, design drawings and essays by noted critics and writers.

41 EPIC EYE PUBLISHING | Design Firm: IF Studio | Client: Epic Litho
Project Manager: Athena Azevedo | Photography Studio: Henry Leutwyler Studio
Photographer: Henrly Leutwyler | Designers: Toshiaki ide, Hisa Ide | Design Director: Hisa Ide
Creative Director: Toshiaki Ide
Assignment: To create the premiere issue of "Epic Eye" magazine - an artistic
collaboration between Epic Litho and IF STUDIO to showcase and celebrate
the work of one accomplished visual artist. Issue no.1 features the work of
photographer Henry Leutwyler.

42 DESIGN YOUR LIFE | Design Firm: Frost*collective | Client: Penguin Books Australia
Designer: Vince Frost | Producer: Miya Bradley | Junior Designer: Adam Vella
Copywriters: Camilla Belton, Denis Seguin
Assignment: In September 2011 Vince Frost was asked by Apple to do a talk
at their flagship store in Sydney CBD. Vince decided to present a talk about
how to Design Your Life. Julie Gibbs from Penguin Lantern Australia went
to see this, and was inspired by this talk and asked Vince if he would be in-
terested turning his talk into a book. A few years later a contract was signed
and the short journey began to create the book (if there wasn't a tight deadline
to the book it would have been a longer journey so there were always jokes
made about this - thank goodness for deadlines) The goal was and and still is
to help people realise that they can design a better life for themselves.
Approach: Vince started a process with daily Skype calls between Sydney
and Toronto with dear friend and writer Denis Seguin for a period of several
months. This was followed by many designs, sketches and approaches for the
final publication. The creative approach was to create a visually appealing
and engaging publication, a hybrid between a self help book and a design
publication. It was important that the book was easy to read, visually arrest-
ing, and consisted of playful affirmations that would engage the reader.
Results: Since last November, there have been over 5000 copies sold in Aus-
tralia alone. The book has been featured in the Australian Financial Review,
Vogue Living Magazine, Weekend Magazine, Belle Magazine, and Mind
Food Magazine among other publications. Vince Frost also held a national
speaker tour around Australia, engaged in conversation for a series of talks
internationally. The book is being reprinted in Australia as stock is running
out. Penguin Books has also finalised details with an international distributor,
and Design Your Life will be available internationally from October 2015.

43 LITA ALBUQUERQUE: STELLAR AXIS | Design Firm: Brad Bartlett Design, LA
Client: SkiraRizzoli / Nevada Museum of Art | Designer: Brad Bartlett
Project Manager: Amy Oppio | Editor: Ellen Cohen
Assignment: Design a large-format, 5-color, 224 page book for Lita Albu-
querque's Stellar Axis, the first large-scale, ephemeral artwork created on the
Antarctica continent. The artwork features a 400-foot array of 99 ultramarine
blue spheres aligned with 99 bright stars to create a map of the sky above.
Approach: The book reflects the artists use of materials, and features an ultra-
marine blue finish with a debossed, gold foil-stamped map of the 99 brightest
stars in the southern hemisphere. The book includes excerpts from the artists
diary along with a customized typeface, informed by artists use of archeoas-
tronomy. The center of the book features a single red page that demarcates
the winter solstice during which the artist performed a sacred ritual on the ice.

Results: The book accompanied the exhibition Stellar Axis and was launched
at the 2014 Art + Environment Conference with praise from the publisher,
artist and museum.

44 MALFORMED: FORGOTTEN BRAINS OF THE TEXAS STATE MENTAL HOSPITAL
Design Firm: Pentagram | Client: Adam Voorhes | Designer: Stu Taylor | Art Director: DJ Stout
Assignment: Pentagram partner DJ Stout and designer Stu Taylor in Austin
have designed and produced a book of photographs by Matt Lankes that doc-
uments the making of Boyhood, Linklater's critically acclaimed film.
Shortly after filming commenced, Lankes began shooting behind-the-scenes
photographs and soulful, black-and-white portraits of the cast and crew with
his 4×5 camera. The Austin-based photographer returned every year, and
over the span of the film's production he created a visual time capsule of the
actors, including a series of portraits of Coltrane, the boy in Boyhood, who
grows from a soft-faced child into a young man during the course of the film.
Distributed by the University of Texas Press, Boyhood: Twelve Years on
Film , presents more than 200 color and black-and-white images and features
essays by Linklater, producer Cathleen Sutherland, Lankes, and actors Ar-
quette, Hawke, Coltrane and Lorelei Linklater.

45 THE BOOK OF STRANGER | Design Firm: Stranger & Stranger | Client: Self-initiated
Designer: Stranger & Stranger
Results: The Book of Stranger features a few hundred of the four and a half
thousand jobs we've done in that time and the cover, inspired a little by Hier-
onymus Bosch, features all of them. We were looking for appropriate pack-
aging and the human skin covered books of the Bosch era seemed appropri-
ate. Just kidding, it's not human. It is skin though.

46, 47 FORBIDDEN CITY EXHIBITION | Design Firm: Karnes Coffey Design
Advertising Agency: Spike Communications | Client: Virginia Museum of Fine Arts
Designer: Jamie Mahoney and Christine Coffey | Illustrator: Eric Karnes and Alice Blue
Creative Director: Hal Tench and John Mahoney | Copywriter: John Mahoney
Assignment: The task was to design a visually arresting campaign for an ex-
hibition of works from the Palace Museum in Beijing. The museum is housed
in the Forbidden City. This exhibition was part of an exchange between the
Virginia Museum of Fine Arts and the Palace Museum in Beijing. Drawn
from the collection of the Forbidden City, featured works included scrolls,
costumes, furniture, and fine decorative arts such as lacquer ware, and jade.
Approach: The letterforms of the design were created using details from the
actual decorative arts—rich and diverse objects from the Ming (1368–1644)
and Qing (1644–1911) dynasties. The campaign was composed of interior and
exterior building signage, banners, and an airport duratran—all typical media.
But the designers also teamed with a local Richmond brewery to craft a special
Forbidden beer (and the coasters and brewery banner to go with it) to com-
memorate the opening of the Virginia Museum of Fine Arts' exclusive exhibit.
Results: The campaign resulted in surpassing attendance projections by 14%.

48, 49 SWT DESIGN BRANDING | Design Firm: TOKY | Client: SWT Design
Executive Creative Director: Eric Thoelke | Designers: Eric Thoelke, Ashford Stamper
Creative Director: Katy Fischer
Assignment: Well-known for their landscape architecture, urban design, and
planning expertise, SWT Design needed a brand platform, brand identity, and
website that would better represent their industry leadership, nationally rec-
ognized work, and laid-back culture. We designed a new identity that evolved
the distinctive wavy bottom of the firm's original logo, doubling it back upon
itself to create a kind of infinity symbol — appropriate for a firm creating
elegant spaces from the cycle of life. Photos of the firm's spaces were pho-
tographed by our team, and the "LIVING DESIGN" theme — the encapsu-
lation of the brand platform — is featured as part art element, part tagline.

50, 51 D.W. ALEXANDER BRANDING | Design Firm: The Community
Client: D.W. Alexander | Designer: Jenny Vivar | Creative Director: Art Mandalas
Assignment: Rebranding a Toronto nightclub formerly known as The Foun-
dation Room, the assignment was to create a new brand that embodied the
architectural characteristics of the building – which was once a leather tan-
nery – and its historic location in Toronto. Our challenge was to fuse both
modern and archival design references to create a brand and voice that would
resonate with today's after-work drink aficionados.
Approach: The namesake for a new bar and restaurant in Toronto, D.W. Alex-
ander was a leather trader from the late 19th century who owned a warehouse
where the current establishment sits. With a nod to the past and an eye on the
present, our design references the industrial character and illustration style of
that era and fuses it with a contemporary style.
Results: The concept was well received by our client and was used to inspire
and drive the design direction for the establishment's interior.

52, 53 ITEM / BRANDING | Design Firm: lg2boutique | Clients: Item, Ross Fraser
Designers: Serge Côté, Elise Cropsal, Pénélope St-Cyr Robitaille
Creative Director: Claude Auchu | Art Director: Jean-François Clermont (lg2)
Account Executive: Antoine Levasseur | Account Director: Catherine Lanctôt
Copywriters: Sylvain Dufresne, Geneviève Langlois, Geneviève Jannelle, Pierre-Luc Loranger
(lg2) | Strategy & Naming: Marc-André Fafard | Print/web Producer: lg2fabrique
Assignment: Create the branding for the new business concept of Fraser Fur-
niture, a 134-year-old, family-owned Montreal institution.
Approach: Embrace high-end consumer behaviours regarding furniture – i.e.,
those who believe that a one-of-a-kind space is created gradually, over time,
piece by piece, from successive discoveries. The essence of any decor is ex-
pressed in each detail, each element, each ITEM.
Results: Massive press coverage. It is too early to gather exact results, but
foot traffic increased and sales per square foot were on par vs. the old Fraser
store, despite a significant decrease in store size.

54, 55 CO-CREATION! CAMP | Design Firm: Recruit Communications Co., Ltd.
Client: Recruit Lifestyle Co., Ltd. | Designer: Kei Sato | Producer: Ai Sanda | Art Director: Kei Sato
Photographer: Kenichi Shimoyana | Logo Designer: Kei Sato, Junko Igarashi
Creative Team: Haruma Yonekawa, Ryo Shimomura, Moe Uchimura, Yasuhiro Tamura,
Daisuke Yano | Creative Director: Takahiro Nagahama | Assistant: Sayaka Igarashi
Assignment: BONFIRE provides an atmosphere in which people can talk
honestly. This is the logo design for the event Co-Creation! Camp, which
triggers talk about future local revitalization. Various colors symbolized every person's will, and it led many ideas and produced more than 100 projects.

56, 57 XINLIN TEA HOUSE | Design Firm: Lin Shaobin Design
Client: Xinlin Tea House | Designer: Lin Shaobin
Assignment: XINLIN TEAHOUSE is a Chaoshan gongfu tea as the business
philosophy of teahouse. Teahouse architecture and interior all is decoration
as Chaoshan old home style. For consumer groups whom love Chaoshan culture and Chaoshan gongfu tea, suitable for them to this tea, chat, party, etc.
meanwhile sale the tea, easy for consumers purchase and taste at home.
Approach: This project has designed many fonts and graphics related Chaoshan culture and Gongfu tea. In the later part of craft design reflected the
hollow effect. The concept is derived from the carved wooden screen and
window grilles which have most Chaoshan characteristics. Both can be pervious to light and can be decorated. It has rich Chaoshan culture and Gongfu
tea culture breath. Also applied to the all design application of whole project.
Results: Hold in praise and recognition by the people who love Chaoshan
gongfu tea, meanwhile won the Gold Award in the race Taiwan International
Graphic Design, was interviewed local newspaper, and aroused people concern of this teahouse. Very good proved design brings market affect.

58 THE MORETON | Design Firm: Hoyne | Client: Mirvac | Designer: Peter Georgiou
Creative Director: Andrew Hoyne | Copywriter: Leesa Gallaher | Account Manager: Eddie Arnott
Assignment: Our client Mirvac wanted to set a new benchmark in design and
quality for an apartment development in the Bondi area. While within the
famous suburb of Bondi, the site was a distance from area's biggest drawcard
being the beach. The project comprised of a number of new buildings as well
as the restoration of a heritage building on site.
Approach: The site benefited from numerous mature Morton Bay Figs and
Norfolk Pines, retained and formed a part of the landscaped grounds within
the development. This was a key strength which we used as the basis for the
identity and campaign. Hoyne created a language to differentiate the campaign from all others in the market. Most apartments from the upper levels
would enjoy views of the beach. While some would consider this an out of
the way location, it was important we marketed the tranquility and convenience of the site. Hoyne developed a campaign of differing but unified messages across online media and print campaigns.
Results: The Moreton was transformed by delivering the message across different platforms to evoke an emotional response to the product. The marketing created a huge amount of noise in the market and 90% of the apartments
were sold on launch weekend, with the balance very soon after.

59 DOLCEZZA BRAND IDENTITY | Design Firm: The General Design Co.
Client: Dolcezza Gelato & Coffee | Designer: An Ly, Soung Wiser | Production: Matthew Batista
Photographer: Matthew Batista | Creative Director: Soung Wiser
Assignment: Those who were familiar with Dolcezza's gelato and coffee
were avid fans but those who didn't have any experience with the local,
iconic brand, were confounded by a visual identity that did not reflect its
higher-end pricing and quality product. We were brought in to develop a new
logo, identity, collateral and packaging to help take their cult-status gelato
and high-quality coffee program to the next level.
Approach: Our inspiration came directly from the owners' personal story of
meeting many years ago, falling in love with each other and then gelato. An
appreciation for old-world methods and traditions informs the typography
and a passionate belief in supporting local farmers and eating seasonally inspires the ornamental flourishes made of fruits and foliage.
Results: The brand evolved from a confusing and busy baroque aesthetic
more reminiscent of clip art, to one that evokes an old-world craftsmanship
conveying all the quality and care that goes into the gelato and coffee itself.

60, 61 THE BRILLIANT MIND | Design Firm: Mangos | Client: Brilliant Graphics
Designer: Justin Moll | Product Photographer: Michael Furman
Production Manager: Sue Trickle | Copywriter: Colleen Berta
Assignment: Create a Brochure to showcase the printing capabilities of Pennsylvania-based Brilliant Graphics.
Approach: Brilliant Graphics can print anything. They are problem solvers so
we made a book with every printing technique and challenge we could think
of, including a poster wrapped cover.
Results: As quoted in a print publication recently, "The Brilliant Mind is a
full on production party of varnishes, colors and typefaces." The client was
thrilled to be able to showcase so many of their capabilities in one fabulous
piece. They have gotten very positive results as they have shared this with
perspective and existing clients.

62, 63 15 RENWICK BROCHURE | Design Firm: IF Studio | Client: IGI USA, Core Group
Traffic Manager: Athena Azevedo | Photographer: Henry Leutwyler
Managing Director: Amy Frankel | Illustrator: March | Account Director: Anya Baskin
Design Director: Hisa Ide | Creative Director: Toshiaki Ide | Designers: Hisa Ide, Toshiaki Ide

64, 65 JEFF ANDREWS FOR A.RUDIN BOOK | Design Firm: Vanderbyl Design
Client: A.Rudin | Designers: Michael Vanderbyl, Tori Koch | Photographer: David Peterson
Creative Director: Michael Vanderbyl | Art Director: Michael Vanderbyl
Approach: Product overview book of furniture designed by Jeff Andrews.

66, 67 TEKNION DETAIL BOOK | Design Firm: Vanderbyl Design
Client: Teknion | Designers: Michael Vanderbyl, Malin Reedijk

Creative Director: Michael Vanderbyl | Art Director: Michael Vanderbyl
Approach: This book features the importance of detail in design. Developed
for an architecture and design audience.

68 ELEVENTH AND THIRD BROCHURE | Design Firm: IF Studio
Client: Benchmark Real Estate Group | Designer/Design Director: Hisa Ide
Creative Director: Toshiaki Ide
Assignment: The Eleventh and Third Brochure was designed to market a high
end rental located in the East Village. We came up with a manifesto list of
rules to live by as seen in this brochure, to target the young renters of that area.

69, 70 FLAWLESS BEAUTY | Design Firm: Toppan Printing Co., Ltd.
Client: Komori Corporation | Print Designer: Akihiro Inde, Yuki Ogawa
Photographer: Christopher Marley | Designer: Masahiro Aoyagi
Art Directors: Masahiro Aoyagi, Fuyuki Hashizume | Agency: Office Square LLC.

71 TENDER CATALOGUE | Design Firm: Tiny Hunter | Client: Argyle Pink Diamonds
Designer: Jen Wotherspoon | Illustrator: Evan Barbour | Creative Director: Emma Scott
Assignment: Each year Argyle Pink Diamonds put to tender their extraordinary collection of pink diamonds and as part of this process they create the
Argyle Pink Diamonds Tender Catalogue; a highly sought after set of books
housed in a beautifully designed slipcase, showcasing the year's tender collection. Every year the tender event creative is based around a new theme.
The 2014 tender theme was the Gouldian Finch - an extremely rare, colourful
bird found in the Kimberley; the birthplace of the Argyle Pink Diamonds.
Approach: The design for the Argyle Pink Diamonds Tender Catalogue 2014
features coloured feathers, representing the flight of the Gouldian Finch, in
the celebratory colours of the birds. The slip case introduced the theme with
a cloth cover, printed in full colour. The feathers were contrasted with a charcoal grey background, so the colourful bird was represented but softened by
the sophisticated grey. The cover of Volume 1 featured a large artistic crop
of the botanical illustration of a Gouldian Finch, whilst Volume 2, the tender,
returned to the theme of the vibrant feathers, reminding us of the celebratory
nature of the collection.
Results: The final books and slipcase were hand created. Every finish from
material to print technique was carefully considered. The finished product,
we can proudly say, is a work of art and Argyle Pink Diamonds recorded their
highest ever bids for the tender this year.

72 AUDI MAGAZINE 106 | Design Firm: designory. | Client: Audi USA
Designer: Anashe Abramian | Programmer: Jackie Diener | Project Manager: Crystal Gilbert
Production: Kurt Renfro | Editor-in-Chief: Jay Brida | Copywriter: Kit Smith
Artist: Anashe Abramian | Art Directors: Ulrich Lange, Kathy Chia Cherico
Account Management: Sella Tosyaliyan, Adriana Molina | Account Director: Chris Vournakis
Assignment: Move. Drive. Inspire. This is what Audi magazine is designed to
do and more. With original content centered around the world's hottest luxury automotive company, this magazine combines stories on new Audi vehicles and technologies while showing owners and enthusiasts what inspires us.
Approach: In edition 106, new models from the 2015 Audi Q3 to the redesigned Audi TT are covered in detail. There's an in-depth story on the evolution of the four rings and a look at the French city of Le Mans, home of the
legendary endurance race. The magazine is a true enthusiast piece and speaks
to the level of commitment Audi has for its owners and fans alike.
Results: Audi clients and customers are very happy with this printed piece.

73 2013-2014 WAKE FOREST SCHOOL OF BUSINESS MAGAZINE
Design Firm: Elephant In The Room | Client: Wake Forest University School of Business
Designer: Will Hackley
Assignment: We were hired to re-design the look and feel for the Wake Forest University School of Business magazine that accentuated the bold new
architectural design of the new Business School home, Farrell Hall. Along
with the cover story, each article required a thoughtful approach to design
and layout. Evolving the magazine closer to the business school's new visual
identity, we created a new mast head, establishing a more bold approach for
the presentation of content to business leaders.
Approach: For each of the 67 features, articles and editorials, we developed
custom illustrations and typography to compliment the editorial and the annual noteworthy events and achievements for the school.. The individual stories and spreads were designed with full-bleed photographs and bold graphic
treatments when necessary.
Results: The magazine and new approach to it's design has been met with
wide acceptance. We are currently in the process of designing the 2014-2015
magazine for the School of Business.

74 GROUSES OF THE HOLY | Design Firm: GQ | Client: Self-initiated
Designer: Benjamin Bours | Design Director: Fred Woodward

74 THE ACCIDENT | Design Firm: GQ | Client: Self-initiated
Designer: John Munoz | Design Director: Fred Woodward

75 THE MOST ADVENTUROUS RESTAURANT IN THE WORLD | Design Firm: GQ
Client: Self-initiated | Designer: Andre Jointe | Design Director: Fred Woodward

75 WHO WANTS TO SHOOT AN ELEPHANT? | Design Firm: GQ | Client: Self-initiated
Designer: Martin Salazar | Design Director: Fred Woodward

76 EMILY | Design Firm: GQ | Client: Self-initiated
Designer: Andre Jointe | Design Director: Fred Woodward

76 THIS IS YOUR BODY ON SUPER FOODS | Design Firm: GQ | Client: Self-initiated
Designer: Benjamin Bours | Design Director: Fred Woodward

76 THE STRANGE & CURIOUS TALE OF THE LAST TRUE HERMIT | Design Firm: GQ
Client: Self-initiated | Designer: Martin Salazar | Design Director: Fred Woodward

77 THE 15 FUNNIEST PEOPLE ALIVE RIGHT NOW! | Design Firm: GQ
Client: Self-initiated | Designer: Benjamin Bours | Design Director: Fred Woodward

78 NAKED AND FAMOUS | Design Firm: GQ | Client: Self-initiated
Designer: John Munoz | Design Director: Fred Woodward

79 APRIL 2014 COVER STORIES | Design Firm: GQ | Client: Self-initiated
Designer: Chelsea Cardinal | Design Director: Fred Woodward

80, 81, 82 CONVENT OF THE SACRED HEART ATHLETICS AND WELLNESS CENTER
Design Firm: Poulin + Morris Inc. | Client: Convent of the Sacred Heart
Designer: Andreina Carrillo | Design Director: Richard Poulin

Assignment: Convent of the Sacred Heart, established in 1881, is the oldest independent school for girls in New York City. As part of the Society of the Sacred Heart, a worldwide network of over 150 schools dedicated to the education of girls and young women, Convent of the Sacred Heart is committed to addressing the intellectual, spiritual, social, and emotional development of its students. Originally situated in a Madison Avenue brownstone, the School moved into the Otto Kahn Mansion on East 91st Street in the 1930s and expanded into the adjacent James Burden Mansion in the 1940s. The School currently has an enrollment of 670 students from pre-kindergarten through grade 12. The School purchased 406 East 91st Street to serve as their state-of-the-art Athletics and Wellness Center.

Approach: The designers created graphics that promote school spirit by focusing on students and the athletic activities in which they excel. They directed photography shoots to create life-size, color murals depicting some of the School's top athletes of varying ages and grade levels, dressed in their red team uniforms. The photography accentuates the sequence of their motions frame by frame as they enact movements, giving the murals a sense of vitality and action. The photographs of the student athletes appear to interact with the words, creating empowering imagery.

Results: An inspiring and empowering branding and environmental graphics program was created for Convent of the Sacred Heart's Athletics and Wellness Center. The firm has continued to work with Convent of the Sacred Heart in developing a comprehensive base building sign and donor recognition program for the Athletics and Wellness Center.

83, 84, 85 GLAXOSMITHKLINE US HEADQUARTERS ENVIRONMENTAL GRAPHICS
Design Firm: Pentagram | Client: GlaxoSmithKline
Designers: Michael Gericke, Don Bilodeau, Jed Skillins, Qian Sun, Beth Gotham, Elizabeth Kim | Art Director: Michael Gericke | Photographer: Peter Mauss/Esto

Assignment: A bold program of large-scale environmental graphics was created for the United States headquarters of GlaxoSmithKline, the global pharmaceuticals and consumer healthcare company. Located in Philadelphia's Navy Yard, the innovative "smart" workspace is 100 percent mobile—no one has an assigned desk, not even the company president—and the iconic graphics help foster a spirit of connection for a new collaborative way of working. The designers worked closely with GlaxoSmithKline and Francis Cauffman, the building's interior architects, to develop the graphics for the unique, 208,000 square foot offices. Conceived as a healthy and sustainable headquarters, the modern, contemporary interiors are open and loft-like, with a series of gathering spaces that include shared work stations, team tables and meeting areas.

Approach: A series of graphics were designed for the space, inspired by the idea of connections, with dot-to-dot networks forming images that convey a sense of community and collaboration, interaction and creativity. The collaborative focus extends to the materials. Many of the graphic surfaces use magnetic dry-erase wall coverings, so teams can write and post on them during brainstorming sessions. The bold and contemporary colors of the program have been coordinated with the overall palette for the interiors.

Results: The client was very pleased with the results and the offices were even honored with an International Interior Design Association Award in 2013.

86, 87, 88 PEPSI GATE AT METLIFE STADIUM | Design Firm: Pentagram
Client: Pepsi Co./Pepsi Design and Innovation Center | Art Director: Michael Gericke
Designers: Michael Gericke, Don Bilodeau, Matt McInerney, Qian Sun, Kelly Sung, Jed Skillins, Beth Gotham, Elizabeth Kim, Jessie Wu | Photographer: Albert Vecerka/Esto

Assignment: Pentagram created the branding and graphic identity for the Pepsi entrance at Gate G of MetLife Stadium in New Jersey for the XLVII Super Bowl, and beyond. The installation transformed the gate into an unexpected celebration of the Pepsi brand, complete with a pair of unique graphic sculptures inspired by the Pepsi bottle and rendition of the famous Pepsi Globe logo.

Approach: To create a real sense of arrival, a super-scale Pepsi logo stretches across four levels of the stadium, with the brand's classic red, white and blue palette visible through the building's outer skin of aluminum louvers. The monumental Pepsi emblem can be seen for miles across the Meadowlands Sports Complex, making the gate a landmark in the area. Up close, the logo reveals itself to be made up of a typographic pattern of words and phrases celebrating the connection between Pepsi and the game of football. Escalators to the various stadium levels run along the wall, and the typography builds anticipation and excitement for the fans as they enter the stadium.
Almost as big as New York City buses or New Jersey Transit trains, a pair of massive hanging Pepsi bottles have been created from a series of cross-section "slices" of the Pepsi Globe. The discs form the distinctive shape of the recently redesigned Pepsi bottle, extending the identity into three dimensions and turning Pepsi's signature brand elements into a dynamic sculpture that appears to change as fans move around it.

Results: The installation was a huge success, as the design captured the spirit of fun, authenticity and excitement of the Pepsi brand and connected it with fans' game day experience. The client was very happy with the results.

89 HBF WASHINGTON D.C. SHOWROOM | Design Firm: Vanderbyl Design | Client: HBF
Designers: Michael Vanderbyl, David Hard, Peter Fishel | Creative Director: Michael Vanderbyl
Art Director: Michael Vanderbyl

Approach: HBF's new Washington DC 14th floor showroom features floor to ceiling windows on one side that allows for' an abundance of incoming natural light. The challenge was to create a dramatic backdrop with minimal construction. To achieve this goal, walls were removed to open up the space; light cerused oak floors were installed and the walls were painted white to enhance the natural light reflection. HBF has the honor of working with many talented designers that have been instrumental to the company's success. To celebrate this contribution, their portraits are featured on six double-sided 8'x8' monoliths. These twelve portraits represent a cross-selection of the many furniture designers that have created product for HBF over the years. These large-scale photographs also act to provide a visual separation between the company's products.

90, 91, 92 THE FIRST WORLD WAR IN THE AIR
Design Firm: Ralph Appelbaum Associates, Inc. | Client: The Royal Air Force Museum
Designer: Ralph Appelbaum Associates | Project Manager: Deborah Miller
Project Leader: Patrick Swindell | Senior Graphic Designer: Mat Mason
Graphic Oversight: Rosanna Vitiello | Media Developer: Lai Couto | AV Integration: Atlas
Content Developer: Holles Houghton | Designer and Visualiser: Mirko Cerami
Parametric Modeller: Gabi Ivorra | Media Production: SquintOpera
Interactive Exhibits: AIVAF Ltd | Lighting Design: DHA | Director: Phillip Tefft
Graphic Designers: Kate Brangan, Steve Roberts | Content Coordinator: Charlotte Kingston

Assignment: The story of aviation during the First World War is one that, until now, has remained largely untold. The First World War in the Air, a major new permanent exhibition at the Royal Air Force Museum in Hendon, London, brings to life the compelling stories of the people, the innovations, the engineering, and the aircraft of the war, and ultimately helps audiences understand the pivotal role of aviation—then and now. The exhibition, which displays one of the world's most significant World War I aviation collections, was a key part of the RAF Museum's World War I centenary commemorations, and is rich with interactivity, dramatic media, and period collections. The thrilling story of the evolution of flight, from its earliest incarnations to today's full-force fighting machines, is underpinned by stories of the people "on the ground." The exhibition also explores the extraordinary expansion of the Royal Flying Corps from 250 men in 1914 to a Royal Air Force of 250,000 men and women in 1918.

Approach: Working with the Museum, RAA developed an innovative approach to the interpretation and exhibition design that reshaped the way that visitors would encounter the collections. Rather than simply showcasing the collections, the exhibition is strongly narrative-led and coalesces around a single strong message: He who controls the air controls the battlefield. The exhibition's primary creative strength lies in its seamless fusion of design and narrative. The inspiring story of the evolution of flight is dynamically embodied in the space through an innovative feat of design and engineering: As the chronology unfolds, the exhibition literally takes off—from the ground-based collection of early aircraft to a suspended display. The Museum's collection is brought to life as the aircraft soar upward, occupying the air as they were originally designed to do.
RAA also took an innovative approach to the exhibition's media and interactivity to provide visitors with unique first-person experiences. Hands-on interactives, such as the Rocking Nacelle—an important early training device, allow visitors to feel what it was like to fly in the early 20th century. An interactive based on aerial reconnaissance challenges visitors to piece together sections of World War I battlefields. Visitors can also communicate with each other via a Gosport tube re-creation, an example of how pilots would have communicated with each other in the cockpit. A re-created Nissen hut allows visitors to experience life on the ground and try their hand at Morse code. A strong graphic identity throughout the exhibition, drawn from the eye-catching graphic markings of the aircraft themselves, also plays a key role in the interpretive hierarchy by creating a simple, easy-to-navigate layering of stories and information.

Results: The First World War in the Air opened in December 2014 in a special ceremony attended by the Duke of Edinburgh. The exhibition has already welcomed more than 9,000 visitors, and the Museum is currently in the process of undertaking formal evaluation.

93 CANADIAN MUSEUM FOR HUMAN RIGHTS | Design Firm: Ralph Appelbaum Associate
Client: Canadian Museum for Human Rights | Designer: Ralph Appelbaum Associates
President: Ralph Appelbaum | Image and Footage Research Director: Dahlia Kozlowsky
Project Director: Josh Dudley | Project Coordinator: Rachel Gershman
Other: North Shore Productions / Upswell; Gagarin; gsmprjct°; Idéeclic; Tactable; Bruce Mau
Design / Potion; Media Rendezvous; InMotion | Media Production: CMHR Digital Media
Exhibit Fabrication: Kubik | Content Director: Mary Beth Byrne | Interior Fit-Up: PCL
Project Manager: Marianne Schuit | Principal: Melanie Ide | Media Coordinator: Naomi Seixas
Artifact/Object Researcher: Fred Wasserman | Artifact/Object Coordinator: Elizabeth Walker
Image and Footage Research: Ian Samplin | Copy Editors: Susan Packard and Emily Goodman
Audio and Acoustic Design: SH Acoustics | Audio-Visual Systems Engineering: Electrosonic
Accessibility Consulting: Design For All Inclusive; Design Research Centre, OCAD University
Architecture: Architecture 49 | Lighting Design: Tillotson Design Associates
Graphic Designers: Mary Choueiter and Michael Lum | Art Director: Christiaan Kuypers
Exhibition Designers: Nico Guillin, Sylvia Feng | Content Coordinator: Rebecca Bureau
Architects: Anthony Dong (Project Manager), Grit Vltavsky (Project Manager)

Assignment: The Canadian Museum for Human Rights is the first museum solely dedicated to the evolution, celebration, and future of human rights. Its aim is to build not only a national hub for human rights learning and discovery but a new era of global human rights leadership. The goal of the permanent exhibition is to engage visitors in an immersive, interactive experience that offers inspiring encounters and the tools to make a difference in the lives of others. This project is about communicating that ideas and actions matter, both as a way to acknowledge the many (often unacknowledged) wrongs that various groups have experienced and as a way for people to gain an understanding of the rights and freedoms others have struggled to attain.

Approach: In designing the permanent exhibition for the Canadian Museum for Human Rights, RAA aimed to transform an abstract concept into a tangible understanding of what human rights are, and can be—for others and for oneself. Housed in a spectacular 240,000 square foot building by architect Antoine Predock, the Museum's singular architecture creates an upward path from darkness to light, symbolizing hope for a changed world. We embraced the highly idiosyncratic architecture of the building. In laying out the exhibit environments only a few clear, synergetic interventions were made. Exhibit colors and finishes were designed to harmonize with the honest and direct materials of the building—concrete, steel, wood and stone. Images and artifacts make human rights history palpable. Films, interactive media, and haptic experiences allow visitors to discover the human rights instruments at their disposal. Photography and media introduce life-sized people as recurring presences—witnesses, workers, champions, and sometimes victims.
Results: The Canadian Museum for Human Rights' visitation since opening has surpassed initial projections by about 100 percent. In a visitor survey conducted for the museum, 94 percent of visitors rated themselves as "very satisfied" or "satisfied." Even more important, four in five visitors rated the museum an inspiration, while nine in ten felt the museum should be seen by as many people as possible.

94, 95 TING: TECHNOLOGY AND DEMOCRACY
Design Firm: Ralph Appelbaum Associates, Inc.; Tamschick Media+Space GmbH
Client: The Norsk Teknisk Museum (NTM) I Developer: Vanessa Offen (Ralph Appelbaum Associates)
Designer: Ralph Associates, Inc.; Tamschick Media+Space GmbH
Project Managers: Karin Knott (Ralph Appelbaum Associates), Tobias Ziegler (Tamschick Media+Space GmbH) I Production Manager: Tobias Ziegler (Tamschick Media+Space GmbH)
Other: Stefan Will (Sound Design, BLUWI Music & Sounddesign GbR) I Graphic Designers: Sharmila Sandrasegar (Ralph Appelbaum Associates) I Design Director: Timothy Ventimiglia (Ralph Appelbaum Associates) I Creative Director: Marc Tamschick (Tamschick Media+Space GmbH) I Art Directors: Natalie van Sasse van Ysselt (Tamschick Media+Space GmbH), Marc Osswald (Tamschick Media+Space GmbH)

Assignment: On the occasion of the Museum's 100th anniversary and the 200th anniversary of the Norwegian constitution of 1814, TING—Technology and Democracy was created to explore the complex relationship between specific technologies—historic and emerging—and their impact on and relevance to the development of democratic societies.
Museum curators posed the question "Is any given technology good, bad, or neutral in the development of democracy?" The answer to this question required the invention of a highly participatory experience in which the visitors themselves would play an essential role in exploring the premise, engage in a dialogue with other visitors, discuss their ideas and emotions, debate the facts, and collectively decide an outcome.
Approach: In its ancient form, the Ting was a circular space where governing assemblies would gather to put things up for discussion. Here, in the central "Ting" section, it has been reinvented as a giant object theater—a discursive social space where object displays and immersive, interactive media work together to facilitate a participatory experience with the visitor at its center. Surrounding the Ting table, a 25-meter-wide, 5-meter-high shelf displays 100 objects, and at the same time functions as a 180° projection surface. A basic wooden cube, analog to the digital pixel, becomes a haptic tool for visitors to trigger digital interactions that bring the objects to life. Eight controversial objects are put up for discussion and voting. Each one of these revolutionary technologies is introduced with a short film illustrating the object's past, current, and possible future impacts on democracy and society. Visitors can express their thoughts and opinions, and use the wooden cube (or an interactive tablet) to place their vote. A moderator facilitates the group in discussing the outcome. Past results of previous sessions appear as a cumulative landscape that dynamically changes over the duration of the exhibition. Visitors can express their thoughts one last time by either scanning the bar code with their smartphone or using the tablets, adding up over time and generating a multifaceted, democratic voice. At the end of the experience, visitors use their cubes to cast a final vote on the concluding question: "Is it possible to control technological development in a democracy?"
Results: Public response to the exhibition has been overwhelmingly positive, and visitors' numbers have risen. Visitors stay longer in the exhibition and interact with each other in ways not common for a temporary exhibition. Ting discussions between visitors are at once passionate and intelligent. They take on a life of their own and have exceeded all expectations. From all observations, the TING experience is successfully providing visitors with an inspiring setting for active and consequential participation in the topics of their time. It is an affirmation that museums do indeed provide meaningful discursive spaces for society on the whole.

96, 97 DELTA FLIGHT MUSEUM I Design Firm: Lorenc+Yoo Design I Client: Delta Air Lines
Designer: Jan Lorenc, Steve McCall, Chung Youl Yoo, Stewart Sonderman
Photographer: Rion Rizzo, Creative Sources Photography, Atlanta, GA
Assignment: Design of Delta Airlines Museum housed in 1940 and 1950 vintage hangars at Atlanta International Airport and Delta Headquarters Campus. This museum would be open to the public and used as an event space by Delta and other firms for dramatic events like launching the new Porsche Automobile to the US dealerships.
Approach: We designed the museum to be two tiered one featuring the Prop Era in the smaller hangar and the other the Jet Age in the larger hangar. We featured the historical materials from both eras in display cases. The display cases in the Jet Age were in luggage carts and could be moved for large events held in this space. The space contained an auditorium that would graduate flight attendants and honor the top corporate performers in customer service.
Results: The spaces are at a juncture of corporate headquarters and the airport

property so staff as well as public would be able to learn about Delta and its operations. The jet age contained a the only working flight simulator in a public museum. It is a museum for both internal staff and the public.

98 MECHANICAL MOSQUITO INTEGRATION #6 I Design Firm: Michael Pantuso Design
Client: Self-initiated I Designer: Michael Pantuso
Approach: This work is part of a limited edition series titled "Mechanical Integrations" which are conceived and created digitally. Subjects from nature are composed and integrated with illustrated mechanical elements. The final result becomes a balance between realism and graphic expression. A place where shapes, colors and textures come together to form expressions of vision, imagination and emotion.

99 HANSON STATIONERY I Design Firm: Stranger & Stranger
Client: Hanson of Sonoma I Designer: Stranger & Stranger
Results: The Hanson Family, Californian through and through, built a distillery in Sonoma wine country and is making vodka out of local grapes. They believe in checking quality and hand crafting, so we wanted the brand to reflect the hand finished part of the product and stand out as a Californian icon.

100 LUDOTALLERES I Design Firm: El Paso, Galería de Comunicación I Designer: Alvaro Perez
Client: SP Psychology Cabinet I Creative Team: Alvaro Perez & Curra Medina
Assignment: SP Psychology Cabinet is specialized in children and teenagers with relationship problems. SP Psychology Cabinet opened a new space with one objective: help and teach children to relate with others, to communicate, and to share. The way to do it is with a therapy that looks and feel like funny games.
Approach: Our identity work had two ways: first we looked for a concept and name, and later we designed the logo. The naming process drove us to "Ludotalleres", something like Games Workshop in spanish. A place to learn while playing. To design the logo we were observers in the starting of the therapy for a week. And we looked and found a little ritual: both children and therapist take off their shoes in the starting moment. This way they had a relaxed play, and represented something more: problems and formalism out. And it was very funny to observe a lot of socks: solids, colours, strips, spots... We had it clear: a funny sock to mean Ludotalleres. And a classical L to mean order, confidence and professionalism.
Results: SP Psychology Cabinet was very pleased with the result, both naming as logo. The logo-sock was easily accepted by children and therapists as something natural, very close to their game/therapy.

101 BOUNDLESS LOGO I Design Firm: Butler Looney Design I Client: Boundless
Designer: Butler Looney
Assignment: Create a logo for Boundless, a company specializing in corporate promotional materials.
Approach: The idea of kangaroos bounding along seemed like a natural pun for this brand. Add to that the discovery of the lowercase "b", and this mark just seemed to really comes together.
Results: Infusing a little visual wit into what people perceive as a dry business.

101 EARLY START I Design Firm: Frost*collective I Client: University of Wollongong
Designer: Benjamin Hennessy I Strategy Director: Catriona Burgess
Other: Carlo Giannasca - Head of Environments I Executive Creative Director: Vince Frost
Design Director: Charlie Bromley I Creative Director: Anthony Donovan
Assignment: Early Start is a $44m initiative based at the University of Wollongong in Sydney Australia. Based on research that demonstrates that social disadvantage is strongly tied to children's access to opportunities in the earliest years of their lives, Early Start seeks to pioneer new links between children, parents, schools, research and students studying early education. Key to the brief was a brand and identity that could span this diverse range of audiences and across a wide range of applications including digital learning and a Children's Discovery Centre where children engage in hands-on developmental play. Frost* Design developed the idea of "exciting potential" to capture the idea of using play and engaging experiences as a way of stimulating not only children's potential but also wider social opportunity.
Approach: Working from the brand platform our creative team developed the idea of "Imaginaction" – to embody how imagination can be a force for change. The identity was realised through the adoption of a dual approach that encapsulated the two sides of this idea, with a cloudburst representing imagination, and a starburst representing action. The logo is designed around these two elements. We applied the brand to the Childrens' Discovery Centre and the new building on the University's campus. We also workshopped signage systems with children to understand how they relate to typical icons and wayfinding systems. This resulted in a highly engaging system based on characters.
Results: The partnership between UOW and Frost* Design has been very fruitful and the new brand is being rolled out on the building by Urbanite, the environmental graphics specialists in the Frost*collective. Frost*collective's client, Pauline Lysaght has said the following of the Frost* experience: It was wonderful to work with the very creative team from Frost* Design on the development of a distinctive signage and way-finding solution that so clearly reflects our brand... also generated by Frost* Design. Their designs reflect the Early Start concept perfectly, enhancing the internal and external architecture of our new building very effectively. The fact that we have adopted their innovative designs without change is a tribute to their skillful approach.

101 SHURE BRAND ICON I Design Firm: MiresBall I Client: Shure I Designer: Miguel Perez
Partner, Creative Director: John Ball
Assignment: A refreshed identity palette to address emerging needs.
Approach: MiresBall expanded the Shure identity palette to include a new asset. Inspired by the iconic Shure 55 Vocal Microphone, the new asset was designed to serve as the brand's profile image in social media, while complementing the Shure word mark and strengthening ties to the company's heritage.

Results: In addition to being used across Shure social media channels, the brand icon was embraced throughout multiple marketing communications including merchandise and stationary. The new icon was also applied to Shure products, enhancing their existing identity system.

101 HUMBLE COFFEE LOGO | Design Firm: 3 Advertising | Client: Humble Coffee
Designer: Tim McGrath
Assignment: Design a logo for a local coffee company named Humble Coffee.
Approach: Keep it humble. A simple coffee bean in the shape of an H.
Results: The logo was well received and liked by the owner and customers.
Tag line: Stay Grounded.

101 PROOF LOYALTY | Design Firm: Vanderbyl Design | Client: Proof Loyalty
Designers: Michael Vanderbyl, Katelyn Peterson | Creative Director: Michael Vanderbyl
Art Director: Michael Vanderbyl
Approach: Identity for a reward-based app for the luxury wine industry.

101 REYKJAVIK KARATE CLUB LOGO | Design Firm: Leynivopnid
Client: Reykjavik Karate Club | Designer: Einar Gylfason | Art Director: Einar Gylfason
Assignment: Design a logo for Reykjavik Karate Club.
Approach: The goal was to design a strong, yet simple typographic logo that portrays what the club stands for.
Results: Strong and identifying logo combining the letter K and a fist as a symbol for the karate sport.

102 DRIZLY LOGO | Design Firm: Breakaway | Client: Drizly
Designers: Heather Crosby, Jeshurun Webb | Chief Creative Officer: Scott Maney
Assignment: Drizly is a start-up alcohol delivery app. It delivers booze to your door in under an hour and is targeting the 21-40 year-old crowd. With a lot of competition sprouting up, we needed to find a way to be heard, be different and be remembered. First mover status is huge here and it has to be sticky.
Approach: There are lots of hipster cocktail brands out there. Why be another, annoying one? Drizly is the buddy you want to have a beer with. It's fun (it's alcohol delivery for christsakes). It's smart. It doesn't take itself too seriously. Drizly celebrates the joy of drinking. It's a cool name. And it kind of sounds like grizzly. Good mnemonic. Let's ride that bad boy. Let's poke the bear.
Results: Drizly is now in 11 markets, raised over $5M and is the category leader in online alcohol delivery.

102 BRIDGELINE PROPERTY MANAGEMENT LOGO | Design Firm: Mermaid, Inc.
Client: BridgeLine Property Management | Designer: Sharon Lloyd McLaughlin
Illustrator: Sharon Lloyd McLaughlin | Creative Director: Sharon Lloyd McLaughlin
Assignment: BridgeLine Property Management approached Mermaid, Inc to create a logo for their new company.
Approach: We wanted to create a logo that symbolizes BridgeLine's role as the bridge between building ownership & renters. We created a unique icon that forms an uppercase "B", visualizing both the "Bridge" and the "Line" elements in the name. It is an exceptionally versatile mark & can be used with & without the logo type, used both as bleed & non-bleed, positive & negative.
Results: The owner is pleased & it has been received very well by both building ownership & renters.

102 PN MAFRA | Design Firm: João Machado Design
Client: Palácio Nacional de Mafra | Designer: João Machado
Assignment: This logo was requested by the Mafra National Palace.
The Mafra National Palace is a monumental Baroque and Italianized Neoclassical palace-monastery located in Mafra, Portugal. It was built during the reign of King John V (1707–1750).
This sumptuous building also includes a major library, with about 40,000 rare books and the basilica is decorated with several Italian statues. The interior makes abundantly use of local rose-coloured marble, intermingled with white marble in different patterns. The multi-coloured designs of the floor are repeated on the ceiling.
Approach: The construction of this logo is based on the building's façade and it was inspired by the different colors of marbles that decorate the interior of the palace and the basilica (the impact of marble stone, the different colors and the patterns are really amazing). The logo acts as an association of pixels (using multiple polychrome squares / pixels as a central element in this construction) drawing the façade of the building.
Results: This logo has been successfully applied in the stationary of this institution. It is being used also in the advertising campaign for the celebration of the 300 Years of the Mafra National Palace in 2017.

102 THE AMINATA MATERNAL FOUNDATION | Design Firm: SML Design
Client: The Aminata Maternal Foundation | Designer: Wendy Cho | Creative Director: Vanessa Ryan
Assignment: Shine a light on women and children in Sierra Leone in the creation of The Aminata Maternal Foundation. Mothers in Sierra Leone face one of the highest risks of maternal death in the world, where 1 in 21 is likely to die in pregnancy or childbirth; 30 newborns die every day and the average life expectancy is just 47. Recent attempts to redress this dire situation have been put back decades by the deadly spread of the Ebola virus which has impacted hardest upon women and children. This new Foundation envisions a Sierra Leone with a healthy and productive population where women give birth safely and live a happy life alongside their children. SML Design has supported the founder, Aminata Conteh-Biger, from the beginning, donating our time and work to help create a strong vision for a cause committed to becoming a force for real change.
Approach: Our approach was to highlight the mother with child within a simple strong mark. The founder wanted it to be nurturing and positive, to bring light and a joyful spirit to the cause. The crafted A mark creates the feeling of the mother toward her baby, one of providing comfort and safety to the child within

and the vision of that deep connection. The colour palette foundation of black & white gives the depth and strength for the serious nature of the cause, juxtaposed with bright yellow to highlight and bring positive hope and care as well.
Results: The foundation is now in the final phase of establishment to begin its mission to raise funds and community awareness to bring real change to the women and children of Sierra Leone. The Identity has helped to set the scene for the incredible efforts and vision of the founder to bring it to global realisation. From here on, the Foundation and their many supporters will work with people on the ground in Sierra Leone to provide immediate assistance and work towards long-term solutions that will address maternal health issues.

102 BAYGEO | Design Firm: Butler Looney Design | Client: BayGeo | Designer: Melissa Chavez
Assignment: Logo and visual identity for a geospatial professional organization in the Bay Area.
Approach: We wanted to evoke a sense of place and allude to purpose of the organization. The Golden Gate bridge, topographic lines, and waves all come together to create a unique and ownable mark.
Results: This is something a small community organization can rally around, boost their brand presence, and unite their various chapters.

102 OZTRAIN | Design Firm: Shadia Design | Client: Denise Picton, oztrain pty ltd
Designer: Shadia Ohanessian
Assignment: Logo rebrand for 'oztrain' a training and consultancy firm with an enviable reputation for the delivery of excellent tailor made programs for public and private sectors which build the capabilities of people and the capacity of departments and companies with a focus on the development of people.
Approach: I created a bright, colourful 'rising' logo with movement/energy to show development, growth and the future. The design highlights the letters OZ. The 'O' draws you in to see more, revolving and evolving like oztrain. The 'Z' is created from 2 3D arrows showing directions and future paths.
Results: Client very happy with the new logo and rebrand. We are in the process of developing the website and other communication tools that are branded with the new logo and colours.

103 12E13TH ST BROCHURE LOGO | Design Firm: IF Studio
Clients: DHA Capital and Continental Properties, Cantor & Pecorella, Inc.
Designers: Toshiaki Ide, Hisa Ide, John Balbarin | Managing Director: Amy Frankel
Design Director: Hisa Ide | Creative Director: Toshiaki Ide | Account Director: Anya Baskin

104, 105 TOKYO SINFONIA 10TH ANNIVERSARY CONCERT POSTER 2ND
Design Firm: beacon communications k.k. graphic studio | Client: Tokyo Sinfonia
Designer: Takashi Kaneko | Art Director: Mayumi Kato | Project Manager: Noritsugu Endo
Assignment: A concert announcement poster for Tokyo Sinfonia, a unique string orchestra consisting of 19 players to celebrate their 10th anniversary. This is the second poster in a series. This not only announces 10th anniversary concert to their fans but also to attract those who are not interested in classic music by using unique design approach.
Approach: We used actual woods, strings and bridges to make a three-dimensional poster. It represents Tokyo Sinfonia's innovative attitude while the classic concert poster design tends to be conventional. The title typography depicts a bow for playing the instrument. On the bottom is a list of concert titles, musical pieces and composers they have been playing for the past 10 years with players' names.
Results: It became a popular topic since this was the first three-dimensional poster at the concert hall, and thicket sales boosted.

105 LIONDUB - STREET SERIES ALBUM COVERS | Design Firm: HOOK
Client: Liondub International | Designer: Brady Waggoner
Assignment: Design and Illustrate the flagship in a series of special drum and bass records by the Brooklyn-based electro-reggae label known as Liondub International. Liondub released a single called Money Me Say before Street Series. So currency became the aesthetic. Each one of the Artists is from a different part of the world. From London to Latvia.
Approach: Street level and intensely detailed. Use design cues and texture from currency. As much detail as possible as large as possible so it will look great on the matte album jacket.
Results: In a recent interview on the radio in England, Liondub was pressed hard by an enthusiastic host to know who was designing all these album covers. Liondub wouldn't tell. He kept it a secret. And we take that as a compliment.

106 KOLOSSOS OLIVE OIL | Design Firm: zünpartners
Clients: Kolossos Incorporated, Edward Billys, Giorgios Karayannis
Designers: Bill Ferdinand, Jane Robert | Creative Director: Bill Ferdinand
Assignment: Client research identified a market opportunity for high quality Greek olive oil in the Chicago/Midwest market. Greece makes the finest olive oil in the world and much like wine grapes, fine olive oil is also distinguished in flavor by the type of olive and region it's grown. Kolossos with family ties to the olive oil industry in Greece identified the very best olive groves with the goal of importing the finest 100% extra virgin olive oil from Greece's most select regional varietals. The branding and marketing strategy was to firmly establish the new comers brand name, support the products origin, claims of quality and position the product specifically by regional flavor attributes (a first in the olive oil industry). The design approach was to further qualify the product within the fine olive oil category as well as differentiate it within that same category of competitors.
Approach: Kolossos olive oil is 100% Greek, 100% Virgin, each flavor is of only one regional varietals and the olive oil is unfiltered. The product is as authentically itself as it can be. Therefore, the design strategy became about getting out of the way of a great product and letting that product sell itself boldly, with transparency, confidence and strength inherent in the Kolossos name. The industry expectation for olive oil containers was dark tinted glass,

an expectation that didn't let consumers to see the product. Not seeing the product was incongruent with the design strategy, a custom-made clear glass bottle was chosen. A minimal design approach was undertaken to incorporate only what was needed to stage the product for ideal shelf appeal.

Results: Upon its launch, Kolossos olive oil met with immediate success, they contracted representation with America's largest specialty food distributor (a decision heavily influenced by the packaging). The consumer food retailers that carry the Kolossos brand are a national, regional and local list of who's who. Kolossos has also had commercial success selling their olive oil to restaurateurs with Michelin Star credentials to James Beard winning chefs. Kolossos is often invited to show case their olive oil at many of Chicago's progressive food, fashion and design events, in 2014 Kolossos olive oil was voted the City of Chicago's best new "Indie" food.

107 BUDWEISER ALUMINUM BOTTLE | Design Firm: Jones Knowles Ritchie Inc.
Client: Anheuser-Busch InBev | Designer: Saskia Naidu | Typographer: Ian Brignell
Photographer: Matthew Coluccio | Managing Director: Sara Hyman
Design Director: Daniel D'Arcy | Creative Director: Tosh Hall | Account Executive: Nikki Kaminoff

Assignment: How do you reinvigorate an iconic brand to make today's generation pay attention? Budweiser came to us with an opportunity to use the twist off aluminum bottle as a catalyst for change for the 138 year old beer brand. They asked us break the rules and introduce a new Budweiser that Millennials could feel proud to hold in their hands; something fresh and relevant.

Approach: If there is one thing that millennials crave, it's authenticity. Being a brand full of rich heritage, Budweiser simply needed to go back to its roots. We identified today's most authentic and celebrated Budweiser icon; the label. Then, we reinterpreted it into a bolder and more contemporary version of itself.

Results: By crafting all new custom typography, the final product was the perfect balance of old and new.

108, 109 JEREMIAH WEED | Design Firm: Raison Pure NYC | Client: Diageo
Designer: Kyle Wessel | Illustrator/Designers: Emily Sylvester, Tim Devereaux
Creative Director: JB Hartford | Chief Creative Officer: Laurent Hainaut

Assignment: To create a fun, irreverent, approachable and unique new flavored whiskey range to target the growth in the flavored whiskey market and the increase in female whisky drinkers. One of the main challenges was the incredibly fast turnaround for the project of approximately 1 year, from brief to launch. The second challenge was the lack of ancillary marketing support, meaning that the packaging had to work extra hard to standout, engage and win consumers from the shelf. Without the time to create a bespoke bottle shape, the emphasis of the project was firmly on the label and neck design to drive market penetration and uptake.

Approach: We needed to cCreate something to disrupt the whiskey category by breaking its rules and conventions, and challenge the perception of whiskey being male dominated, stuffy and unapproachable. To create a quirky, tongue-in-cheek and ownable design, we worked with the client to delve into the story and personality of Jeremiah Weed. We defined the target audience to include female whiskey drinkers, so brought in some crafted detailing to bring the proposition to life and took a new way to communicate flavors.

Results: It was a real paradigm-shifting project in such a stuffy, heritage driven category lacking in design innovation. The range challenged the perception of whiskey by targeting a social positioning; a whiskey for sharing with friends that disrupted the mundane with curiosity, whimsy and craft.

110 OLD ST. PETE | Design Firm: Dunn&Co. | Client: St. Petersburg Distillery
Designer: Grant Gunderson | Chief Creative Officer: Troy Dunn | Printer: Blue Label Digital
Chief Creative Director: Jim Darlington | Account Executive: Jalyn Rivera

Assignment: In early 2014, St. Petersburg Distillery approached us about its fledgling company. It didn't have an identity, a logo or a brand strategy. It simply had a name and the ability to make fine craft spirits. Over the months that followed, we'd be tasked with branding the distillery and creating four separate spirits brands from scratch, with more on the way. The first was the distillery's flagship line of four craft spirits, including gin, vodka, whiskey and rum.

Approach: To establish provenance and local craftsmanship, we playfully channeled the authentic heritage of the distillery's hometown: St. Petersburg Florida, and named this line of spirits Old St. Pete. Our winking sun logo and Land Boom era postcard imagery bring surprise and whimsy to a market built on leisure and recreation.

Results: In a market packed with fervor for craft breweries, Old St. Pete stands alone among locally distilled spirits, and is being celebrated accordingly. Retail outlets, bars and restaurants lined up to request distribution even before products were formally released.

111 AMERICAN BARRELS BOURBON | Design Firm: Flowdesign
Client: American Barrels | Designers: Dan Matauch, Tracey Barraco, Dennis Nalezyty

Assignment: Develop a brand package that embodies the never-say-die fighting spirit of the United States and targets the small batch whiskey drinker looking for the perfect drink for any occasion.

Approach: We researched the bourbon category and American history pertaining to the American Revolution. Our goal was to create a structure out of glass that would be like no other structure in the bourbon whiskey category. The rattlesnake, a symbol for American independence, dates back to the American revolution, coils around the tailored shotgun shell-shaped bottle. The bottom of the bottle is finished off with a custom embossed base to represent the brass casing of the shotgun shell. The neck closure is a wood bar-top cork and the neck is dressed with a leather strap.

Results: As a new entry into the ever growing bourbon category, American Barrels Bourbon has been picked up by distributors based on its unique package and product taste. Early sales have been promising.

112, 113, 114 MORTLACH | Design Firm: Raison Pure | Client: Diageo
Designers: Alex Boulware, Kyle Wessel | Creative Director: Lorena Seminario
Strategy Director: Nicole Duval | Senior Designer: Loren Kulesus
Chief Creative Officer: Laurent Hainaut | Art Directors: Ann Chen, Harry Chong, William Kang
Account Manager: Megan Bradley

Assignment: Translate the Mortlach legacy into an exquisite physical form that celebrates the brand's rich Scottish history and heritage. A single-malt brand that has been integral in many of the world's most famous whisky blends for over 100 years, our task was to respect and reflect the Mortlach's character, a signature that comes from the unique 2.81 distillation process developed by entrepreneur, engineer and master distiller, Dr Alistair Cowie in 1896.

Approach: Beginning our exploration at the original distillery, which was founded in 1823 and the first legal distillery in Dufftown, the epicenter of Scotch whisky production, the creative team steeped in the sights and stories of the brand and its rich history, the Speyside region and its legendary characters. Inspired by the Cowies, the distilleries most influential owners, the agency centered on the concept of extraordinary engineering as it related to Britain's Victorian architecture and infrastructure. To define an appropriately elegant structure and graphics, the team worked closely with the client to distil the Mortlach story into a compelling and unique creative direction for four expressions, each commemorating Mortlach's rich industrial heritage.

Results: The bottle designs are reminiscent of trestle bridges, with geometric bases and tapering silhouettes to give the impression of looking upwards. Metal highlights on the caps, on the base of the 18 year-old variant, and girding on the sides of the 25 year-old expression speak to the brand's longstanding modernity and precision, creating a consistent look and feel but successfully differentiating the variants and communicating the different price points. The brand's color-palette pulls from Speyside's natural and manmade landscape, becoming increasingly industrial and elegant as the expressions tier-up in value.

115, 116, 117 OAK & PALM | Design Firm: Dunn&Co. | Client: St. Petersburg Distillery
Designer: Grant Gunderson | Chief Creative Officer: Troy Dunn | Printer: Blue Label Digital
Chief Creative Director: Jim Darlington | Account Executive: Jalyn Rivera

Assignment: In early 2014, St. Petersburg Distillery approached us about its fledgling company. It didn't have an identity, a logo or a brand strategy. It simply had a name and the ability to make fine craft spirits. Over the months that followed, we'd be tasked with branding the distillery and creating four separate spirits brands from scratch, with more on the way. One of these brands was a premium line of coconut and spiced rums.

Approach: Maintaining the local flavor of the distillery's brand, we celebrated two locally dominant trees: Oak & Palm, assigning each to one of the two flavors of rum. We explored the qualities they impart on the leisurely local lifestyle, while maintaining a premium brand through ornate and handcrafted design.

Results: As the Oak & Palm brand has launched, a market that serves up more than its share of tropical rum drinks has found itself rethinking its loyalties to the corporate standbys of the rum industry and started looking to a local favorite.

118 PAVIMENTO TEQUILA | Design Firm: Pavement | Client: Self-initiated
Designer: Michael Hester | Creative Director: Michael Hester | Photographer: StudioSchulz

Assignment: Pavimento Tequila is a brand created by Pavement to welcome the new year and promote the studio . A limited run of 100 bottles were sent to existing and prospective clients.

Approach: As a brand created from top to bottom to promote the studio, we wanted to be sure every detail was considered and stood out. Every detail is considered, including the name, bronze-engraved labels, custom typography, brand seals/logos, bottle structure and cork/jute twine closures. All of the elements in combination create an intricate, yet authentic brand experience.

Results: The brand and bottle was received with great enthusiasm by our clients and followers. It has served as a good example of how far we can push a brand when necessary.

119 ABERFELDY | Design Firm: Stranger & Stranger | Client: John Dewar and Sons
Designer: Stranger & Stranger

Assignment: Restore Aberfeldy from a bland, forgettable brand to its noble, real Scotch roots.

Approach: There's real gold in the Aberfeldy spring water, so we embraced a new strategy of 'The Golden Dram'

Results: 12 months of stock sold in 3 months

120, 121 DUELING GROUNDS KENTUCKY CLEAR | Design Firm: Bohan Advertising
Clients: Dueling Grounds Distillery | Designer: Josh Ford | Writer: John Sharpe
Creative Director: Jon Arnold | Art Director: Josh Ford

Assignment: Dueling Grounds Distillery in Franklin, Kentucky, is located in one of the last places in America where it was actually legal for gentlemen to settle their differences the old fashioned way: Twenty paces, turn and fire. "September 22, 1826: Representative Sam Houston of Tennessee severely wounded General William A. White in a pistol duel near Franklin, Kentucky, over the patronage political appointment of the Nashville Postmaster." Fast-forward 189 years to Nashville and meet under-the-radar music business legend Marc Dottore who's spent 30+ years in artist management with talent like the iconic Marty Stuart, Connie Smith, Kathy Mattea and Sturgill Simpson. Not a country music fan? You'll soon know Sturgill regardless. Featured recently in Rolling Stone and Garden & Gun, Sturgill's a game-changer who made his television debut last summer on Late Night with David Letterman. But even successful music business execs need a retirement plan, so Marc and his wife Anne who live in Franklin, Kentucky, came up with the idea for a Kentucky craft Bourbon distillery and named it Dueling Grounds. Bourbon must be aged in the cask three years, but in the meantime Marc needed a distilled product he could begin marketing at once – and the idea for Kentucky Clear was born. By law, this kind of grain-based distilled clear spirit doesn't

even need to be aged three days before it's sold, hence the cap label "Barely Legal." Basically it's government sanctioned illegal moonshine.

Approach: BOHAN Advertising was totally immersed in this project from day one. We counseled Marc on the bottle design and the name of the product, we created the brand story, sourced bottles, designed the logo and bottle labels, and created the promotional boxes in which the company's Kentucky Clear moonshine spirits would be presented to distributors – and to key influencers like the South's best bartenders and clubs, editors at Garden & Gun, etc. Also inside the box we included a commemorative set of pewter shot glasses to play off the Dueling Grounds name – and the Kentucky Clear moonshine experience - as soon as the box was opened. Appropriate to the brand's dueling heritage theme, those shot glasses are labeled "Shot 1" and "Shot 2."

Results: The packaging was created by BOHAN with the purpose of helping Marc sell his product in distributors that would in turn get him placement at retail. The initial order was for only 15 units. On his first sales call however, his product was accepted by his #1 target, the largest liquor distributor in Kentucky. It didn't take long for Marc to realize that with packaging had something he could sell at retail for far more than he could get for just the bottle itself. He's now sourcing boxes from China in lots of 500. Marc has now asked us to create packaging for three new products including Kentucky Sunshine (flavored with botanicals of lemongrass, orange peel and spearmint) and Kentucky Winter with a flavor profile including cinnamon, nutmeg and vanilla, aged in oak casks. By the year's end, production will begin for the flagship product, Dueling Grounds Kentucky Bourbon. It looks like the time for Marc to give up his day job is finally here. About time – it only took 189 years.

122, 123 GOODBELLY | Design Firm: LRXD | Client: NextFoods | Designer: Brian Son
Creative Directors: Kelly Reedy, Jamie Reedy | Copywriter: Jamie Reedy

Assignment: With its sleek black carton and emphasis on a unique probiotics feature, GoodBelly had distinguished itself from other fruit juices in the natural channel. But the brand's marketing team had a gut feeling it was ready for wider distribution beyond specialty food stores. In order to communicate to this broader audience, the company decided to design new cartons for its quart- and single-shot-sized juice products to speak and appeal to these new customers. Shoppers who peruse natural-foods stores had always responded positively to GoodBelly's packaging, which conveyed it as a functional product that aids the digestive tract. However, company research found a hitch as it was about to pitch the product to the masses: Since probiotics were the packaging's priority, most consumers couldn't identify GoodBelly as a juice despite complementary images of produce and a glass of the colorful drink. It needed to boost its flavor appeal. The brand chose to play down the biology lesson and focus on taste to achieve the perfect balance of form and function. The carefully planned rollout took more than a year from focus group to grocery store shelf.

Approach: The packages' principal photography was altered to showcase larger, almost three-dimensional images of mouth-watering fruit combos animated with colorful, hand-scrawled highlights, such as drops of juice and motion lines. The hierarchy of images and information were rejiggered and simplified. The bold "Probiotics" message that got prime, central real estate on old packaging was adjusted to "Probiotic Juice Drink" and isolated in colored text boxes to match each flavor. The package now carries a prescriptive tagline to prompt regular usage in one's regimen: "Drink daily for healthy digestion."

Results: Although, the wider supermarket channel is very recent, consumer reaction has been unanimously positive and sales are on the rise. One major grocery retailer has seen accelerated growth in the last 2+ months vis–à–vis the last 12, 24 or 52 week period, indicating we are on to something.

124 WASATCH BREWERY 12-PACK PACKAGING | Design Firm: Sandstrom Partners
Client: Wasatch Brewery | Designer: Chris Gardiner | Project Manager: Kelly Bohls
Production Designer: Danny Jacobs | Illustrator: Howell Golson
Creative Director: Chris Gardiner | Copywriter: Tom Lux

Assignment: Since 1986, Wasatch Brewery has been known for its playful irreverence towards dominant Utah cultures, whether they be political, cultural, or beer-based. In order to accentuate this irreverent stance, their entire (and sizable) line of craft beers was redesigned.

Approach: Showcased on large fields of black to visually create quiet space on-shelf, this 12-pack uses bold, Utah–centric full–color illustration to grab consumers' attention. Humorous back label and bottom panel copy really helps to amplify the message of the irreverent illustration. Playing card symbols A, K, Q, J and 10 in all four suits are printed on the underside of the bottle caps. A number of bottle cap/card games can be found on the website.

Results: "It's been a whirlwind these last few months, but the results of our investments have blown us away — growth is over 43 percent year to date and that's before all our new packaging is fully implemented!" —Greg Schirf, Wasatch Founding Partner.

125 SHURE UNIDYNE 55 SPECIAL EDITION MICROPHONE PACKAGING
Design Firm: MiresBall | Client: Shure | Designer: Angela Renac | Photographer: Steve Simar
Patner, Creative Director: John Ball | Copywriter: David Fried | Account Director: Holly Houk

Assignment: To commemorate the 75th anniversary of the iconic Unidyne 55 Microphone, Shure produced a limited edition version of the mic, based on the original "fatboy" birdcage design. It thus needed a package to reflect the product's rich history.

Approach: To capture the spirit of the Shure brand, MiresBall took inspiration from archival Unidyne packaging, vintage ads and catalogs. A glossy sleeve carried meticulously detailed photography and the back story of a rich product.

Results: According to Shure sources, the product sold out shortly after release.

126 IVXX | Design Firm: Anthem Worldwid | Client: Terra Tech
Designers: Teresa Diehl, Kimberly Bates, Miri Chan, Sebastian Fraye
Production Specialist: Daryl Buhrman | Design Director: Teresa Diehl
Chief Creative Director: Carl Mazer | Account Director: Bill Larsen

Assignment: Anthem San Francisco was tasked with developing a new, groundbreaking luxury cannabis brand to redefine a highly chaotic and misunderstood category. Partnering closely with the client, Anthem developed a robust program encompassing: brand positioning, tag line, identity system, packaging, structure, collateral, digital, apparel and gear.

Approach: The new name, IVXX, references 420, the widely recognized code for cannabis. Targeting both seasoned connoisseurs and new consumers seeking an elevated cannabis experience, IVXX is positioned around unrivaled purity, authenticity and optimism. Anthem developed the profound tag line, 'Elevate,' which promises the highest quality products and experiences. It's also a call to action. The sophisticated design system features a powerful identity supported by a toolkit of inspiring brand elements, all supporting the brand's positioning. The IVXX symbol is comprised of stylized Roman numerals. The letterforms define an upward 'elevating' arc, while their negative spaces hint of rolled joints.

The lush color palette and system of rich gradients all communicate the various product strains and effects, ranging from the calming and sedative purple for Indica to Sativa's vibrant orange. Positioned to become a lifestyle brand, the design features secondary graphic elements, including a smoke-inspired floral motif and an identity formed wallpaper pattern.

A welcome departure in the category, the custom designed packaging includes sophisticated flower bags, joint tubes and unique silicon concentrate jars, all based on the square geometry of the identity. Anthem also developed graphic product information panels that simply communicate the often-complex facts and attributes associated with each cannabis product.

Results: With the goal of becoming a highly respected national brand, IVXX is just beginning to launch in California. It's already drawing media and consumer attention within the category and beyond. Both products and apparel are flying off the shelves.

127 3D TYPE EXHIBITION | Design Firm: Dankook University | Client: Self-initiated
Designer: Hoon-Dong Chung | Art Director: Hoon-Dong Chung

Assignment: This promotional poster is designed for an experimental project 'Unstable Unity' and used the letters '3D TYPE' in conceptual aspects. The project is continuously focuses on expanding 2D types into 3D environment.

Approach: Transforming 2D types into 3D imagery / Expanding possibilities in Dimensional Typography

Results: This got good reviews on the design field.

128 HOOKED POSTER | Design Firm: Airbnb | Client: Self-initiated
Designer: David Minh Nguyen | Creative Director: Matt Luckhurst

Assignment: This poster was designed for Nir Eyal's talk at Airbnb HQ.

Approach: This poster was meant to reflect elements of Nir Eyal's book "Hooked: How to Build Habit-Forming Products," such as the profile and use of yellow. In his book, the idea of habit-forming products is not meant to be highly profitable commercial products, but products that enhance the well-being of its users. The play of repetition through stripes ending with a gradient illustrate the idea of a habit contributing to the betterment of an individual.

Results: The poster was a striking visual piece that attracted a lot of people to learn more about the talk. A lot of people grabbed posters off the walls soon after the event and Nir requested to keep one too.

129 TO COMMEMORATE THE 400 ANNIVERSARY OF THE SHAKESPEARE THEATRE POSTER | Design Firm: Zibo Industrial Design Co., Ltd.
Client: Shakespeare 400 years of Theatre | Designers: Yang Haibo, Wu keqiang, Wu zhonghao

Assignment: Wu Zhonghao, designer, curator, teacher, master of education psychology. The vision of strategic alliance sponsor / director. AGDIE Asia graphic design exhibition founder / Chief Curator, ICO-D International Graphic Design Council member, America Graphic Designers Association AIGA member, member Chinese Industrial Design Association and interaction design committee, China Packaging Federation national member of Design Committee, "Chinese Design Yearbook" editorial, "APD Asia Pacific Design Yearbook" guest editor. During the 2013 Beijing International Design Week design retrospective, 2013 "China Design Yearbook Vol. ninth" official poster designer, the International Association of graphic design 2013ICO-GRADA 50 anniversary of the establishment of outdoor design exhibition in London only invited Chinese designers, design work has won the Leipzig International Poster Festival Audience Award, the German Political Poster Biennial award etc. honor. 2015 invited to serve as the Italy A International Design Award in visual communication design competition of international judges invited to Spain REGGAEPOSTERCONTEST2015 International Poster Festival International Review, 2015 Mexico Segundallamada International Poster Festival International Review (Ministry of Culture), the China Intangible Cultural Heritage Exhibition Poster contest. Is committed to the exploration and Research on related theory and the effect of design and promotion, management, exhibition and black and white graphics heart.

130 CHENGDU IFS MUSIC FEST POSTER | Design Firm: Wharf China Estates Limited
Client: Chengdu IFS | Designer: Lucas Chan

Assignment: Being one of the highlight events of Chengdu's landmark IFS, IFS Music Fest was a 2-day Rock 'n' Roll fever filled with music, games, cuisine, wine and fun. This poster is dedicatedly designed for communicating this music festival to the public.

Approach: Inspired by the Chinese name of Music Fest '有樂會', which shares the same meaning of 'have a date' in Putonghua pronunciation, the key visual was a illustration of woman and man's holding hands in metallic effect,

not only showing the key message of 'let's have a date!' at a glance, but also expressing a hidden message of connecting the world by Rock 'n' Roll music.
Results: The IFS Music Fest was closed with a overwhelming response from the youths in the Chengdu city, and resulted with a favorite-able exposure in the media coverage and became the talk-of-the-town event in the summer.

131 ART CENTER OPEN HOUSE POSTER | Design Firm: Brad Bartlett Design, LA
Client: Art Center College of Design | Designer: Brad Bartlett
Assignment: Create a poster to announce Art Centers Annual Open House Event.
Approach: The letters "O" and "H" symbolize the opening of a door and the vibrant colors reflect the energy of the creative process.
Results: The event hosted over 700 prospective students and their families.

132 THE MISSING | Design Firm: Starz | Client: Self-initiated
Designers: Kirk Fennel, Barbara Donelan | SVP Creative Advertising: Michael Vamosy
Photo Retouching: Tom Hamilton | Photographer: Robbi Dixon | Creative Director: Kirk Dalton
Art Directors: Kirk Fennel, Barbara Donelan
Assignment: Promote the airing of "The Missing" Series on STARZ.
Approach: Create a piece of art that captures the thrilling, dramatic nature of a father's nearly decade-long search for his 5-year-old son.
Results: The haunting image that plays off every parent's worst fear resonated with the client and was something they felt would attract many TV viewers.

133 AMERICAN HORROR STORY: FREAK SHOW | Design Firm: ARSONAL
Client: FX | Designer: FX/ARSONAL | Photographer: Matthias Clamer
Creative Directors: Stephanie Gibbons, ARSONAL
Art Directors: Todd Heughens, Michael Brittain, ARSONAL
Assignment: American Horror Story was a huge success for FX and they asked us to push the show's brand further with their latest season "Freakshow."
Approach: The title alone gave us a lot of inspiration. So we explored the world of a carnival to create images that were familiar to it, yet odd and creepy.
Results: The campaign got the existing fan base excited, generated some new viewers and helped FX have another successful season.

134 AGM EXHIBITION POSTER 2015 | Design Firm: The White Room Inc.
Client: Art Gallery Of Mississauga | Designers: Neil Rodman, Karolina Loboda
Assignment: Art Gallery Of Mississauga Exhibition poster highlighting the exhibits for 2015 year listed on the back. A portion where folded twice and mailed, while the rest were hung at various locations around Mississauga.
Approach: We evolved the key graphic pattern to include peak through art elements as a teaser for the viewer for the art shows to come.
Results: Applause from the staff and visitors.

135 WARREN MILLER - TICKET TO RIDE | Design Firm: Starz | Client: Self-initiated
Designers: Greg O'Leary, Thomas Papesca | SVP Creative Advertising: Michael Vamosy
Project Manager: Steven Cederberg | Photo Retouching: Tom Hamilton
Photographer: Getty Images/ mmac72 | Creative Directors: Kirk Dalton, Rama Wong
Copywriter: Greg Cotton | Art Director: Ken Burke
Assignment: Create a poster that promotes the airing of Warren Miller's "Ticket to Ride" movie on STARZ.
Approach: To convey the excitement of the extreme skiing and snowboarding featured in the movie with a simple, arresting image that played off the title.
Results: The client got the concept right away and felt it was a strong visual message that'd help them meet their goals.

136 WARREN MILLER'S TICKET TO RIDE | Design Firm: Moxie Sozo
Client: Warren Miller Entertainment | Designer: Laura Kottlowski | Creative Director: Leif Stiener
Art Director: Laura Kottlowski | Photographer: Markus Zimmermann, Brian Nevins, Ilja Herb, Braden Gunem, Matt Powers
Assignment: Design a poster announcing Warren Miller's Ticket To Ride film tour. The film Ticket to Ride highlights an exhilarating worldwide tour of exotic locations with the world's best skiers and snowboarders. The poster should attract attention from far away and close up as marketing for this event is vast and utilizes the poster "as-is" in such collateral as 6x9in mailers and 27x36in window displays. It is important that Warren Miller's logo command attention and all top sponsor logos are featured. Additional information to be included were the CTA "Get Your Tickets Now", website and hashtag. The client also wished to utilize all athlete names and locations if space allowed.
Approach: Our approach was to differentiate from traditional action sport film posters that feature a singular athlete action shot and movie title. Our goal was to engage and inspire the viewer to attend a showing of the movie by giving them a glimpse of the different movie segments, locations, athletes and exude the feeling and energy of the film.
Results: The client was thrilled as this concept told the film story, utilized a lot of their photographic content and featured multiple athletes.

137 JURIED STUDENT SHOW | Design Firm: Randy Clark Graphic Design
Client: Department of Visual Arts/South Dakota State University
Designer: Randy Clark | Department Chair: Timothy Steele
Assignment: Poster announcing call for entries into the annual student show
Approach: Use an unconventional approach to poster making
Results: Many of the students submitted work for a great show turnout

138 FILLMORE JAZZ SINGER | Design Firm: Michael Schwab Studio
Client: Fillmore Jazz Festival | Designer: Michael Schwab
Assignment: Michael Schwab Studio was commissioned to created exciting street banners announcing the annual Fillmore Jazz Festival.
Approach: We wanted to evoke the proud history of this San Francisco neighborhood and it's jazz heritage, dating back to the 1920's. We created a series of poster prints to help celebrate the event along with the street banners.
Results: The banners are flying up and down Fillmore Street adding festive color, excitement and local pride for this neighborhood celebration.

139, 140 THE SCIENTIFIC METHOD | Design Firm: John Gravdahl Design
Client: Colorado State University | Designer: John Gravdahl
Assignment: Design a four-part mural/poster series for the Office of the Vice President of Research at Colorado State University, Fort Collins.
Approach: I was commissioned to create image content about the overlapping goals of scientific and creative research at Colorado State University. I chose steps in the Scientific Method to best display this synergy: Inquire, Experiment, Analyze, Communicate.
Results: The "Research Wall" was installed for permanent display at the Lory Student Center at Colorado State University. Posters and collateral items were produced for public sale.

141 ALVIMEDICA POSTER | Design Firm: Vanderbyl Design | Client: Alvimedica
Designers: Michael Vanderbyl, Malin Reedijk | Creative Director: Michael Vanderbyl
Art Director: Michael Vanderbyl
Approach: Commemorative poster for Volvo Ocean Race.

142 TIME FOR YOURSELF | Design Firm: Michael Schwab Studio
Client: Peet's Coffee & Tea | Designer: Michael Schwab
Assignment: Peet's Coffee & Tea commissioned Michael to create a series of large format poster prints for the new store interior walls.
Approach: We redesigned an existing graphic portrait that Michael had created many years ago evoking a calm moment of reflection and re-sized it as a large, horizontal print. These large sweeping prints have become a integral part of the new Peet's interiors.
Results: They have continued to order more of these large graphic prints for all of the stores across the U.S.

142 SAN ANSELMO LIBRARY POSTER | Design Firm: Michael Schwab Studio
Client: San Anselmo Library | Designer: Michael Schwab
Assignment: To commemorate the centennial of the historic Carnegie Library, the town of San Anselmo wanted street banners to announce the celebration.
Approach: We created a timeless design that reflected the era. In addition to the banners, we created this limited edition of 100 signed and numbered prints commemorating this historic occasion.
Results: The town folks were very happy with the designs which helped to spread the word about this local celebration.

143 AAF OMAHA AD WARS POSTER | Design Firm: Webster | Client: AAF Omaha
Designer: Sean Heisler | Writer: Jason Fox | Creative Director: Dave Webster
Assignment: Design a poster promoting the AAF Omaha Ad Wars event.
Approach: A clean modern, engaging illustration play of medieval imagery.
Results: It was received well. The design and printing techniques were engaging.

144, 145 THÉÂTRE DE QUAT'SOUS 2014-2015 SEASON / POSTERS
Design Firm: lg2boutique | Clients: Théâtre de Quat'Sous, Éric Jean, Sophie de Lamirande
Designer: Claude Auchu | Strategy & Naming: Sabrina Côté (lg2)
Photographer: Pierre Manning (Shoot Studio) | Creative Director: Claude Auchu
Copywriter: Jean-François Perreault (lg2) | Computer Graphics: Maxime David
Account Executive: Noémie Martin | Account Director: Natacha Laflamme
Assignment: Presenting the characters of a variety of plays, the symbol of the 4, a key element of the Quat'Sous identity, takes centre stage in this new campaign for the 2014-2015 season, deployed in wild postings and integrated on the Web. The concept presents life-sized characters that literally come right out of the frame to surprise passers-by. The wild postings are designed to have an urban look and harmonize with the environment in which they are found. The posters showcase not only the inner emotions of the characters, but also the dynamic use of each poster's location.

146 PREVENTIVE WAR | Design Firm: Sergio Olivotti
Client: Spontaneous protest movement | Designer: Sergio Olivotti
Assignment: It was a poster against Wars and their specious reasons.
The attitude is the first step. shaking hands fraternally is the first step for peace and mutual respect : stop preventitive war!

147 THE GENE SISKEL FILM CENTER POSTER INVITATION | Design Firm: VSA Partners
Client: Gene Siskel Film Center | Designer: Chris Marino | Project Manager: Luise Barnikel
Creative Director: Jamie Koval
Assignment: To create an invitation that elevates this specific event and the mission of The Gene Siskel Film Center.
Approach: The invite concept was to be striking: It's exciting to unfold and read, and pays tribute to Morgan Freeman as one of the most recognizable figures in American cinema. In a format that portrays Freeman as literally larger than life, this design illustrates the depth and elegance of his career while paying homage to the motion of film.
Results: "We have received an overwhelmingly positive response on the invitation, [which] has exceeded all of our expectations," said Jean de St. Aubin, Executive Director of the Gene Siskel Film Center. "As Chicago's premier movie theater, it is important that our materials reflect the same high standard that we put into our film programming and presentation. VSA not only created a design that mirrors Morgan Freeman's larger than life talent but also were extremely pleasant and organized to work with."

148 TERMS AND VISUALS | Design Firm: Konstantin Eremenko | Designer: Konstantin Eremenko
Client: FHNW HGK Visual Communication Institute, Basel School of Design
Assignment: Poster for the course "Term and Visuals" at FHNW HGK Visual Communication Institute, Basel School of Design.
Approach: This project based on negative and positive approaches for making a structure with different types and hierarchical layers of information. Crucial point is relationship between foreground and background, intersection and penetration, overflow and switching one form to another forming a game of spaces on a surface.
Results: Final version printed by silkscreen with white colour on black paper.

149, 150 THE BLACK REP CAMPAIGN | Design Firm: Rodgers Townsend DDB
Client: The Black Rep | Designer: Danny Mehl | Production Artist: Evan Willnow
Production: Cheryl Sparks | Creative Director: Erik Mathre | Copywriter: Erik Mathre
Account Supervisor: Tracy Sykes-Long

Assignment: The Black Rep, considered the largest African American theater company in the nation, moved into its 38th season without a physical home and in dire need of maintaining organizational support from its primary subscribers. The client asked us to develop posters that would resonate with their primary subscriber base and drive new ticket sales.
Approach: We designed powerful, illustrative posters using a collage of high-contrast, black and white photography. We used key visual elements and metaphors in the artwork, inspired by the core essence of each play. While each play's storyline varied, our approach gave the season a cohesive visual synergy.
Results: The season is now in full swing and has garnered sold out shows and rave reviews of the artwork, which is being used on playbills, take-one postcards and the website, in addition to the posters.

151 STARLIGHT MUSIC SERIES | Design Firm: Pentagram | Client: Tishman Speyer
Designers: Michael Gericke, Matt McInerney, Kelly Sung, Min Ji Lee
Art Director: Michael Gericke

Assignment: The Starlight Music Series campaign for the Rockefeller Center celebrates a once-a-year event at the Top of the Rock observation deck where musicians play music up on the sky deck at night.
Approach: To celebrate and drum up excitement for the event, the campaign plays off two elements: the 30 Rock Building Graphic, which is a common motif in the Rockefeller Center's marketing material, and a musical element, in this case, a microphone. We connected these two shapes to "play" off one another. Set against a dramatic, black background, the graphic shapes take on the magical character of a nighttime event. Stars twinkle in the background, reminding the viewer that the event will be high up in the sky.
Results: The client was pleased with the campaign, which was printed in New York print magazines, and posted in the Rockefeller Center plaza. Set against the multi-colored plaza, the simple, arresting design and colors capture one's attention and curiosity, and draw in the viewer to learn more about the event.

152 ULTRA FLEX MESH SERIES | Design Firm: Kojima Design Office Inc.
Client: Okada Medical Supply co.,ltd. | Designer: Toshiyuki Kojima
Photographer: Takashi Mochizuki | Artist: Atsushi Toyoshima
Art Director: Toshiyuki Kojima

Assignment: Sales promotion posters. (ULTRA FLEX MESH Series is medical treatment material of dental surgery.)

153, 154 TOP OF THE ROCK, ANY POINT OF VIEW CAMPAIGN | Design Firm: Pentagram
Client: Tishman Speyer | Designers: Michael Gericke, Matt McInerney, Kelly Sung, Min Ji Lee
Art Director: Michael Gericke

Assignment: The series celebrates Top of the Rock's spectacular views, of Manhattan and beyond, from the summit of 30 Rockefeller Center. To capture the extraordinary moment when you step out onto the observation deck, dramatic and expansive panoramic vistas are paired with detailed neighborhood close ups—echoing the range of experiences a visitor will encounter at Top of the Rock.
Approach: In 2015, we updated the bold and elegant advertising campaign and graphic program that was designed for Top of the Rock in 2013, the campaign that highlights the one-of-a-kind vista seen from its observation deck with a fresh take on the original design. To emphasize the breathtaking moment you step out onto the Top of the Rock deck, we updated the visual on the original, stunning campaign design. The ad features two different views, one a vast panorama, and one a zoomed-in detail of the city. The reduction in panels simplifies the previous design, and emphasizes the fullness of the view, maintaining the quality of seeing the New York skyline many times of day. The ad also capitalizes on new photographs, giving people a glimpse of a more exquisite view of the city than they have experienced before.
Results: The updated campaign was very well received. The client was especially eager to promote it in New York's three main airports—JFK, La Guardia, and Newark—to pique the interests of those coming into the city, eager to begin their New York experience.

155 TAIPEI SOUTH TOWN ART FESTIVAL 2014 ;THE CONTEMPORARY ART OF CHINESE CHARACTERS | Design Firm: Ken-Tasi Lee Design Lab/Taiwan Tech
Client: The General Association of Chinese Culture,GACC | Designer: Ken-Tasi Lee

156, 157 ZOOPORTER | Design Firm: Agent | Client: Omaha Zoo Foundation
Designers: James Strange, Ryan Choi, Jared Rawlings | Creative Directors: James Strange, Raleigh Drennon | Writer: Raleigh Drennon | Photographer: Joel Sartore
Art Directors: James Strange, Jared Rawlings | Account Manager: Elise Hernandez
Account Director: Monte Olson

Assignment: Create a stirring, highly sharable campaign idea for the Omaha Zoo Foundation's patron membership program.
Approach: Omaha's Henry Doorly & Aquarium is a point of pride for all Nebraskans, so we decided to offer Nebraskans the chance to become supporters – or zooporters, if you will – for their zoo and their community.
Results: Donations are rolling in. The client loves it.

158 COLLEGE FOOTBALL PLAYOFF TROPHY | Design Firm: Pentagram
Client: College Football Playoff | Designer: Michael Gericke, Matt McInerney
Art Director: Michael Gericke

Assignment: Ohio State triumphed over Oregon 42-20 to win the inaugural College Football Playoff National Championship game at AT&T Stadium in Arlington, Texas. Watched by a capacity crowd of 85,689 in the stands and a cable television record of 33.4 million viewers—ESPN's largest audience and highest overnight rating ever—the game represented a stunning success for the new era in college football. A visual identity and iconic trophy were created to build the foundation for the new four-team playoff and raise its profile in the national conversation. The designs were fundamental elements in shaping every aspect of a mega sports event.
Approach: Sleek and contemporary, the 24-karat gold, bronze and stainless steel trophy was a key symbol of the National Championship. The trophy and symbol's two rising brackets represent the coming together of the best teams in the playoff system and form the shape of a virtual football—the four laces of the ball portray the four playoff teams.
Results: The identity and trophy images were ever-present at the championship game. Bold environmental graphics include an eight-story-high "2015" wordmark on the façades of AT&T Stadium and supersize CFP and 2015 Championship logos on the field.

159 PHOENIX ADDY'S WINNER BELTS | Design Firm: Kitchen Sink Studios
Client: Phoenix ADDY Awards | Designer: Jason Johnson | Producer: Sebastian Sandersius
Creative Director: Doug Bell

Assignment: Based on our winning work from the previous year, the Phoenix AdClub asked Kitchen Sink Studios to concept and design the theme for the 2015 Phoenix ADDY Awards.
Approach: The venue where the Phoenix ADDYs is annually held, the Duce, is home to a full-size boxing ring. We built the concept around a creative bout, using the boxing ring as the focal point of this year's event. All of the materials, including banners, signage, winner's book and trophies, were designed around a "gentlemanly brawl aesthetic".
Results: The ADDYs were sold out this year and the popularity of this year's event was high. By partnering with local craftsman, including a custom leather company and a custom metal dye company, we were able to create one-of-a-kind trophies handcrafted to the likeness of vintage championship belts. The response to the custom trophy belts from other agencies and the top award winners has been overwhelming. The craftsmanship and quality were unlike any award they had seen previously.

160, 161, 162 VISUAL IDENTITY OF TAIWAN DESIGNERS' WEEK 2014
Design Firm: Ken-Tasi Lee Design Lab/Taiwan Tech | Client: Taiwan Designers' Web
Designer: Ken-Tsai Lee

163 CHEERS TO 21 YEARS PINT GLASS | Design Firm: Iron Design
Client: Self-initiated | Designer: Kim White

Assignment: Cheers to 21 Years is our theme to celebrate our 21st anniversary. Our small, down-to-earth studio wanted to announce our anniversary in a memorable and casual way, and allow our friends and family to celebrate with us. We also wanted our announcement to be something that was not disposable, but a keepsake that would appeal to a wide variety of friends and clients.
Approach: Traditionally, business' celebrate milestones like their 10th, 20th, and 50th year anniversary, but what fun is that? In our society, turning 21 represents reaching the age of becoming a fully responsible adult, and being able to enjoy all that the world has to offer. Not to mention that it is the number of the institutional amendment that ended prohibition, allowing a countless number of amazing breweries to pop up all over the U.S., creating the need for a great pint glass in which to pour their beer. To drink out of our "21st" pint glass is to celebrate all of these things: creativity and exploration, and the award-winning success that we are so grateful to celebrate.
Results: Recipients of our anniversary announcement piece have been surprised to receive an edgy black, mystery box in the mail. Interacting with its various stages of opening, they are guaranteed to recognize the Iron brand, and unmask a brightly wrapped pint glass hidden under a blanket of additional black wrapping. The feedback we have receive so far on this piece shows high praise for our sensible packaging design, has served as a great means of reconnecting with our community, and also with our past and present clients.

164, 165 YOUTUBE PULSE CAMPAIGN | Design Firm: Underline Studio
Client: Google Canada | Designer: Clea Forkert | Typographer: Clea Forkert
Printer: Flash Reproductions Ltd. | Creative Directors: Fidel Peña, Claire Dawson

Assignment: Google Canada was hosting an event called YouTube Pulse, aimed at Media Buyers and Creative Directors in Toronto to highlight the advantages of advertising in YouTube over traditional mediums such as television. Labeled, the New Prime Time, these materials needed to communicate the premium quality of this medium to a highly visually literate audience.
Approach: Underline, in collaboration with Google Canada's Marketing Team, came up with a visual approach that would portray the personality behind the personas of some of YouTube's top creators. Working with photographer Michael Graydon and stylist Nikole Herriott, and developing a custom typeface for the event materials we created a entire visual language that challenges the conventional notions of YouTube programming and content.
Results: The event was a complete success, with media buyers and creative directors in Toronto and other cities requesting copies of the look books. Only days after the launch of the campaign social media has already caught with the campaign's look. We'll receive more sales results in the coming months.

166, 167 STONES THROW BRAND DEVELOPMENT | Design Firm: UNIT partners
Client: Hi Neighbor | Designers: Catherine Dimalla, Ann Jordan, Shardul Kiri
Creative Directors: Ann Jordan, Shardul Kiri

Assignment: The Hi Neighbor hospitality group came to UNIT to brand their inaugural restaurant. The objective was to integrate within San Francisco's Russian Hill neighborhood, a quiet neighborhood with predominantly older residents, while appealing to the younger tech audience infiltrating the neighborhood.
Approach: UNIT developed the tagline, inspired fare and spirited cheer, to encapsulate the restaurants goal of becoming a vibrant and lively scene paired with great food and tall pours. Drawing inspiration from "killing two birds with one stone" UNIT was able to encapsulate the name and experience

into one succinct visual. The logo features two dead sparrows in a tattoo illustration style to play up the irreverent nature of the restaurant team. The brand extension straddles the playful wit of the identity with traditional design queues that nestle into the established neighborhood.
Results: The restaurant opened with a bang, paying out its investors within a year (nearly unheard of). It's been consistently rated as a must dine location within San Francisco. And the bathroom signage is a social media hit, repeatedly featured on the guests' Instagram feeds.

168 ART SERIES HOTEL GROUP WEBSITE | Design Firm: Toben | Digital partner: Carter
Client: Art Series Hotel Group | Designers: Katja Hartung, Thorsten Kulp
Assignment: The Art Series Hotel Group is an umbrella brand for a multitude of 5 and 4-star boutique art hotels. Each is inspired by and dedicated to an Australian contemporary artist, with a hotel experience and brand to match. They required an innovative and visually engaging website – a web portal that leads customers across the different hotel offering, whilst showcasing their hotel brands and contents in much depth. The site had to be in line with the brand, highly aesthetic, buzzing and engaging, with a focus on the art experience, and user-friendly. The ASHG website needed to house all contents in CMS and SEO friendly format, be responsive, and quickly adaptable to facilitate the company's growth. Toben was asked to design the new site. We assisted UX and AI decisions, and designed the site's interface from layouts to responsive systems, global navigation and style guides.
Approach: Our objective was to create a system that could host the in-depth contents across a realm of six separate brands. We opted for an editorial look and feel that embraced the activities, activations, news and 'buzz' around the hotels in a clean contemporary format. Embracing the contents was important, to ensure that the brand could come to life through its ongoing media, activity and guest experiences more-so than singular high-end photography. The reduced editorial aesthetic created room for the individual hotel brands to shine through. The menu design was a true challenge in making the complex elegant and functional. To allow for an easy access to all levels of the group's offering, an additional navigation of three levels was needed: the hotel contents, access to other hotels and global group offerings. We designed a triple accordion navigation that structure a complex pathways in a clear way – non-intrusive, easy to understand, and intuitive to use without appearing overly complex.
Results: "We're really thrilled with the result and comments back from the wider community have been really positive. Thanks all for you help and guidance over the last three months."

169 IF STUDIO WEBSITE | Design Firm: IF Studio | Client: Self-initiated
Web Developer: Sung Yong Kim | Web Designer: Sung Yong Kim
Photographers: Michael Imlay, Kumiko Ide, Henry Leutwyler | Illustrator: Tara Hardy
Designers: Toshiaki Ide, Hisa Ide | Creative Director: Toshiaki Ide

GRAPHIS SILVER WINNERS:

172 OZHARVEST ANNUAL REPORT | Design Firm: Frost*collective
Client: OzHarvest | Executive Creative Director: Vince Frost | Designer: Ryan Curtis
Account Director: Jarred Katzenberg

173 PROGRESSIVE CORPORATION 2014 ANNUAL REPORT
Design Firm: Nesnadny + Schwartz | Client: The Progressive Corporation
Writer: Glenn Renwick | Photographer: Lee Friedlander | Interactive Designer: Shawn Beatty
Creative Director: Michelle Moehler | Designers: Shawn Beatty, Keith Pishney, Michelle Moehler

173 FOOTBALL EXTRA | Design Firm: Next Brand Strategy & Design
Client: Football Federation of Victoria | Designer: David Eynaud | Creative Director: Lee Selsick

174 COLLEGE FOOTBALL PLAYOFF TROPHY | Design Firm: Pentagram
Client: College Football Playoff | Designers: Michael Gericke, Matt McInerney
Art Director: Michael Gericke

175 IMBELNHI'S BESTIARY | Design Firm: 21XDESIGN | Client: Flying Nightbear Games
Editor: Judy Schatz | Creative Director: Patricia McElroy | Author: Caleb McEntire
Designers: Patricia McElroy, Dermot MacCormack, Mitzie Testani, John Kutlu,
Anthony DeLuca, Mary Claire Cruz, Kristen McCann | Illustrators: Alison Blackwell,
Chris McInerney, Rob Rey, Jesse Thompson, and Cory Turner, John Kutlu
Contributor: Robin McEntire, Jordan Campbell, Simon McEntire

176 REDISCOVERING | Design Firm: Konstantin Eremenko | Designer: Konstantin Eremenko
Client: FHNW HGK Visual Communication Institute, Basel School of Design

176 FESTIN DE BABETTE / BOOK | Design Firm: lg2boutique
Client: Communications Johanne Demers | Designer: Jean-Philippe Dugal, David Kessous
Print Producer: lg2fabrique | Photographer: Luc Robitaille | Creative Director: Claude Auchu
Copywriters: Marie-Ève Leclerc-Dion, Pierre Lussier | Art Director: Jean-Philippe Dugal
Account Executives: Thalie Poulin, Marion Haimon

177 CENTER 18: MUSIC IN ARCHITECTURE/ARCHITECTURE IN MUSIC
Design Firm: Dyal and Partners | Client: The University of Texas School of Architecture
Designer: Dyal and Partners

177 FREUNDSCHAFT/PAGKAKAIBIGAN (60 YEARS OF FRIENDSHIP BETWEEN GERMANY AND THE PHILIPPINES) | Design Firm: Studio 5 Designs, Inc. (Manila)
Client: Philippine Embassy in Germany | Designer: BG Hernandez | Illustrator: Ermil Carranza
Editor-in-Chief: Dr. Isagani Cruz | Assistant Account Executive: Jay Bautista
Account Supervisor: Marily Orosa

177 THE WOMAN WHO READ TOO MUCH | Design Firm: Anne Jordan and Mitch Goldstein
/ www.annatype.com | Client: Stanford University Press
Designers: Anne Jordan and Mitch Goldstein | Art Director: Rob Ehle

177 MICHAEL ARNDT | Design Firm: animalopoeia | Client: Chronicle Books
Designers: Michael Arndt, Amy Yu Gray

177 CONVULSING BODIES | Design Firm: Anne Jordan and Mitch Goldstein
/ www.annatype.com | Art Director: Rob Ehle | Client: Stanford University Press
Designers: Anne Jordan and Mitch Goldstein

177 E100 CHARTER DIRECTORY | Design Firm: Steven Taylor Associates
Client: Edmiston | Designers: Steven Taylor and Cos Iacovou

178 LAUMEIER SCULPTURE PARK MOUND CITY BOOK | Design Firm: TOKY
Client: Laumeier Sculpture Park | Designers: Kelcey Towell, Liz Mohl
Executive Creative Director: Eric Thoelke | Editor: Marilu Knode

178 AKZONOBEL BRAND BOOK | Design Firm: AkzoNobel
Client: Self-initiated | Designers: Caroline Meads
Head of Design; Design Team: Floor Gianotten, Claire Jean Engelmann; John O'Neill

179 TASMEEM 2015: 3AJEEB! | Design Firm: Arcadian Studio
Client: Virginia Commonwealth University in Qatar | Designer: Nathan Ross Davis

179 SPEED & POWER PRESENTED BY THE BIZHUB 2250P
Design Firm: Studio C, Creative Consultants | Client: Konica Minolta Business Solutions, USA
Designers: C. Horosz, K. Levy

180 RAINBOW ROOM IDENTITY | Design Firm: Pentagram | Client: Rainbow Room
Photographer: Martin Seck | Art Director: Michael Gericke
Designers: Michael Gericke, Don Bilodeau, Matt McInerney, Beth Gotham

181 NEXT 2015 EXHIBITION BRANDING PROGRAM | Design Firm: Corcoran Design Lab
Client: Corcoran School of the Arts & Design at the George Washington University
Corcoran Design Lab | Creative Director: Francheska Guerrero
Designers: Lucien Liz-Lepiorz, Grace Boyle, Anders Larsson, Nora Mosley, David Hodgson,
Francheska Guerrero | Production Managers & Designers: David Hodgson, Nora Mosley
Wordmark, website, app, interior wayfinding signs: Lucien Liz-Lepiorz
Exterior banners and signage: Lucien Liz-Lepiorz, Francheska Guerrero
Print invitation: Lucien Liz-Lepiorz, Anders Larsson | Electronic invitation: Grace Boyle
Animation and video production: Grace Boyle | Gallery guide and table centerpiece: Grace Boyle
Merchandise: t-shirts, stickers, buttons: Grace Boyle | Interior wall graphics and banners:
Anders Larsson | Desig Lab retrospective: Anders Larsson, Grace Boyle
Posters: Grace Boyle, Anders Larsson | Print and electronic advertisements: David Hodgson,
Nora Mosley | Exhibition Photography: Denny Henry
Overhead interior signage: Francheska Guerrero | Marketing: Denise St.Ours, Fabiola Joubert,
Adrian Parsons, GW Corcoran Marketing | Student Photography: William Atkins, Denny Henry
Videography: Lesley Grier, GWU Creative Services

181 TOUS DEBOUT POUR NOS P'TITS LOUPS / BRANDING | Design Firm: lg2boutique
Client: Communications Johanne Demers | Designer: Cindy Goulet | Print Producer: lg2fabrique
Photographer: Luc Robitaille | Creative Director: Claude Auchu | Account Director: Catherine Lanctôt
Copywriters: Gilles Chouinard, Geneviève Jannelle (lg2) | Account Executive: Marion Haimon

182 CORPORATE LOGO DESIGN IKIAM | Design Firm: ÁNIMA
Client: IKIAM, Universidad Regional Amazónica | Designer: Pablo Iturralde

182 COLLEGE FOOTBALL PLAYOFF IDENTITY | Design Firm: Pentagram
Client: College Football Playoff | Designers: Michael Gericke, Matt McInerney
Photographer: Kevin Jairaj | Art Director: Michael Gericke

182 HENDERIK & CO. BRAND IDENTITY | Design Firm: Concrete Design Communications
Client: Henderik & Co. | Designer: Thomas Van Ryzewyk
Creative Director: John Pylypczak, Diti Katona

182 SAGA KAKALA BRAND | Design Firms: Karousel, karlssonwilker | Client: Saga Kakala
Designer: Maria Ericsdóttir | Artist: Helga Björnsson

182 CREATIVE ART WORKS IDENTITY | Design Firm: Lippincott | Client: Creative Art Works
Designers: Imri Larsen, Connie Birdsall, Connie Birdsall, Elena Gil-Chang, Leonard Barszap,
Chet Purtilar, Liz Mamey | Strategy & Namings: Katie Danon, Catherine Roedel, Wendy Tsang,
Emily Guilmette, Melanie Shor | Productions: Jeff Cross, Jeremy Darty, Brendan deVallance,
Luis Vieira | Photographers: Lippincott, Creative Art Works
Creative Directors: Brendán Murphy, Connie Birdsall

182 MOROSO LOVES LONDON | Design Firm: SVIDesign Ltd | Client: Moroso
Designer: Sasha Vidakovic

183 PAUL & BABE CYCLING CLUB | Design Firm: Target Creative
Client: Self-initiated | Designer: Target Creative

183 MATSU MATSUMOTO (JAPANESE CUISINE RESTAURANT) LOGO
Design Firm: beacon communications k.k. graphic studio | Client: Matsu Matsumoto
Designers: Yusuke Sano, Takashi Kaneko, Chie Arakawa | Project Manager: Noritsugu Endo
Creative Director: Mayumi Kato | Art Director: Takashi Kaneko

183 +RING | Design Firm: omdr Co.,Ltd. | Client: TAIYO KIKAKU Co.,Ltd. | Designer: Osamu Misawa

183 LE QUARTIER BAKERY & CAFÉ IDENTITY | Design Firm: Agent
Client: Le Quartier Bakery & Café | Designer: James Strange | Writer: Raleigh Drennon
Creative Directors: James Strange, Raleigh Drennon | Account Manager: Elise Hernandez

184 BURGER RADIO FOOD TRUCK BRAND IDENTITY DESIGN | Design Firm: Vigor
Client: Burger Radio / David Levine | Designer: Joseph Szala

184 MS2 / BRANDING | Design Firm: lg2boutique | Client: MS2 | Designer: Claude Auchu,
Sophie Valentine, Julie Gélinas | Creative Director: Claude Auchu

184 CARLA HALL BRAND IDENTITY | Design Firm: The General Design Co.
Client: Carla Hall | Designers: Carrie Brickell, Soung Wiser | Production: Matthew Batista
Photographers: Greg Powers, Matthew Batista | Creative Director: Soung Wiser

184 MACK TRUCKS BRANDING | Design Firm: VSA Partners
Client: Mack Trucks | Designers: Matt Ganser, Todd-Piper Hauswirth, Ian Koenig, Collin Hall

184 NEW CITY IDENTITY FOR PORTO, PORTUGAL | Design Firm: White Studio
Client: City Hall of Porto, Portugal | Art Director: Eduardo Aires
Designers: Eduardo Aires, Ana Simões, Raquel Rei, Lucille Queriaud, Joana Mendes,
Maria Sousa, Dário Cannatà, Tiago Campeã | Photographer: Alexandre Delmar

184 SOUTHWEST AIRLINES IDENTITY | Design Firm: Lippincott
Client: Southwest Airlines | Designers: Rodney Abbot, Sam Ayling, Jung Kwon, Mike Sloan,
Leonor Montes de Oca | Strategy & Namings: Steve Lawrence, Hilary Folger, Jake Hancock,
Amaka Nneji, Adela Jaffe | Productions: Jeremy Darty, Jeanine Colgan | Ad Agency: GSD&M
Photographers: Lippincott, Southwest Airlines, Esto Photographics, Travis Rathbone Studio
Digital Art & Multimedia: Razorfish | Creative Directors: Rodney Abbot

185 AGRICOLE GUSSALLI BERETTA | Design Firm: Raineri Design Srl
Client: Agricole Gussalli Beretta | Designer: William Raineri

185 QUEEN SONJA PRINT AWARD | Design Firm: Kitchen Leo Burnett
Client: The Royal House of Norway | Designer: Marianne Sæther
Art Directors: Torkel Bjørnstad Sveen, Marianne Sæther | Account Managers: Ellen Sørnes,
Suzanne Lorck | Account Director: Rune Roalsvig

185 AN 'A' FOR EVERY EXPERIENCE | Design Firm: Landor
Client: Cinnamon Hotels & Resorts | Senior Designers: Aarti Darware, Hiren Dedhia
Production Artist: Yogesh Rai | Creative Director: Ektaa Aggarwal

185 LORTON BRAND IDENTITY | Design Firm: Brand & Deliver | Client: Lorton
Designer: Rob Pratt | Music & Sound: Joel Evenden | Design Director: Rob Pratt
Creative Director: Ben Gallop | Animator: Nick Wood

185 BALDORIA | Design Firm: Another Collective | Client: Baldoria – Garrafeira x Bar
Designers: Bruno Soares, Eduardo Rodrigues, Paulo Portela, Beatriz Barros, Rui Canedo

185 BRIGADE IDENTITY | Design Firm: BRIGADE | Client: Self-initiated
Designers: Dave Grasso, Joe Marden | Creative Director: Kirsten Modestow

186 ASAHI KINDERGARTEN BRAND DEVELOPMENT BOOK (A GREAT EAST JAPAN EARTHQUAKE RECONSTRUCTION SUPPORT PROJECT)
Design Firm: beacon communications k.k. graphic studio | Client: Asahi Kindergarten
Designers: Takashi Kaneko, Misako Maruyama, Noritsugu Endo | Art Director: Mayumi Kato

186 AUDI A3 BROCHURE | Design Firm: designory. | Client: Audi USA
Designers: Fakih Amin, Hera Cheung | Project Managers: Alan Louie, Crystal Gilbert
Programmer: Kurt Renfro | Print Production: Kurt Renfro | Editor: Jay Brida
Copywriter: Kit Smith | Artists: Fakih Amin, Hera Cheung, Wil Conerly
Art Directors: Ulrich Lange, Kathy Chia Cherico | Account Director: Chris Vournakis

186 KREKOW JENNINGS BROCHURE | Design Firm: Sandstrom Partners
Client: Krekow Jennings | Designers: Steve Sandstrom, Danny Jacobs | Copywriter: Jim Carey
Project Manager: Kay Zerr | Printer: Premier Press | Illustrator: Dave Plunkert

186 JANUS ET CIE: THE MASTERS ALUMINUM SERIES | Design Firm: Vanderbyl Design
Client: JANUS et Cie | Designers: Michael Vanderbyl, Malin Reedijk | Art Director: Michael Vanderbyl
Photographer: David Peterson | Creative Director: Michael Vanderbyl

186 SAVANNAH FILM FESTIVAL POCKET GUIDE COVER
Design Firm: Savannah College of Art and Design | Client: Self-initiated
Designer: Savannah College of Art and Design

187 2015 CALENDAR POSTER | Design Firm: Apatitex | Client: Self-initiated | Designer: Joe Chau

187 LUCHA LIBRE | Design Firm: Odear | Client: Zetatrade
Designers: Karl-Magnus Boske, Thomas Palmbäck

187 THE SHAPE OF JAPAN -BOUNDARY- | Design Firm: TOPPAN PRINTING CO., LTD.
Client: Obayashi Corporation | Designer: Masahiro Aoyagi | Photographer: Sadao HIbi
Art Directors: Masahiro Aoyagi, Maho Shimada

187 SÁIT | Design Firm: TOPPAN PRINTING CO., LTD.
Client: Toyo Ink SC Holdings, Co. Ltd. | Designer: Masahiro Ogawa
Photographer: Michael Benson | Art Director: Maho Shimada

188 BLACK SWAN STATE THEATRE 2015 SUBSCRIPTION CATALOGUE
Design Firm: Dessein | Client: Black Swan State Theatre | Art Director: Geoff Bickford
Designers: Esther Lee, Geoff Bickford | Photographer: Robert Frith

188 SUR LA TABLE CATALOGS | Design Firm: Sur La Table Creative Department
Client: Self-initiated | Designers: Naomi Parker, Dean Fuller
Illustrators: Dean Fuller, Naomi Parker | Creative Director: Robb Ginter
Copywriter: Jon Decker | Art Directors: Dean Fuller, Sarah Hunter

188 IN DIALOGUE | Design Firm: Level Design Group
Client: Pratt Graduate Communications & Package Design, Pratt Institute
Designers: Jennifer Bernstein, Sarah Bradford, Kristen Myers, Eduardo Palma, Robert Wilson
Printer: Oddi Printing, Iceland | Editorial Advisor: Alan Rapp
Department Chair: Santiago Piedrafita | Creative Directors: Jennifer Bernstein,
Visiting Associate Professor Pratt GradComD / Principal, Level Design Group

188 KEILHAUER AND EOOS 15 YEARS | Design Firm: Concrete Design Communications
Client: Keilhauer | Creative Directors: John Pylypczak, Diti Katona
Designer: Matthew Boyd | Writer: James Grainger | Photographer: Colin Faulkner

189 THE OTHER SHORE | Design Firm: Counterform studio
Client: Galleri Image | Designer: Konstantin Eremenko

190 BEARD ME! | Design Firm: GQ | Client: Self-initiated
Designer: Martin Salazar | Design Director: Fred Woodward

190 FRED WOODWARD | Design Firm: GQ | Client: Self-initiated | Designer: John Munoz

190 "SON, MEN DON'T GET RAPED" | Design Firm: GQ
Client: Self-initiated | Designer: Andre Jointe

191 NEW FACE | Design Firm: GQ | Client: Self-initiated
Designer: Chelsea Cardinal | Design Director: Fred Woodward

191 BROOKLYN'S BADDEST | Design Firm: GQ | Client: Self-initiated
Designer: Benjamin Bours | Design Director: Fred Woodward

191 CHEEKY GENIUS | Design Firm: GQ | Client: Self-initiated
Designer: Benjamin Bours | Design Director: Fred Woodward

192 LMU MAGAZINE [WINTER 2015] | Design Firm: Pentagram
Client: Loyola Marymount University | Designer: Barrett Fry

192 WORLD WILDLIFE MAGAZINE [SPRING 2015] | Design Firm: Pentagram
Client: World Wildlife Fund | Designer: Carla Delgado | Art Director: DJ Stout

192 GEORGIA TECH RESEARCH HORIZONS | Design Firm: Pentagram
Client: Georgia Tech | Designer: Stu Taylor | Art Director: DJ Stout

193 THE MUSEUM OF FINE ARTS, HOUSTON MAGAZINE [WATER]
Design Firm: Pentagram | Client: The Museum of Fine Arts, Houston
Designer: Carla Delgado | Art Director: DJ Stout

193 PRINT MAGAZINE 75TH ANNIVERSARY COMMEMORATIVE ARTWORK
Design Firm: Morla Design | Client: Print Magazine | Designers: Jennifer Morla, Reymundo Perez III

194 SPACE AGE | Design Firm: McCandliss and Campbell
Client: Earshaw's magazine | Designers: Trevett McCandliss, Nancy Campbell

194 ROYAL REBELS | Design Firm: McCandliss and Campbell | Art Director: Tim Jones
Client: Earshaw's magazine | Designers: Nancy Campbell, Trevett McCandliss
Photographer: Trevett McCandliss | Creative Directors: Nancy Campbell, Trevett McCandliss

194 WORK HISTORY | Design Firm: McCandliss and Campbell | Art Director: Tim Jones
Client: Footwear Plus magazine | Designers: Nancy Campbell, Trevett McCandliss
Photographer: Trevett McCandliss | Creative Directors: Nancy Campbell, Trevett McCandliss

195 BIZ–SINGAPORE | Design Firm: Brandient | Client: BIZ | Designer: Ciprian Badalan

195 "225 PLUS" – CUSTOMER MAGAZINE | Design Firm: Peter Schmidt Group
Client: Sal. Oppenheim jr. & Cie. | Designers: Bernd Vollmöller, Gerrit Hinkelbein
Creative Director: Bernd Vollmöller

196 15 RENWICK SIGNAGE | Design Firm: IF Studio | Client: IGI USA, Core Group
Designers: Toshiaki Ide, Hisa Ide | Traffic Manager: Athena Azevedo
Photographer: Henry Leutwyler | Managing Director: Amy Frankel | Design Director: Hisa Ide
Creative Director: Toshiaki Ide | Account Manager: Anya Baskin

196 WEBSTER/CWPA BUILDING BANNERS | Design Firm: Webster
Client: Webster/CWPA | Designer: Sean Heisler | Creative Director: Dave Webster

196 SIKORSKY CH-53K HELICOPTER ROLLOUT EVENT | Design Firm: McMillan Group
Client: Sikorsky | Designer: Charlie McMillan | Videos: Dave Hendrie, inhance digital
Productions: Jim Ballentine, Multi Image Group | Constructions: Larry Oley, Elite Exhibits
Photographers: Stu Walls, Woodstock Studio Photography

196 GOOGLE NEW YORK | Design Firm: Graham Hanson Design
Client: Google | Designers: Graham Hanson, Nico Curtis, Jose Traconis

196 BIG TEN HEADQUARTERS ENVIRONMENTAL GRAPHICS
Design Firm: Pentagram | Client: Big Ten | Art Director: Michael Gericke
Designers: Michael Gericke, Don Bilodeau, Janet Kim, Eric Aragon

196 COOPER HEWITT, SMITHSONIAN DESIGN MUSEUM SIGNAGE AND ENVIRONMENTAL GRAPHICS | Design Firm: Pentagram
Client: Cooper Hewitt, Smithsonian Design Museum
Designers: Michael Gericke, Don Bilodeau, Elizabeth Kim, Jed Skillins, Qian Sun Jessie Wu,
Beth Gotham | Photographer: Peter Mauss/Esto | Art Director: Michael Gericke

197 THE FRANKLIN INSTITUTE NICHOLAS AND ATHENA KARABOTS PAVILION
Design Firm: Poulin + Morris Inc. | Client: The Franklin Institute
Designers: Erik Herter, Sherry Leung | Design Director: Richard Poulin

198 PRESIDIO HERITAGE CENTER AT THE OFFICERS' CLUB
Design Firm: Ralph Appelbaum Associates, Inc. | Client: Presidio Trust
Designer: Ralph Appelbaum Associates, Inc. | Writer: Mary Shapiro
Project Director: Nicolas Guillin | Composer and Sound Designer: Andrew Green
Content Developer: Evelyn Reilly | 3D Designer: Jande Wintrob | Art Directors: Josh Hartley,
Susan Merrell | Animators: Andrew Papa, Jamie Boud | Graphic Designer: Sarah Pokora
Interactive Producer: Michael Neault | Associate Producer: Carlin Wragg
Interactive Designer: Nina Boesch Content | Coordinators: Maggie Jacobstein, Michael Abraham
Executive Producer: Alex Vlack | Editor: Hudson Lines | Director and Producer: Lillian Preston
Content Coordinators: Maggie Jacobstein, Michael Abraham

Assignment: In collaboration with the Presidio Trust, RAA designed exhibits for the Historic Spaces as well as the more recently- constructed Heritage Gallery of the Presidio Officers' Club. The Officers' Club is a collective of buildings erected sequentially over 200 years, starting with Spanish colonial fortifications dating to the late 18th century.

The goal of this exhibition was to share the vast history of the Presidio, once home to Native Ohlone people, then the site of military fortifications for Spain, Mexico, and eventually the U.S. Army. It had to immerse visitors in a broad story of the flow of human history through this unique place, revealing the changes in people's relationships to the land, to each other, and to the idea of serving a cause greater than oneself.

Approach: RAA's interpretive approach was inspired by archaeology projects conducted at the site over the past 15 years. Early on, the metaphor of "peeling back the layers" of human history embedded in the site became an important design conceit and was incorporated into the 3D, graphic, and media components. Our approach centers around the idea that uncovering the Presidio story—like its archaeology—is an ongoing endeavor. Therefore, objects, images, oral histories, and linear and interactive media immerse visitors in this history, while leaving open questions about that story that remain unanswered.

The historic importance of the buildings demanded a design in accord with the highest standards of historic preservation. Each layer, representing four distinct eras of building history, is brought to life by gobo silhouettes of people who once inhabited the room. A multichannel soundscape provides a more poetic storytelling experience by animating the space with sounds that reflect the changing use of the space over time.

In the Heritage Gallery, emotional connections are forged with visitors through vivid storytelling and theatrical immersion. Graphics in the shape of books, with pages that can be turned, emphasize storytelling aspects of the exhibits, while other elements, such as a timeline keyed to national and international events and a large map that can be changed as more areas of the Presidio are restored or uncovered, evoke the notion of "layers."

A suite of interactive and linear media programs complement exhibit elements such as graphic panels and casework. The most dramatic of these are the Media Headers—three large-scale, staggered projection screens suspended above the historical exhibits; an ever-changing panoply of landscapes, places, and faces fills the upper levels of the gallery, expressing not only the physical beauty of the place but also the wealth of its cultural fabric.

Results: The Presidio Officers' Club is its most significant visitor resource to date and now serves as the principal gateway to the larger park experience. It is the key site of historic interpretation for the park, bringing together all its stories in an accessible and comprehensive way, and gives both locals and tourists the tools they need to better appreciate the rest of the site.

199 LOVE TO HATE—PARA_SITE | Design Firm: Konstantin Eremenko
Client: SfG Basel, FHNW HGK Visual Communication Institute, Plakatsammlung Basel
Designer: Konstantin Eremenko | Printers (Silkscreen): Arni Siebdruck, Basel
Printer (Offset) : Steudler Press

199 JIM BEAM PHOTO BOOTH LABEL PROJECT | Design Firm: Doe-Anderson Advertising
Client: Beam Suntory, Inc. | Designer: Mike Bagby | Chief Creative Officer: David Vawter

200 PH STUDIO PROMOTIONS COVER | Design Firm: PH Studio
Client: Self-initiated | Designer: Richard Patterson | Illustrator: Richard Patterson

200 AUDI A3 APP | Design Firm: designory. | Client: Audi USA | Production: Kurt Renfro
Designers: Fakih Amin, Hera Cheung | Project Manager: Courtney Parker
Copywriter: Kit Smith | Artists: Fakih Amin, Hera Cheung | Account Director: Chris Vournakis
Art Directors: Ulrich Lange, Kathy Chia Cherico | Account Executive: Sella Tosyaliyan

201 »LICHTGESTALTEN« INSTALLATION | Design Firm: KMS TEAM | Client: Self-initiated
Designer: Markus Sauer | Managing Director: Knut Maierhofer | Design Directors: Markus Sauer,
Sascha Zolnai | Creative Director: Patrick Märki | Designer: Jana Schauhuber

201 ZOO BALL INVITATION | Design Firm: Schaefer Advertising Co.
Client: Fort Worth Zoo | Designer: Blair Babineaux | Production Manager: Maren Gibbs
Printer: Cockrell Ennovation | Creative Director: Todd Lancaster | Art Director: Charlie Howlett
Project Vendors: Cockrell Ennovation, printer, Artifacture Studios, laser die cutting,
Lauren Essl, Blue Eye Brown Eye, calligraphy | Account Supervisor: Erin Naterman

202, 203 NEBRASKA CITY TOURISM & COMMERCE STATIONERY | Design Firm: Webster
Client: Nebraska City Tourism & Commerce | Designer: Nate Perry | Creative Director: Dave Webster

204 JAZZ PIANO NIGHT | Design Firm: Ken-Tasi Lee Design Lab/Taiwan Tech
Client: Taiwan TECH | Designer: Ken-Tsai Lee

205 SANTA CECILIA AL PARCO DELLA MUSICA | Design Firm: Venti caratteruzzi
Client: Accademia Nazionale di Santa Cecilia | Designer: Carlo Fiore

205 SHIHAD FVEY | Design Firm: Alt Group | Client: Warner Music NZ
Designers: Dean Poole, Tyrone Ohia, Dean Murray, Kris Lane | Photographer: Toaki Okano
Creative Director: Dean Poole

206 FRANCISCAN WELL | Design Firm: Trinity Brand Group | Designer: Dexter Lee
Client: Franciscan Well Brewery | Executive Creative Director: Alan Smith

206 GOOD PEOPLE BREWING COMPANY CAN DESIGN
Design Firm: Lewis Communications | Client: Good People Brewing Company
Designer: Roy Burns

206 SESSION LAGER | Design Firm: Sandstrom Partners | Project Manager: Robin Olson
Client: Full Sail Brewing Company | Designers: Trevor Thrap, Danny Jacobs

207 MYTHICUS | Design Firm: Vanderbyl Design | Client: Blankiet Estate
Designer: Michael Vanderbyl, Malin Reedijk | Creative Director: Michael Vanderbyl
Art Director: Michael Vanderbyl

207 JOHNNIE WALKER PRIVATE COLLECTION | Design Firm: Sedley Place
Client: Diageo | Designers: Jason Barney, Jeremy Roots

207 BOTTEGA VENETA KNOT FRAGRANCE | Design Firm: LLOYD&CO
Clients: Coty, Bottega Veneta | Designer: Asako Aeba | Photographer: Robin Broadbent
Creative Director: Doug Lloyd

207 IMPETUOUS | Design Firm: Vanderbyl Design | Client: Checkerboard Vineyards
Designers: Michael Vanderbyl, Kellie McCool | Creative Director: Michael Vanderbyl
Art Director: Michael Vanderbyl

207 HONEY OF THE MESSESTADT | Design Firm: Joel Derksen | Client: Birgit Wolff
Designer: Joel Derksen | Translator: Bastian Fuhrmann
Photographer: Lina Skukauské | Copywriter: Jason Thomas

207 BLAKE'S HARD CIDER CO. - CYSER | Design Firm: Adam Yarbrough
Client: Blake's Hard Cider Co. | Designer: Adam Yarbrough | Photographer: Raymond Rivard

208 DEWAR'S | Design Firm: Stranger & Stranger
Client: John Dewar and Sons | Designer: Stranger & Stranger

208 MARCH PANTRY MAPLE SYRUP | Design Firm: Design is Play | Client: March
Designers: Angie Wang, Mark Fox | Creative Director: Sam Hamilton | Art Director: Angie Wang

208 SILENT POOL GIN | Design Firm: Seymourpowell
Client: Silent Pool Distillers | Designer: Neil Hirst

208 NEW PACKAGING FOR 'SULA' | Design Firm: Alok Nanda & Company
Client: Sula wines | Designer: Xerxes Baria | Chief Creative Officer: Alok Nanda

208 EAST LONDON LIQUOR COMPANY | Design Firm: Stranger & Stranger
Client: East London Liquor Company | Designer: Stranger & Stranger

208 BIB & TUCKER | Design Firm: Studio 32 North | Client: 35 Maple Street Spirits
Designer: Sallie Reynolds Allen | Typographer: Tom Lane | Copywriter: Elliott Allen

209 MONTE ROSSA COUPÉ | Design Firm: Raineri Design Srl
Client: Monte Rossa | Designer: William Raineri

209 BEERENBERG DESSERT SAUCES | Design Firm: Tiny Hunter | Client: Beerenberg
Designer: Jen Wotherspoon | Creative Director: Emma Scott

210 AMERICAN ROYAL MEAD | Design Firm: Dunn&Co.
Client: St. Petersburg Distillery | Designer: Grant Gunderson | Printer: Blue Label Digital
Chief Creative Officers: Troy Dunn, Jim Darlington | Account Executive: Jalyn Rivera

210 PITORICO | Design Firm: Dunn&Co | Client: PitoRico | Designers: Grant Gunderson,
Conrad Garner | Chief Creative Officers: Troy Dunn, Glen Hosking

211 BLAKE'S HARD CIDER CO. - FLANNEL MOUTH CAN | Design Firm: Adam Yarbrough
Client: Blake's Hard Cider Co. | Designer: Adam Yarbrough | Photographer: Raymond Rivard

211 THE LOST BLEND | Design Firm: Stranger & Stranger
Client: Compass Box Whisky Co. | Designer: Stranger & Stranger

212 TOGGLE PHONE CASE CAMPAIGN | Design Firm: Rodgers Townsend DDB
Client: AT&T | Designer: Danny Mehl | Senior Art Director: Eric Tatham | Editor: Noah Readhead
Senior Account Executive: Katie Chadek | Production: Cheryl Sparks
Executive Creative Director: Michael McCormick | Copywriter: John Jackson
Creative Directors: Erik Mathre, Steve LaLiberte | Account Supervisor: Chris Rarick

212 HUNSA HEAT & EAT BANGERS | Design Firm: Dessein | Client: Hunsa
Designer: Leanne Balen | Stylist: Leanne Balen | Photographer: Geoff Bickford
Art Director: Geoff Bickford

212 WALLACE CHURCH HOLIDAY GIFT WINE_FOOTLOOSE AND FANCY "FREE"
Design Firm: Wallace Church, Inc | Client: Self-initiated | Designer: Stan Church

212 WALLACE CHURCH GIFT WINE_THAT'S IT IN A NUTSHELL
Design Firm: Wallace Church, Inc | Client: Self-initiated | Designer: Stan Church

212 SESSION EXPORT 12-PACK | Design Firm: Sandstrom Partners
Client: Full Sail Brewing Company | Designers: Trevor Thrap, Danny Jacobs
Project Manager: Robin Olson | Art Director: Steve Sandstrom

212 SESSION IPA 12-PACK | Design Firm: Sandstrom Partners
Client: Full Sail Brewing Company | Designers: Trevor Thrap, Danny Jacobs
Project Manager: Robin Olson | Art Director: Steve Sandstrom

213 WATT | Design Firm: Alchemy Branding Group | Client: Buszesz
Designer: Alicia Gaines | Photographer: Andrews Braddy | Chief Creative Director: Kristen Caston

213 SEASONAL PICKLES | Design Firm: Red Peak | Designer: Stewart Devlin
Client: Lisa Sanders Public Relations | Chief Creative Officer: Stewart Devlin
Copywriters: Stewart Devlin, Stephen Lipman, Anthony Perez, Rafael Medina

213 INDIA IN A BAR | Design Firm: Alok Nanda & Company | Client: Filter
Designers: Mahesh Ramparia, Ajoy Advani | Photographer: Nital Patel
Creative Directors: Ajoy Adwani, Mahesh Ramparia

213 SHURE SRH 144/145 PORTABLE HEADPHONES PACKAGING
Design Firm: MiresBall | Client: Shure | Designer: Angela Renac | Account Director: Holly Houk
Photographer: Steve Simar | Partner, Creative Director: John Ball | Copywriter: David Fried

213 JOSIE FRAGRANCE | Design Firm: Sayuri Studio, Inc.
Client: LUXE Brands, Josie Natori | Designer: Sayuri Shoji

213 XL PACKAGING | Design Firm: VSA Partners
Client: D'Addario | Designers: Thomas Wolfe, Kate Trogan and Dave Hanicak

214 ST-GERMAIN LE PEEP TABLE TOPPER | Design Firm: Sandstrom Partners
Client: Bacardi USA | Designer: Trevor Thrap | Project Manager: Kay Zerr
Art Director: Steve Sandstrom

214 SKYY VODKA AND SKYY INFUSIONS BOTTLE + SHIPPER REDESIGN
Design Firm: Turner Duckworth Design: San Francisco London | Client: Gruppo Campari
Designers: David Turner, Bruce Duckworth, Sarah Moffat, Jamie McCathie, Daniel D'Arcy,
Rebecca Williams, Georgiana Ng

214 GOODS & SERVICES HOLIDAY GIFT | Design Firm: Goods & Services Branding
Client: Self-initiated | Designer: Christian Blau | Printer: Flash Reproductions
Project Managers: Heather Horton, Kyra Cohen | Production Designer: Derek Moxon
Creative Directors: Carey George, Sue McCluskey

215 ELVIS FESTIVAL | Design Firm: Zulu Alpha Kilo | Studio: Greg Heptinstall
Clients: Town of Collingwood, Rosemarie O'Brien | Designer: Allan Mah | Writer: Nick Asik
Photographer: Jamie Morren | Agency Planner: Zoe Neuma | Digital Artist: Brandon Dyso
Creative Director: Zak Mroueh | Art Director: Allan Mah | Agency Producer: Kari MacKnight,
Kate Spencer | Account Directors: Dic Dickerson, Nevena Djordjevic

215 POLTERGEIST | Design Firm: ARSONAL | Client: 20th Century Fox - Ely Orias
Designer: ARSONAL | Photographers: Kerry Hayes, RSONAL | Creative Directors: Ely Orias,
ARSONAL | Art Director: ARSONAL

215 KEIRA WATERING CANS | Design Firm: McCann Worldgroup
Client: Keira Watering Cans | Designer: Ed Parks, David Brajdic
Retoucher: Jamie Menary | Photographer: Nathan Garcia
Executive Creative Directors: Mike Stocker, Robin Chrumka
Copywriters: Ed Parks, Keira Watering Cans | Art Directors: Ed Parks, David Brajdic

215 BABY SOCIAL "MOMISMS" | Design Firm: Target Creative
Client: Self-initiated | Designer: Target Creative

215 TWR POSTER PROMO | Design Firm: The White Room Inc. | Client: Self-initiated
Designers: Karolina Loboda, Sharon Ho

215 TWR POSTER PROMO | Design Firm: The White Room Inc. | Client: Self-initiated
Designers: Karolina Loboda, Sharon Ho

215 THE STRAIN | Design Firm: ARSONAL | Client: FX | Designers: FX, ARSONAL
Photographer: Frank W. Ockenfels III | Creative Director: Stephanie Gibbons, ARSONAL
Art Directors: Todd Heughens, Michael Brittain, ARSONAL

216 TARGET 2015 BRANDING CAMPAIGN | Design Firm: Target Creative
Client: Self-initiated | Designer: Target Creative

216 DESIGN BARCELONA | Design Firm: Underline Studio
Client: Advertising and Design Club of Canada | Designer: Fidel Peña
Printer: Flash Reproductions Ltd. | Creative Directors: Fidel Peña, Claire Dawson

217 WONDERFILLED WILD POSTINGS | Design Firm: The Martin Agency | Client: Oreo
Designers: Chris Peel, Will Godwin | Studio: Matt Wieringo | Project Manager: Giao Roever
Print Producer: Paul Martin | Group Account Director: Darren Foot
Account Coordinator: James Salusky | Group Planning Director: John Gibson
Strategic Planner: Gigi Jordan | Junior Print Producer: Jamie Parker
Business Affairs Supervisor: Juanita McInteer | Managing Director: Steve Humble
Executive Creative Director: Jorge Calleja | Creative Directors: Magnus Hierta,
David Muhlenfeld | Chief Creative Officer: Joe Alexander | Art Producer: Anya Mills
Account Supervisor: Molly Holmes | Account Directors: Leslie Hodgin, Britta Dougherty

217 MAKER'S MARK COLORADO POS | Design Firm: Doe-Anderson | Client: Maker's Mark
Designer: Wes Keeton | Retouching: We Monsters | Production Artist: Tim Kennedy
Photographer: Dean Lavenson | Copywriter: Jonathan Bell Chief Creative Officer: David Vawter

217 ICONS | Design Firm: Zulu Alpha Kilo | Clients: Beyond the Beats, David MacKenzie
Designer: Jenny Luong | Writer: Jerry Brens | Studio: Brandon Dyson | Art Director: Jenny Luong
Photographer: Daniel Ehrenworth | Creative Director: Zak Mroueh
Agency Producer: Kari Macknight Dearborn | Account Supervisor: Jessica DeSantis

**217 I LIKED THINGS BEFORE THEY WERE COOL BEFORE LIKING THINGS BEFORE
THEY WERE COOL WAS COOL** | Design Firm: Vanderbyl Design
Client: The Wolfsonian, Florida International University | Art Director: Michael Vanderbyl
Designers: Michael Vanderbyl, Malin Reedijk | Creative Director: Michael Vanderbyl

218 UNDERLINE JOGO BONITO | Design Firm: Underline Studio | Client: Self-initiated
Designers: Fidel Peña, Claire Dawson, Clea Forkert, Cameron McKague, Yosub Jack Choi
Printer: Andora Graphics Inc. | Creative Directors: Fidel Peña, Claire Dawson

218 AWARDS HOUNDS POSTER SERIES | Design Firm: Fluid | Client: AAF-Utah
Designer: Ryan Anderson | Illustrators: Alex Nabaum, Christopher Thornock, David Habben
Creative Director: Ryan Anderson

218 "THE 38TH" - LINCOLN MARATHON | Design Firm: Bailey Lauerman
Client: Lincoln Marathon | Designer: Ron Sack | Retoucher: Gayle Adams
Project Manager: Matt Emodi | Production Manager: Gayle Adams | Photographer: Bob Ervin
Copywriter: Michael Weitz | Chief Creative Director: Carter Weitz
Associate Creative Director: Ron Sack | Account Executive: Rich Claussen

218 "THE 38TH" - LINCOLN MARATHON | Design Firm: Bailey Lauerman
Client: Lincoln Marathon | Retoucher: Gayle Adams | Project Manager: Matt Emodi

Production Manager: Gayle Adams | Photographer: Bob Ervin | Copywriter: Michael Weitz
Chief Creative Director: Carter Weitz | Associate Creative Director: Ron Sack
Account Executive: Rich Claussen

218 ST-GERMAIN VINTAGE POSTERS | Design Firm: Sandstrom Partners
Client: Bacardi USA | Designers: Trevor Thrap, Danny Jacobs | Project Manager: Robin Olson
Art Director: Steve Sandstrom

218 ULYSSES THEATRE - SEASON 15 - IN THE MIDDLE OF NOWHERE
Design Firm: design center | Client: ulysses theatre | Designer: Eduard Cehovin

219 DODGE MUSCLE | Design Firm: DD&A | Client: Dodge Data & Analytics
Designer: Jason Scuderi | Writer: Dean Noble | Creative Director: William Taylor

219 DODGE MUSCLE | Design Firm: DD&A | Client: Dodge Data & Analytics
Designer: Jason Scuderi | Writer & Content Developer: Dean Noble
Creative Director: William Taylor

220 POSTER OF TYPE DIRECTORS CLUB ANNUAL EXHIBITION IN TAIWAN /HOMAGE TO IKKO TANAKA | Design Firm: Ken-Tasi Lee Design Lab/Taiwan Tech
Client: Taiwan TECH | Illustrator: kuan-Ting Pan | Designers: Ken-Tsai Lee, Cheng Shiun You
Creative Director: Ken-Tsai Lee | Art Director: Ken-Tsai Lee

220 THE SIMPSONS | Design Firm: ARSONAL | Client: FX
Designer: ARSONAL | Creative Director: Stephanie Gibbons, ARSONAL
Art Directors: Todd Heughens, Michael Brittain, ARSONAL

220 SALEM | Design Firm: ARSONAL | Clients: WGN America, Brian Dollenmayer
Designer: ARSONAL | Photographers: Justin Stephens, ARSONAL | Art Director: ARSONAL

221 SUBPLOT'S OFF COLOUR GUIDE TO THE HOLIDAYS
Design Firm: Subplot Design Inc. | Client: Subplot | Designers: Max Young, Jacquie Shaw
Creative Directors: Roy White, Matthew Clark

221 FLEET OF TIME FILM MEMORABILIA | Design Firm: BEAMY
Client: Le Grand Films Co., Ltd | Designers: Ronn Lee, Linz Lim | Senior Designer: Linz Lim
Creative Director: Ronn Lee | Account Management: Jess Zhao | Account Director: Yutien Peng

221 OUTSTANDING CHINESE CHARACTER DESIGN WORKS INVITATION EXHIBITION | Design Firm: Ken-Tasi Lee Design Lab/Taiwan Tech
Client: Taiwan TECH | Designer: Ken-Tsai Lee | Assistants: Chiu Yuan Chen, Hsiang Wen Chun, Wu Yi Jung, Lin Chun Ying, Pan Kuan Ting, Tsao Hsin Chi

221 DS INCITE MAGAZINE PAPER | Design Firm: Dixon Schwabl | Client: Self-initiated
Designer: Ryan Moore | Traffic Manager: Jordan Dixon | Proofreader: Jennifer Moritz
Production Manager: Bob Charboneau | Production Artists: Stephanie Miller, Daniel Owens
Printer: Cohber Press | Copywriter: Karl Wiberg | Chief Creative Officer: Mark Stone
Associate Creative Directors: Marshall Statt, Ann McAllister
Account Executive: Megan Steenburgh

221 ACCIDENTALLY EXTRAORDINARY FLYER | Design Firm: Accidentally Extraordinary
Client: HUB STRATEGY & COMMUNICATION | Creative Directors: DJ O'NEIL, PETER JUDD
Designer: JASON ROTHMAN | Associate Creative Directors: JASON ROTHMAN, HUGH GURIN
Account Director: ANGELINA DILG | Photographer: KEVIN TWOMEY | Copywriter: HUGH GURIN

221 DESIGN WEEK BIRMINGHAM | Design Firm: Lewis Communications | Client: Design Week
Designers: Roy Burns, David Blumberg, Andrew Thompson | Agency Producer: Leigh Ann Motley

222 KNOCK, INC REBRAND | Design Firm: KNOCK, inc | Client: Self-initiated
Designer: Jason Miller | Typeface: Jeremy Mickel – MCKL
Production Manager: Creighton King | Printer: Studio on Fire | Creative Director: Dan Weston
Chief Creative Officer: Todd Paulson | Account Manager: Caitlin Sidey

222 POSTCARD SERIES OF THE 2ND OUTSTANDING CHINESE CHARACTERS DESIGN EXHIBITION | Design Firm: Ken-Tasi Lee Design Lab/Taiwan Tech
Client: Taiwan TECH | Designers: Ken-Tsai Lee, Jou-Yu Cheng, Yang-Chun Cheng
Creative Director: Ken-Tsai Lee | Art Director: Ken-Tsai Lee

222 ST-GERMAIN HOLIDAY HAT | Design Firm: Sandstrom Partners | Client: Bacardi USA
Designer: Trevor Thrap | Project Manager: Robin Olson | Art Director: Steve Sandstrom

223 PALETTE | Design Firm: FutureBrand | Client: sáv hospitality | Designers: Celia Leung, Debbie Poon, Gareth Joe, Hung Po, Venus Lin | Creative Director: Young Kim

223 THE PANTRY | Design Firm: Toben | Art Director: Thorsten Kulp
Client: Art Series Hotel Group / The Schaller Studio | Photographer: Lucas Allen
Designers: Thorsten Kulp, Louise Odelberg, Katja Hartung

223 GLO SIGNAGE | Design Firm: Leynivopnid | Client: Glo
Designers: Einar Gylfason, Unnur Valdis | Art Director: Einar Gylfason

223 STREETZ AMERICAN GRILL | Design Firm: Cue, Inc. | Client: Streetz American Grill
Designer: Laura Wright | Creative Director: Alan Colvin

224 RETROSPEKTIVE HEINZ BEIER – STAMPS | Design Firm: beierarbeit
Client: Haus Wellensiek | Designers: Heinz Beier, Christoph Beier

225 HELVETICA FOR TARGET | Design Firm: Target Creative
Client: Self-initiated | Designer: Target Creative

225 GLAZOV | Design Firm: 12 points | Client: Glazov Furniture Factory
Designers: Mikhail Puzakov, Alexey Poteychuk, Kirill Guryanov
Creative Strategist: Oleg Vvedensky | Art Director: Mikhail Puzakov

226 BENCHMARK REAL ESTATE GROUP WEBSITE | Design Firm: IF Studio
Client: Benchmark Real Estate Group | Designer: Toshiaki Ide, Hisa Ide
Web Developer: Sung Yong Kim | Web Designer: Sung Yong Kim
Photographer: Athena Azevedo | Design Director: Hisa Ide | Creative Director: Toshiaki Ide

226 CLODAGH WEBSITE | Design Firm: IF Studio | Client: Clodagh
Designer: Toshiaki Ide, Hisa Ide | Web Developer: Rev Systems | Web Designer: Sung Yong Kim
Design Director: Hisa Ide | Creative Director: Toshiaki Ide

226 THE FEW & FAR BETWEEN: TALES OF MISCHIEF, REVELRY AND WHISKEY
Design Firm: Arnold Worldwide | Client: Jack Daniel's | Production Company: MediaMonks
Designers: Daran Brossard, Travis Robertson, Kjegwan Leihitu | Director: Joe Roberts
Producers: Tim Ruiters, Todd Buffum, Ben Ouellette, Nathalie Visser
Executive Creative Director: Pete Johnson, Wade Devers | Art Directors: Travis Robertson, Daran Brossard | Developers: Victor Ga, Dinesh Vitharanage, René Drieënhuizen
Creative Directors: Greg Almeida, Travis Robertson, Jouke Vuurmans
Copywriters: Greg Almeida, Madhu Kalyanaraman

226 THE PEARL WEBSITE | Design Firm: Mermaid, Inc. | Client: National Resources
Designer: Sharon Lloyd McLaughlin | Web Developer: Bart McLaughlin
Photo Illustrator: Sharon Lloyd McLaughlin | Photographer: Adrian Bonvento

Marketing Manager: Adrian Bonvento | Creative Director: Sharon Lloyd McLaughlin
Copywriter: Adrian Bonvento

FILM/VIDEO:

228 SFMOMA ARCHITECTURE + DESIGN COLLECTION VIDEO | Design Firm: Morla Design
Client: San Francisco Museum of Modern Art | Production Companies: Kris Johnson, KrisFilms
Designer: Jennifer Morla | Project Managers: Olivia Teter, Arlene Susmilch Mayne
Production Designer: Jen Humphries | Photographer: Deborah Jones

229 DESTINY USER INTERFACE | Design Firm: Bungie | Client: Bungie
Designer: David Candland | Creative Director: Christopher Barrett | Artists: Andrew Davis, MacKay Clark, Ryan Klaverweide

230 »LICHTGESTALTEN« INSTALLATION | Design Firm: KMS TEAM | Client: Self-initiated
Designer: Markus Sauer | Managing Director: Knut Maierhofer | Creative Director: Patrick Märki
Account Director: Jana Schauhuber | Design Directors: Markus Sauer, Sascha Zolnai

231 JUKE COLOR STUDIO VIDEO | Design Firm: The Designory, Inc.
Client: Nissan North America, Accessories Marketing | Designer: Patrick Dougherty
Director: Rich Lee | Creative Director: Carol Fukunaga | Copywriter: Alisha Westerman
Animator: Blackbird | Agency Producer: Carmen Lam | Account Manager: Katie Kleinheksel

232 MOTO MAXX :60 BROADCAST SPOT | Design Firm: 50,000feet | Client: Motorola
Designer: 50,000feet | Production Company: Snog Productions | Producer: Deborah Burch
Motion Graphics: Bubba's Chop Shop | Music & Sound: Huma-Huma | Director: Jeff Luker
Editor: Bennett Barbakow | Director of Photography: Russell Brownley

Assignment: Motorola Mobility teamed up with 50,000 feet for the Latin American launch of the company's innovative, new smartphone—Moto Maxx. Tasked with developing a creative strategy that would support the global launch across markets, platforms and channels, 50,000feet crafted the campaign to focus on the fast-paced, action-packed lifestyle of Motorola Mobility's target consumer—an upwardly mobile segment who places importance on performance, style and value.

Approach: The introductory campaign includes broadcast spots that aired throughout Latin America. The premier spot features two days in the life of a Moto Maxx consumer, highlighting the product's differentiating features—a 48-hour battery life and 15-minute turbo charge that yields another eight hours of use. The ads also showcase Moto Maxx's exterior, designed with premium ballistic nylon—also an industry first. To bring the product to life, 50,000feet introduced a more personal side to the story by connecting the powerful features of Moto Maxx with the ambitions and interests of the audience, concepting the campaign not only to follow two days in the life but also to comment on a modern-day way of living.

Results: Since the campaign's debut, the broadcast spots have been translated and adapted for North American markets, where the smartphone is marketed as Droid Turbo. 50,000feet also directed lifestyle and product photography that captures how Moto Maxx fits in with consumers' busy schedules. Sales of the Moto Maxx have exceeded expectations since the launch of the campaign, which has extended to Mexico, Puerto Rico and Chile. Creative assets from the campaign have been incorporated and used by global product groups in cross-channel marketing and on the corporate website.

232 BOY SCOUTS OF AMERICA BUILD AN ADVENTURE CAMPAIGN
Design Firm: FleishmanHillard Creative | Client: Boy Scouts of America
Designer: Zach Arnold | Executive Creative Director: Tom Hudder | Animator: Danny Drabb
Editors: Ben Bohling, Stephen Grizzle | Art Director: Rebecca Rausch

Assignment: There was a time when the only activities vying for a boy's time were baseball and scouting. That's no longer the case. With boys and their parents trying to make the best of the their time together, The Boy Scouts of America needed a recruitment campaign that not only positioned Scouting as a great experience, but the best way to prepare a boy for the future. *Goals:* Motivate kids to join Scouting and their parents to sign them up. Our target was parents, including Hispanic families, looking to make the most of their time with their son while preparing him for the future. Secondary: Boys spending less time outdoors. They perceive Scouting as uncool and time-consuming. Our strategy was simple: If parents felt like the clock was ticking on their time with their son, we needed to convince them that Scouting was the best way to make the most of their time together and prepare him for the future. To do that, we couldn't just tell them about the breadth of activities Scouting offers, we needed them to see the variety for themselves—and understand where it could take their son in the future. *Execution:* Build an Adventure showed parents how Scouting was not only a great way to prepare their son for the future, but an extension of the life skills they were already teaching him at home. Everything we shot featured boys of various ages and ethnicities in a geographically agnostic setting. *Results:* Launched in May, the campaign was well received across the organization, including a debut at the national meeting. Since the campaign was not supported with a national buy, we are awaiting results from local troops and councils who only began using these assets this fall. Early reports indicate a heavy adoption of campaign assets across the country.

233 WHERE IMPOSSIBLE COMES TO DIE | Design Firm: Breakaway
Client: Coghlin Companies | Designer: Mike McQuaid | Production Company: Giant Ant
Producer: Liam Hogan | Writer: Scott Maney | Chief Creative Officer: Scott Maney
Art Director: Lucus Brooking | Animator: Jorge Canedo

233 GRAPHICS RCA 50 | Design Firm: Q | Client: Royal College of Art | Designer: Kyuha Shim

233 AUSTERE | Design Firm: xose teiga, studio. | Client: Self-initiated
Designer: Xose Teiga | Production Company: no necesariamente | Art Director: Xose Teiga
Graphic Designer: Sabela Barcelo | Director of Photography: Asunta Riotorto
Director: Hector Cerdeira | Creative Director: Xose Teiga | Copywriter: Xose Teiga

233 ÁNIMA PROMO | Design Firm: Trasluz / Ánima | Client: Self-initiated
Designer: Pablo Iturralde | Producers: Pedro Orellana, Martin Guerrero
Photographer: Thomás Astudillo | Director: Pedro Orellana

DESIGN FIRMS/ADVERTISING AGENCIES

CLIENTS

DESIGNERS

CREATIVE DIRECTORS/EXECUTIVE CREATIVE DIRECTORS

ART DIRECTORS

PHOTOGRAPHERS/PHOTOGRAPHY STUDIOS

ILLUSTRATORS

PLATINUM

Airbnb www.airbnb.com
Dietla 111, 33-332 Kraków, Poland

Brad Bartlett Design, LA
www.bradbartlettdesign.com
2125 E. Orange Grove Blvd.
Pasadena, CA 91104 United States
Tel 626 639 3120
contact@bradbartlettdesign.com

Bungie www.bungie.net
550 106th Ave. NE #207
Bellevue, WA 98005, United States
Tel 425 440 6800
info@bungie.com

Dankook University
www.dankook.com
152 Jukjeon-ro, Suji-gu, Yongin-si
Gyeonggi-do, South Korea
Tel 82 1899 3700
letsdoit@dankook.ac.kr

The Designory Inc.
www.designory.com
211 E. Ocean Blvd., Suite 100
Long Beach, CA 90802 United States
Tel 562 624 0200
inquire@designory.com

DSPI & Zibo Industrial Design Co., Ltd.
www.art.ujn.edu.cn
Ji'nan City, Shandong province
nanxinzhuang Road No. 336, Room 608
University of Jinan,
Academy of Fine Arts, China
Tel 8610 0531 82767126
vis2009@sina.com

The General Design Co.
www.generaldesignco.com
1624 Q St. NW.
Washington DC 20009, United States
Tel 202 640 1842
hello@generaldesignco.com

Jones Knowles Ritchie Inc.
www.jkrglobal.com
57 E. 11th St., Floor 7
New York, NY 10003, United States
Tel 347 205 8200
newyork@jkrglobal.com

Karnes Coffey Design
www.karnescoffey.com
Tel 804 424 0850
christine@karnescoffey.com

Ken-Tsai Lee studio / Taiwan TECH
17F No. 31, Lane 49, Alley Chung
Cheng St., Peitou Taipei 112, Taiwan
Tel 886 2 2893 5236
leekentsai@gmail.com

KMS TEAM GmbH
www.kms-team.com
Toelzer Strasse 2c
81379 Munich, Germany
Tel 49 0 89 490 411 0
info@kms-team.com

Morla Design
www.morladesign.com
1008A Pennsylvania Ave.
San Francisco, CA 94107
United States
Tel 415 543 6548
info@morladesign.com

Pentagram Design, New York
www.pentagram.com
204 Fifth Ave., New York, NY 10010
United States
Tel 212 683 7000
info@pentagram.com

Ralph Appelbaum Associates, Inc.
www.raany.com
88 Pine St. Suite 29
New York, NY 10005, United States
Tel 212 334 8200
nycontact@raai.com

TOKY www.toky.com
3001 Locust St., Floor 2
St. Louis, MO 63103, United States
Tel 314 534 2000
info@toky.com

GOLD

50,000feet www.50000feet.com
1700 W. Irving Park Road, Suite 110
Chicago, Illinois 60613
United States
Tel 773 529 6760
brown@50000feet.com

Addison www.addison.com
48 Wall St.
New York, NY 10005, United States
Tel 212 229 5000
info@addison.com

Agent www.agentthinking.com
440 N. Eighth St., Suite 110
Lincoln, NE 68508, United States
Tel 402 486 3200
info@agentthinking.com

Anthem Worldwide
www.anthemww.com
1100 Circle 75 Parkway, Suite 400
Atlanta, GA 30339
United States
Tel 770 333 9432

ARSONAL www.arsonal.com
3524 Hayden Ave.
Culver City, CA 90232, United States
Tel 310 815 8824
info@arsonal.com

Beacon communications k.k.
graphic studio
JR Tokyu Meguro Bldg.
3-1-1 Kami-Osaki, Shinagawa-ku
Tokyo, 141-0021, Japan
Tel 81 3 5437 7560
noritsugu.endo@beaconcom.co.jp

BOHAN Advertising
www.bohanideas.com
124 12th Ave. S.
Nashville, TN 37203, United States
Tel 615 327 1189
hello@bohanideas.com

Brad Bartlett Design, LA
www.bradbartlettdesign.com
2125 E. Orange Grove Blvd.
Pasadena, CA 91104 United States
Tel 626 639 3120
contact@bradbartlettdesign.com

The Community
www.thecommunity.ca
822 Richmond St. W., Suite 400
Toronto, ON M6J 1C9, Canada
Tel 416 361 0030
kyle@thecommunity.ca

The Designory Inc.
www.designory.com
211 E. Ocean Blvd., Suite 100
Long Beach, CA 90802
United States
Tel 562 624 0200
inquire@designory.com

Dunn&Co. www.dunn-co.com
202 S. 22nd St.
Tampa, FL 33605, United States
Tel 813 350 7990
hello@dunn-co.com

El Paso, Galería de Comunicación
www.elpasocomunicacion.com
Sagunto 13, 28010, Madrid, Spain
Tel 91 594 22 48
elpaso@elpasocomunicacion.com

Elephant In The Room
www.elephantinein
105 W. Fourth St., Floor 6
Winston-Salem, NC 27101
United States
Tel 336 692 2402
hello@elephantintheroom.com

FleishmanHillard Creative
www.fleishmanhillard.com
Tel 314 982 1700
info@fleishman.com

Flowdesign www.flow-design.com
200 N. Center St.
Northville, MI 48167, United States
Tel 248 349 7250
info@flow-design.com

Frost*collective
www.frostcollective.com.au
1/15 Foster St.
Surry Hills, NSW 2010, Australia
Tel 61 2 9280 4233
hello@frostcollective.com.au

GQ www.gq.com
One World Trade Center
New York, NY 10007, United States
Tel 212 286 2860
info@gq.com

HOOK www.hookworldwide.com
522 King St.
Charleston, SC 29403, United States
Tel 843 853 5532
info@hookusa.com

Hoyne www.hoyne.com.au
117 Reservoir St.
Surry Hills, NSW 2010, Australia
Tel 61 02 9212 2255
andrew@hoyne.com.au

IF Studio www.ifstudiony.com
670 Broadway, Suite 301
New York, NY 10012, United States
Tel 212 334 3465
info@ifstudiony.com

Iron Design www.irondesign.com
120 N. Aurora St., Suite 5A
Ithaca, NY 14850, United States
Tel 607 275 9544

John Gravdahl Design
406 E. Lake St.
Fort Collins, CO 80524, United States
Tel 970 482 8807
info@propeller-press.com

Ken-Tsai Lee studio / Taiwan TECH
17F No. 31, Lane 49, Alley Chung
Cheng St., Peitou Taipei 112, Taiwan
Tel 886 2 2893 5236
leekentsai@gmail.com

Kitchen Sink Studios
www.kitchensinkstudios.com
828 N. Third St.
Phoenix, AZ 85004, United States
Tel 602 258 3150
info@kitchensinkstudios.com

Kojima Design Office Inc.
www.kojimadesign.jp
Mansion Minami Aoyama 101
Minami Aoyama 4-27-20
Minato-ku, Tokyo,107-0062, Japan
Tel 81 03 5469 3537
info@kojimadesign.jp

Konstantin Eremenko
Claragraben 78, Basel CH-4058
Switzerland
cf.eremenko@gmail.com

lg2boutique www.lg2boutique.com
3575 Saint-Laurent Blvd., Suite 900
Montréal, QC H2X 2T7, Canada
Tel 514 281 8901
info.boutique@lg2.com

Lin Shaobin Design
www.lsb-design.blog.sohu.com
write000@sina.com

Lorenc+Yoo Design
www.lorencyoodesign.com
109 Vickery St.
Roswell, GA 30075, United States
Tel 770 645 2828
info@lorencyoodesign.com

LRXD www.lrxd.com
1480 Humboldt St.
Denver, CO 80218, United States
Tel 303 333 2936
info@lrxd.com

Mangos www.mangosinc.com
10 Great Valley Parkway
Malvern, PA 19355, United States
Tel 610 296 2555
info@mangosinc.com

Michael Pantuso Design
www.pantusodesign.com
820 S. Thurlow St.
Hinsdale, IL 60521, United States
Tel 312 318 1800
michaelpantuso@me.com

Michael Schwab Studio
www.michaelschwab.com
108 Tamalpais Ave.
San Anselmo, CA 94960, United States
Tel 415 257 5792
studio@michaelschwab.com

MiresBall www.miresball.com
2605 State St.
San Diego, CA 92103, United States
Tel 619 234 6631
info@miresball.com

Moxie Sozo www.moxiesozo.com
1140 Pearl St., Floor 2
Boulder, CO 80302, United States
Tel 720 599 3715
info@moxiesozo.com

Pavement www.pavementsf.com
1285 66th St., Floor 2
Emeryville, CA 94608, United States
Tel 917 558 3985
info@pavementsf.com

Pentagram Design, New York
www.pentagram.com
204 Fifth Ave.
New York, NY 10010, United States
Tel 212 532 0181
info@pentagram.com

PepsiCo Design & Innovation
www.design.pepsico.com
350 Hudson St.
New York, NY 10014, United States
joelle.garofalo@pepsico.com

Poulin + Morris Inc.
www.poulinmorris.com
46 White St., Floor 2
New York, NY 10013, United States
Tel 212 675 1332
info@poulinmorris.com

Raison Pure USA
www.raisonpurenyc.com
119 Fifth Ave., Suite 2
New York, NY 10003, United States
Tel 212 625 0708
mmccoy@raisonpureusa.com

Ralph Appelbaum Associates, Inc.
www.raany.com
88 Pine St., Suite 29
New York, NY 10005, United States
Tel 212 334 8200
nycontact@raai.com

Randy Clark Graphic Design
105 Lincoln Lane S.
Brookings, SD 57006, United States
Tel 605 692 2385
randy.clark@sdstate.edu

Recruit Communications Co., Ltd.
Sumitomo Seimei Yaesu Bldg.
7F 2-2-1 Yaesu, Chuo-ku
Tokyo 104-0028, Japan
Tel 81 3 6835 8188
number8_creative@yahoo.co.jp

Rodgers Townsend DDB
www.rodgerstownsend.com
1000 Clark Ave.
St. Louis, MO 63102, United States
Tel 314 436 9960
terri.french@rodgerstownsend.com

Sandstrom Partners
www.sandstrompartners.com
808 SW. Third Ave., Suite 610
Portland, OR 97204, United States
Tel 503 248 9466
info@sandstrompartners.com

Sergio Olivotti www.olivotti.net
Via Caviglia, 1, 17024
Finale Ligure SV, Italy
Tel 39 3389185170
sergioolivotti@icloud.com

Starz www.starz.com
8900 Liberty Circle
Englewood, CO 80112, United States
Tel 720.852.7700

Stranger & Stranger
www.strangerandstranger.com
239 Bleecker St., Floor 2
New York, NY 10014, United States
Tel 212 625 2441
nyc@strangerandstranger.com

Tamschick Media+Space GmbH
www.tamschick.com
Gewerbehof Bülowbogen
Bülowstrasse 66, Aufgang D3
10783 Berlin, Germany
Tel 49 30 21965090
info@tamschick.com

Tiny Hunter www.tinyhunter.com.au
20 Hutchinson St., Level 1
Surry Hills, NSW 2010, Australia
Tel 61 2 9360 0099

Toben www.toben.com.au
48 Chippen St., Level 3
Chippendale, NSW 2008, Australia
Tel 61 2 8060 1136
hello@toben.com.au

Toppan Printing Co., Ltd.
www.toppan.co.jp
9F 1-3-3, Suido Bunkyo-ku
Tokyo, 112-8531, Japan
Tel 81 3 5840 2192
mescal@mac.com

Turner Duckworth Design:
London & San Francisco
www.turnerduckworth.com
831 Montgomery St.
San Francisco, CA 94133, United States
Tel 415 675 7777
info@turnerduckworth.com

Underline Studio
www.underlinestudio.com
247 Wallace Ave.
Toronto, ON M6H 1V5, Canada
Tel 416 341 0475
info@underlinestudio.com

UNIT partners www.unitpartners.com
1416 Larkin St.
San Francisco, CA 94109, United States
Tel 415 409 0000
info@unitpartners.com

Vanderbyl Design www.vanderbyl.com
171 Second St., Floor 2
San Francisco, CA 94105, United States
Tel 415 543 8447
mail@vanderbyl.com

VSA Partners www.vsapartners.com
95 Morton St, Floor 7, New York
NY 10014, United States
Tel 877 422 1311
info@vsapartners.com

Webster www.websterdesign.com
5060 Dodge St., Suite 2000
Omaha, NE 68132, United States
Tel 402 551 0503
www.websterdesign.com

Wharf China Estates Limited
www.wharfholdings.com
Floor 16, Ocean Centre, Harbour City
Canton Road, Kowloon, Hong Kong
Tel 852 2118 8118
ir@wharfholdings.com

The White Room Inc.
www.thewhiteroom.ca
1173 Dundas St. E., Studio 235
Toronto, ON M4M 3PI, Canada
Tel 416 901 7736
info@thewhiteroom.ca

zünpartners www.zunpartners.com
676 N. LaSalle St.
Chicago, IL 60654, United States
Tel 312 951 5533
bill.ferdinand@zunpartners.com

SILVER

12 points
Yubileynaya 3a, 28 Elektrostal
Moscow, 144009, Russia
Tel 7 9030063152
puzakovm@mail.ru

21XDESIGN www.21xdesign.com
2713 S. Kent Road
Broomall, PA 19008, United States
Tel 610 325 5422
info@21xdesign.com

3 Advertising www.3advertising.com
1550 Mercantile Ave. NE., Floor 2
Albuquerque, NM 87107, United States
Tel 505 293 2333
info@3advertising.com

Adam Yarbrough
www.adamyarbrough.com
adamwayneyarbrough@gmail.com

Agent
440 N. Eighth St.
Lincoln, NE 68506, United States
Tel 402 486 3200
jrawlings@agentthinking.com

AkzoNobel www.akzonobel.com
Strawinskylaan 2555
P.O. Box 75730, Amsterdam 1070 AS
The Netherlands
Tel 31 65 208 1904
caroline.meads@akzonobel.com

Alchemy Branding Group
www.alchemygp.com
1441 E. Maple, Suite 303
Troy, MI 48083, United States
Tel 248 840 1139
elixir@alchemygp.com

Alok Nanda & Company
www.aloknanda.com
Great Western Building, Floor 2
Shahid Bhagat Singh Road
Fort, Mumbai 400 001, India
Tel 91 022 40 66 6333
info@aloknanda.com

Alt Group
16-18 Mackelvie St., Grey Lynn
P.O. Box 47873, Ponsonby 1144
Auckland, New Zealand
Tel 64 9 360 3910
info@altgroup.net

ĀNIMA www.anima.com.ec
Olmedo OE5-56 Y Benalcazar
Quito, Ecuador
Tel 02 228 3781
jazz@anima.com.ec

animalopoeia www.annatype.com
www.michaelparndt.com
148 W. 70th St., Suite 16
New York, NY 10023, United States
mpa@michaelparndt.com

Another Collective
www.anothercollective.pt
Rua Conde São Salvador, 352 7º
4450-264, Matosinhos, Portugal
Tel 351 229 370 019
info@anothercollective.pt

Apatitex www.etsy.com/shop/apatitex
Hong Kong

Arcadian Studio
www.oliverbonacinievents.com
401 Bay St.
Toronto, ON M5H 2Y4, Canada
Tel 416 364 1211
events@oliverbonacini.com

Arnold Worldwide www.arn.com
205 Hudson St.
New York, NY 10013, United States
Tel 212 463 1000
pgrossman@am.com

ARSONAL www.arsonal.com
3524 Hayden Ave.
Culver City, CA 90232, United States
Tel 310 815 8824
info@arsonal.com

Bailey Lauerman
www.baileylauerman.com
1299 Famam St., Suite 930
Omaha, NE 68102, United States
Tel 402 514 9400
hello@baileylauerman.com

**Beacon communications k.k.
graphic studio**
JR Tokyu Meguro Bldg.
3-1-1 Kami-Osaki, Shinagawa-ku
Tokyo, 141-0021, Japan
Tel +81-3-5437-7560
noritsugu.endo@beaconcom.co.jp

BEAMY www.wearebeamy.com
49 Fuxing W. Road No. 7, Floor 1
Xuhui District, Shanghai, 200031, China
Tel 86 21 5423 3675
hello@wearebeamy.com

Beierarbeit www.beierarbeit.de
Sattelmeyerweg 1
33609 Bielefeld, Germany
Tel 49 521 7871030
chb@beierarbeit.de

Brand & Deliver
www.brandanddeliver.co.uk
5-6 Mallow St.
London, EC1Y 8RQ, United Kingdom
Tel 44 20 7490 9200
info@brandanddeliver.co.uk

Brandient www.brandient.com
4 Varsovia St., Floor 2
Bucharest, 011807, Romania
Tel 40 212 308 173
europe@brandient.com

Breakaway
Tel 617 399 0635
smaney@breakaway.com

BRIGADE www.wearebrigade.com
251 Russell St.
Hadley, MA 01035, United States
Tel 413 387 0307
kirsten@wearebrigade.com

Butler Looney Design
2400 10th St., Berkeley, CA 94710
United States
Tel 214 215 2504
butlerlooney@me.com

Concrete Design Communications
www.concrete.ca
2 Silver Ave.
Toronto, ON M6R 3A2, Canada
Tel 416 534 9960
mail@concrete.ca

Corcoran Design Lab
www.corcoran.gwu.edu
500 17th St. NW.
Washington DC, 20006
United States
corcoranschool@gwu.edu

Counterform studio
Claragraben 78, Basel CH-4058
Switzerland
cf.eremenko@gmail.com

Cue, Inc. www.designcue.com
520 Nicollet Mall, Suite 500
Minneapolis, MN 55402
United States
Tel 612 465 0030
info@designcue.com

DD&A mhcstudio.viewbook.com
61 Pierrepont St., Suite 43
Brooklyn, NY 11201, United States
Tel 917 439 6516
williamtaylordesign@me.com

design center

Design is Play www.designisplay.com
855 Folsom St., Suite 931
San Francisco, CA 94107
United States
Tel 415 505 6242
studio@designisplay.com

The Designory Inc.
www.designory.com
211 E. Ocean Blvd., Suite 100
Long Beach, CA 90802
United States
Tel 562 624 0200
inquire@designory.com

Dessein www.dessein.com.au
130 Aberdeen St., Northbridge
WA 6003, Australia
Tel 08 9228 0661
geoff@dessein.com.au

Dixon Schwabl
www.dixonschwabl.com
1595 Moseley Road
Victor, NY 14564, United States
Tel 583 383 0380
mark_stone@dixonschwabl.com

Doe-Anderson Advertising
www.doeanderson.com
620 W. Main St.
Louisville, KY 40202, United States
Tel 502 589 1700
info@doeanderson.com

Dunn&Co. www.dunn-co.com
202 S. 22nd St., Suite 202
Tampa, FL 33605, United States
Tel 813 350 7990
hello@dunn-co.com

Dyal and Partners
www.dyalpartners.com
1801 Lavaca St., Suite 115
Austin, TX 78701, United States
Tel 512 810 3311
cfraser@dyalpartners.com

Fluid www.getfluid.com
1065 S. 500 W.
Bountiful, UT 84010, United States
Tel 801 295 9820
info@getfluid.com

Frost*collective
www.frostcollective.com.au
1/15 Foster St.
Surry Hills, NSW 2010, Australia
Tel 61 2 9280 4233
hello@frostcollective.com.au

FutureBrand www.futurebrand.com
Floor 8 Oxford House, Taikoo Place
979 King's Road, Quarry Bay
Hong Kong
Tel 852 2501 7979
Jochan@futurebrand.com

Goods & Services Branding
www.gsbranding.com
488 Wellington St. W., Suite 302
Toronto, ON M5V 1E3, Canada
Tel 416 703 9142
cgeorge@gsbranding.com

GQ www.gq.com
One World Trade Center
New York, NY 10007, United States
Tel 212 286 2860
info@gq.com

Graham Hanson Design
www.grahamhanson.com
475 Park Ave. S.
New York, NY 10016, United States
Tel 212 481 2858
info@grahamhanson.com

HUB STRATEGY & COMMUNICATION
www.hubsanfrancisco.com
39 Mesa St., Suite 212
San Francisco, CA 94129
United States
Tel 415 561 4345
jill@hubsanfrancisco.com

IF Studio www.ifstudiony.com
670 Broadway, Suite 301
New York, NY 10012, United States
Tel 212 334 3465
info@ifstudiony.com

João Machado Design
www.joaomachado.com
R. Padre Xavier Coutinho 125
4150 Porto, Portugal
Tel 351 22 610 6772
geral@joaomachado.com

Joel Derksen www.jderksen.com
joel@jderksen.com

Karousel www.karousel.is
Bragagata 29, Reykjavik, 101, Iceland
Tel 354 864 6640
hello@karousel.is

Ken-Tsai Lee studio / Taiwan TECH
17F No. 31, Lane 49, Alley Chung
Cheng St., Peitou Taipei 112, Taiwan
Tel 886 2 2893 5236
leekentsai@gmail.com

Kitchen Leo Burnett www.kitchen.no
Drammensveien 130
Bygning B8, 3. etg, PO Box 114 Skøyen
0212 Oslo, Norway
Tel 47 90 63 44 00
helle.hakonsen@kitchen.no

KMS TEAM GmbH www.kms-team.com
Toelzer Strasse 2c, 81379 Munich
Germany
Tel 49 0 89 490 411 0
info@kms-team.com

KNOCK, inc www.knockinc.com
1315 Glenwood Ave.
Minneapolis, MN 55405, United States
Tel 612 333 6511
hello@knockinc.com

Konstantin Eremenko
Claragraben 78 , Basel CH-4058
Switzerland
cf.eremenko@gmail.com

Landor www.landor.com
230 Park Ave S.
New York, NY 10003, United States
Tel 212 614 5050
hello@landor.com

Level Design Group www.levelnyc.com
57 W. 28th St., Floor 3
New York, NY 10001, United States
Tel 212 594 2522
design@levelnyc.com

Lewis Communications
www.lewiscommunications.com
600 Corporate Parkway, Suite 200
Birmingham, AL 35242
United States
Tel 205 980 0774
newbiz@lewiscommunications.com

Leynivopnid www.leynivopnid.is
Klapparstig 16, Reykjavik 101, Iceland
Tel 354 840 0220
einar@leynivopnid.is

lg2boutique www.lg2boutique.com
3575 Saint-Laurent Blvd., Suite 900
Montréal, QC H2X 2T7, Canada
Tel 514 281 8901
info.boutique@lg2.com

Lippincott www.lippincott.com
499 Park Ave.
New York, NY 10022, United States
Tel 212 521 0000
info@lippincott.com

LLOYD&CO www.lloydandco.com
180 Varick St., Suite 1018
New York, NY 10014, United States
Tel 212 414 3100
info@lloydandco.com

McCandliss and Campbell
www.mccandlissandcampbell.com
36 Cooper Square, Floor 4
New York, NY 10003, United States
Tel 917 326 1843
t@9threads.com

McCann Worldgroup
www.mccannworldgroup.com
622 Third Ave.
New York, NY 10017, United States
Tel 646 865 2000
alex.lubar@mccann.com

McMillan Group
www.mcmillangroup.com
25 Otter Trail
Westport, CT 06880, United States
Tel 203 227 8696
info@mcmillangroup

Mermaid, Inc. www.mermaidnyc.com
41 Union Square W.
New York, NY 10003, United States
Tel 212 337 0707
sharon@mermaidnyc.com

Michael Schwab Studio
www.michaelschwab.com
108 Tamalpais Ave.
San Anselmo, CA 94960, United States
Tel 415 257 5792
studio@michaelschwab.com

MiresBall www.miresball.com
2605 State St.
San Diego, CA 92103, United States
Tel 619 234 6631
mackenzie@miresball.com

Morla Design www.morladesign.com
1008A Pennsylvania Ave.
San Francisco, CA 94107
United States
Tel 415 543 6548
info@morladesign.com

Nesnadny + Schwartz
www.nsideas.com
10803 Magnolia Drive
New York, NY 10012, 11040
United States
Tel 212 673 8888
hello@NSideas.com

Next Brand Strategy & Design
www.nextbrand.com.au
25 Fifth St.
Black Rock, VIC 3193, Australia
Tel 61 3 9008 8988
info@nextbrand.com.au

Odear www.odear.se
Bolinders Plan 2, Family Business
Stockholm 112 24, Sweden
Tel 46 70 738 21 01
contact@odear.se

omdr Co.,Ltd. www.omdr.co.jp
Unit 202 6-12-10, Minami Aoyama
Minato-ku, Tokyo, 107-0062, Japan
Tel 81 3 5766 3410
contact@omdr.co.jp

Pentagram Design, Austin
www.pentagram.com
1508 W. Fifth St.
Austin, Texas 78704, United States
Tel 512 476 3076
howdy@texas.pentagram.com

Peter Schmidt Group
www.peter-schmidt-group.de
Westhafenplatz 8
60327 Frankfurt am Main, Germany
Tel 49 69 8509930
gregor.ade@peter-schmidt-group.de

PH Studio www.ph-studio.com
530 Miller Ave.
Mill Valley, CA 94941, United States
Tel 415 380 5034
info@ph-studio.com

Poulin + Morris Inc.
www.poulinmorris.com
46 White St., Floor 2
New York, NY 10013, United States
Tel 212 675 1332
info@poulinmorris.com

Raineri Design Srl
www.raineridesign.com
Via Nazario Sauro, 3/C
25128 Brescia, Italy
Tel 39 30 381740
info@raineridesign.com

Ralph Appelbaum Associates, Inc.
www.raany.com
88 Pine St.
New York, NY 10005, United States
Tel 212 334 8200
nycontact@raai.com

Red Peak www.redpeakgroup.com
560 Broadway, Suite 506
New York, NY 10012, United States
Tel 212 792 8930
sdevlin@redpeakgroup.com

Rodgers Townsend DDB
www.rodgerstownsend.com
100 Clark Ave.
St. Louis, MO 63102, United States
Tel 314 259 8319
terri.french@rodgerstownsend.com

Sandstrom Partners
www.sandstrompartners.com
808 SW. Third Ave., Suite 610
Portland, OR 97204, United States
Tel 503 248 9466
info@sandstrompartners.com

Savannah College of Art and Design
www.scad.edu
342 Bull St.
Savannah, GA 31402, United States
Tel 915 525 5100
contact@scad.edu

Sayuri Studio, Inc.
Unit 5-10-27, Minami Azabu
Minato-ku, Tokyo, Japan
Tel 81 3 5447 2201
sayuri@ss-studio.com

Schaefer Advertising Co.
www.schaeferadvertising.com
1228 S. Adams St.
Fort Worth, TX 76104, United States
Tel 817 226 4332
info@schaeferadvertising.com

Sedley Place www.sedley-place.com
68 Venn St.
London, SW4 0AX, United Kingdom
Tel 44 20 7627 5777
fiona.nash@sedley-place.co.uk

Seymourpowell
www.seymourpowell.com
265 Merton Road, London
SW18 5JS, United Kingdom
Tel 44 20 7381 6433
design@seymourpowell.com

Shadia Design
www.shadiadesign.com.au
207 The Parade, Norwood
SA 5067, Australia
Tel 61 8 8332 9922
shadia@shadiadesign.com.au

SML Design
www.smallmediumlarge.com.au
87 Cubitt St., Cremorne
VIC 3121, Australia
Tel 61 403 814 001
vanessa@smldesign.com.au

Steven Taylor Associates
317, The Plaza, 535 King's Road,
London, SW10 0SZ
United Kingdom
Tel 44 20 7351 2345
info@steventaylorassociates.com

Stranger & Stranger
www.strangerandstranger.com
239 Bleecker St., Floor 2
New York, NY 10014, United States
Tel 212 625 2441
nyc@strangerandstranger.com

Studio 32 North
www.studio32north.com
3315 Thorn St.
San Diego, CA 92104, United States
Tel 415 6113 4136
sallie@studio32north.com

Studio 5 Designs, Inc. (Manila)
28 Paseo de Roxas St., Bel Air Village
Makati City, Metro Manila
D1209, Philippines
Tel 63 917 885 5507
marilyo@yahoo.com

Studio C, Creative Consultants
www.studioccreative.com
411 Hackensack Ave.
Continental Plaza, Suite 200
Hackensack, NJ 07601, United States
Tel 201 881 0019
info@studioCcreative.com

Subplot Design Inc. www.subplot.com
The Mercantile Building,
318 Homer St., Suite 301
Vancouver, BC V6B 2V2, Canada
Tel 604 685 2990
info@subplot.com

Sur La Table Creative Department
www.surlatable.com
6100 Fourth Ave. S., Suite 500
Seattle, WA 98108, United States
Tel 206 613 6264
dean.fuller@surlatable.com

SVIDesign Ltd www.svidesign.com
124 Westbourne Studios
242 Acklam Road, London
W10 5JJ, United Kingdom
Tel 44 20 7524 7808
studio@svidesign.com

Target Creative www.target.com
33 S. Sixth St.
Minneapolis, MN 55402, United States
Tel 612 304 8723

The General Design Co.
www.generaldesignco.com
1624 Q St. NW.
Washington DC, 20009, United States
Tel 202 640 1842
hello@generaldesignco.com

The Martin Agency
www.martinagency.com
One Shockoe Plaza
Richmond, VA 23219, United States
Tel 804 698 8000
kerry.ayers@martinagency.com

The White Room Inc.
www.thewhiteroom.ca
1173 Dundas St. E., Studio 235
Toronto, ON M4M 3P1, Canada
Tel 416 901 7736
info@thewhiteroom.ca

Tiny Hunter www.tinyhunter.com.au
20 Hutchinson St., Level 1
Surry Hills, NSW 2010
Australia
Tel 61 2 9360 0099

Toben www.toben.com.au
48 Chippen St., Level 3
Chippendale, NSW 2008
Australia
Tel 61 2 8060 1136
hello@toben.com.au

TOKY www.toky.com
3001 Locust St., Floor 2
St. Louis, MO 63103, United States
Tel 314 534 2000
info@toky.com

TOPPAN PRINTING CO., LTD.
www.toppan.co.jp
9F 1-3-3, Suido Bunkyo-ku, Tokyo
112-8531, Japan
Tel 81 3 5840 2192
mescal@mac.com

Trasluz / Ánima www.anima.com.ec
Olmedo OE5-56 y Benalcazar
Guanguiltagua N38 57 y a Tola
Quito Pichincha 170401 Ecuador
Tel 593 2 228 3781
pabloiturralde@mac.com

Trinity Brand Group
www.trinitybrandgroup.com
817 Bancroft Way
Berkeley, CA 94710, United States
Tel 510 982 7177
hello@trinitybrandgroup.com

Turner Duckworth Design:
San Francisco London
www.turnerduckworth.com
831 Montgomery St.
San Francisco, CA 94133, United States
Tel 415 675 7777
amy@turnerduckworth.com

Underline Studio
www.underlinestudio.com
247 Wallace Ave.
Toronto, ON M6H 1V5, Canada
Tel 416 341 0475
info@underlinestudio.com

Vanderbyl Design
www.vanderbyl.com
171 Second St., Floor 2,
San Francisco, CA 94105, United States
Tel 415 543 8447
mail@vanderbyl.com

Venti Caratteruzzi
www.venticaratteruzzi.com
via Principe di Villafranca
83 Palermo 90141, Italy
Tel 39 0919820530
venticaratteruzzi@fastwebnet.it

Vigor www.vigorbranding.com
927 Lenox Hill Court NE.
Atlanta, GA 30324, United States
Tel 678 861 8119
info@vigorbranding.com

VSA Partners www.vsapartners.com
95 Morton St., Floor 7
New York, NY 10014, United States
Tel 877 422 1311
info@vsapartners.com

Wallace Church, Inc
www.wallacechurch.com
330 E. 48th St., Suite 1
New York, NY 10017, United States
Tel 212 755 2903
info@wallacechurch.com

Webster www.websterdesign.com
5060 Dodge St., Suite 2000
Omaha, NE 68132, United States
Tel 402 551 0503
www.websterdesign.com

White Studio www.whitestudio.pt
Rua Alexandre Braga, 94 1E Porto
4000-049, Portugal
Tel +351 226169080
editions@whitestudio.pt

Xose Teiga Studio
Av. de Rodriguez de Viguri, 31, 15703
Santiago de Compostela, A Coruña
Spain
Tel 34 607 15 55 21
xoseteiga@gmail.com

Zulu Alpha Kilo www.zulualphakilo.com
260 King St. E., Suite B101
Toronto, ON M5A 4L5, Canada
Tel 416 777 9858
awards@zulualphakilo.com

21xdesign
50,000feet
601 Design, Inc.
Actia
Adam Yarbrough
Addison
Agent
Airbnb
Alchemy Brand Group
Allemann Almquist & Jones
Am I Collective
Amanda Acevedo
Anagraphic
ÁNIMA
ASCD Creative
Bailey Lauerman
beacon communications k.k.
 graphic studio
beierarbeit
BEK Design
Bohan Advertising
Brand & Deliver
Brandient
Cepheid
Chase Design Group
Chemi Montes Design
Christie's Creative Studios EMERI
Christopher Hadden Design
CLAUS KOCH™
Communication Design SAL
Concrete Design Communications
Constrata
Counterform studio
CP+B
Craig-Teerlink Design

CREATIVE ASSOCIATES INC.
Cushman Creative
DESIGN DIRECTORS
Design is Play
Design Ranch
designory.
Dessein
Doe-Anderson Advertising
Dorian
Dunn&Co.
Dyal and Partners
El Paso, Galería de Comunicación
Elephant In The Room
Emerson, Wajdowicz Studios
Experiences For Mankind
flake company
FleishmanHillard Creative
Founded by Design Pty Ltd
Frank Design Strategy
FUDGE Creative
Gauger + Associates
Gee + Chung Design
Gensler
GQ
Graham Hanson Design
Greenhaus
Haluk Tuncay Design
Hans Design
hgDesign NYC
Hiebing
HOOK
Hornall Anderson
Hoyne
Hub Strategy & Communication
hufax arts

IF Studio
Interbrand
Jill Misawa
João Machado Design
Joaquim Cheong Design
John McNeil Studio
John Sposato Design & Illustration
Jones Knowles Ritchie Inc.
Julian Peploe Studio
Karousel
Ken-tasi Lee design lab/Taiwan TECH
KMD Inc.
KMS TEAM
KNOCK
Konstantin Eremenko
Landor Milan
Lattke und Lattke GmbH
Lewis Communications
lg2boutique
Lin Shaobin Design
Lippincott
McCandliss and Campbell
McCann Rome
McCann Worldgroup
Mermaid, Inc.
Michael Schwab Studio
MiresBall
Moroch
Neiman Marcus Group Services
Neon
Nesnadny + Schwartz
NONOBJECT
omdr Co.,Ltd.
Opus Design LLC
Pentagram Design

PepsiCo Design & Innovation
Peter Schmidt Group
PH Studio
Publicis Kaplan Thaler
Randy Clark Graphic Design
Red Peak, Dalton Maag Design Team
Rick Slusher
Riordon Design
Rocket @ Starz
Rodgers Townsend DDB
Roger Archbold
Sadowsky Berlin
Sandstrom Partners
Scott Adams Design Associates
Self
Shadia Design
Sherry Matthews Advocacy Marketing
Shine United
SML Design
Spela Draslar s. p.
Squires & Company
SteersMcGillanEves Design Ltd
Steven Taylor Associates
Stranger & Stranger
Studio 5 Designs, Inc. (Manila)
Studio C, Creative Consultants
Studio DES
Studio Scott
StudioNorth
studiotwentysix2
Subplot Design
Sumo
susanjouflas.com
Target Creative
Tetsuro Minorikawa

Texas State University Art + Design
 Department
The Community
The General Design Co.
The Martin Agency
The Rivalry
The White Room Inc.
Tiny Hunter
Toben
Todd Childers
TOKY
Toni Damkoehler
Touchwood Design
Trinity Brand Group
Turner Duckworth Design:
 London & San Francisco
Uhlein Design
Ultra Creative
UNIT partners
University of La Verne
 Creative Services
Vanderbyl Design
Ventress Design Works
Vogue Italia
VSA Partners, Inc.
Wael Morcos
Webster
Wharf China Estates Limited
William Raineri
Windows Brand Studio
WONGDOODY
WPA Pinfold
xose teiga,studio.
Zulu Alpha Kilo

THE HENLEY COLLEGE LIBRARY

Visit Graphis.com to view top design work within each Country, State or Province.

A designer knows he has achieved perfection not when there is nothing left to add, but when there is nothing left to take away.

Antoine de Saint-Exupéry, *French Aristocrat, Writer, Poet, and Pioneering Aviator (1900-1944)*

Poster Annual 2016

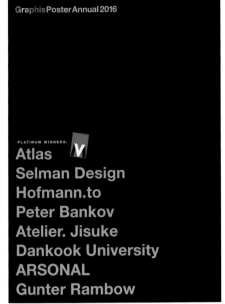

GraphisPosterAnnual2016

PLATINUM WINNERS:

Atlas
Selman Design
Hofmann.to
Peter Bankov
Atelier. Jisuke
Dankook University
ARSONAL
Gunter Rambow

2015
Hardcover: 256 pages
200-plus color illustrations

Trim: 8.5 x 11.75"
ISBN: 978-1-932026-95-5
US $120

Most of the eye-arresting work in this book is presented with full-page images from some of the accomplished poster designers from across the world. Also featured is an interview with Kari Savoleinen, Curator of the Lahti Poster Museum in Finland, with an internationally famed collection of more than 70,000 contemporary and historic posters. Also included are Platinum award-winning entries from **Gunter Rambow, Atelier. Jisuke, ARSONAL, Atlas, Bankov, Dankook University, Hofmann. to, and Selman Design**. The book features 8 Platinum, 72 Gold, and 100 Silver winners in full color, each with credits and commentary about the process behind the posters. An invaluable resource and practical reference, Poster Annual 2016 is an important library addition for designers, art directors, clients, photographers, educators and students.

Typography 3

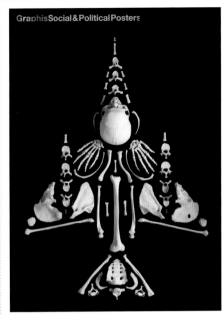

GraphisTypography3

PLATINUM WINNERS:

Atelier Bundi AG
Concept Arts Inc.
Graham Hanson Design
Gunter Rambow
Hofmann.to
Joaquim Cheong Design
Marcus King
Shin Matsunaga
Stranger & Stranger
Visual Dialogue

2015
Hardcover: 256 pages
200-plus color illustrations

Trim: 8.5 x 11.75"
ISBN: 978-1-932026-97-9
US $120

Graphis Typography 3 presents work of some of the top international design and type design masters in the industry. We feature typography from the past 100 years, and an index of top independent type foundries. Highlighted is the work of typography and design masters **Ikko Tanaka, Gerard Huerta, Steve Sandstrom, Fred Woodward, DJ Stout and Stephan Bundi**, in addition to Platinum, Gold, and Silver winning work from **Michael Schwab, Toshiaki & Hisa Ide, Gunter Rambow, Kit Hinrichs and Armando Milanim**, among others. The book also includes a historic timeline of typography, and articles about the Didot font family, the differences between lettering, and the AIGA Minnesota Poster. Typography 3 is an indispensable inspiration resource for designers, type foundries, and students of type and design.

Social&Political Protest Posters

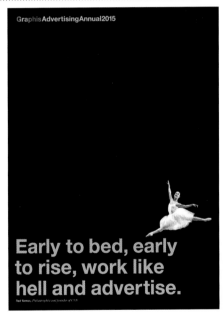

GraphisSocial&PoliticalPosters

2015
Hardcover: 240 pages
200-plus color illustrations

Trim: 8.5 x 11.75"
ISBN: 978-1-932026-92-4
US $120

The problems of the world have generally never changed, and this book is cry from some of the world's top designers. The subjects confronted include anti-war, anti-violence, the environment, disasters, human rights, health and politics. There are also statements from numerous historic figures, such as Jefferson, Adams, Gandhi, Mandela and Eisenhower. All the winning posters are afforded a full-page presentation and all entrants will have their work archived on our website. There are Platinum, Gold & Silver award-winning posters from numerous countries around the world. Winning designers include **Takashi Akiyama, Andrea Castelletti, Pascal Colrat, Paul Garbett, Milton Glaser, Mark Gowing, Boris Ljubicic, Finn Nygaard, Harry Pearce, Ryand Russell, Jan Sabach and Hajime Tsushima**, among many others.

New Talent Annual 2015

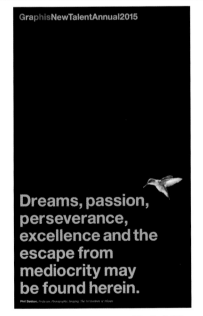

GraphisNewTalentAnnual2015

Dreams, passion, perseverance, excellence and the escape from mediocrity may be found herein.

Phil Dekker, *Professor, Photographic Imaging, The Art Institute of Atlanta*

2015
Hardcover: 256 pages
200-plus color illustrations

Trim: 7 x 11.75"
ISBN: 978-1-932026-94-8
US $120

This is collection of the year's best work from Professors who have challenged and inspired their students to create outstanding work in Advertising, Design, Photography and Film. In this year's edition, we feature commentary from the students of platinum-winning instructors: **Frank Anselmo, Jack Mariucci, Patrick Minassian, Robert Mackall, Jillian Coorey, Ryan Russell, Lanny Sommese, Hank Richardson, Josef Astor and Jessica Craig-Martin, Carin Goldberg and John Gall**. This book presents award-winning work, along with descriptions of the assignment, approach and results, which provides insight into the process of both the student and instructors. Additional medalists include, Adrian Pulfer, Vinny Tulley, Henry Hikima, Richard Wilde, Theron Moore, Kristin Sommese and Cassie Hester.

Photography Annual 2015

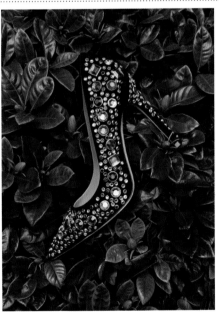

2015
Hardcover: 256 pages
200-plus color illustrations

Trim: 8.5 x 11.75"
ISBN: 978-1-932026-93-1
US $120

Platinum, Gold & Silver winners are presented in this book, including **Bill Diodato, Frank P. Wartenberg, Henry Leutwyler, Mark Zibert, Peter Arnold, Colin Faulkner, Marcin Muchalski and Terry Heffernan**, among others. Also featured are Q&A's with RJ Muna, a cutting edge San Francisco photographer, and Heinz Baumann, a conceptual and still life photographer. The book also includes descriptions of the assignment, approach and results of work, which provide insight into each photographer's creative process. Each winner is given a full-page presentation of their work. This is a must-have for anyone interested in successful, creative photography — photographers, agencies, students and fans alike. Up to 500 submissions will be archived permanently at graphis.com.

Advertising Annual 2015

GraphisAdvertisingAnnual2015

Early to bed, early to rise, work like hell and advertise.

Ted Turner, *Philanthropist and founder of CNN*

2015
Hardcover: 240 pages
200-plus color illustrations

Trim: 8.5 x 11.75"
ISBN: 978-1-932026-91-7
US $120

Featured are this year's Platinum, Gold & Silver winners, which includes **Lewis Communications, LLOYD&CO, The Richards Group, Doner Advertising, DeVito/Verdi, WONGDOODY and Dunn&Co**, among others. Also included are Q&A's with Butler, Shine, Stern & Partners CEO Greg Stern and executive creative director John Butler, who reveal some of their successful philosophies. The book also includes a description of the assignment, approach and result of the campaigns, which provides insight into the agency's creative process and how they met the needs of their clients. Graphis Platinum, Gold and Silver winning entries are an essential reference for advertising professionals, clients, students and designers interested in some of the great ideas this demanding profession offers.